000 32674 686.22
 HAL

AYLESBURY COLLEGE LIBRARY
OXFORD ROAD
AYLESBURY, BUCKS. HP21 8PD
Tel: 01296 588588

Please return book on or before last date stamped below

2 4 MAR 2003

2 3 FEB 2004
1 9 APR 2006

2 6 MAR 2007

TYPO HICS

AYLESBURY COLLEGE
LEARNING RESOURCES
CENTRE

D1382253

the art of typography from digital to dyeline

typographics 1

General Editor: Roger Walton

Typographics 1 is published here for the first time
with Typographics 2

Each title first published separately by
Hearst Books International. Now published by
HBI, a division of HarperCollins Publishers
10 East 53rd Street,
New York, NY 10022-5299,
United States of America

ISBN 0688-17875-8

Distributed in the United States and Canada by:
North Light Books, an imprint of
F & W Publications, Inc.,
4700 East Galbraith Road
Cincinnati, Ohio 45236
Tel: (800) 289-0963

Each title first published separately
in Germany by NIPPAN
Nippon Shuppan Hanbai
Deutschland GmbH
Krefelder Str. 85
D-40549 Düsseldorf
Telephone: (0211) 5048089
Fax: (0211) 5049326

ISBN 3-931884-54-6

Typographics 1
Copyright © Hearst Books International and
Duncan Baird Publishers 1995
Text copyright © Duncan Baird Publishers 1995

The captions, information, and artwork in this book
have been supplied by the designers. All works have
been reproduced on the condition that they are
reproduced with the knowledge and prior consent
of the designers, client company, and/or other
interested parties. No responsibility is accepted by
the Publishers for any infringement of copyright
arising out of the publication.

While every effort has been made to ensure
accuracy, the Publishers cannot under any
circumstances accept responsibility for errors
or omissions.

All rights reserved. No part of this book may be
reproduced in any form or by any electronic or
mechanical means, including information storage
and retrieval systems, without permission in
writing from the copyright owners, except by a
reviewer who may quote brief passages in a review.

Edited and Designed by
Duncan Baird Publishers
Castle House
75-76 Wells Street
London W1T 3QH

Designers: Karen Wilks (Typographics 1); and
Gabriella Le Grazie (Typographics 2)
Editor: Lucy Rix (Typographics 1 and 2)

10 9 8 7 6 5 4 3 2

Typeset in Rotis Sans Serif (Typographics 1); and
Letter Gothic MT (Typographics 2)
Color reproduction by Colourscan, Singapore
Printed in China

NOTE: Dimensions for spread formats are single page
measurements; all measurements are for width
followed by height.

656.22
W.AL
00032674
AYLESBURY COLLEGE
LEARNING RESOURCES
CENTRE

Foreword 6

Type as Composition: 10
designing with words

Type Plus: 72
the alliance of type and imagery

Type as Text: 150
typography as a medium for writer
and reader

Type Itself: 194
recent font designs

Index 220
List of Colleges 224
Acknowledgments 224
Future Editions 224

FOREWORD

Typographics 1 is the first volume in a series that will bring together recent examples of innovative, experimental, and outstanding work from professional and student typographers. The book is divided into four categories:

Type as Composition, showing designs that use minimal quantities of text;

Type Plus, the alliance of type and imagery;

Type as Text, compositions based on continuous text;

Type Itself, featuring recent font designs.

The aim of the book is not only to generate inspiration and promote debate, but also to focus attention on the current state of typography. The selection of work, made from over 1,000 submissions, was a difficult but rewarding task – the final choice represents the tremendous range and diversity of contemporary design.

In recent years, advanced technology and changing economic conditions have had a profound impact on the teaching and practice of typography. The widespread use of computers has brought about a significant increase in the number of self-initiated publications, many examples of which are shown here. The production costs of a modest publication seem now to

8

be within the reach of the many rather than the few. This, alongside the imaginative use of digital technology and a wide range of printing processes, has generated a wonderful diversity of material. The work included in this book has been reproduced using litho presses, letter-press printing, silk-screen printing, color xeroxing, monochrome xeroxing, the fax machine, and dyeline processing.

Designers currently enjoy the luxury of access to highly sophisticated technology as well as to older printing and production techniques. It may be that this diversity will be short-lived as the older tools gradually become obsolete. There is, for example, only one design in this book that was originated entirely on a manual typewriter. The authentic typewriter typeface, with all its eccentricities and imperfections, and its connotations of journalistic urgency, is just one form of typographic language that will soon disappear. But the replacement of mechanical techniques

by electronic processes does not necessarily restrict creativity or limit choice. Digital technology opens up new possibilities for the designer: typeface development, the positioning and repositioning of the elements of a design, the sourcing and manipulation of images, and the unprecedented speed with which change can be effected, combine in the new environment in which today's designers work. The dramatic pace of technological change also ensures that new techniques are discovered daily – by the time this book is printed, the software with which it was created will already have been modified.

Future editions of **Typographics** will continue to focus on changing trends in design and will draw on an even broader range of sources. As technological developments further influence typography, and as older traditions are reassessed and reappropriated, the most inspiring results will be celebrated here.

R.W.

type as composition

type as composition

type as composition

designer
Dirk van Dooren

design company
Tomato

country of origin
UK

work description
Typo-psalm, a page from
Jetset magazine

dimensions
268 x 345 mm
10½ x 13⅝ in

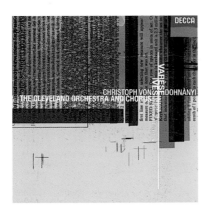

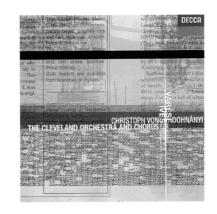

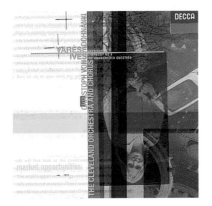

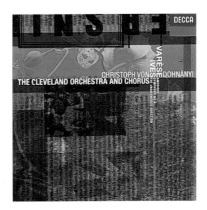

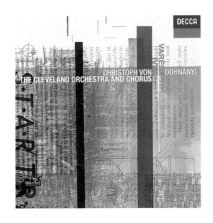

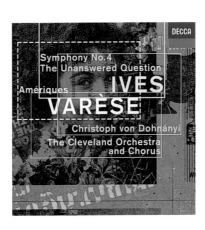

designer
Nick Bell

art director
David Smart

design company
Nick Bell

country of origin
UK

work description
CD cover visuals for
Decca records, using
multi-printed litho press
set-up sheets that allude
to the layered nature of
Ives' music

dimensions
120 x 120 mm
4¾ x 4¾ in

13

designer
Melle Hammer

design company
Plus X

country of origin
The Netherlands

work description
Case binding of the book
Een Vaste Vriend, for
Contact Publishers

dimensions
shown actual size
128 x 190 mm
5 x 7½ in

14

een vaste vriend

roman
Mirjam Windrich

designer
Irma Boom

design company
Irma Boom

country of origin
The Netherlands

work description
Card-coverings from *The Spine*, publications bound together to form a single volume, published by De Appel Foundation

dimensions
300 x 210 mm
11⁷⁄₈ x 8¼ in

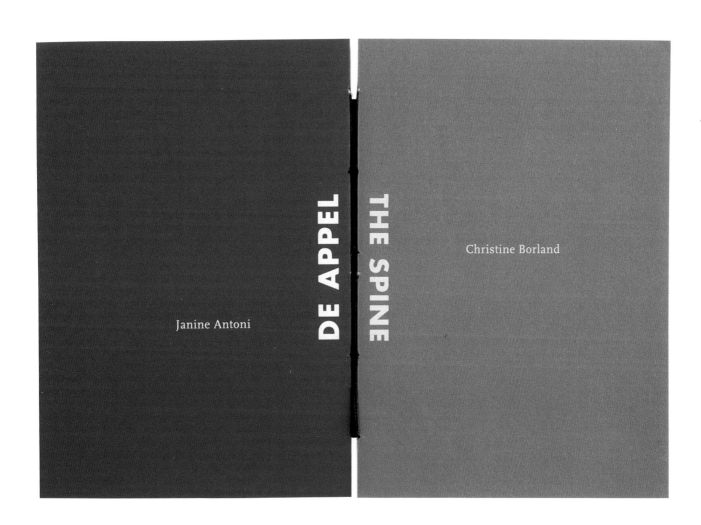

designers
Mario A. Mirelez
Jim Ross

16 **art director**
Mario A. Mirelez

design company
Mirelez/Ross Inc.

country of origin
USA

work description
Exhibition catalog cover,
for the Herron Gallery

dimensions
280 x 227 mm
11 x 8⅞ in

ADRIAN PIPER · CARL POPE HERRON GALLERY

Adrian Piper
Carl Pope

designer
Robbie Mahoney

college
Central Saint Martin's
College of Art and Design,
London

country of origin
UK

work description
Spreads from an
experimental magazine

dimensions
445 x 297 mm
17½ x 11¾ in

John Zorn

My background was mostly classical, studying composition, and through that I went towards improvisation - through having performers mess up my pieces to the extent that I felt I should do them myself, and have them realised in such a way that they couldn't be messed up.

other places

Other windows

designer
André Baldinger

college
Atelier National de
Création Typographique,
Paris

18

country of origin
France

work description
Poster for the Atelier
National de Création
Typographique

dimensions
274 x 410 mm
10¾ x 16⅛ in

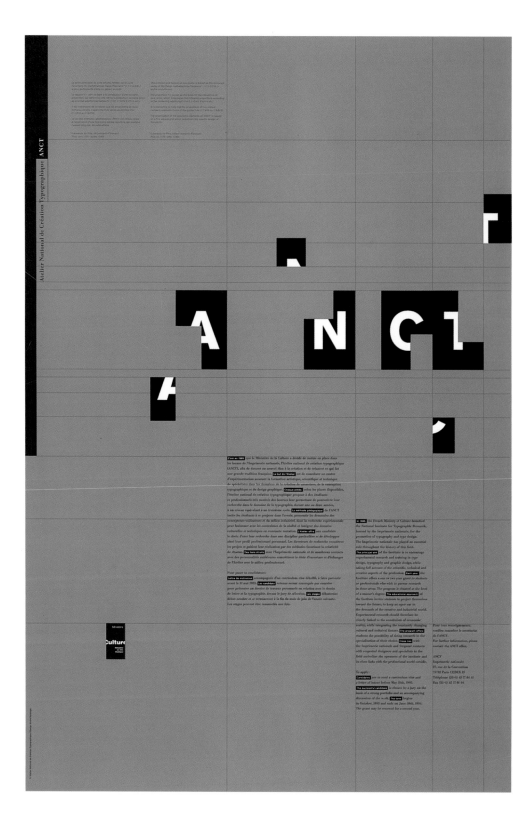

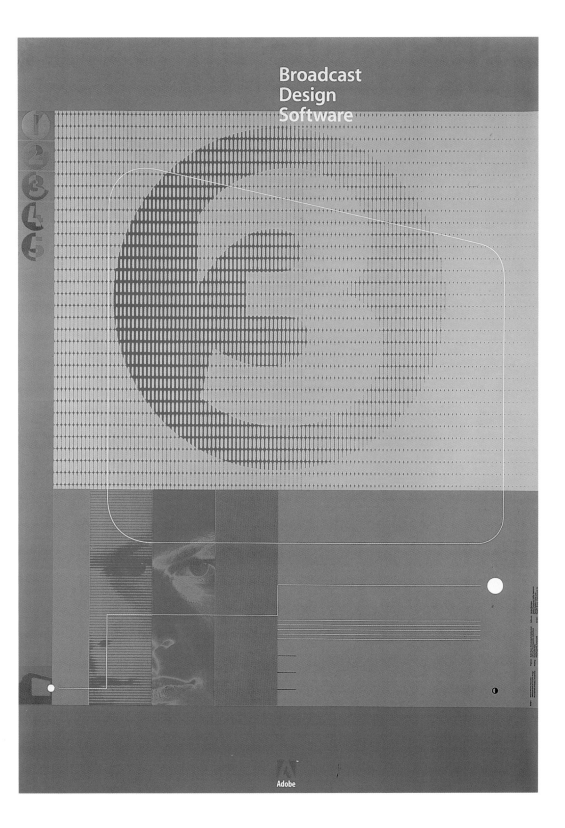

designer
Michael Renner

photographer
Michael Renner

design company
Michael Renner Design

country of origin
Switzerland

work description
*Broadcast Design
Software*, a poster for
Adobe Systems Inc.

dimensions
905 x 1275 mm
35⅝ x 50 in

designer
Irma Boom

design company
Irma Boom

country of origin
The Netherlands

work description
Case binding from an
exhibition catalog, *Round
Transparency, Marian
Bijlenga 1993*

dimensions
198 x 198 mm
7¾ x 7¾ in

designer
Irma Boom

design company
Irma Boom

photographer
Ido Menco

country of origin
The Netherlands

work description
Case binding from an
exhibition catalog, *Tomas
Rajlich*

dimensions
161 x 208 mm
6⅜ x 8¼ in

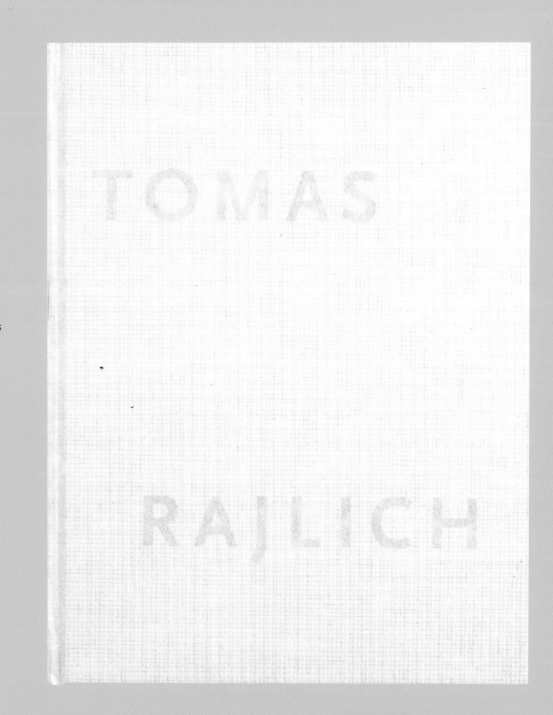

Columbia Architecture Planning Preservation

Lectures

6:30pm
Wood Auditorium
Avery Hall

Doors open to
the general public
6:15pm

Frank Lloyd Wright's Wasmuth Folios: Representing the Ideal

February 12-March 12
Arthur Ross Architecture Gallery
Buell Hall
Tuesday-Saturday 12-6:00pm

Frank Lloyd Wright: The Perspective of a New Generation

A symposium co-sponsored by
The Museum of Modern Art
and the Buell Center for the Study
of American Architecture

Friday, February 18, 7:00pm
at The Museum of Modern Art
Philip Johnson, Neil Levine

Saturday, February 19, 9:00am
at Columbia University
Wood Auditorium, Avery Hall
Terence Riley, Anthony Alofsin,
James O'Gorman, Kenneth Framp-
ton, Leo Marx, Alice T. Friedman,
Kathryn Smith

For further information
please call 854-8165

Building for Nature

The Architectural Landscapes
of Walter Burley Griffin
and Marion Lucy Mahony

January 31-February 26
100 Level
Avery Hall

Duneray

Spatial sequences generated
from a Cubist Painting:
computer drawings from
Duncan Brown

February 7-March 12
400 Level
Avery Hall

Traces of Islamic Architecture in Spain

Photographs by Anita Ayerbe

February 28-March 26
200 Level
Avery Hall

Luigi Snozzi

Buildings and projects
1958-1992

March 9-April 9
100 Level
Avery Hall

Student Projects

Current work

April 11-May 21
Buell Hall, Avery Hall

designer
Willi Kunz

design company
Willi Kunz Associates

22

country of origin
USA

work description
Lecture series posters for
Columbia University,
Graduate School of
Architecture, Planning,
and Preservation, New
York

dimensions
304 x 610 mm
12 x 24 in

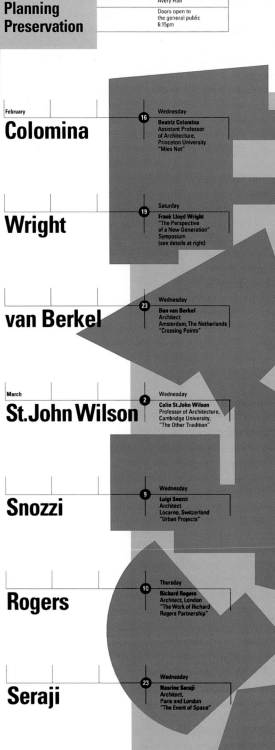

February

Colomina

16 Wednesday
Beatriz Colomina
Assistant Professor
of Architecture,
Princeton University
"Mies Not"

Wright

19 Saturday
Frank Lloyd Wright
"The Perspective
of a New Generation"
Symposium
(see details at right)

van Berkel

23 Wednesday
Ben van Berkel
Architect
Amsterdam, The Netherlands
"Crossing Points"

March

St. John Wilson

2 Wednesday
Colin St.John Wilson
Professor of Architecture,
Cambridge University,
"The Other Tradition"

Snozzi

9 Wednesday
Luigi Snozzi
Architect
Locarno, Switzerland
"Urban Projects"

Rogers

10 Thursday
Richard Rogers
Architect, London
"The Work of Richard
Rogers Partnership"

Seraji

23 Wednesday
Nasrine Seraji
Architect,
Paris and London
"The Event of Space"

Kipnis

30 Wednesday
Jeffrey Kipnis
Director of Graduate Design
Architectural Association
London
"The End of an -age"

April

Cook

18 Monday
Peter Cook
Bartlett Professor of
Architecture, The Bartlett
School of Architecture,
Building, Environmental
Design and Planning, London
"Instead of Greenery"

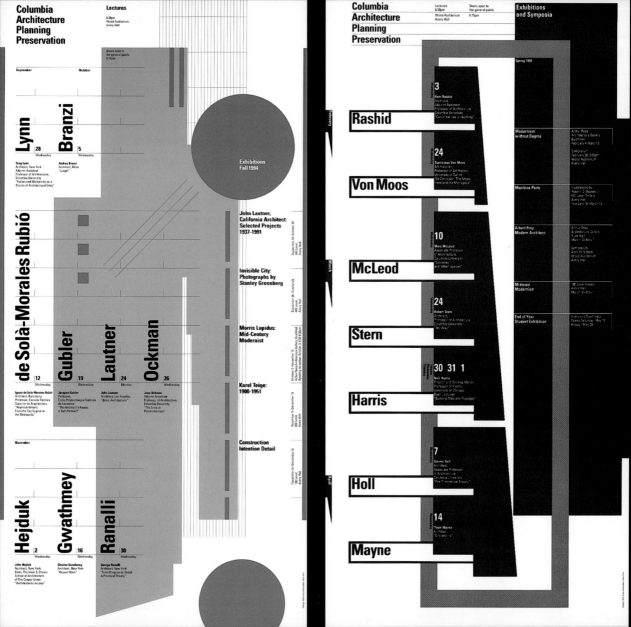

designer
Sloy

art director
Rudy VanderLans

design company
Emigre Graphics

country of origin
USA

work description
Advertising poster for
Emigre Graphics,
handlettered by Sloy

dimensions
830 x 570 mm
32⅝ x 22½ in

24

emigre emigre

designer
Luca Dotti

college
Atelier Nationale de
Création Typographique,
Paris

country of origin
France

work description
Poster for Atelier
Nationale de Création
Typographique

dimensions
1700 x 596 mm
66⅞ x 23½ in

© Atelier National de Création Typographique / Design: Luca Dotti

In 1985, the French Ministry of Culture launched the National Institute for Typographic Research, housed by the Imprimerie nationale, for the promotion of typography and type design.

The Imprimerie Nationale has played an essential role throughout the history in this field.

The principal aim of the Institute is to encourage experimental research and training in type design, typography and graphic design, while taking full account of the scientific, technical and creative aspects of the profession.

Each year, the Institute offers a one or two year grant to students or professionals who wish to pursue research in these areas.

The program is situated at the level of a master's degree.

The educational approach of the Institute invites students to project themselves toward the future, to keep an open ear to the demands of the creative and industrial world. Experimental research should therefore be closely linked to the constraints of economic reality, while integrating the constantly changing cultural and technical factors.

The program offers students the possibility of doing research in the specialization of their choice.

Close ties with the Imprimerie nationale and frequent contacts with renowned designers and specialists in the field underline the openness of the institute and its close links with the professional world outside.

To apply:
Candidates are to send a curriculum vitae and a letter of interest before May 31st, 1994.
The successful candidate is chosen by a jury on the basis of a strong portfolio and an accompanying discussion of the work.
The term begins in October, 1994 and ends on June 30th, 1995.
The grant may be renewed for a second year.

designer
The Designers Republic

country of origin
UK

work description
Dos Dedos Mis Amigos LP
by Pop Will Eat Itself
(Infectious Records, UK);
center of a gatefold
sleeve

dimensions
430 x 310 mm
16⅞ x 12¼ in

designer
The Designers Republic

country of origin
UK

work description
Aaah EP by Sun Electric,
(R & S records, Belgium);
center of a gatefold
sleeve

dimensions
430 x 310 mm
16⅞ x 12¼ in

29

designer
Caroline Pauchant

college
Ecole Nationale
Supérieure des Arts
Décoratifs, Paris

tutor
Philippe Apeloig

country of origin
France

work description
Qu'est ce que tu dis?, a
project based on a poem
by Raymond Queneau

dimensions
180 x 261 mm
7⅛ x 10¼ in

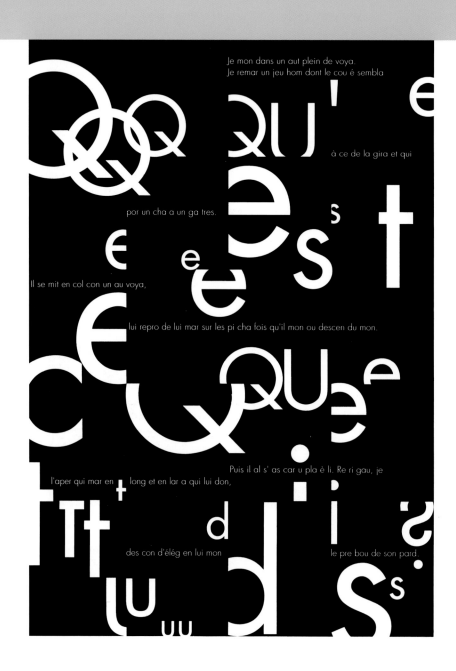

Déjeuner le matin
Il a mis le café
il a mis le lait
dans la tasse de café
il a mis le sucre
dans le café au lait
avec la petite cuillère
il l'a tourné
il a bu le café au lait

et il a reposé la tasse
sans me parler
il a allumé
une cigarette
il a fait des rondes
avec la fumée
il a mis les cendres
dans le cendrier
sans me parler

sans me regarder
il s'est levé
il a mis son chapeau
sur la tête
il a mis son
manteau de pluie
parce qu'il pleuvait
et il est parti
sous la pluie

silence

sans une parole
sans me regarder
et moi j'ai pris ma
tête dans ma main
et j'ai pleuré.
Jacques Prévert

«qui parle avec moi?»

**Nous sommes
des muets
dans le monde
des muets.**

**Donc c'est à nous
de faire l'effort
d'apprendre leur
langage des signes
pour communiquer
avec eux.**

designer
Anje Booken

college
Ecole Nationale
Supérieure des Arts
Décoratifs, Paris

tutor
Philippe Apeloig

country of origin
France

work description
Muets/Silence, a project
based on a poem by
Jacques Prévert

dimensions
170 x 220 mm
6¾ x 8⅝ in

31

designer
Christophe Ambry

college
Ecole Nationale
Supérieure des Arts
Décoratifs, Paris

tutor
Philippe Apeloig

country of origin
France

work description
Project on Dyslexia

dimensions
200 x 303 mm
7⁷⁄₈ x 11⁷⁄₈ in

32

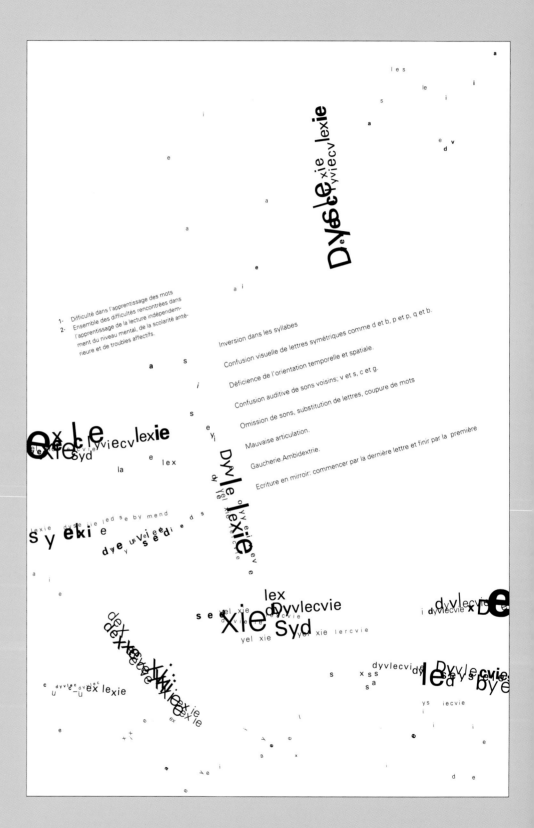

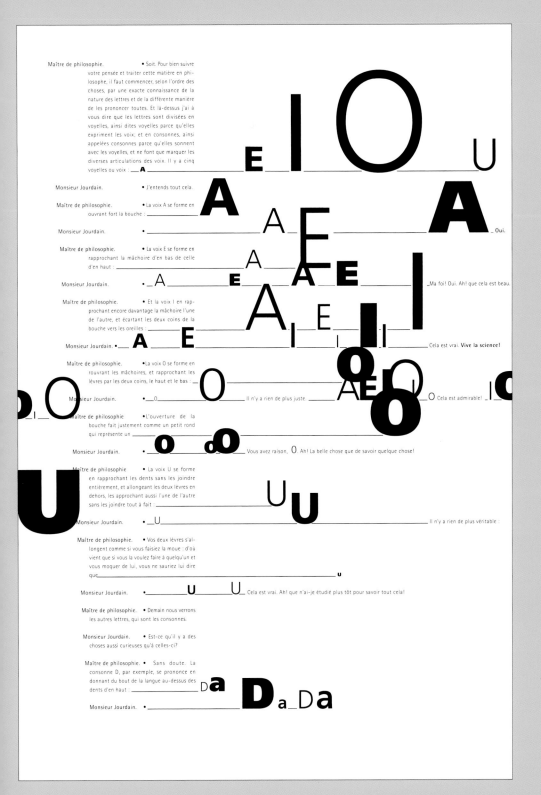

Maître de philosophie. • Soit. Pour bien suivre votre pensée et traiter cette matière en philosophe, il faut commencer, selon l'ordre des choses, par une exacte connaissance de la nature des lettres et de la différente manière de les prononcer toutes. Et là-dessus j'ai à vous dire que les lettres sont divisées en voyelles, ainsi dites voyelles parce qu'elles expriment les voix; et en consonnes, ainsi appelées consonnes parce qu'elles sonnent avec les voyelles, et ne font que marquer les diverses articulations des voix. Il y a cinq voyelles ou voix : __A

Monsieur Jourdain. • J'entends tout cela.

Maître de philosophie. • La voix A se forme en ouvrant fort la bouche : _____

Monsieur Jourdain. • _____ Oui.

Maître de philosophie. • La voix E se forme en rapprochant la mâchoire d'en bas de celle d'en haut : __

Monsieur Jourdain. •_A_____ Ma foi! Oui. Ah! que cela est beau.

Maître de philosophie. • Et la voix I en rapprochant encore davantage la mâchoire l'une de l'autre, et écartant les deux coins de la bouche vers les oreilles : __

Monsieur Jourdain. • _____ Cela est vrai. **Vive la science!**

Maître de philosophie. •La voix O se forme en rouvrant les mâchoires, et rapprochant les lèvres par les deux coins, le haut et le bas : __

Monsieur Jourdain. •___O_____ Il n'y a rien de plus juste. _____ O Cela est admirable! _I_

Maître de philosophie. • L'ouverture de la bouche fait justement comme un petit rond qui représente un

Monsieur Jourdain. • ___o_____ Vous avez raison, O. Ah! La belle chose que de savoir quelque chose!

Maître de philosophie. • La voix U se forme en rapprochant les dents sans les joindre entièrement, et allongeant les deux lèvres en dehors, les approchant aussi l'une de l'autre sans les joindre tout à fait : __

Monsieur Jourdain. • _U_____ Il n'y a rien de plus véritable :

Maître de philosophie. • Vos deux lèvres s'allongent comme si vous faisiez la moue : d'où vient que si vous la voulez faire à quelqu'un et vous moquer de lui, vous ne sauriez lui dire que_____ u

Monsieur Jourdain. •_____U_____U_ Cela est vrai. Ah! que n'ai-je étudié plus tôt pour savoir tout cela!

Maître de philosophie. • Demain nous verrons les autres lettres, qui sont les consonnes.

Monsieur Jourdain. • Est-ce qu'il y a des choses aussi curieuses qu'à celles-ci?

Maître de philosophie. • Sans doute. La consonne D, par exemple, se prononce en donnant du bout de la langue au-dessus des dents d'en haut : _____Da_Da

Monsieur Jourdain. •_____Da_Da

designer
Jérôme Mouscadet

college
Ecole Nationale
Supérieure des Arts
Décoratifs, Paris

tutor
Philippe Apeloig

country of origin
France

work description
AEIOU, a project based on *Le Bourgeois Gentilhomme*, a play by Molière

dimensions
244 x 360 mm
9⅝ x 14⅛ in

designer
Dirk van Dooren

design company
Tomato

country of origin
UK

work description
Detail from a poster
for the Institute of
Contemporary Art,
London

dimensions
550 x 510 mm
21 ⅝ x 20 in

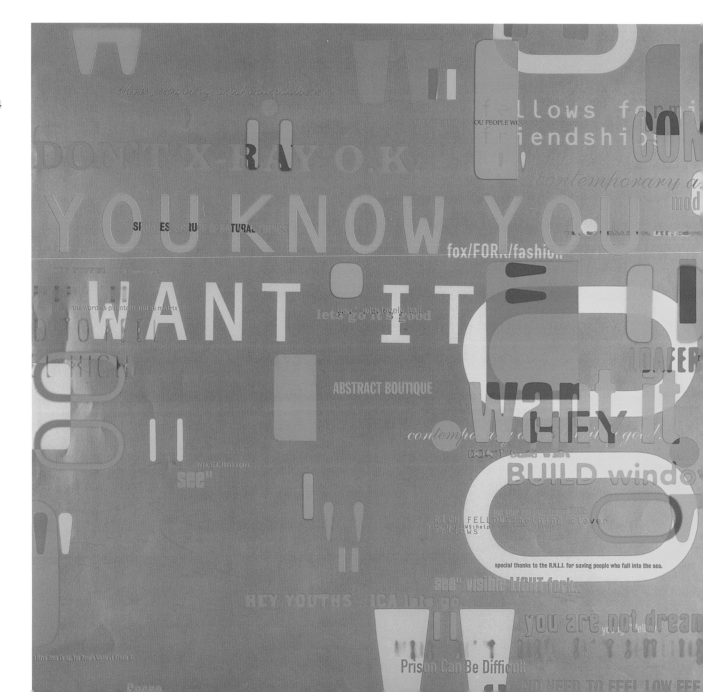

designers
Lies Ros
Rob Schröder

design company
Wild Plakken

country of origin
The Netherlands

work description
The last poster of the
Dutch Anti-Apartheid
Movement, announcing
an event to celebrate the
end of apartheid in South
Africa: BLANK (white)
and BLACK (black)
cooperating

dimensions
594 x 840 mm
23⅜ x 33 in

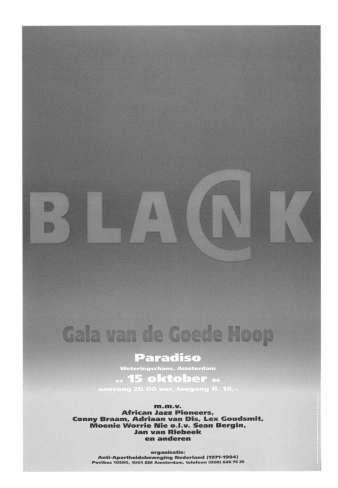

designer
Melle Hammer

design company
Plus X

country of origin
The Netherlands

work description
Het Ontbrekend Teken [*The Missing Sign*], a poster

dimensions
605 x 280 mm
23¾ x 11 in

zaterdag 10 december
aanvang: 20.00 u.
Stichting Perdu,
Kerkstra 391
Toegan ƒ 7.50
Tel. 6234874
'Het ontbreken
door de vakklas
typografie van
Gerrit Rietveld
samen met Stichting Perdu en
veertien auteurs

designer
Karen Wilks

design company
Karen Wilks Associates

country of origin
UK

work description
One from a set of four
self-promotional
postcards for 1994

dimensions
105 x 148 mm
4⅛ x 5⅞ in

karen wilks

designer
Karen Wilks

design company
Karen Wilks Associates

country of origin
UK

work description
One from a set of four
self-promotional
postcards for 1995

dimensions
148 x 105 mm
5⁷⁄₈ x 4¹⁄₈ in

designer
Huw Morgan

country of origin
UK

work description
Idiot Boy, a project for
the Royal College of Art,
London, that explores
attitudes toward the
mentally ill

dimensions
1524 x 1016 mm
60 x 40 in

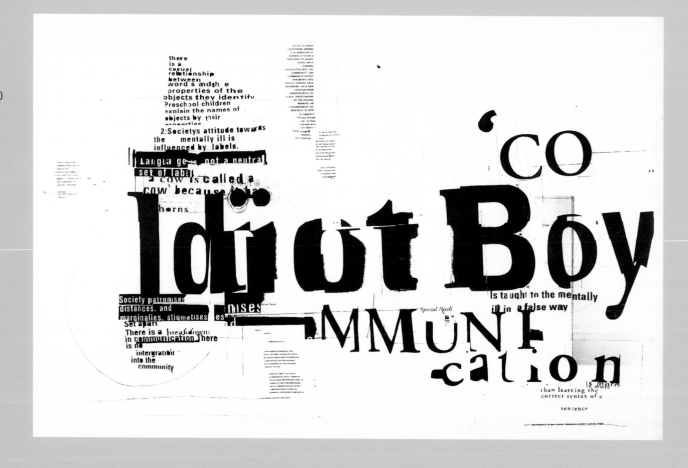

design

INTERNSHIP

$400—500 WEEKLY

The Disney Store, Inc.

SUBMIT RESUME AND COVER LETTER TO STUDENT AFFAIRS

SEE WILHEMINE SCHAEFFER FOR DETAILS

designers
Michael Worthington
Christa Skinner

college
California Institute of
the Arts

41

country of origin
USA

work description
*Internship: The Disney
Store Inc.*, a poster

dimensions
280 x 431 mm
11 x 17 in

designers
Betina Muller
Birgit Tummers
Claudia Trauer
Nauka Kirschner
Petra Reisdorf

design company
Atelier

country of origin
Germany

work description
Berliner Sommernacht der Lyrik, third in a series of posters for the annual summernight of lyric poetry, read in the garden of the Berlin Literaturwerkstatt [literature workshop]

dimensions
840 x 594 mm
33⅛ x 23⅜ in

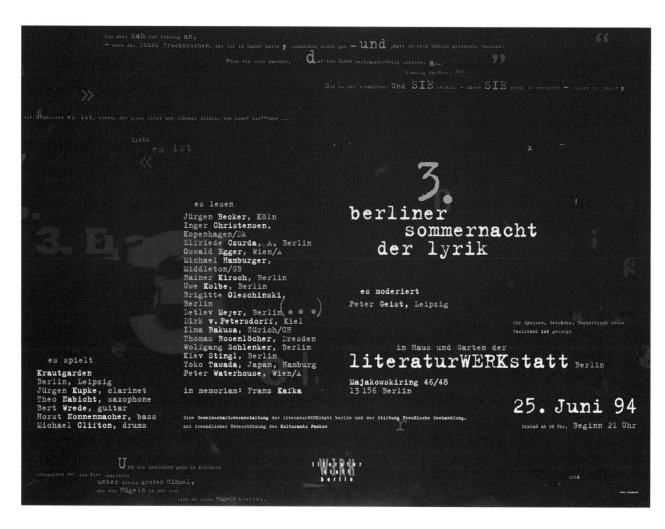

designer
Jim Ross

design company
Mirelez/Ross Inc.

country of origin
USA

work description
Clayfest No. 8, an
exhibition poster

dimensions
660 x 874 mm
25⅜ x 34⅜ in

HERRON GALLERY
Indianapolis Center for Contemporary Art

CLAYFEST No. 8

A Juried Biennial of

INDIANA CERAMIC ARTISTS

and

AMACO SELECTS: TEN YEARS OF CERAMIC WORKSHOPS

DECEMBER *5, 1992* - JANUARY *8, 1993*

HERRON SCHOOL OF ART
1701 N. PENNSYLVANIA ST.
INDIANAPOLIS, IN. 46202
317 920-2420

MONDAY - THURSDAY
10:00 AM TO 7:00 PM
FRIDAY 10:00 AM TO 5:00 PM

AMACO 73 ANNIVERSARY

IUPUI

IIAC

These exhibitions are funded in part by The Mary Howes
Woodsmall Foundation, American Art Clay Co., Inc., the Friends
of Herron, the Indiana Arts Commission and the National
Endowment for the Arts.

designers
Karl Hyde
John Warwicker

design company
Tomato

country of origin
UK

work description
Spreads and details from
the book *Skyscraper*, for
Booth-Clibborn publishers

dimensions
205 x 297 mm
8¹⁄₈ x 11³⁄₄ in

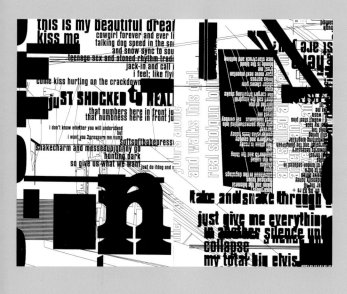

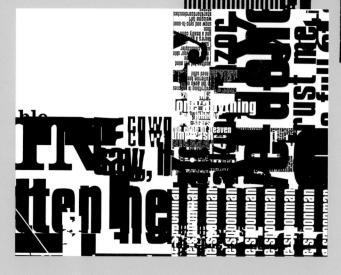

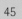

45

designers
Fernando Gutiérrez
Pablo Martín

photographer
Marie Espeus

art director
Fernando Gutiérrez

design company
Martín & Gutiérrez

country of origin
Spain

work description
Front cover, cover verso,
title, and opening page of
text from an exhibition
catalog

dimensions
165 x 295 mm
6½ x 11⅝ in

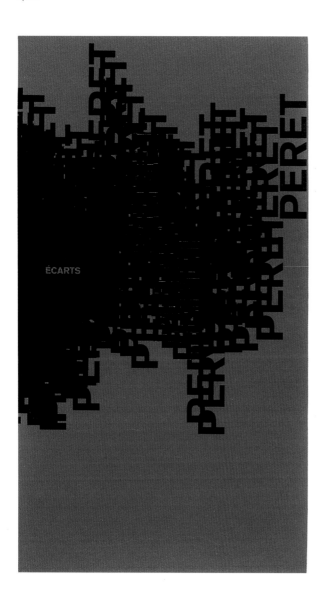

ÉCARTS

PERET

SEPTEMBRE NOVEMBRE 1994

LE MONDE DE L'ART

PARIS

Dans

la hiérarchie des acceptions du mot écart que l'on trouve dans Le Petit Robert celle avec que je m'identifie le plus est celle définie en numéro 6. On y lit: "Loc. adv. A L'ÉCART dans un endroit écarté, à une certaine distance (de la foule, d'un groupe). V. Loin : etc." Et pour préciser encore plus, c'est avec le sens: à une certaine distance que je m'identifie. Pointilleux je le suis, je tiens à signaler que ce n'est pas à distance de la foule ou d'un groupe que je veux me placer, au contraire, c'est plutôt à une certaine distance de moi-même que je cherche à me tenir. Jusqu'à présent, j'ai travaillé dans le graphisme et l'illustration. J'ai pu jouer avec toute sorte de moyens d'expression. J'ai touché à tout, ou presque, dans le domaine de la communication. Mais on n'exerce pas, impunément un métier pendant vingt cinq années sans s'en lasser. C'est donc un écart par rapport à une route professionnelle, qui, même variée, est trop balisée et n'arrive plus à combler les caprices de ma curiosité. Le seul moyen, pour moi, d'y échapper: d'éviter de suivre une impulsion, de travailler sur une intuition.

Malheureusement cela n'a pas été facile. Car ce n'est qu'avec une perspective différente que l'on peut essayer de se comprendre, de saisir l'ensemble. Se voir du dehors pour essayer de décortiquer ce qu'on est et ce qu'on fait, bien qu'être et faire soient inextricablement liés.

Tout d'abord pas l'effet de miroir, car rien de mieux qu'un miroir pour avoir une approche de soi-même. Un de mes amis soutient que l'on est obligé de cultiver les symboles dans lesquels on se reconnaît et qui nous constituent, que c'est dans la qualité des miroirs, dans lesquels on cherche notre reflet, que l'on peut récupérer notre fragile identité et mesurer notre taille. Je ne saurais être plus en accord. Les miroirs dans lesquels je suis allé me chercher ont été variés mais reliés par le fil invisible des affinités. Je leur en suis, aujourd'hui, très reconnaissant à ces miroirs, car ils ne m'ont pas seulement renvoyé mon image, ils me l'ont rendue enrichie de leurs trésors et en plus ils m'ont appris à regarder. À regarder, à voir et à apprécier la richesse cachée dans le plus humble des objets. ▶▶

designer
Alan Kitching

illustrator
Raffaella Fletcher

design company
The Typography Workshop

art director
Alan Kitching

country of origin
UK

work description
Posters and the slip-case
(overlaid, right) from *A
Brief History of Type* (self-
published)

dimensions
slip-case
210 x 210 mm
8¼ x 8¼ in

48

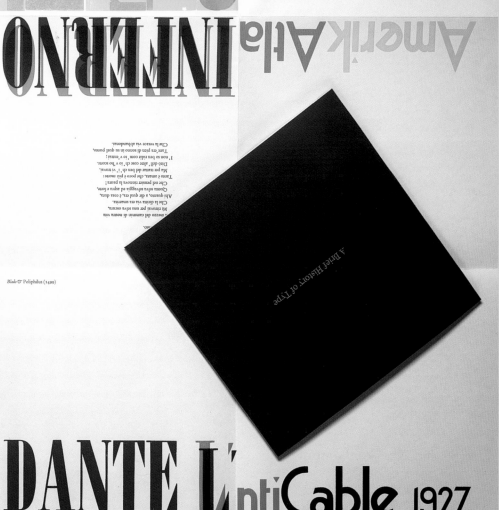

classic ['klaesik],
1. *adj*., -al, *adj*.
KLASSISCH.

Justus Erich Walbaum of Weimar 1800

INFERNO

Blado & Poliphilus (1499)

A Brief History of Type

DANTE L'

ntiCable. 1927

designer
Anukam Edward Opara

college
London College of
Printing and Distributive
Trades

country of origin
UK

work description
HET, a page from a
calendar of typographers
and designers: Julius
[June] represents the
Hungarian designer,
Moholy-Nagy, with the
typeface Akzindenz
Grotesk Regular

dimensions
1680 x 2376 mm
66⅛ x 93½ in

50

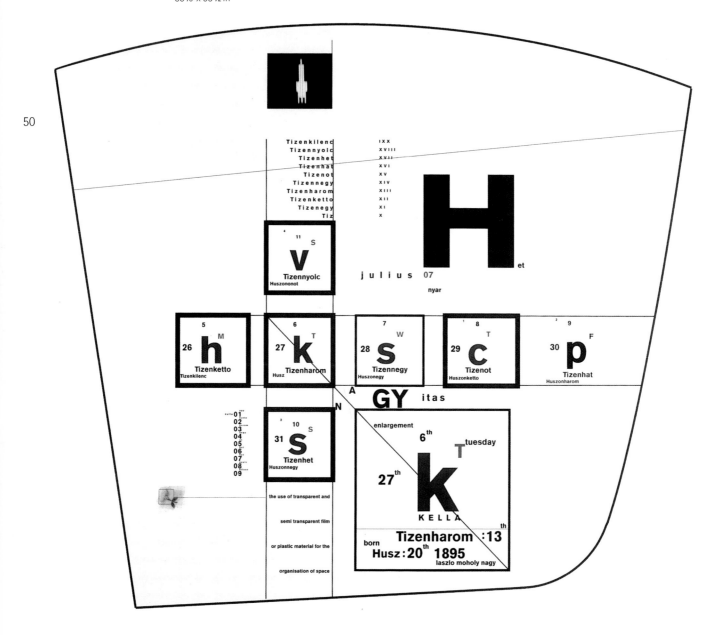

designer
David Harlan

college
California Institute of
the Arts

country of origin
USA

work description
Sketch for an information
system

dimensions
279 x 216 mm
11 x 8½ in

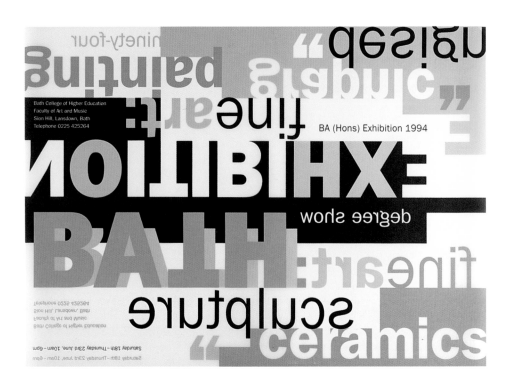

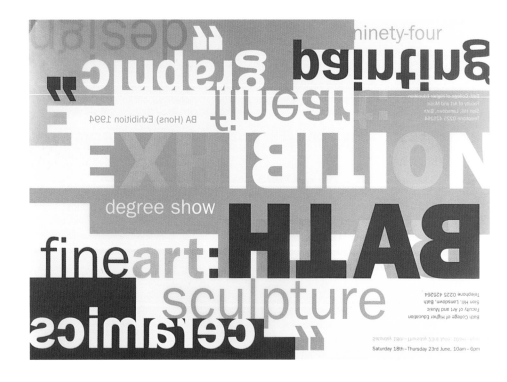

designer
Chris Roberts

college
Bath College of Higher
Education

52

country of origin
UK

work description
Front and back of a
double-sided degree show
poster, on tracing paper,
for Bath College

dimensions
594 x 420 mm
23⅜ x 16½ in

designer
Chris Roberts

college
Bath College of Higher
Education

country of origin
UK

work description
Lecture poster

dimensions
600 x 450 mm
23⅝ x 17¾ in

53

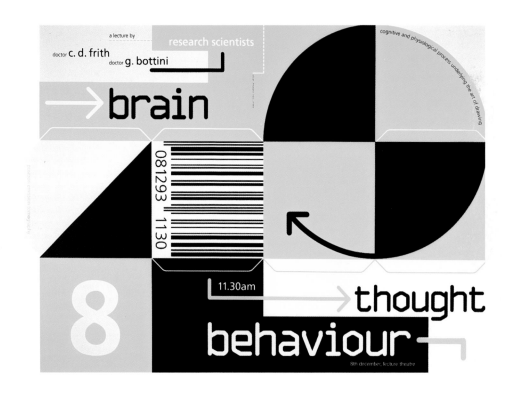

designer
Jörg Herzog

art director
Jörg Herzog

design company
Herzog Grafik und Design

country of origin
Germany

work description
Pages from a calendar

dimensions
420 x 594 mm
16½ x 23⅜ in

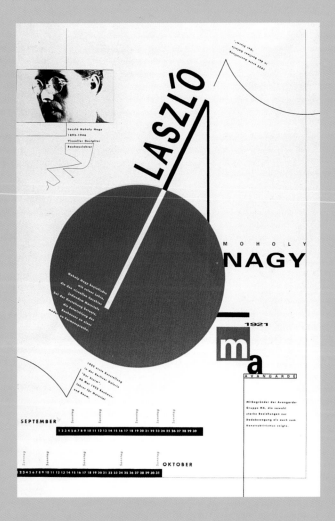

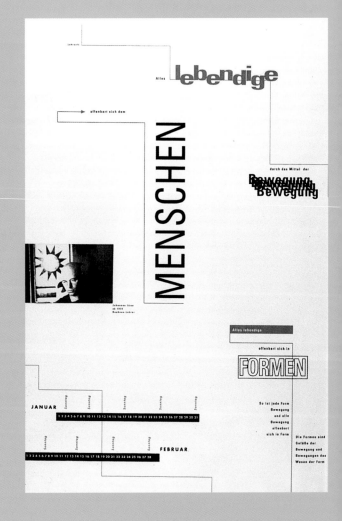

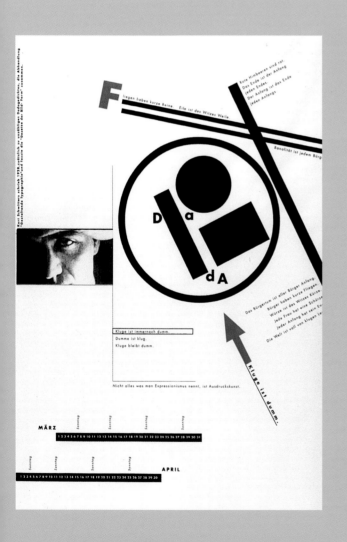

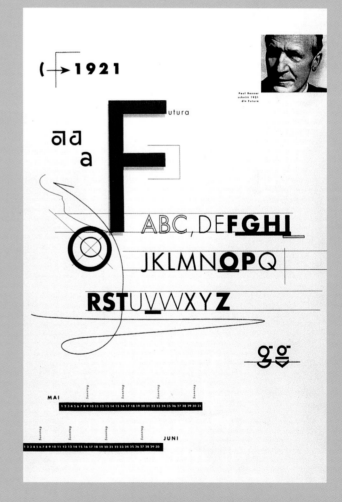

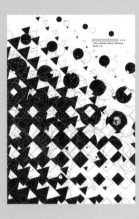

left and below

designer
Hans P. Brandt

design company
Total Design

country of origin
The Netherlands

work description
Front cover and spread
from the 1993 Annual
Report for Internationales
Design Zentrum, Berlin

dimensions
210 x 297 mm
8¼ x 11¾ in

56

right

designers
Weston Bingham
Chuck Rudy

design company
Deluxe

country of origin
USA

work description
Stationery for Deluxe
design company

dimensions
letterhead
215 x 280 mm
8½ x 11 in

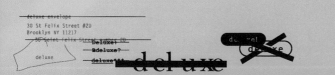

deluxe envelope
30 St Felix Street #2D
Brooklyn NY 11217
30 Saint Felix Street number 2D

deluxe

Deluxe!
Bdeluxe?
deluxe***

deluxe!
d e l u x e

05en
v.001

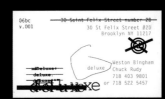

06bc
v.001

30 Saint Felix Street number 2D
30 St Felix Street #2D
Brooklyn NY 11217

xDeluxe!
deluxe:
deluxe**

deluxe

Weston Bingham
Chuck Rudy
718 403 9801
or 718 522 5457

deluxe

01,021h
v.001

Delux
30 St Felix Street 2D
718 403 9801
or 718 522 5457.

Bdeluxe!
Deluxe!
deluxe***
30 Saint Felix Street number 2D
30 St Felix Street #2D
Brooklyn NY 11217

deluxe
Weston Bingham
Chuck Rudy
718 403 9801
or 718 522 5457

designer
Neil Fletcher

design company
Pd-p

country of origin
UK

work description
Peaches and Cream, a
poster for Sheffield
Hallam University Union
of Students

dimensions
594 x 840 mm
5½ x 7⅛ in

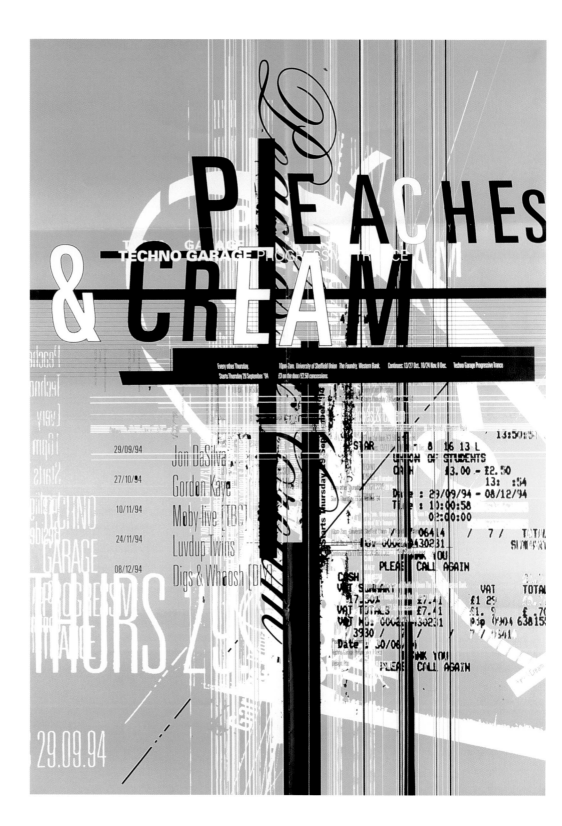

designers
Elisabeth Charman
Edwin Utermohlen

art directors
Elisabeth Charman
Edwin Utermohlen

design company
doubledagger

country of origin
USA

work description
Poster for the Herron
Gallery (unpublished)

dimensions
250 x 320 mm
9⅞ x 12⅝ in

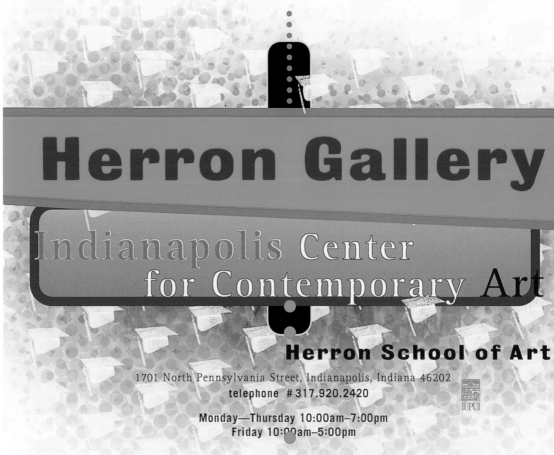

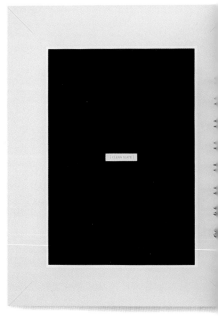

designers
Laura Lacy-Sholly
James Sholly

design company
Antenna

country of origin
USA

work description
Front cover and spreads from the *Indiana Civil Liberties Datebook*, an educational tool for the Indiana Civil Liberties Union with the theme "Who Decides?"

dimensions
140 x 180 mm
5½ x 7⅛ in

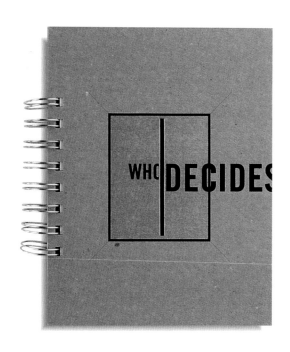

BEGIN HERE.

WHO DECIDES

[CLEAN SLATE]

JULY 1995

MON 31
Sanna Yoder

I wish that women, instead of being walking show-cases, instead of begging of their fathers and brothers the latest and gayest new bonnet, would ask of them their rights.
— Lucy Stone

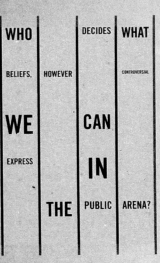

WHO · DECIDES · WHAT

BELIEFS, · HOWEVER · CONTROVERSIAL

WE · CAN

EXPRESS · IN

THE · PUBLIC · ARENA?

DEAR FRIEND OF THE INDIANA CIVIL LIBERTIES UNION

There's something inspiring about a new calendar:
365 blank spaces, all of them awaiting your plans,
aspirations and activities. . .

the promise of a fresh year and the chance to spend time more wisely.

(Or at least to try.)

I think there's something *awe-inspiring* about this new calendar. While it certainly will tell you what date to write at the top of your checks, the 1995 ICLU Datebook is so much more. It's a repository of wise words. It's a gathering of friends. It's a hard-working fundraiser. Most of all, it's a labor of love.

We're thrilled that you've chosen to make this book a part of your new year. We hope that you'll take the time to explore all that it holds. Notice the many bits of wisdom, two on each week, from the creative

thinkers and civil libertarians of the last few centuries. Deep in February—when you cannot rise to one more stark, gray day—just open your datebook. Oscar Wilde's commentary on truth will give you a jump-start.

Your new calendar brings together friends from around the state. Hoosiers of all ages and persuasions have given both the time and financial resources to make this project possible. Many have teamed up with colleagues to underwrite particular dates. Others have worked on producing the book. Still others apply themselves behind-the-scenes preserving and promoting the ideas represented in these pages.

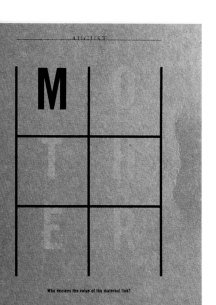

M O
T H
E R

Who decides the value of the maternal link?

62

designer
Shelley Stepp

college
California Institute of
the Arts

country of origin
USA

work description
Typographic assignments
based on poetic and
didactic texts

dimensions
254 x 254 mm
10 x 10 in

designer
Shelley Stepp

college
California Institute of
the Arts

country of origin
USA

work description
Studies with identical
texts – the changing
forms create new
meanings

dimensions
762 x 762 mm
30 x 30 in

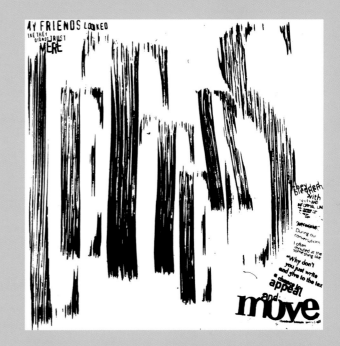

designer
Jan C. Almquist

art directors
Jan C. Almquist
Hans-U. Allemann

design company
Allemann Almquist &
Jones

country of origin
USA

work description
Front cover of
A Compelling Argument,
a brochure for the
Winchell Company,
printers

dimensions
158 x 292 mm
6¼ x 11½ in

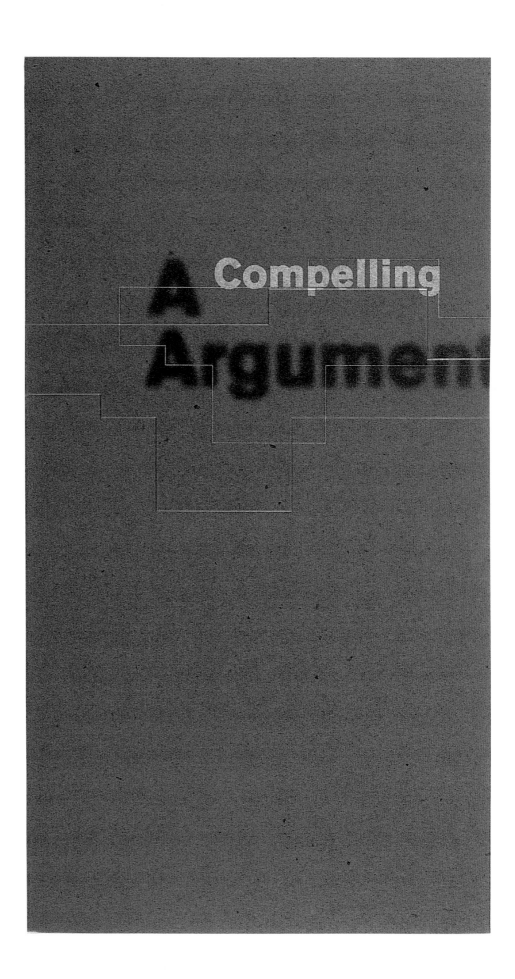

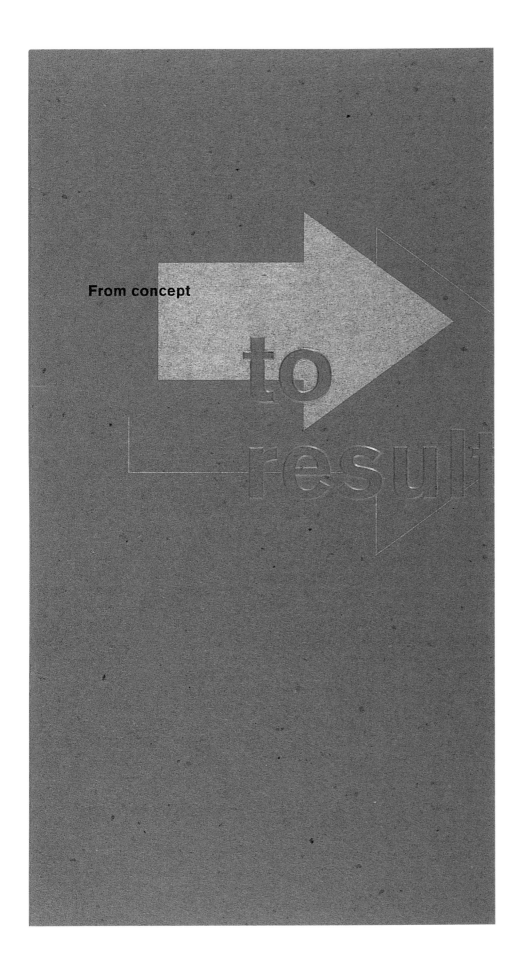

From concept to result

designers
Stephen Shackleford
Jan C. Almquist

art directors
Jan C. Almquist
Hans-U. Allemann

design company
Allemann Almquist &
Jones

country of origin
USA

work description
Front cover of *From
Concept to Result*, a
brochure for the Winchell
Company, printers

dimensions
158 x 292 mm
6¼ x 11½ in

65

designer
Christopher Ashworth

design company
Invisible

country of origin
UK

work description
Letterhead for Shaun
Bloodworth; designed for
a typewriter with a wide
carriage

dimensions
297 x 210 mm
11¾ x 8¼ in

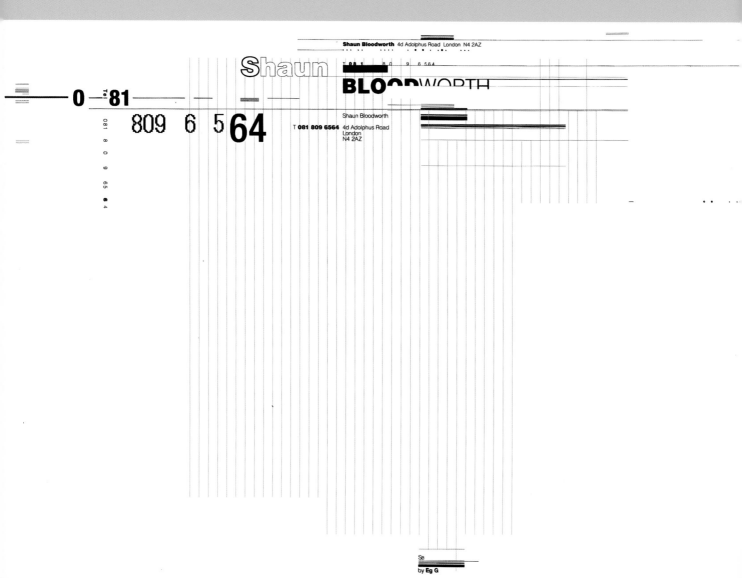

designer
Jeremy Francis Mende

college
Cranbrook Academy of
Art, Michigan

country of origin
USA

work description
Dada Invoice

dimensions
203 x 254 mm
8 x 10 in

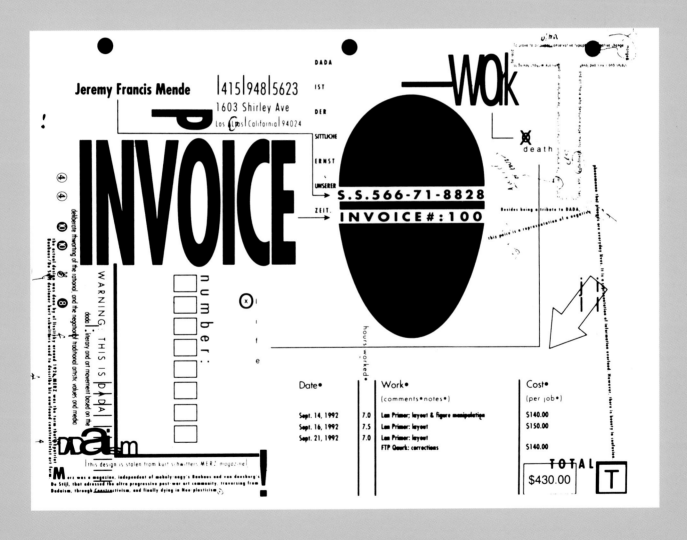

designer
Christopher Ashworth

design company
Orange

art director
Christopher Ashworth

country of origin
UK

work description
Three flyers from a set of
four, for Libido Nightclub

dimensions
right and far right
206 x 99 mm
8⅛ x 3⅞ in
far right, below
130 x 130 mm
5⅛ x 5⅛ in

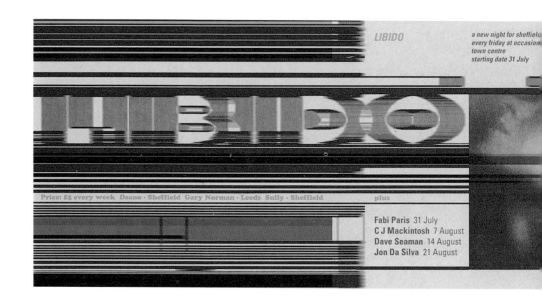

LIBIDO

a new night for sheffield
every friday at occasion
town centre
starting date 31 July

Price: £5 every week Deano - Sheffield Gary Norman - Leeds Sully - Sheffield plus

Fabi Paris 31 July
C J Mackintosh 7 August
Dave Seaman 14 August
Jon Da Silva 21 August

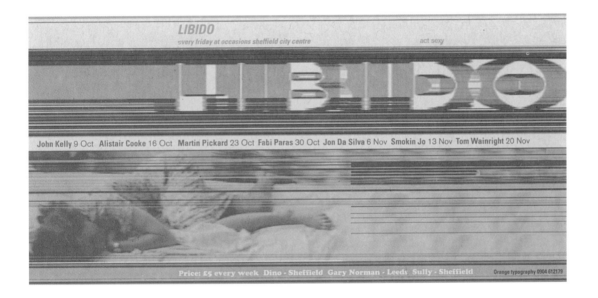

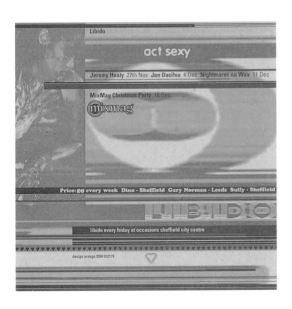

designer
John O'Callaghan

college
Ravensbourne College
of Design and
Communication,
Chislehurst

tutor
Paul Elliman

country of origin
UK

work description
Spreads from a project
responding to media
representation of the
Gulf War

dimensions
420 x 594 mm
16½ x 23⅜ in

70

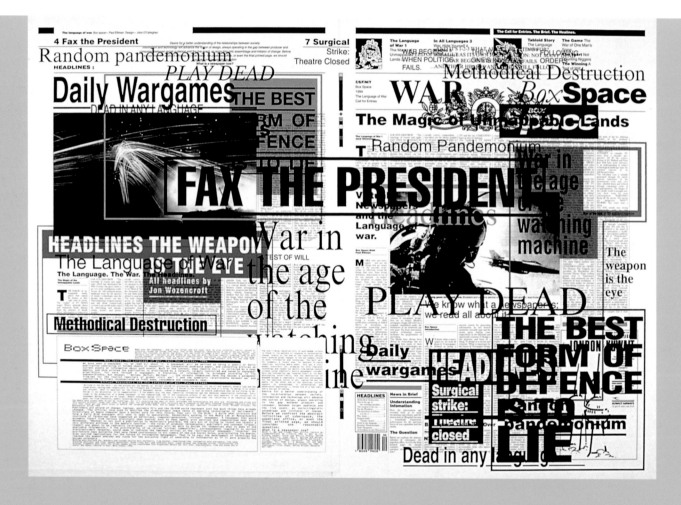

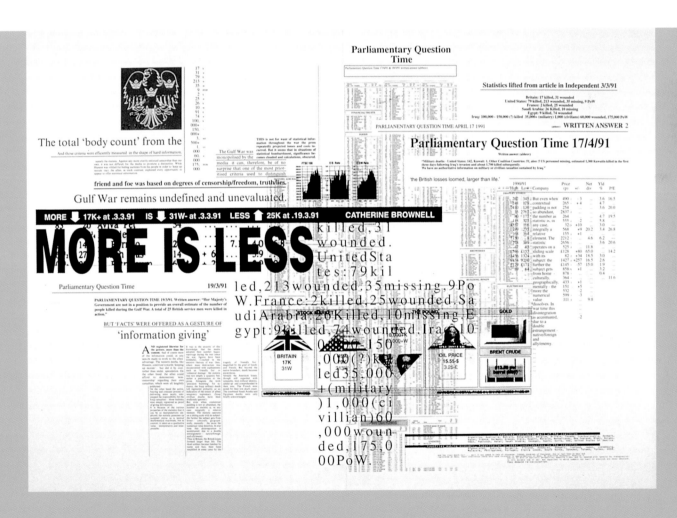

The total 'body count' from the

And those criteria were efficiently measured in the shape of hard information.

The Gulf War was monopolised by the media it can, therefore, be of no surprise that one of the most prioritised criteria used to distinguish friend and foe was based on degrees of censorship/freedom, truth/lies.

Gulf War remains undefined and unevaluated.

Parliamentary Question Time

Statistics lifted from article in Independent 3/3/91

Britain: 17 killed, 31 wounded
United States: 79 killed, 213 wounded, 35 missing, 9 PoW
France: 2 killed, 25 wounded
Saudi Arabia: 26 Killed, 10 missing
Egypt: 9 killed, 74 wounded
Iraq: 100,000 - 150,000 (?) killed 35,000+ (military) 1,000 (civilians) 60,000 wounded, 175,000 PoW

PARLIAMENTARY QUESTION TIME APRIL 17 1991 WRITTEN ANSWER 2

Parliamentary Question Time 17/4/91

"Military deaths - United States: 142, Kuwait: 1, Other Coalition Countries: 51, also: 5 US personnel missing, estimated 1,300 Kuwaitis killed in the first three days following Iraq's invasion and about 1,700 killed subsequently. We have no authoritative information on military or civilian casualties sustained by Iraq."

the British losses loomed, larger than life.

MORE ⬇ 17K+ at .3.3.91 IS ➡ 31W- at .3.3.91 LESS ⬆ 25K at .19.3.91 CATHERINE BROWNELL

MORE IS LESS

killed,31 wounded. UnitedStates:79killled,213wounded,35missing,9PoW.France:2killed,25wounded.SaudiArabia:26Killed,10missing.Egypt:9killed,74wounded.Iraq:100,000-150,000(?)killled35,000+(military)1,000(civillian)60,000wounded,175,000PoW.

Parliamentary Question Time 19/3/91

PARLIAMENTARY QUESTION TIME 19/3/91. Written answer: "Her Majesty's Government are not in a position to provide an overall estimate of the number of people killed during the Gulf War. A total of 25 British service men were killed in action."

BUT 'FACTS' WERE OFFERED AS A GESTURE OF

'information giving'

BRITAIN
17K
31W

OIL PRICE
15.55-$
3.25-£

GOLD

BRENT CRUDE

type plus

type plus

typeplus

typeplus

designers
Simon Taylor
Dirk van Dooren

design company
Tomato

country of origin
UK

work description
Promotional photographs
for Urban Reaction
Clothing Label, Japan

dimensions
51 x 76 mm
2 x 3 in

74

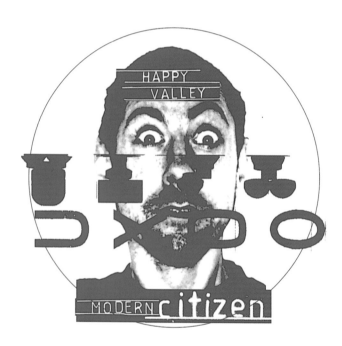

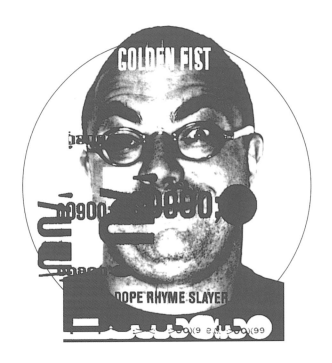

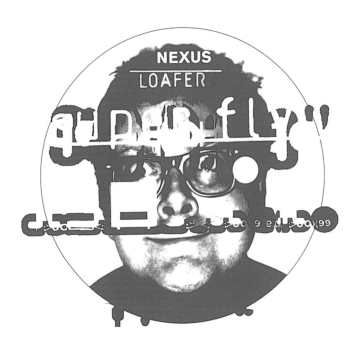

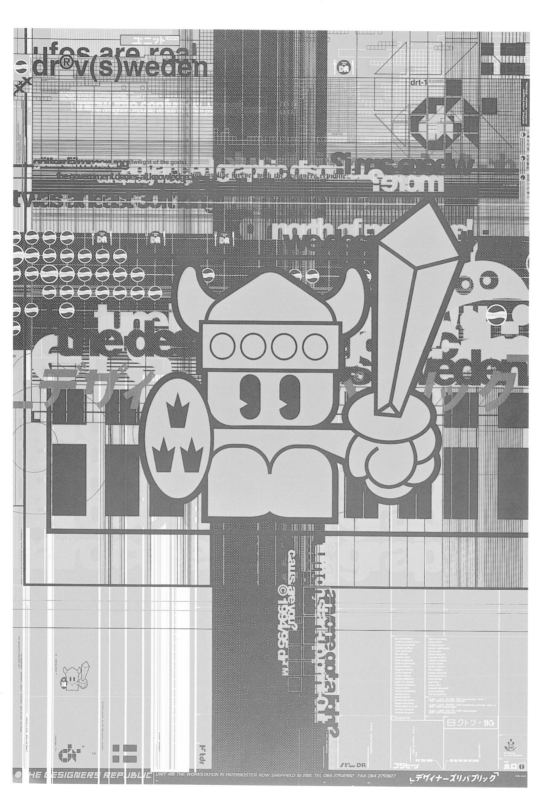

left

designer
The Designers Republic

country of origin
UK

work description
The Designers Republic vs the Entire Population of Sweden, a self-promotional poster

dimensions
297 x 420 mm
11¾ x 16½ in

right

designer
Dirk van Dooren

art director
Trichett & Webb

design company
Tomato

country of origin
UK

work description
Page from a self-promotional calendar

dimensions
325 x 410 mm
12¾ x 16⅛ in

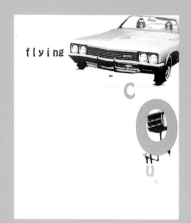

designers
Heather Ferguson
Amy Jo Banton

photographers
Heather Ferguson
Amy Jo Banton

art directors
Heather Ferguson
Amy Jo Banton

design company
2 Bellybuttons

country of origin
USA

work description
Front cover and spread
from the magazine *Flying
the Coupe*

dimensions
253 x 305 mm
10 x 12 in

H: how were the mounds discovered? I mean how did they discover the mounds? W: the mounds here? H: yeah W: they're pretty evident H: they are? W: you got one out there that's 70, over 70 feet high H: wow W: so i mean you're gonna stumble over them H: yeah AJ: (laughter) W: the mounds have been known, they were first reported in the 1860's,1870's H: uh-huhh W: like the ridges were not discovered until the 1950's, when this air-eal view photograph was found H: oh W: here were some people working there. they knew they had a huge site H: yeah W: but, ahh, they were digging on mound B over that, that a way. and. and. ahhh, James Ford from the American Museum of Natural History went over to Vicksburg Waterways experimental station and he got and he found this photograph RIDGES!! and you can see them. Actually this earlier photograph shows them but no one ever noticed H: they just odd that there was another indian hill and um, there you are (AJ has finally located subject with view came subdivision around it W: okay , north of Monroe ? AJ & H: yeah W: yeah, that's Frenchman's Bend and, ah, tha W: and, ah, it was very exciting and they're not destroying it. they're just kind of working around it and they're gonni mounds will be part of the golf course AJ: oh really W: uh huh AJ: wow H: (laughter) W: yeah the developer there has been very, very responsible and it's really great to have some one like that AJ: yeah, we saw it, we saw it yesterday. it was, it just seems really strange, usually they, you know,usually, like in Virginia they would just, like, put up, ah, you know, i don't know, sort of like a place. they would put up a whole mon-ument around it and everything W: well we have too many of them AJ: oh really W: yeah if you were to do that with every indian site, you would have prob-lems AJ: yeah W: and, ah, further more, the state doesn't have the money to do it, so... AJ: so why don't they just excavate them and... W: all right what happens when you excavate a site? AJ: everybody gets all up in a uproar. i don't know about moving the artifacts W: no, stop and think. when you've excavated a site, what happens to that site? H: it's been destroyed W: so therefore, the best thing to do on a site is to excavate enough to find out what you need know and then leave, because techniques change H: yeah W: ah, i went on my first dig in 1955 H: wow W: an the differences in the way digs are done then and now are just incalculable H: uh huh W: the different techniques and everything else from what we've been able to find H: yeah W: ah, see i was digging in the southwest about the time they were finding that photograph H: wow W: and ah, so as a result, no you don't want to dig them H: you destroy them W: no you want to preserve them by putting a golf course on it it's perfectly preserved H: yeah W: what's going to happen? you're going to mow the grass. H: (laughter) AJ: yeah but don't you think all these unknowns will try to excavate themselves? W: no AJ: you don't think so? H: (laughter) W: because all the local pot hunters know that there's nothing in there worth it H: yeah W: i mean it's that site okay, the type of material that's in that site is microflint, they found one or two pi and they found lots of fire-cracked rock which is really something H: yeah AJ & H: (laughter) W: it's nothing to write home to mother about, so

rlier photograph H: yeah AJ: we found it
aughter) and um, there was another indian hill and they're like, building a
mer, it's a mid-archaic site AJ: mmhnm

French-men's bend, but the exciting part about it is that they got charcoal, so they were able to get site dates from about 4000 b.c. AJ & H: oh wow

below

designers
Paula Benson
Paul West

photographer
Spiros

art directors
Paula Benson
Paul West

design company
Form

country of origin
UK

work description
Spread from a press
release in the form of a
mini newspaper, for 2WO
THIRD3

dimensions
294 x 415 mm
11⅝ x 16⅜ in

right

designers
Paula Benson
Paul West

photographers
above
Lawrence Watson
below
Tim Platt

art directors
Paula Benson
Paul West

design company
Form

country of origin
UK

work description
I Want the World and *Ease
the Pressure*, open CD
boxes for 2WO THIRD3

dimensions
140 x 125 mm
5½ x 5 in

80

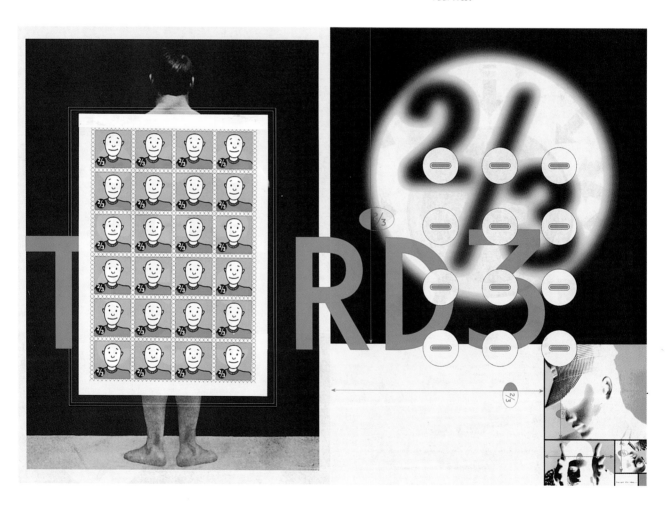

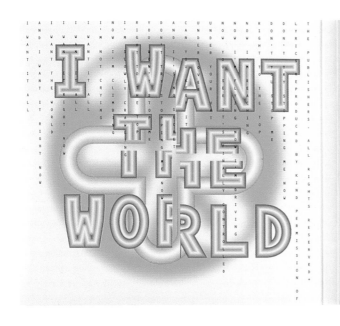

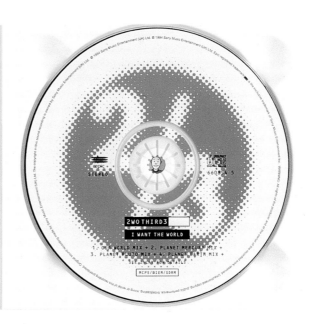

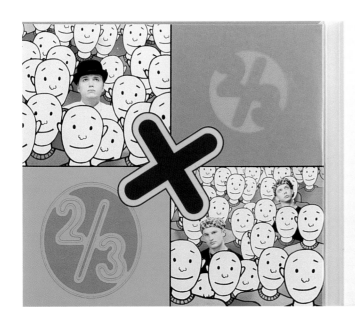

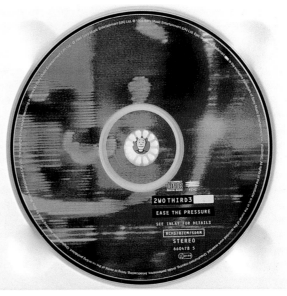

82

designer
Willi Kunz

photographers
right
Skyviews
far right
Richard Plunz

design company
Willi Kunz Associates

country of origin
USA

work description
Program posters for
Columbia University,
Graduate School of
Architecture, Planning,
and Preservation, New
York

dimensions
305 x 609 mm
12 x 24 in

Columbia University
Graduate School of Architecture
Planning and Preservation

Introduction to Architecture

A Summer Studio in New York

A summer program giving university credit which introduces the student to aspects of the design, history, theory, and practice of architecture. The program is intended both for those without previous academic experience in design who are interested in architecture as a potential career, and for those with previous experience in architectural design who would like to develop additional studio design skills, perhaps in preparation for application to graduate school.

Courses are given in the studios of Avery Hall, home of Columbia University's world-renowned Graduate School of Architecture, Planning, and Preservation, on the Morningside Heights campus in New York City. Studios and seminar courses are taught by experienced architects and designers, coordinated and supervised by members of the faculty of the Graduate School. For those who may require it, housing is available on the University campus, with direct access to Avery Hall.

Students attend classes four days a week for five weeks, both morning and afternoon sessions. In the morning session, students are introduced to the fundamentals of architectural history and theory, structures, technology, and professional practice. Also, this course will introduce the student to the extraordinary city of New York, with its world famous collection of museums, cultural institutions, and architectural monuments. Lectures, seminar presentations, tours of architect's offices, and field-trips to active building sites, museums, and famous works of architecture in New York City are led by the instructors.

In addition, students will attend a series of special lectures to be given by distinguished and renowned architects, including the following:

Kenneth Frampton
Architect; professor; author of "Modern Architecture: A Critical History"

Steven Holl
Architect; professor; winner of numerous Progressive Architecture Awards

James Stewart Polshek
Architect; professor; designer for the renovation of Carnegie Hall

Robert A. M. Stern
Architect; professor; author of "Pride of Place"

Bernard Tschumi
Architect; Dean, Columbia University; designer of the park "La Villette", Paris

In the afternoon, the students attend the design studio – an educational method unique to architecture – a place where students are given an intensive training in the skills and critical thinking involved in architectural design. Students, in small groups, work directly with studio instructors to develop their individual designs, which the students then present in periodic reviews or "juries", where they hear the comments and criticism of the invited architects and professors. The design projects given in studio are frequently situated in New York City, so that the student is able to apply the knowledge he or she has gained from the morning sessions. The development of supporting skills such as drawing and model-building is also included in the studio curriculum.

Together the studio and lectures present a comprehensive introduction to every aspect of architecture as it is practiced today. In addition, through the various field-trips and tours, the student learns from the extraordinary examples of architectural and urban design in New York City, the world's preeminent center for architectural culture.

Program Director:
Thomas Hanrahan,
Architect; professor

Introduction to Architecture:
July 6 to August 6
Monday, Tuesday, Wednesday, Thursday
10:00am-5:00pm
3 credits, studio and seminar
Tuition for 1992: $1590
Housing on the Columbia University campus (if required): approximately $600

Applications should include a transcript of the applicant's academic record; a resume summarizing education, employment, and other types of experience; and, where appropriate, examples of the applicant's design work. Also please include a $35 application fee (checks made out to Columbia University).

Applications are due by June 30

For information and
applications write or call:

Office of Admissions –
Introduction to
Architecture Program
Columbia University
Graduate School
of Architecture, Planning,
and Preservation
400 Avery Hall
New York, NY 10027
(212) 854-3414

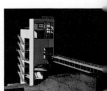

Master of Science in Architecture and Urban Design

The Master of Science Degree in Architecture and Urban Design is an intensive three semester program for architects interested in post-professional design specialization.

Program
The curriculum is oriented toward the emerging urbanism in the United States, with a particular emphasis on the situation in New York City. It seeks to define parameters and problems which will carry into the next century. It also embraces a special relationship between the design studio and New York, through collaboration with city agencies and other public interest constituencies. Comparative study with other world cities is also considered central to the pedagogic structure, focused on seminars and case studies.

Emphasis
The degree is intended to augment traditional professional training in architecture for those who wish to further investigate the physical aspects of urbanism. "Urban Design" is seen as an activist, social art: more than a singular representation of physical scale, the term defines a commitment to discourse at all scales of design activity. The design studio is the primary catalyst for the curriculum, centered on a highly individualized, atelier approach. The unique situation of Columbia allows New York City to become a laboratory, in which the discipline of architecture can be applied to a myriad of problems within our urban environment at all scales of inquiry. At the same time, the more theoretical component of coursework allows for comparative study with other world cities and situations. The final studio affords an opportunity for comparative study between New York and another world city.

Resources
The Columbia University Graduate School of Architecture, Planning and Preservation is a unique academic forum within which to pursue studies in Urban Design. The distinguished, multi-disciplinary faculty nurtures a wide-ranging critical perspective on the question of urbanism today. Classroom and studio teaching is reinforced by extensive lecture and publication programs. The Avery Architectural and Fine Arts Library is an invaluable resource, as the nation's finest repository for the literature of architecture, planning, and fine arts. In addition, the innumerable cultural resources of New York City, as a whole, are close at hand.

Bernard Tschumi, Dean
Richard Plunz, Director

Further information and application:
Columbia University
Office of Architecture Admissions
400 Avery Hall
New York, NY 10027
212 854 3414

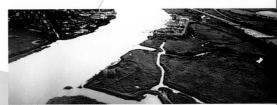
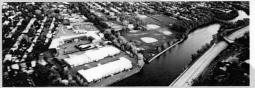
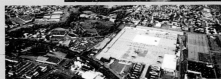

designer
David de Jong

photographers
Jurjen de Jong
David de Jong

college
Utrecht School of
the Arts

country of origin
The Netherlands

work description
Box lid (below, left), open
box (below, right) and
spreads (far right) from
An Interactive Book; texts
are linked by symbols and
numbers which allow the
book to be read in several
directions (unpublished)

dimensions
box size
345 x 345 mm
13⅝ x 13⅝ in

84

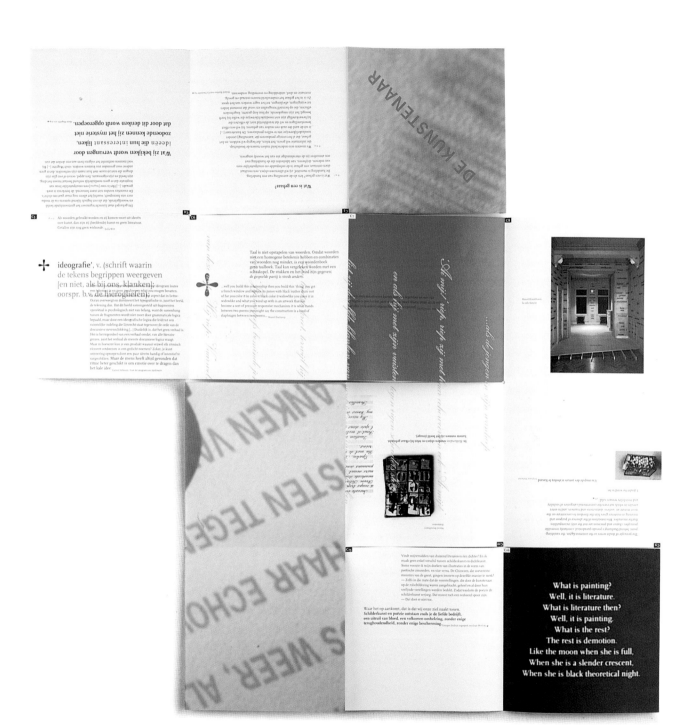

designers
Carlo Tartaglia
Robert Lamb

college
Ravensbourne College
of Design and
Communication,
Chislehurst

tutor
Rupert Bassett

86

country of origin
UK

work description
Cover and spreads from
the 1993 Ravensbourne
College degree show
publication

dimensions
297 x 420 mm
11¾ x 16½ in

designer
The Designers Republic

country of origin
UK

work description
Tournesol by Kokotsu, LP
(R & S Records, Belgium);
center of gatefold sleeve

dimensions
430 x 310 mm
16⅞ x 12¼ in

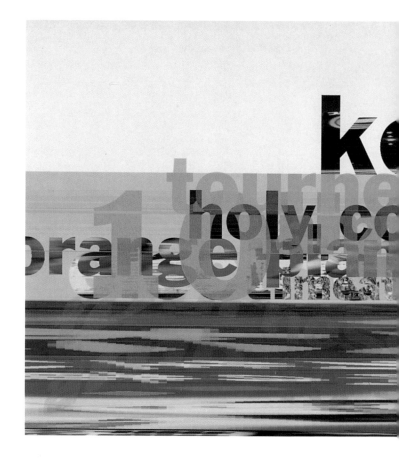

88

designer
The Designers Republic

photographers
Phil Wolstenholme
Jess Scott-Hunter
David Slade

country of origin
UK

work description
Artificial Intelligence II,
compilation LP (Warp
Records, UK); center of
gatefold sleeve

dimensions
430 x 310 mm
16⅞ x 12¼ in

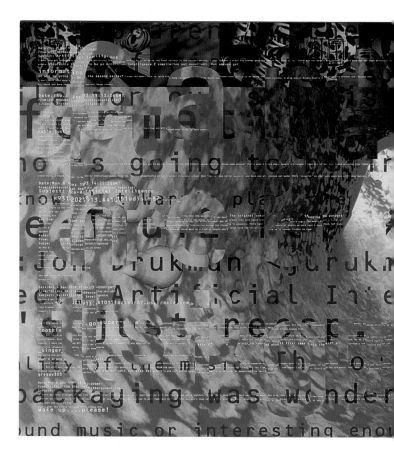

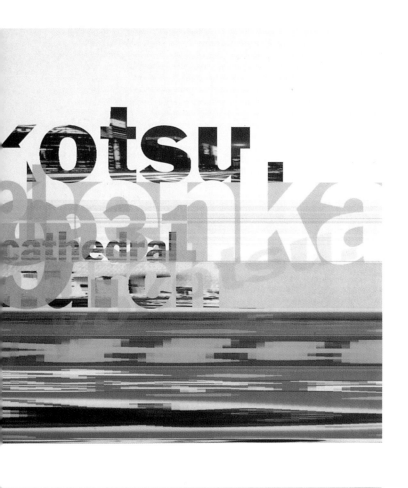

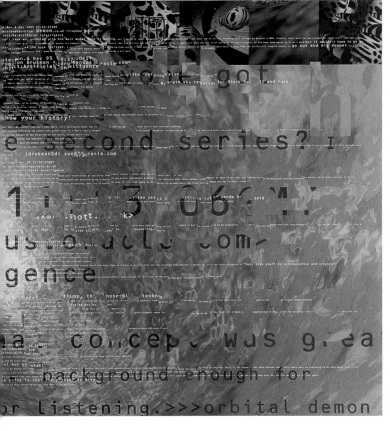

designer
Iain Cadby

country of origin
UK

work description
Two self-published
posters, from a set of
three

dimensions
210 x 297 mm
8¼ x 11¾ in

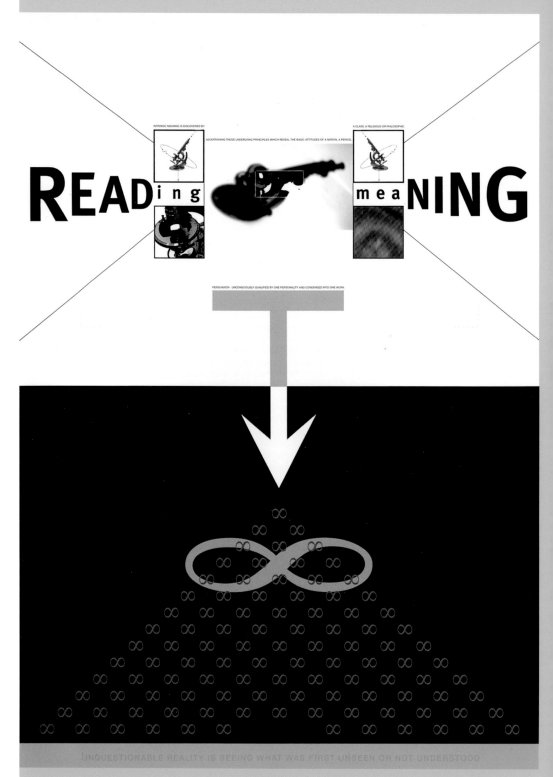

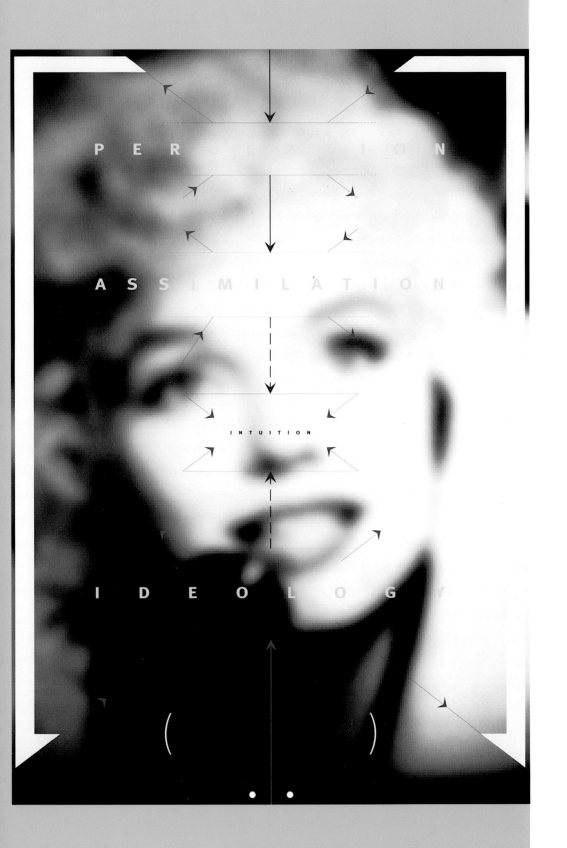

designer
Irma Boom

photographer
Aero photo Schiphol bv

design company
Irma Boom

country of origin
The Netherlands

work description
Telephone cards, with
their reverse images (far
right) combined to form a
picture

dimensions
shown actual size
85 x 54 mm
3⅜ x 2⅛ in

92

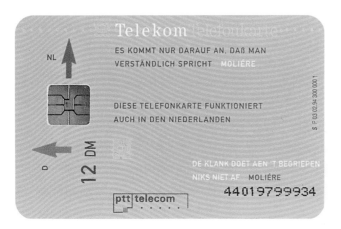

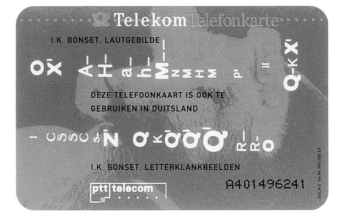

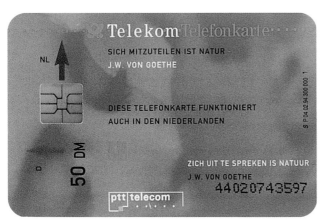

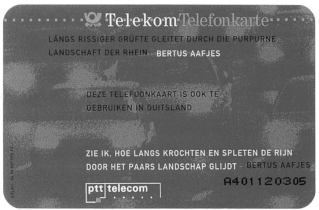

Telekom Telefonkarte

LÄNGS RISSIGER GRÜFTE GLEITET DURCH DIE PURPURNE
LANDSCHAFT DER RHEIN - BERTUS AAFJES

DEZE TELEFOONKAART IS OOK TE
GEBRUIKEN IN DUITSLAND

ZIE IK, HOE LANGS KROCHTEN EN SPLETEN DE RIJN
DOOR HET PAARS LANDSCHAP GLIJDT - BERTUS AAFJES

A401120305

ptt telecom

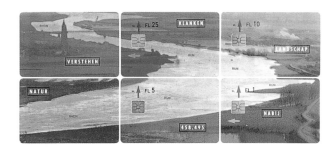

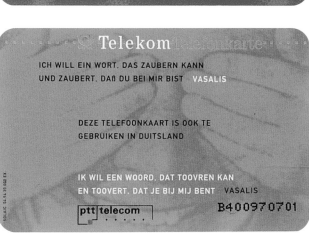

Telekom Telefonkarte

ICH WILL EIN WORT, DAS ZAUBERN KANN
UND ZAUBERT, DASS DU BEI MIR BIST - VASALIS

DEZE TELEFOONKAART IS OOK TE
GEBRUIKEN IN DUITSLAND

IK WIL EEN WOORD, DAT TOOVREN KAN
EN TOOVERT, DAT JE BIJ MIJ BENT - VASALIS

B400970701

ptt telecom

designer
Brad Trost

photographer
Kurt Hettle

art director
Brad Trost

design company
doubledagger

country of origin
USA

work description
Promotional postcard for
Herron Photo Lab

dimensions
195 x 126 mm
7³⁄₅ x 6 in

94

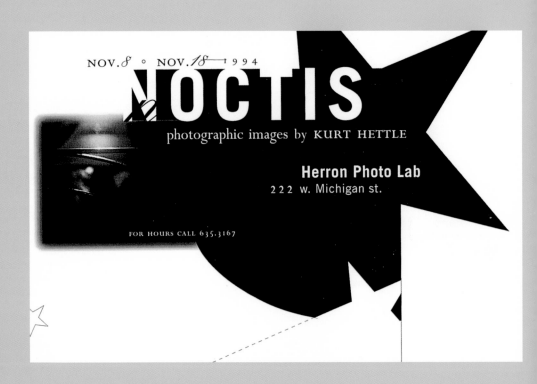

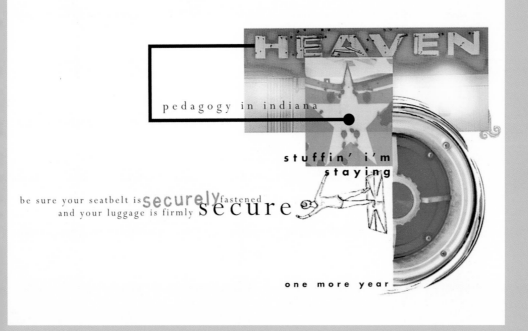

designer
Elisabeth Charman

photographer
Elisabeth Charman

art director
Elisabeth Charman

design company
doubledagger

country of origin
USA

work description
Gold Star Heaven, a self-
promotional postcard

dimensions
152 x 102 mm
5 x 4 in

95

designer
Mark Hough

art director
Jane Kosstrin-Yurick

design company
Doublespace

country of origin
USA

work description
Poster for the Dartmouth
College Conference

dimensions
580 x 430 mm
22⁷⁄₈ x 16⁷⁄₈ in

designer
Chris Myers

photographer
Chris Myers

art director
Nancy Mayer

design company
Mayer & Myers

country of origin
USA

work description
Lecture poster, for The
American Institute of
Graphic Arts, Philadelphia,
and the University of the
Arts, Philadelphia

dimensions
482 x 482 mm
19 x 19 in

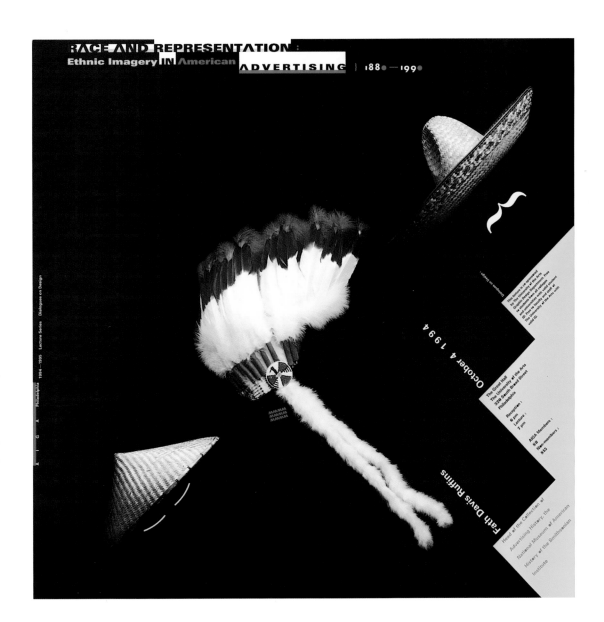

designers
Stephanie Krieger
Maximilian Sztatecsny

photographer
right
Margherita Spiluttini

art director
Stephanie Krieger

design company
Krieger/Sztatecsny

country of origin
Austria

work description
Front covers of two
architecture booklets for
Architektur Zentrum Wien

dimensions
150 x 298 mm
5⅞ x 11¾ in

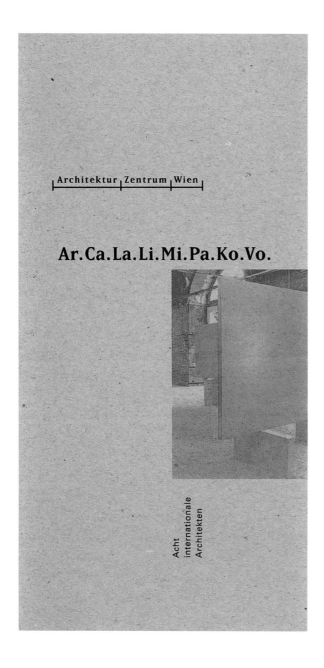

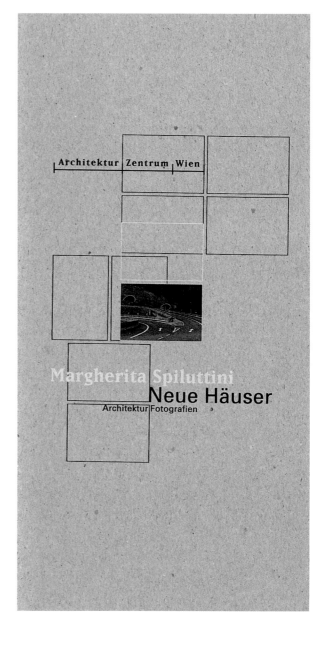

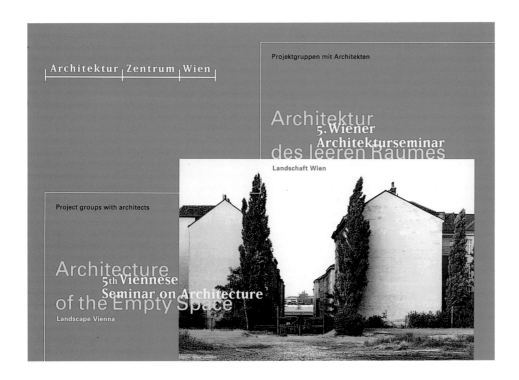

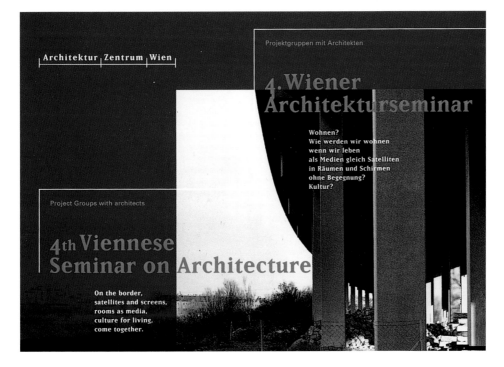

designer
Stephanie Krieger

photographer
Johannes Faber

art director
Stephanie Krieger

design company
Krieger/Sztatecsny

country of origin
Austria

work description
Spreads from leaflets
announcing the fourth
and fifth Viennese
Seminars on Architecture,
for Architektur Zentrum
Wien

dimensions
210 x 148 mm
8¼ x 5⅞ in

designers
Christopher Ashworth
Amanda Sissons
Neil Fletcher
John Holden
Dave Smith

photographer
John Holden

art director
Christopher Ashworth

design company
Invisible

country of origin
UK

work description
Jacket of *Interference*,
a book exploring the
dehumanizing and
sinister effects of security
surveillance in the city,
published by Ümran
projects

dimensions
668 x 290 mm
26¼ x 11⅜ in

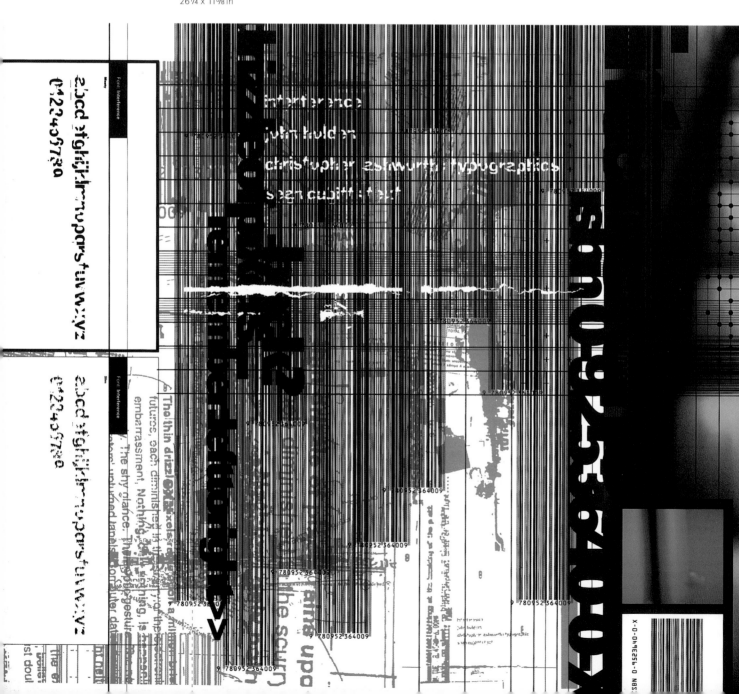

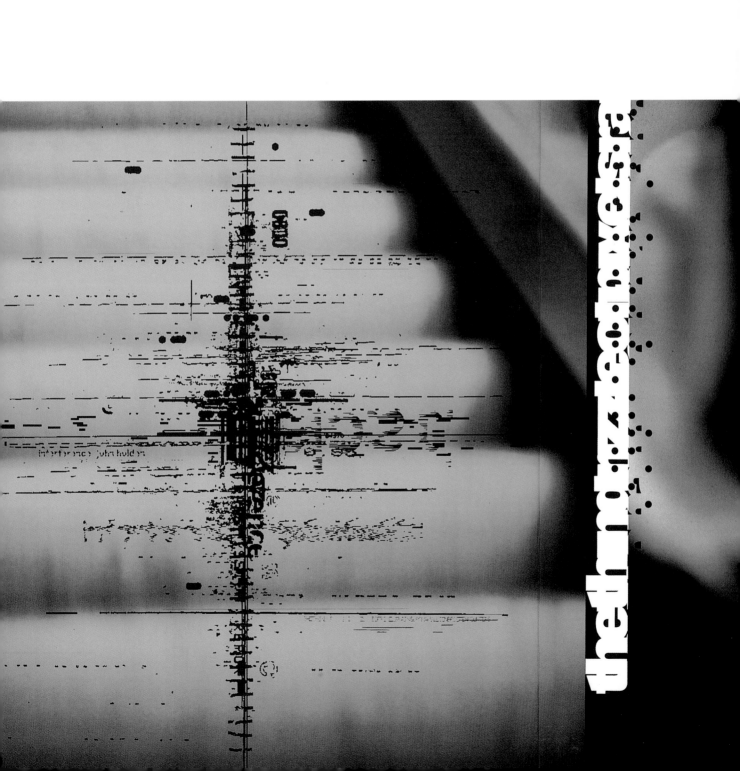

interference john holden

designer
Naomi Mizusaki

photographer
Jennifer Lynch

art directors
Drew Hodges
Vincent Sainato
Elisa Feinman

design company
Spot Design

country of origin
USA

work description
Box (left) and spreads
from a sci-fi channel
marketing planner; the
spreads are interleaved
with sheets of translucent
red gel which obscure
areas of the graphics or
words to create additional
messages

dimensions
299 x 171 mm
11¾ x 6¾ in

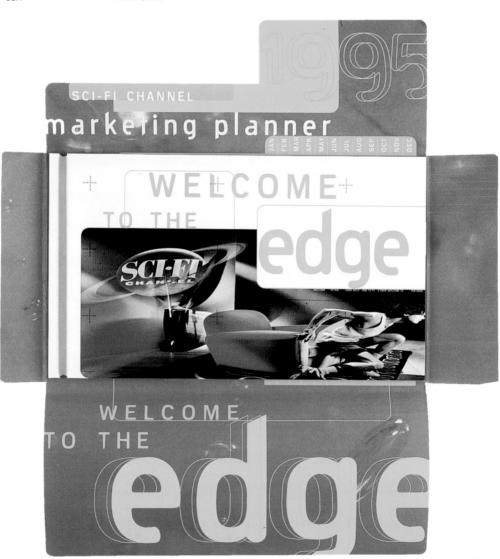

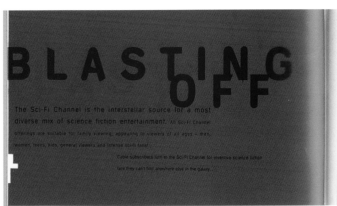

BLASTING OFF

The Sci-Fi Channel is the interstellar source for a most diverse mix of science fiction entertainment. All Sci-Fi Channel offerings are suitable for family viewing, appealing to viewers of all ages - men, women, teens, kids, general viewers and intense sci-fi fans!

Cable subscribers turn to the Sci-Fi Channel for inventive science fiction fare they can't find anywhere else in the galaxy.

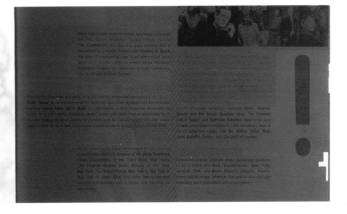

BLASTING OFF

The Sci-Fi Channel is the interstellar source for a most diverse mix of science fiction entertainment. All Sci-Fi Channel offerings are suitable for family viewing, appealing to viewers of all ages - men, women, teens, kids, general viewers and intense sci-fi fans!

Cable subscribers turn to the Sci-Fi Channel for inventive science fiction fare they can't find anywhere else in the galaxy.

designers
Peter Dyer
Conor Brady

photographer
Michael Ormerod

design company
React

country of origin
UK

104

work description
Front and back covers of
the magazine *Cape*, issues
2 & 3

dimensions
274 x 362 mm
10¾ x 14¼ in

JOHN CHEEVER + R
SELL HOBAN + HARO
BRODKEY + DAVID
EFF + ANTHONY HE
ANDEZ + WHITNEY
LLIETT + LEE FRIED
NDER + BETH NUG
T + MICHAEL ORME
D + BOHUMIL HRAB

CHARLES SPRAW
ON + YUKIO MIS
IMA + MICHAEL
'NEILL + ROBER
MAPPLETHORPE
COLM TÓIBÍN + L
NI RIEFENSTAHL
EIKO ISHIOKA +
HARON OLDS + H
ROLD BRODKEY +
ICHAEL COLLINS

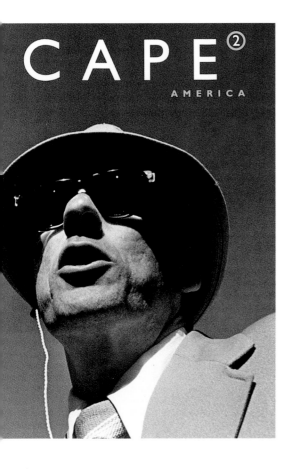

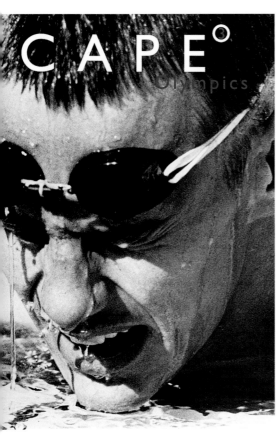

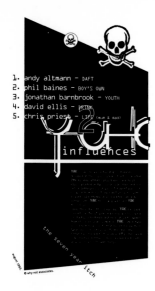

designers
this page
Jonathan Barnbrook
(above)
David Ellis (below)
opposite page
Andy Altmann (left)
Phil Baines (center)
Chris Priest (far right)

design company
Why Not Associates

country of origin
UK

work description
Yak 2, posters

dimensions
this page
762 x 508 mm
30 x 20 in
opposite page
508 x 762 mm
20 x 30 in

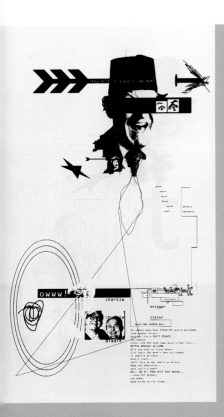

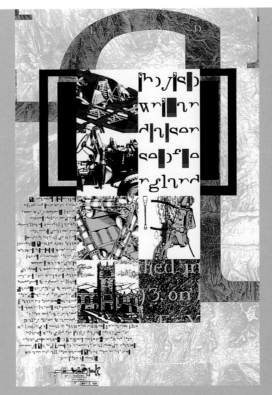

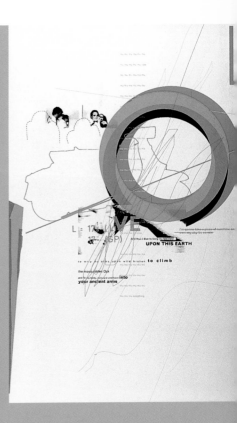

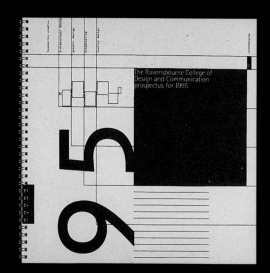

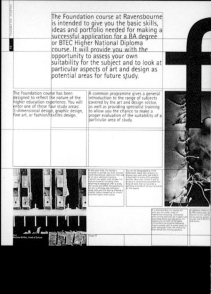

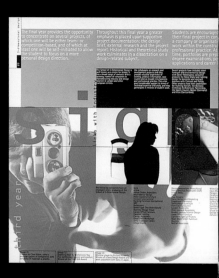

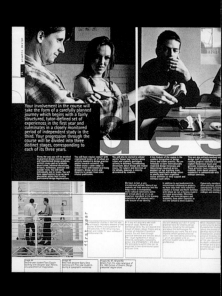

designers
Rupert Bassett
Paul Blackburn

photographer
Ringan Ledwidge

country of origin
UK

work description
Cover, spreads, and
pages from the 1995
catalog/prospectus for
Ravensbourne College
of Design and
Communication,
Chislehurst

dimensions
300 x 285 mm
11 7/8 x 11 1/4 in

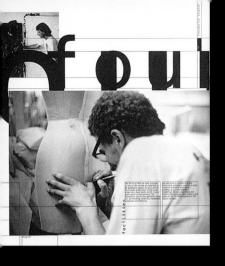

four

facilities

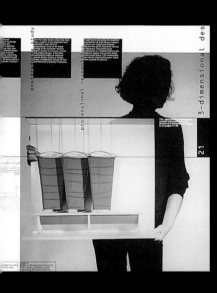

postgraduate study

professional recognition

3-dimensional design

21

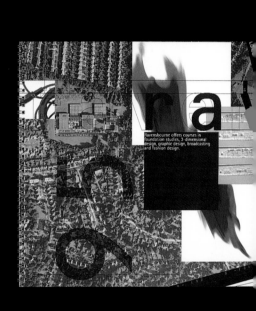

Ravensbourne offers courses in foundation studies, 3-dimensional design, graphic design, broadcasting and fashion design.

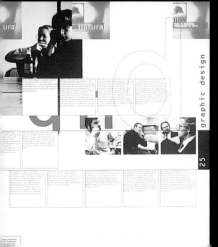

natural

graphic design

25

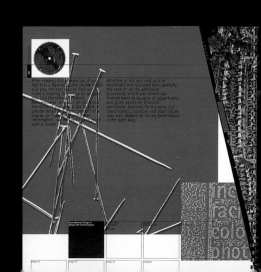

After reading this prospectus, if you feel that a Ravensbourne course might suit you, the best way to find out is to make a booking to come and see us for all the relevant information. However, this will not let you know the campus and we'd like to meet in greater detail either before a course, or if you require further information, we can arrange this with a course.

Whether or not you visit us it is important that you read very carefully the section on the admission procedure, which also covers our commitment to equality of opportunity and gives advice on financial assistance. Applying for a course is a complicated procedure and your future may well depend on having gone about it the right way.

designer
Nick Bell

art director
Jeremy Hall

design company
Nick Bell

country of origin
UK

work description
Ultraviolet series of CDs,
with an advertising
poster, for Virgin Classics

dimensions
CDs
120 x 120 mm
4¾ x 4¾ in
poster
594 x 840 mm
23⅜ x 33⅛ in

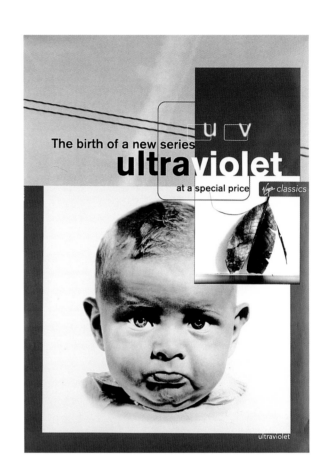

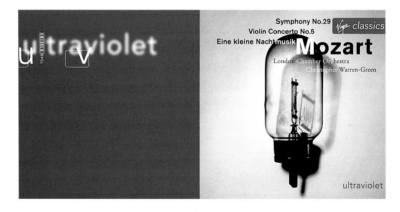

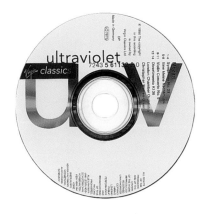

ultraviolet

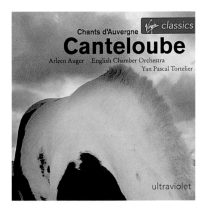

Chants d'Auvergne

Canteloube

Arleen Auger English Chamber Orchestra

Yan Pascal Tortelier

Virgin classics

ultraviolet

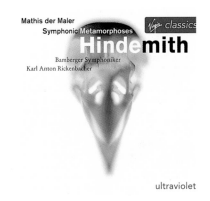

Mathis der Maler
Symphonic Metamorphoses

Hindemith

Bamberger Symphoniker
Karl Anton Rickenbacher

Virgin classics

ultraviolet

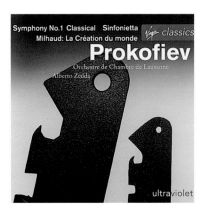

Symphony No.1 Classical Sinfonietta
Milhaud: La Création du monde

Prokofiev

Orchestre de Chambre de Lausanne
Alberto Zedda

Virgin classics

ultraviolet

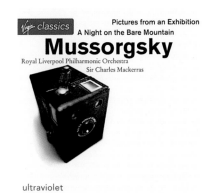

Pictures from an Exhibition
A Night on the Bare Mountain

Mussorgsky

Royal Liverpool Philharmonic Orchestra
Sir Charles Mackerras

Virgin classics

ultraviolet

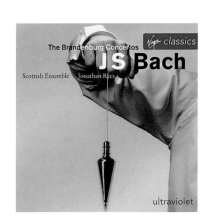

The Brandenburg Concertos

JS Bach

Scottish Ensemble Jonathan Rees

Virgin classics

ultraviolet

Adams Glass Reich Heath

Minimalist

London Chamber Orchestra Christopher Warren-Green

classics

ultraviolet

Symphonies 40 & 41 Jupiter

Mozart

Sinfonia Varsovia Yehudi Menuhin

Virgin classics

ultraviolet

Symphony No.10 Festival Overture

Shostakovich

The London Philharmonic
Andrew Litton

Virgin classics

ultraviolet

12121212 212

designers
Jason Edwards
Tim Hutchinson

college
Royal College of Art,
London

country of origin
UK

work description
Visual research project

dimensions
485 x 415 mm
19⅛ x 16¾ in

Here

rep

DISTRIBUTE

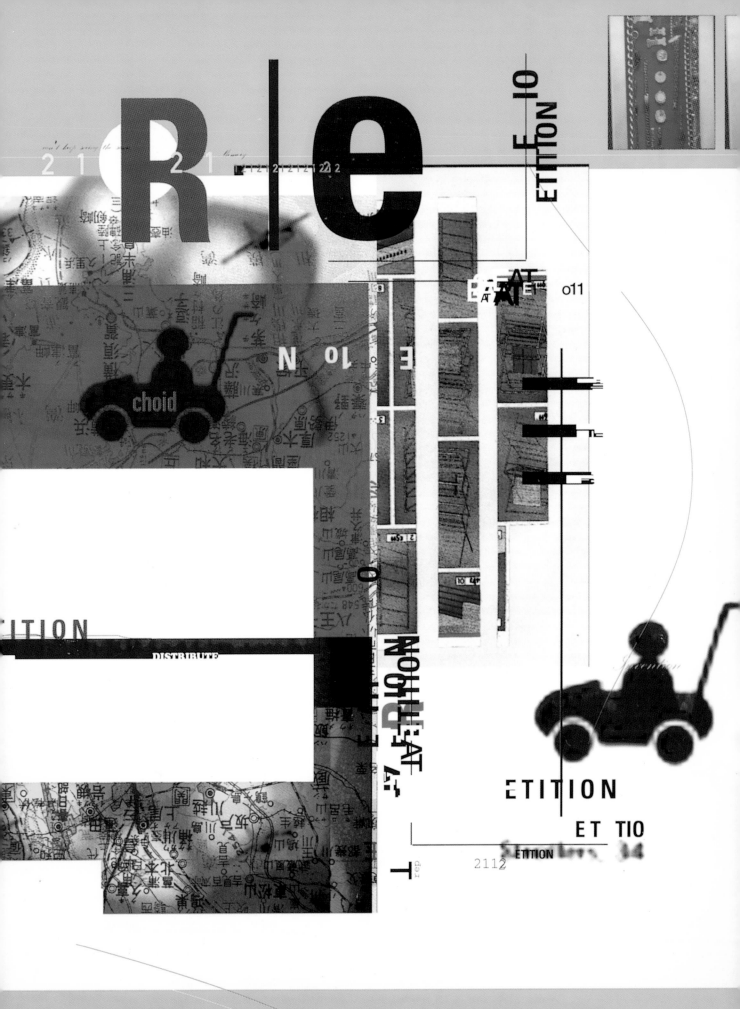

designer
Jeremy Francis Mende

photographer
Jeremy Francis Mende

college
Cranbrook Academy
of Art, Michigan

country of origin
USA

work description
Pages from a proposed
large format book,
*Archilochus: The Severity
of his Satire*, an allegory
exploring the mental
interstices between
developmental stages in
adulthood

dimensions
381 x 559 mm
15 x 22 in

114

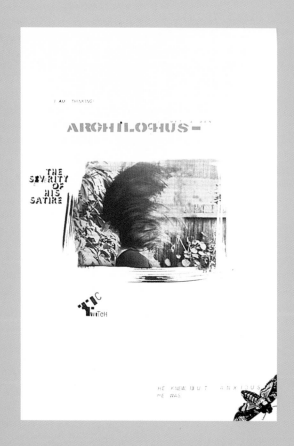

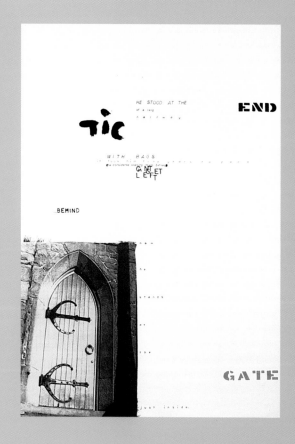

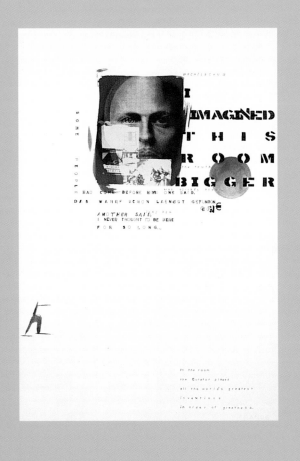

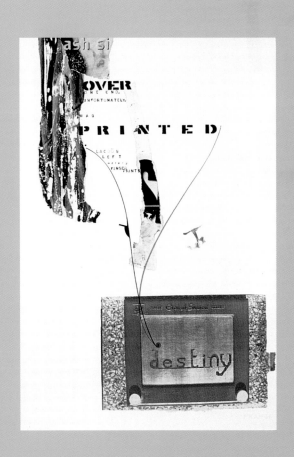

designer
Jennifer E. Moody

college
California Institute of
the Arts

country of origin
USA

work description
Furniture show poster

116

dimensions
711 x 1016 mm
28 x 40 in

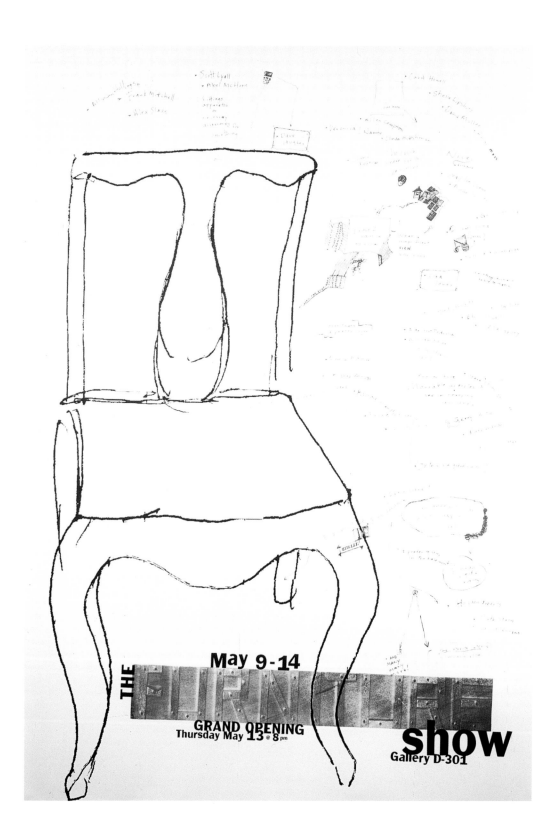

designer
Koeweiden/Postma
Associates

photographer
René Kramers

country of origin
The Netherlands

work description
Letterhead for René
Kramers Photography

dimensions
shown actual size
210 x 297 mm
8¼ x 11¾ in

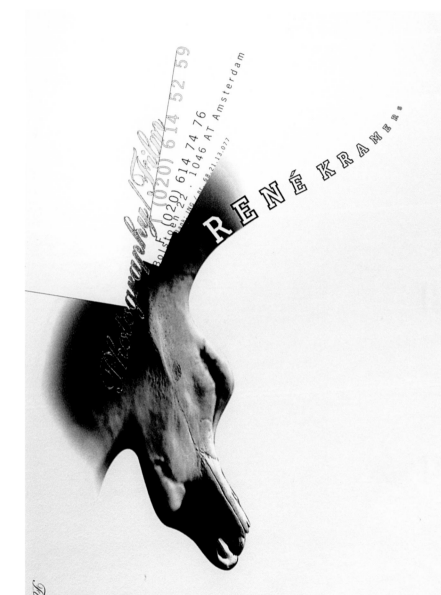

designer
Jeff Düngfelder

illustrator
Jeff Düngfelder

art director
Jeff Düngfelder

design company
Studio DNA

country of origin
USA

work description
Self-promotional poster

dimensions
241 x 419 mm
9½ x 16½ in

118

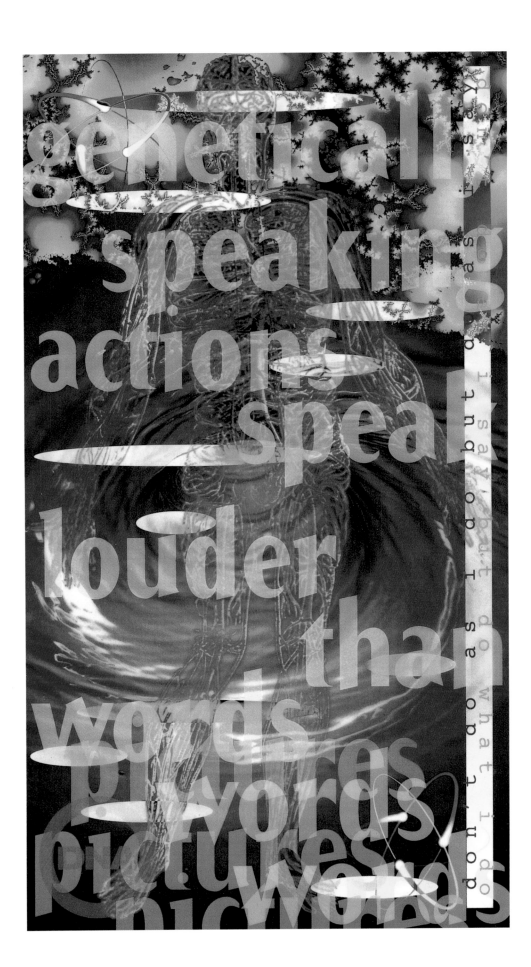

designer
Mark Diaper

photographer
Richard Foster

design company
Lippa Pearce Design
Limited

country of origin
UK

work description
Front cover and fold-out
poster from an AIDS
awareness booklet for the
Terrence Higgins Trust on
World AIDS Day

dimensions
booklet
120 x 120 mm
4¾ x 4¾ in
fold-out poster
347 x 466 mm
13⅝ x 18⅜ in

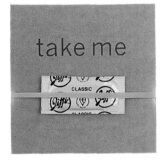

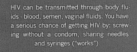

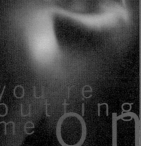

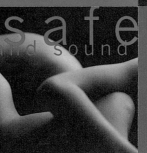

You can't catch AIDS, but you can catch HIV. HIV is the virus that attacks your body's immune system (which protects you from diseases) leaving it vulnerable to serious infections and cancers.

AIDS is a combination of serious infections and cancers that occurs when your immune system is broken down by HIV.

There's no risk in sharing things like - cutlery, toilet seats, swimming pools, cups or kissing. You can't become infected through touching, hugging and shaking hands.

le's talk about hiv

sex: do it when you feel ready it's okay to be different do what you are comfortable doing if you don't want to · you don't have to no-one is worth the risk · look after yourself whatever you do make it safe

HIV can be transmitted through body fluids - blood, semen, vaginal fluids. You have a serious chance of getting HIV by: screwing without a condom, sharing needles and syringes ("works").

Blow jobs carry some risk if you have cuts and sores in the mouth.

Drugs and alcohol - it's easy to forget about safer sex when you're off your head.

Think before you shag. Don't share works.

think before you fuck

The only way to make penetrative sex safer is to use a condom.

Condoms protect you from sexually transmitted diseases (stds) and pregnancy. They are less messy. There is no wet patch. They are free. They come in all shapes, sizes, flavours and thicknesses. They protect you and your partner.

Check the date and the kitemark (tells you it's been tested for safety and strength) on the condom and read the instructions.

Practise makes perfect. You can get them free from family planning clinics, genito-urinary clinics (gum), brook advisory centres.

It's not who you do it with. It's what you do that matters.

you're putting me on

rubber up

you can have fun and be sexy without penetration, here are some ideas: kissing, hugging, licking chocolate mousse off nipples, massage, rubbing, sex talk, masturbation (solo · or with someone) cuddling, sex talk, fantasy, dressing up, having showers together.

safe and sound

Help is at hand. If you're feeling anxious or have any questions about HIV and AIDS, there are people you can call on who will listen and advise you on any issue.

safer sex information issues around being tested what condoms to use and where to get them sexually transmitted diseases if you feel you have been at risk

The Terrence Higgins Trust 0171 242 1010. For free and confidential advice and information on HIV and AIDS and info about where to go for testing. Open 7 days a week from 12 noon to 10pm.

National AIDS Helpline 0800 567123. Open 7 days a week, 24 hours a day for any information on HIV and AIDS and sexually transmitted diseases. It's free and confidential.

Brook Advisory Centres 0171 708 1234. Offers face to face advice on contraception to young people in 12 cities. Phone to find out about the nearest one to you.

Family Planning Association 0171 636 7866 gives advice on all sexual health matters including contraception and condoms.

designer
Richard Horsford

college
Ravensbourne College
of Design and
Communication,
Chislehurst

tutor
Gill Scott

120 **country of origin**
UK

work description
A campaign poster (right),
with information form on
the reverse (far right), to
raise awareness of the
issues facing deaf and
dumb people

dimensions
this page
420 x 594 mm
16½ x 23⅜ in
opposite page
594 x 420 mm
23⅜ x 16½ in

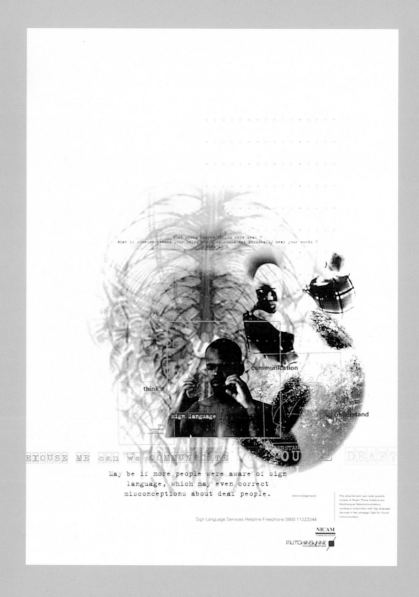

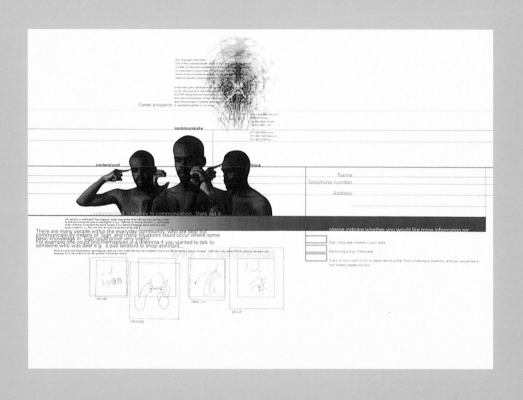

121

designer
Conor Brady

photographer
Conor Brady

design company
React

country of origin
UK

work description
Front cover and spine of
the book *Dreams of a
Final Theory*, for Vintage
publishers

dimensions
145 x 198 mm
5¾ x 7¾ in

designer
Conor Brady

photographer
Tim Simmons

design company
React

country of origin
UK

work description
Front cover and spine
of the book *Small is
Beautiful*, for Vintage
publishers

dimensions
145 x 198 mm
5¾ x 7¾ in

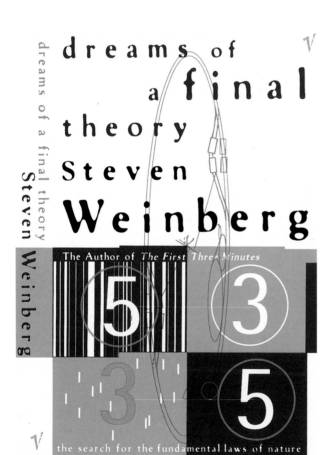

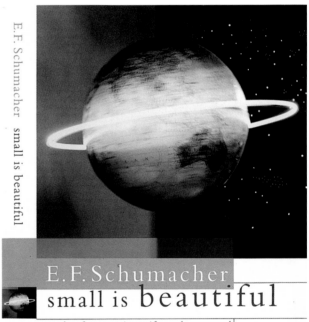

designer
Peter Dyer

photographer
Robert Clifford

design company
React

country of origin
UK

work description
Front cover of the book
The Acid House, for
Jonathan Cape publishers

dimensions
145 x 198 mm
5¾ x 7¾ in

designers
Peter Dyer
Conor Brady

photographer
Conor Brady

design company
React

country of origin
UK

work description
Front cover of the book
Europe: The Rough Guide,
for The Rough Guide
publishers

dimensions
145 x 198 mm
5¾ x 7¾ in

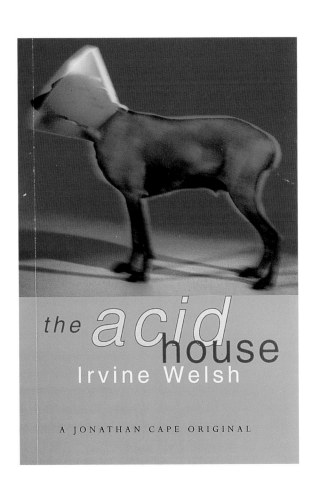

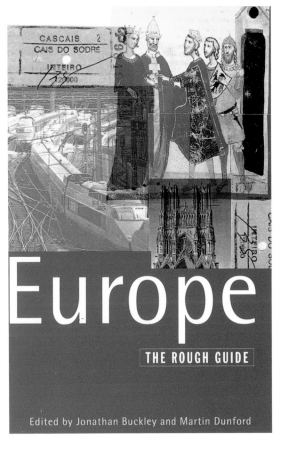

designer
Nick Bell

photographers
BBC Library
Nick Bell

art director
Roger Mann at
Casson Mann

design company
Nick Bell

country of origin
UK

work description
Design for manager's
office and department
reception at BBC Schools
Television: a typographic
skin to wrap around two
reception desks and to
cover the surface of a
freestanding storage wall

dimensions
each laminate sheet
1050 x 1250 mm
41³⁄₈ x 49¹⁄₄ in

124

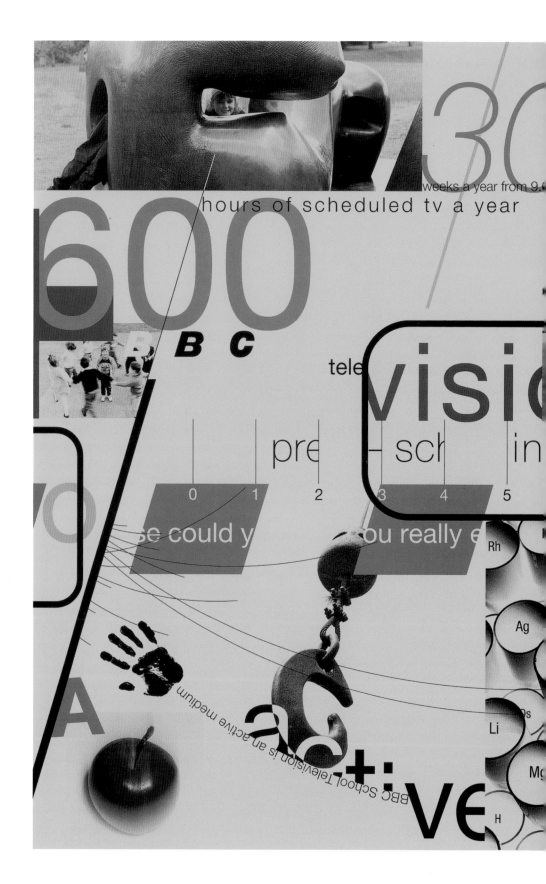

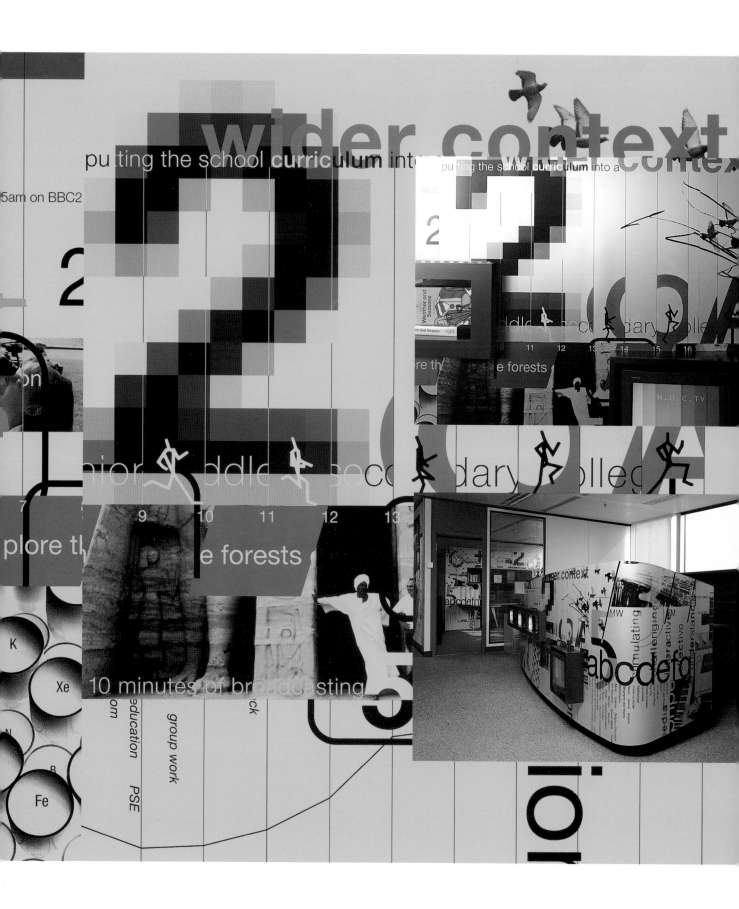

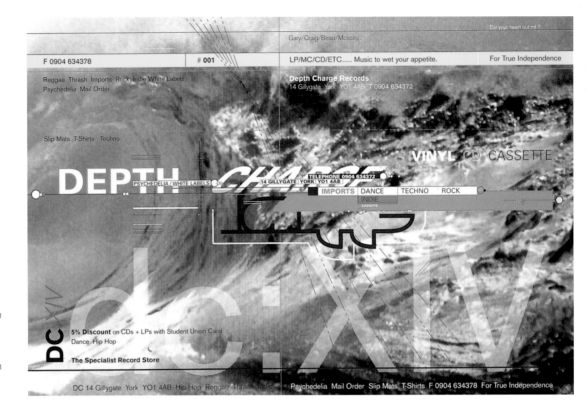

designers
Christopher Ashworth
Dave Smith

art director
Christopher Ashworth

design company
Invisible

country of origin
UK

126

work description
Four from a set of six
promotional postcards
for Depth Charge
Records

dimensions
shown actual size
149 x 100 mm
5⁷⁄₈ x 3⁷⁄₈ in

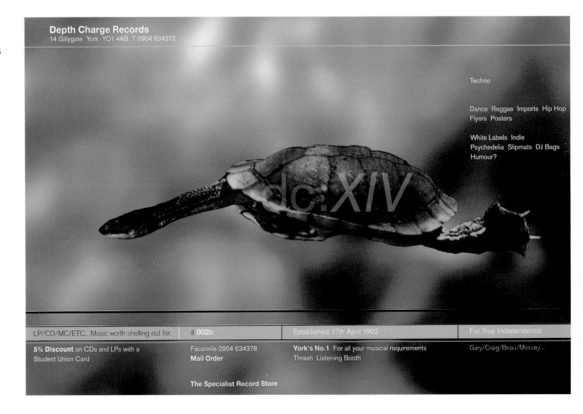

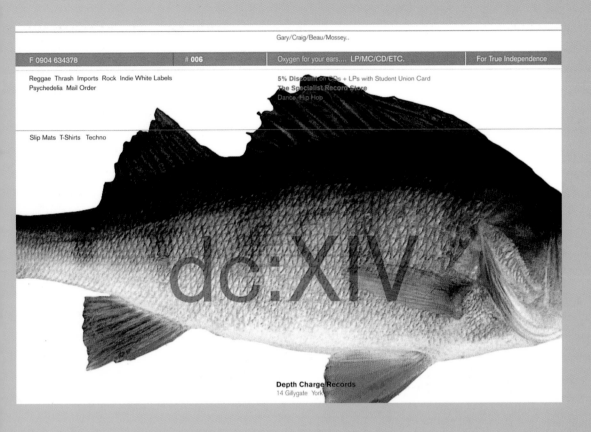

Gary/Craig/Beau/Mossey..

F 0904 634378 # 006 Oxygen for your ears.... **LP/MC/CD/ETC.** For True Independence

Reggae Thrash Imports Rock Indie White Labels
Psychedelia Mail Order

5% Discount on CDs + LPs with Student Union Card
The Specialist Record Store
Dance Hip Hop

Slip Mats T-Shirts Techno

Depth Charge Records
14 Gillygate York

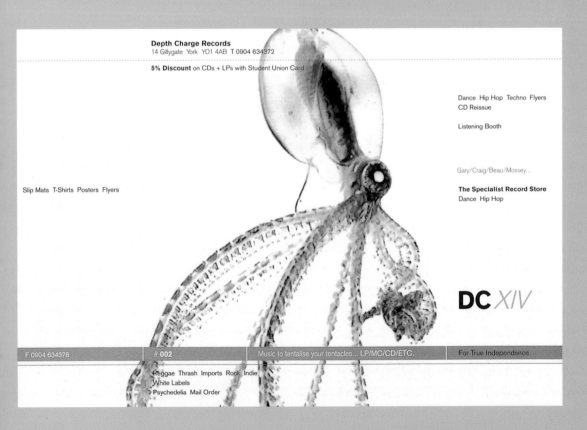

Depth Charge Records
14 Gillygate York YO1 4AB T 0904 634372

5% Discount on CDs + LPs with Student Union Card

Dance Hip Hop Techno Flyers
CD Reissue

Listening Booth

Gary/Craig/Beau/Mossey...

The Specialist Record Store
Dance Hip Hop

Slip Mats T-Shirts Posters Flyers

DC *XIV*

F 0904 634378 # 002 Music to tantalise your tentacles... **LP/MC/CD/ETC.** For True Independence

Reggae Thrash Imports Rock Indie
White Labels
Psychedelia Mail Order

designer
Hans P. Brandt

design company
Total Design

country of origin
The Netherlands

work description
Hubble Space Telescope, a
poster for the European
Space Agency

dimensions
630 x 890 mm
24¾ x 35 in

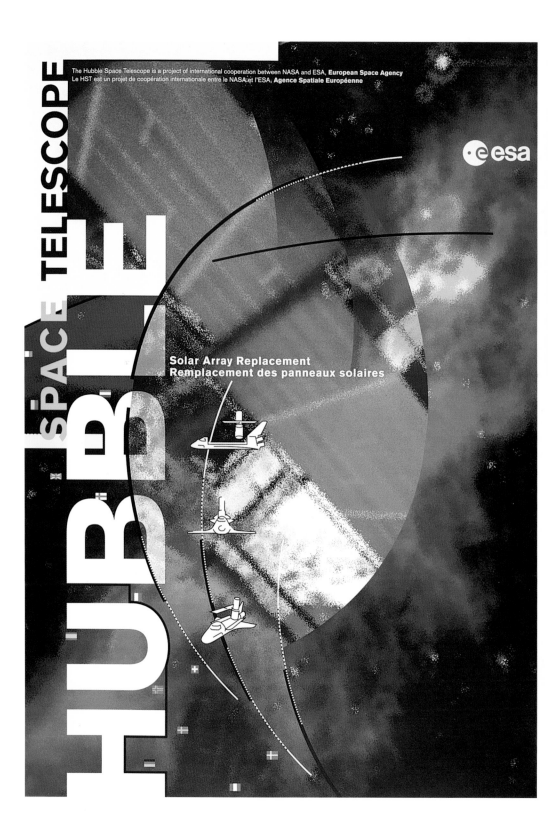

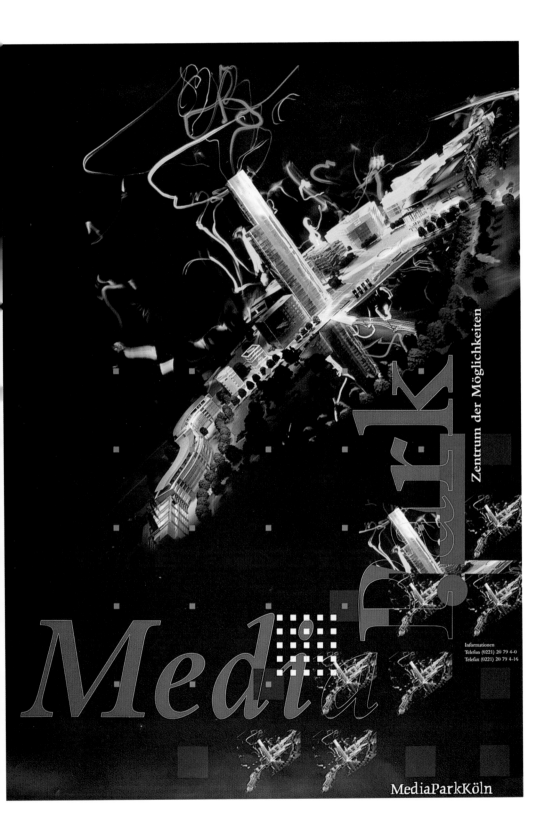

designer
Hans P. Brandt

photographer
Tom Mittemeijer

design company
Total Design

country of origin
The Netherlands

work description
MediaParkKöln, a poster

dimensions
597 x 850 mm
23½ x 33½ in

129

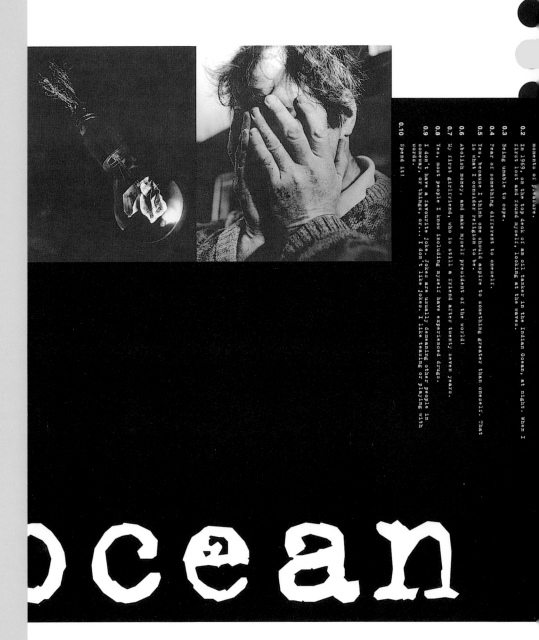

bulb = light water = growth

moments of pleasure.

0.2 In 1969, on the top deck of an oil tanker in the Indian Ocean, at night. When I
 first lost and found myself, looking at the waves.

0.3 Being unable to cope.

0.4 Fear of something different to oneself.

0.5 Yes, because I think one should aspire to something greater than oneself. That
 is what I consider religion to be.

0.6 Abolish money, and make myself president of the world!

0.7 My first girlfriend, who is still a friend after twenty seven years.

0.8 Yes, most people I know including myself have experienced drugs.

0.9 I don't have a favourite joke. Jokes are usually demeaning other people in
 someway, or things, or... I don't like jokes. I like teasing or playing with
 words.

0.10 Spend it!

designers
Nilesh Mehta
Uday Patel

college
Ravensbourne College
of Design and
Communication,
Chislehurst

country of origin
UK

130

work description
Spread from a booklet
displaying the answers
given by people of various
ages and cultures to ten
questions posed by the
designers/publishers

dimensions
295 x 418 mm
11⅝ x 16½ in

ocean

Rose Guat Kheng Lim / John Attwood

0.10

Left (Rose Guat Kheng Lim): If I had a million pounds, I would think of going on a luxury cruise around the w

Right (John Attwood): Well, I think really I would put it into the foundation of a scholarship of some sort. I'd take ten percent for myself. But I've always wanted to fund a scholarship. If I was rich that's what I'd do.

0.9

Left: Favourite joke. It's a riddle. It's very long if I can remember it. What is the difference between a lady and a diplomat? When a diplomat says yes he means perhaps, if he says no he's no diplomat. When a lady says no she means yes, if she says yes, she is no lady!

Right: I've heard hundreds of jokes, but I can't really remember any at the moment.

0.8

Left: Drugs! My great grandmother in the twenties, I know, smoked Opium.

Right: I had a puff of Hashish when I was in Egypt, when I was in the army. One or two had more than one puff, but I didn't really get any kick out of it. Then I had some friends who were artists many years ago, and I did sort of smoke some then as well, but I never got hooked.

0.7

Left: My husband.

Right: Sir Michael Charlesworth. As I say, I never got married. I'm not a poof, but it just so happens he's a man, and a super fellow.

0.6

Left: Teach everybody.

Right: Well, I suppose really the thing that causes more problems than anything is war. I used to be a soldier, and strangely enough, I'm a man of peace. I believe you have to have some sort of discipline, and when you have order and discipline people are happier.

0.5

Left: Yes, I'm a Christian.

Right: Well, it is in a sense. I was brought up as a Christian, but now I find Christianity specifically, is not really pinned to my beliefs anymore. I'm sort of going towards an atheist. I think the sadness is when you've lost your religion, you lose your respect for God, but you also lose your respect for other people as well.

0.4

Left: Economic, I suppose.

Right: I would say when people from overseas don't abide by our laws, if they behave as British people are suppose to behave, all British people aren't perfect-but if they break laws or break our conventions, that's what causes racism. For instance, the other day I was run over by a cyclist on the pavement and he wouldn't get off his bicycle Now the fact that he was a black man wouldn't normally make me racist, but because every time you have a cyclist riding on the pavement it's a black man, it often causes racism when you have people who don't conform with the conventions. You know, British people aren't perfect, but there's so many things like that. For instance getting into a tube train, you wait until the people have got off, almost always you find that it might be someone from overseas, shall we say. I suppose some of them don't understand the conventions. This is really what causes racism. If the authorities favour them, which is what is happening in some working class areas, say Liverpool. I'm not what you would call working-class myself, although I worked damned hard, before I retired. There are extremely poor areas around the country. I think a lot of working-class people feel that especially West Indians have come to take their jobs, I think that is a cause of racism.

0.3

Left: Widowhood.

Right: Certainly not death. I've never really had much pain, I've got arthritis. Oh, I don't know, I suppose being beaten up by a gang. A gang of seven people once tried to beat me up, but I used to be very strong and fit in those days, and I'm big of course, and these seven people once attacked me in the back streets of Manchester. I saw them off and two of them were in hospital and they didn't put me in hospital, but I wouldn't want to be beaten up by a gang. I can look after myself with one person but if I have three or four people that would be a fear.

0.2

Left: The day I got married.

Right: Well I'm not married. I think it was when I qualified as an officer in the army.

0.1

Left: It used to be my collection of theatre programmes, but I didn't have enough room to house them all.

Right: I've got you there, my Library.

Rose Guat Kheng Lim | **John Attwood**

designer
Stephen Banham

art director
Stephen Banham

design company
The Letterbox

country of origin
Australia

work description
Front cover and spreads
from the magazine
Qwerty, issue 5

dimensions
80 x 105 mm
3⅛ x 4⅛ in

132

Feet	Metres	Points
25	8	2275

All I was given was a street-map reference and the promise of something very exciting indeed. Always inclined to take up such an offer, I followed the instructions which led me into the deep industrial heartland of Richmond. I stood on the spot marked X on the map and wondered what it was about. I slowly looked up and there it was. The biggest upper case K I had ever laid my eyes on. This type, despite its scale, was obscured from distant view by the buildings that had since been built around it.

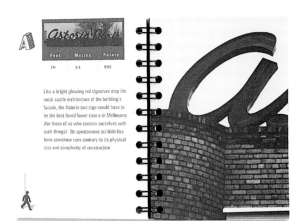

Feet	Metres	Points
10	3.5	995

Like a bright glowing red signature atop the mock castle architecture of the building's facade, the Astoria taxi sign would have to be the best loved lower case a in Melbourne (for those of us who concern ourselves with such things). Its spontaneous scribble-like form somehow runs contrary to its physical size and complexity of construction.

Feet	Metres	Points
10	3	900

This typographic drag queen is possibly the most recognisable in Melbourne. Its scale and sense of occasion beckons the viewer inward asking you to politely ignore its crumbling facade.

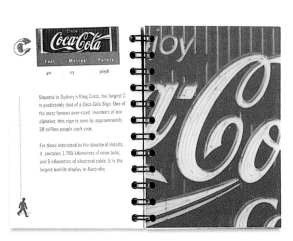

Feet	Metres	Points
40	13	3698

Situated in Sydney's King Cross, the largest C is predictably that of a Coca Cola Sign. One of the most famous over-sized members of our alphabet, this sign is seen by approximately 20 million people each year.

For those interested in the structural details, it contains 1,785 kilometres of neon tube, and 5 kilometres of electrical cable. It is the largest backlit display in Australia.

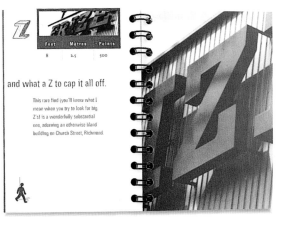

Feet	Metres	Points
8	2.5	500

and what a Z to cap it all off.

This rare find (you'll know what I mean when you try to look for big Z's) is a wonderfully substantial one, adorning an otherwise bland building on Church Street, Richmond.

designer
Alan Chandler

country of origin
UK

work description
Spreads from
typographic
sketch books

dimensions
300 x 420 mm
11⁷⁄₈ x 16½ in

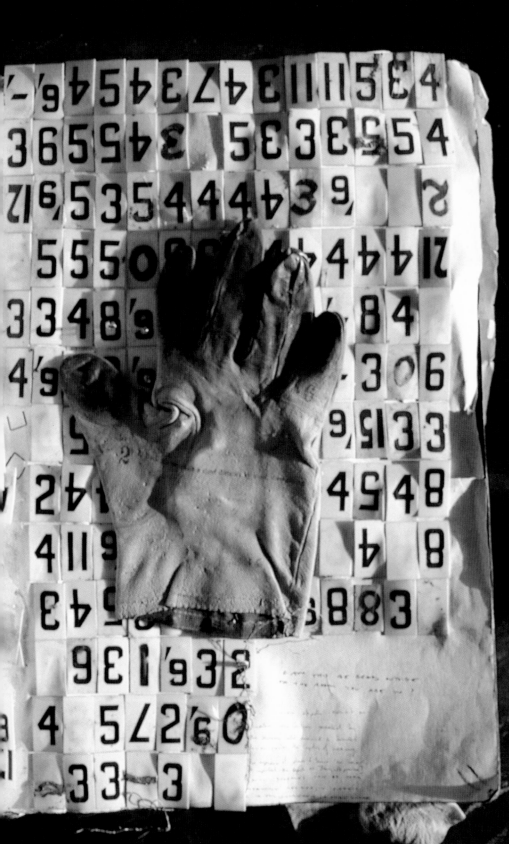

designers
Barbara Gluaber
Somi Kim

design company
Heavy Meta (Barbara
Gluaber)
ReVerb (Somi Kim)

photographer
Steven A. Gunther

country of origin
USA

work description
Spread and front cover
from a catalog/prospectus
for the California Institute
of the Arts

dimensions
200 x 285 mm
7⁷⁄₈ x 11¼ in

136

Steven D. Lavine became CalArts' third president in July of 1988. Before coming to CalArts, he was associate director for Arts and Humanities at the Rockefeller Foundation in New York City. There he provided leadership in the full spectrum of visual, performing and literary arts, with special emphasis on programs that challenge contemporary artists and cultural institutions to work toward an international and intercultural focus. While at the Rockefeller Foundation, he served on the board of directors of the Kitchen Center for Video.

Music, Dance, Performance, and Film and of the Mabou Mines Theater Collective. He was also a selection panelist for the INPUT Public Television Screening Conferences in Montreal, Canada and Granada, Spain.

He currently serves on the board of directors of the Los Angeles Philharmonic, the American Council for the Arts, and KCRW-FM National Public Radio, as well as the Governing Committee of the Institute for Advanced Study and Research in African Humanities at Northwestern University (for Northwestern and the Social Science Research Council), the Visiting Committee of the J. Paul Getty Museum, and the National Advisory Committee of the Smithsonian Institute's Experimental Gallery. He has served on the board of directors of the Operating Company of the Music Center

of Los Angeles, as co-director of the Arts and Government Program for the American Assembly at Columbia University, and co-chair of the Mayor's Working Group of the Los Angeles Theatre Centre. In 1991 he co-edited with Ivan Karp, *Exhibiting Cultures: The Poetics and Politics of Museum Display.* In 1992 the Smithsonian Institution Press released their second co-edited volume, *Museums and Communities: The Politics of Public Culture.*

of providing
their potential to its ful
your chosen art w
Schools of Art, Dance, Film/Video, M
calarts affords you, the stud
where appropriate, to engage in your own interdiscipli
you will work closely with a distinguished fa
give you access to dedicated and experienced faculty through tuto
scheduled classes. We
While teaching the mastery of tech
working with
brought to campus by a variety of ongoing visiting
prepared to recognize the con

president's message

Throughout its history, calarts
has been guided by its founding goal
ironment which enables emerging artists to develop
ent. At calarts you can perfect skills in
ning knowledge of the other arts through our
atre, and the Division of Critical Studies.
opportunity to forge new relationships among the arts, and,
orations. ⬤ At calarts,
racticing artists. Innovative programs
oring, and independent studies as well as through regularly
creativity and self-discipline.
rive to respond to your individual needs. ⬤ In addition to
r faculty, you will have the opportunity to learn from many other distinguished artists
ms. ⬤ As future artists, you must be
ical, social, and aesthetic questions and respond to them

with informed, independent judgment. At calarts, these abilities are fostered in the Division of Critical Studies as well as in the arts
chools. The Critical Studies faculty of dedicated teachers and scholars will introduce you to the basic methods and disciplines of the liberal
rts—the humanities, sciences, and social sciences—and especially to concerns of the arts and thought processes in the arts. This program
ill broaden your knowledge and understanding of the world and help you to analyze issues critically and imaginatively. ⬤ During your
tudies at calarts, you will explore the philosophical, literary, social, and aesthetic dimensions of a diverse culture. You will meet and
work with faculty, students, and visiting artists who represent various ethnic, cultural and national groups. Through our Community
rts Partnership (CAP), you will have the opportunity to work at cultural centers in neighborhoods throughout Los Angeles. ⬤ As we
onsider calarts' future, we see four immediate opportunities for enhancing the education we offer. The first is to continue to work
oward including a broad range of voices—ethnic, cultural, and international—in every area of the Institute. The past decade has
rought rapid change in this arena, but there is still a long road to travel, in the arts as in our society. The second is to make available
he array of resources for interactive and multimedia artmaking. Integrated media technologies will create a firm platform for
nterdisciplinary exploration, the third area in which we hope to see development in the rest of this decade. calarts was designed
ot only to offer the arts individually but to encourage interdisciplinary inquiry. As we enter our second quarter century, we are still
hallenged to fulfill this vision of our founders. Fourth, but not at all least among these priorities, is to strengthen the place of
riting at calarts. Recently, we've put in place an MFA program in Critical Writing/Arts Practice. Now we must work toward a full-
cale writing program that takes advantage of the unique interdisciplinary resources at the Institute. ⬤ During the two and one-
alf decades of its existence, calarts has been, appropriately, in a continual state of evolution. These new initiatives recognize
hat the place of the arts in society is in constant flux, and so necessarily calarts must change and
evelop. At calarts our mandate is to help create the future; we invite you to join us in this adventure. Steven D Lavine

designer
Stephen Hyland

college
The Surrey Institute of
Art & Design, Farnham

tutor
Mike Ryan

country of origin
UK

work description
Spread from *Area 39*,
a magazine project
covering experimental
music, design, and
multimedia

dimensions
210 x 297 mm
8¼ x 11¾ in

138

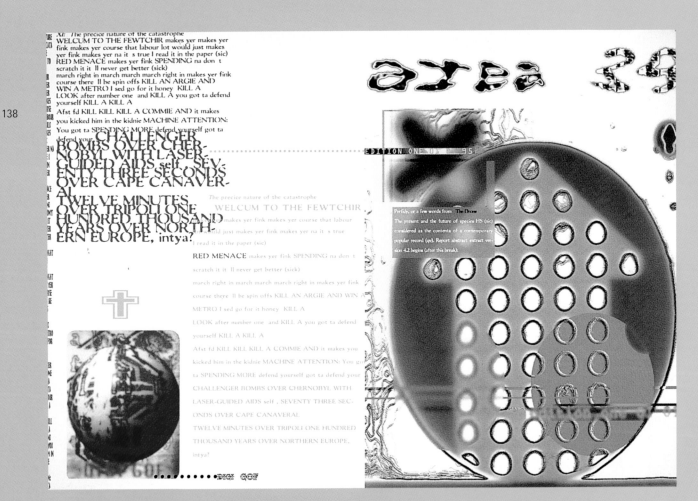

designer
Ed Telling

college
The Surrey Institute of
Art & Design, Farnham

tutor
Mike Ryan

country of origin
UK

work description
Spread from *Area 39*,
a magazine project
covering experimental
music, design, and
multimedia

dimensions
210 x 297 mm
8¼ x 11¾ in

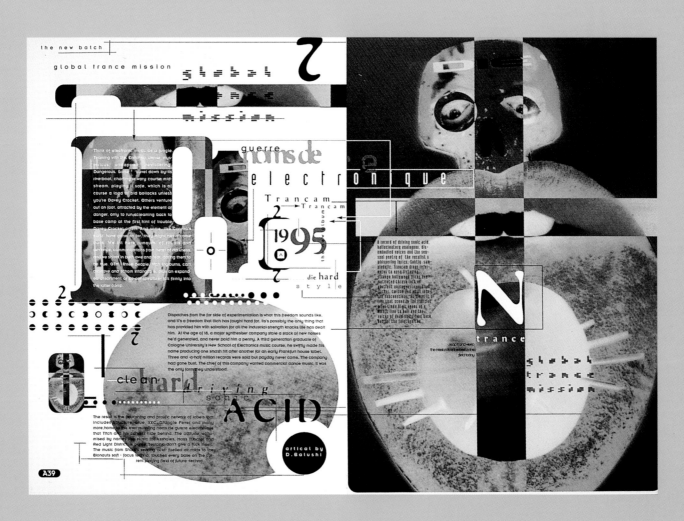

designer
Naomi Mizusaki

art directors
Rosie Pisani
Pete Aguannd
Drew Hodges

design company
Spot Design

country of origin
USA

work description
Advertisements for the
Independent Film Channel

dimensions
200 x 152 mm
7⅞ x 6 in

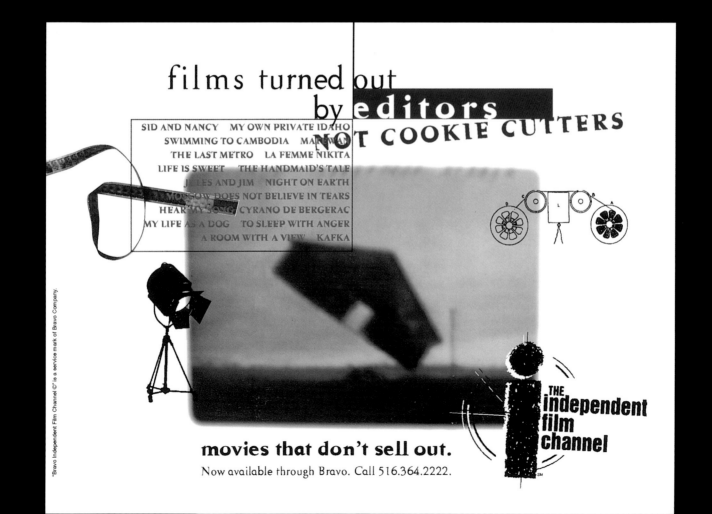

films directed
by directors NOT BANKERS

SID AND NANCY MY OWN PRIVATE IDAHO THE HANDMAID'S TALE
MY LIFE AS A DOG JULES AND JIM LIFE IS SWEET MATEWAN
NIGHT ON EARTH KAFKA HEAR MY SONG CYRANO DE BERGERAC
TO SLEEP WITH ANGER THE LAST METRO
LA FEMME NIKITA A ROOM WITH A VIEW
MOSCOW DOES NOT BELIEVE IN TEARS
SWIMMING TO CAMBODIA

*Bravo Independent Film Channel ℠ is a service mark of Bravo Company.

THE
independent
film
channel

movies that don't sell out.
Now available through Bravo. Call 516.364.2222.

designer
Vincent Sainato

photographer
Mark Hill

art director
Drew Hodges

design company
Spot Design

country of origin
USA

work description
Page from the 1994
Hanna-Barbera
*Flintstones Collectibles
Calendar*

dimensions
280 x 660 mm
11 x 26 in

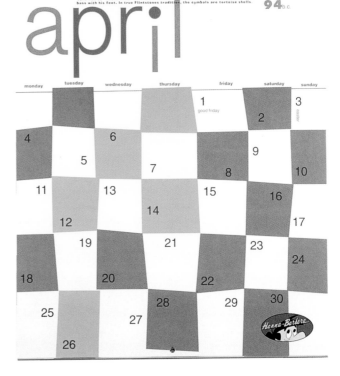

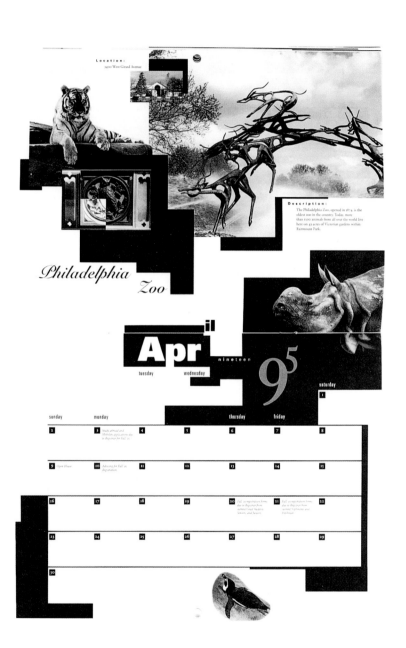

Location:
1400 West Girard Avenue

Description:
The Philadelphia Zoo, opened in 1874, is the oldest zoo in the country. Today, more than 1700 animals from all over the world live here on 42 acres of Victorian gardens within Fairmount Park.

Philadelphia Zoo

April nineteen 9⁵

sunday monday tuesday wednesday thursday friday saturday

designer
George Plesko

photographer
George Plesko
Tom Davies

art director
Nancy Mayer

design company
Mayer & Myers

country of origin
USA

143

work description
Page from *The University of the Arts Calendar and Student Handbook*, for The University of the Arts, Philadelphia

dimensions
277 x 425 mm
10⁷⁄₈ x 16³⁄₄ in

designer
Richard Shanks

college
California Institute
of the Arts

country of origin
USA

work description
Pages from *Shoes Make
The Man*, a false diary
that is a self-authored
experimental typography
project exploring cultural
identity and stereotype

dimensions
254 x 381 mm
10 x 15 in

144

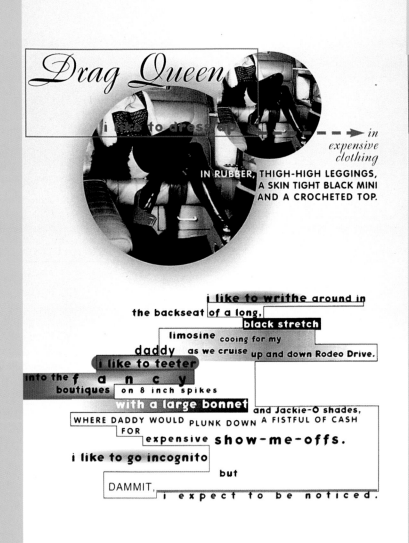

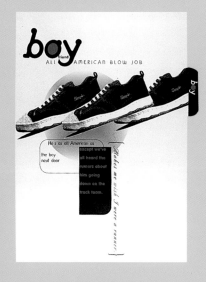

boy
ALL (friend) AMERICAN BLOW JOB

Simple · Simple · Simple

boy

He's as all American as the boy next door · except we've all heard the rumors about him going down on the track team.

Makes me wish I were a runner.

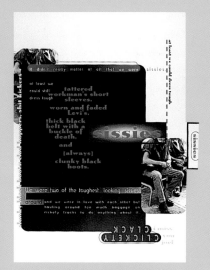

at least we could dress tough, though.

It didn't really matter at all that we were · sissies

at least we could still...

tattered workman's short sleeves,

worn and faded Levi's.

thick black belt with a buckle of death,

and

[always]

clunky black boots.

sissie · sissies

We were two of the toughest looking sissies

around · and we were in love with each other but hauling around too much baggage on rickety tracks to do anything about it.

CLICKETY CLACK

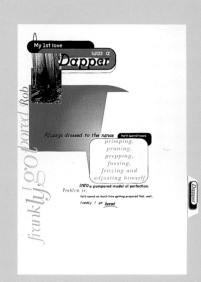

My 1st love · was a · Dapper

bored Rob

Always dressed to the nines · he'd spend hours

priming,
pruning,
prepping,
fussing,
fritzing and
adjusting himself

into a pampered model of perfection.

Problem is,

he'd spend as much time getting prepared that, well...

frankly I got **bored**

frankly I got bored Rob

Dapper

145

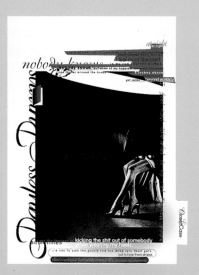

nobody knows

alright

Painless Dreams

nobody knows

Closet Case

sometimes · kicking the shit out of somebody while wearing my heels.

i'd like to sink the pointy red toe deep into their guts.

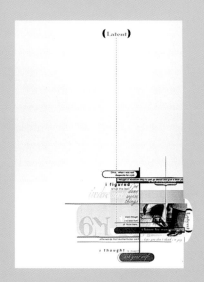

(Latent)

i figured

i thought · ask your wife.

designer
Russell Warren-Fisher

design company
Warren-Fisher

country of origin
UK

work description
Spread and cover from a
brochure for Camilla
Arthur, shown with the
promotional envelope

dimensions
brochure
320 x 255 mm
12⅝ x 10 in
envelope
380 x 300 mm
15 x 11⅞ in

146

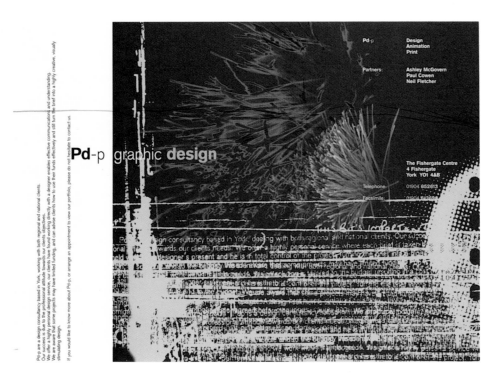

Pd-p graphic design

Pd-p are a design consultancy based in York, working with both regional and national clients.
Our success is due to the professional attitude towards our clients objectives.
We offer a highly personal design service, our clients have found working directly with a designer enables effective communications and understanding.
We are aware that some projects may have limited funding, and can advise clients how to use their funds effectively and still turn the brief into a highly creative, visually stimulating design.

If you would like to know more about Pd-p, or arrange an appointment to view our portfolio, please do not hesitate to contact us.

Pd-p graphic design

Pd-p are a design consultancy based in York, working with both regional and national clients.
Our success is due to the professional attitude towards our clients objectives.
We offer a highly personal design service, our clients have found working directly with a designer enables effective communications and understanding.
We are aware that some projects may have limited funding, and can advise clients how to use their funds effectively and still turn the brief into a highly creative, visually stimulating design.

If you would like to know more about Pd-p, or arrange an appointment to view our portfolio, please do not hesitate to contact us.

designer
Neil Fletcher

design company
Pd-p

country of origin
UK

work description
Self-promotional postcards

147

dimensions
210 x 148 mm
8¼ x 5⅞ in

designer
Cathy Rediehs Schaefer

art director
Tom Geismar

design company
Chermayeff & Geismar
Inc.

country of origin
USA

work description
Front cover and spreads
from a brochure
launching a reorganized
office furniture company,
the Knoll Group

dimensions
279 x 279 mm
11 x 11 in

148

Planning and furnishing the workplace today means thinking far beyond metal, wood and plastic. The people who work are changing, and so are the tools that they use. Demographic trends, leaps in computer and communications technology, reconfigured organizational structures, new sensitivity to workers' well-being and the environment —all make the workplace a focal point for unfamiliar and complex concerns. At **Knoll,** a company uniquely founded on the concept of **design,** we are redefining form and function to accommodate these new dimensions.

The intelligent workspace **adapts to companies and their people.**

ntelligent workspace **supports the**

process.

Knoll embodies a heritage of design and technology.

The intelligent workspace is the result of more than fifty years of excellence in office design, and over a century of technological leadership.

Since 1938, Knoll has followed its vision of applying the finest design to work environments. Inspired by the creative genius of the Bauhaus school in Germany, Hans Knoll founded his company on the idea that good design could benefit everyone. Florence Knoll, his wife and partner, pioneered the modern office by integrating every aspect of its space, furnishings and equipment.

Westinghouse, parent company of The Knoll Group, has been at the technological forefront ever since 1886, when its system of alternating current launched the age of electricity. From energy to microelectronics to furniture, the Westinghouse name guarantees world-class technology and the highest standards of total quality.

These unmatched traditions of advanced design and high technology, along with customer-focused service and global distribution and manufacturing, stand behind the Knoll commitment to create workspaces where people can do their best work and enjoy doing it.

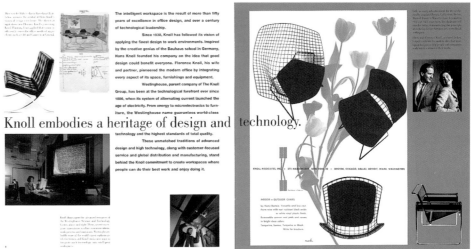

type
type
type
type
type
type
type
type
type

type
type
type
type

type as text

designer
Kees van Drongelen
(with cooperation from
Christine Baart and Harco
van den Hurk)

design company
Post & Van Drongelen,
VisualSpace

country of origin
The Netherlands

work description
Title page and spreads
from the book *The
Invisible in Architecture*,
for Academy Editions

dimensions
250 x 305 mm
9⅞ x 12 in

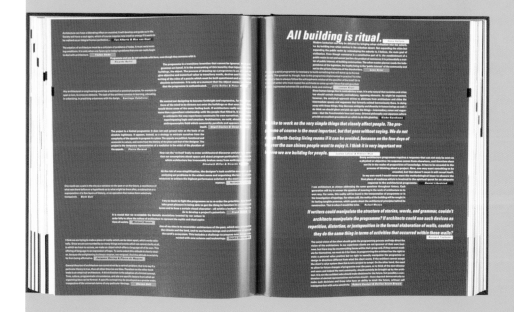

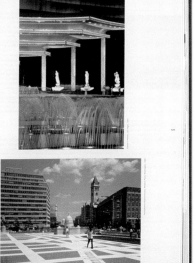

designers
Rudy VanderLans
Gail Swanlund

art director
Rudy VanderLans

design company
Emigre Graphics

country of origin
USA

work description
Spreads from *Emigre*
magazine, issue 32

dimensions
282 x 425 mm
11 1/8 x 16 3/4 in

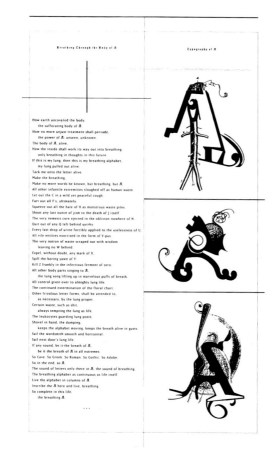

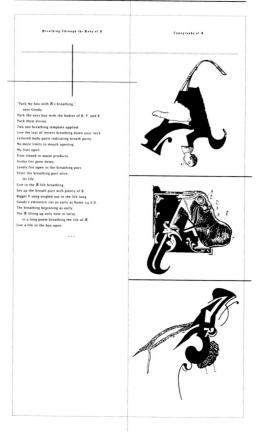

alternative? Now that it can no longer rely on one of the big stories that are dead and buried according to Bell and Lyotard? Many replace the big narratives by micro-narratives or, as we saw, by the "critical" ideologies adopted by the great majority, which retain at least the prospect of a better world. How is the self-centered ethic of the designer yearning for the status of an artist to be avoided?

Two concepts seem to me important as the foundations for a proper design ethic. The first is respect for the other. By that I mean something quite different from taking account of the average preferences of a target group as determined by marketing techniques based on consumer panels, etc. In this respect, what I have in mind is not the other insofar as s/he can be equated with all others who are part of the same target group of a marketing strategy that basically reduces everyone to a consumer. What I envisage is the other insofar as his or her values and images differ from mine. New designs show this openness towards the other - or question the implicitly assumed hegemony of their own culture. The second concept is the d e s i r e of the designer him or herself, for which a design ethic should leave ample scope. S/he could be present in the design as the s u b j e c t o f d e s i r e, not as the manipulator of the demands, needs and wishes of others. So does this mark a return to the romantic image of the designer as autonomous subject, in order to escape from the false romanticizing and sentimentality of commercial communication? No. Desire is a source of poetic production. It aims for the Utopian element, the dream character of reality in the strongest sense of the word. Desire transcends the world of available objects and does not cover up the fundamental shortcoming of the human condition with the endless repetition of satisfying needs.

Desire accepts the shortcoming as an insoluble characteristic of human existence and is diametrically opposed to promises for the not-present object keeps the line to the future open. It can only be put into words by a rich voice.

We can now see that a desire formed the basis of both the Traditionalist and the Modernist ethic, although this was not recognized as such by the spokesmen for each movement. It is the desire for a rational society in which strength of argument will triumph over power and violence, the desire for a society in which justice will be done to everyone, not just to an élite.

Can design be more than it now is: streamlining of communication controlled by the system of power and money? The affirmative answer to this question is based on two observations.

First, this system is not monolithic; fractures and contradictions can be seen. It is not uncommon for these to be intensified by the still operative ideals and sense of responsibility of policy makers. Designers can cooperate productively with them, although often only on a temporary basis.

Second, the system constantly sets its own limits. At the edge of its territory, an extraterritoriality arises in which the interests and wishes of marginalized groups and individuals ask to be articulated. Since the sixties, a rival public domain has existed that has bombarded the system from the flanks with unwelcome counter-information and counter-images.

Strategies aimed at the general good and social/cultural/political priorities form the points of action to a kind of design that positions itself beyond the status quo and wants to be more than the bonus continuo of power and the market. Design like this breathes fresh air into the polluted and blocked lungs of the body of society. It is inspired as much by the rejection of injustice as by the desire for the sublime.

This field is a public domain that must itself be constantly r e d e s i g n e d.

The
End

I owe this typology, in a discussion with new coworkers, architect and professor of architectural design at the technological university of eindhoven, on differences and similarities between students and practitioners of the design disciplines architecture and graphic design.

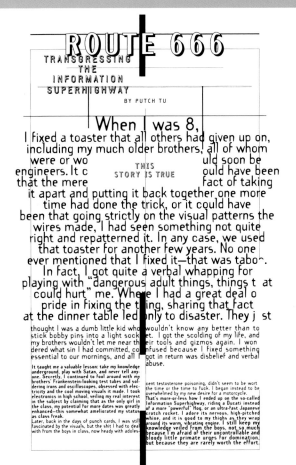

When I was 8, I fixed a toaster that all others had given up on, including my much older brothers, all of whom were or wo uld soon be engineers. It c ould have been that the mere fact of taking it apart and putting it back together one more time had done the trick, or it could have been that going strictly on the visual patterns the wires made, I had seen something not quite right and repatterned it. In any case, we used that toaster for another few years. No one ever mentioned that I fixed it—that was taboo.

THIS STORY IS TRUE

In fact, I got quite a verbal whapping for playing with "dangerous adult things, things t at could hurt" me. Where I had a great deal o pride in fixing the t ing, sharing that fact at the dinner table led only to disaster. They j st thought I was a dumb little kid who wouldn't know any better than to stick bobby pins into a light socket. I got the scolding of my life, and my brothers wouldn't let me near their tools and gizmos again. I wondered what sin I had committed, confused because I fixed something essential to our mornings, and all I got in return was disbelief and verbal abuse.

It taught me a valuable lesson: take my knowledge underground, play with Satan, and never tell anyone. Secretly, I continued to fool around with my brothers' Frankenstein-looking test tubes and soldering irons and oscilloscopes, obsessed with electricity and the cool moving visuals it made. I took electronics in high school, veiling my real interest in the subject by claiming that as the only girl in the class, my potential for more dates was greatly enhanced—this somewhat ameliorated my status as class freak.

Later, back in the days of punch cards, I was still fascinated by the visuals, but the shit I had to deal with from the boys in class, now heady with adoles-cent testosterone poisoning, didn't seem to be wort the time or the time to fuck. I began instead to be overwhelmed by my new desire for a motorcycle. That's more-or-less how I ended up on the so-called Information Superhighway, riding a Ducati instead of a more "powerful" Hog, or an ultra-fast Japanese crotch rocket. I adore its nervous, high-pitched whine, and it is good to my thighs as they wrap around its warm, vibrating engine. I still keep my knowledge veiled from the boys, not so much because I'm afraid of their uncontrollable and bloody little primate urges for domination, but because they are rarely worth the effort.

designers
Stephen Shackleford
Jan C. Almquist

photographer
James B. Abbott

art director
Jan C. Almquist

design company
Allemann Almquist
& Jones

country of origin
USA

work description
Front covers and spreads
from a two-part 1993
Annual Report for The
Franklin Institute Science
Museum

dimensions
210 x 290 mm
8¼ x 11⅜ in

In 1934, The Franklin Institute opened a museum with the new idea of "learning by doing," using interactive exhibits. When the Mandell Futures Center and Tuttleman Omniverse Theater opened in 1990, the Museum took another step forward, presenting the science and technology of the 21st century—technology that is currently shaping our lives—in informative, engaging, and entertaining ways.

Almost 1,000,000 people visit the Institute each year. Using interactive videodisks, computer games, demonstrations and interactive displays, science is a lively art at The Franklin Institute.

The Strategic Plan calls for another new look at how the Museum is organized and for the redesign and renovation of almost every Institute exhibit. Exhibits in the Science Center

Museum Visitors	
Groups	155,748
Individuals	834,127
Camp-In Overnight Program	15,000
Facility Rentals	30,000
Workshops	2,000
Total	**1,036,875**

will be expanded and organized around broad themes of basic science—life science; earth and the environment; transportation; and space and astronomy. An expanded traveling exhibition gallery will enable the Institute to accommodate larger special exhibits.

The Mandell Futures Center will focus on two areas of rapidly changing technology—biotechnology and information technology. The information technology exhibit, "Inside Information," is scheduled to open to coincide with the 50th anniversary of the ENIAC computer in 1996.

A renewed focus on evaluation will provide guidance in developing these new initiatives. Key criteria for future growth are enhanced staff training, expanded family programming, and a commitment to continuous quality improvement and to serving a diverse public.

The Franklin Institute will continue its proud tradition of meeting the needs of a changing community. Exhibits and programs will be reorganized, refurbished, and reinvented with a focus on new technologies and the complex issues they raise.

The Franklin Institute Science Museum

Annual Report

1 9 9 3

Programs for recognizing scientific excellence are critical in building excitement and interest in science and take place on many levels. For students, the Institute coordinates the region's largest science fair and works to help girls achieve science merit badges. Scientists and inventors have been recognized through Franklin Institute award programs since 1825. Through the Bower Award and Prize for Achievement in Science, founded in 1988, the Institute conducts an international search to identify a distinguished scientist to receive one of the largest American cash prizes in science.

In 1994, The Journal of The Franklin Institute will be reissued as The Journal of The Franklin Institute: Engineering and Applied Mathematics. A second journal, Technology: The Journal of The Franklin Institute, will also be launched in 1994.

Scientists

Bower Awards	300 reviewers	200 participants	
Scholarly Journals	500 subscribers		
Symposia, lectures	3,000 attendees		
Science and Arts Committee	50 members		
		4,050	

These activities fulfill an important and unique aspect of the Institute's mission, providing opportunities for students, visitors, and educators to interact with scientists whose contributions are shaping our world and our future.

Recognizing scientific excellence and promoting scientific scholarship have been hallmarks of The Franklin Institute since 1825. These efforts will be strengthened by the year 2000.

157

designer
Kees Nieuwenhuijzen

country of origin
The Netherlands

work description
Front cover, title page,
and spread from *The
Low Countries*, for the
Flemish-Netherlands
Foundation "Stichting
Ons Erfdeel"

dimensions
175 x 234 mm
6⁷/₈ x 9¹/₄ in

THE LOW COUNTRIES

ARTS AND SOCIETY IN FLANDERS
AND THE NETHERLANDS
A YEARBOOK

1994-95

Published by the

Flemish-Netherlands Foundation 'Stichting Ons Erfdeel'

OMA, *Kunsthal*, Rotterdam.
(Photo by Michael Bullinga).

attention to one aspect that is often neglected or undervalued: Koolhaas' unconventional use of materials. He uses steel sections next to debarked tree trunks, yellow travertine next to roughly worked concrete. All materials are of equal value to the artist, wrote Adolf Loos in 1898, adding that the cladding was more important than the construction which held it in place, and that textiles are the common origin of both architecture and clothing. A particularly clear illustration of this thesis is the Kunsthal's auditorium, which is separated from the surrounding space by a thick curtain. When the auditorium is not in use, the curtain is kept open; when it is rolled up the rising hem gives it the elegance of an evening gown. The architect noted for his conceptual rigour has here produced an especially tactile building. Outside, the walls and roofs are covered with semi-transparent corrugated sheets. They reveal what usually remains unseen: the skeleton of the wall, the movement of the lift – but they conceal the windows. In the evening when artificial light projects the windows onto the corrugated sheets, the effect is unearthly.

PAUL VERMEULEN
Translated by John Rudge.

The designs marked with an asterisk have not been built.

An exhibition of the work of OMA will be held at the Museum of Modern Art in New York at the end of 1994. On this occasion the book *Small, Medium, Large* (a survey of the history of OMA) will be presented.

FURTHER READING

Rem Koolhaas – Office for Metropolitan Architecture. In: Architecture and Urbanism, 217, October 1988.

DIJK, HANS VAN, *Rem Koolhaas. Architect* (text in Dutch and English). Rotterdam, 1992.

F

Gazettiers to Newspaper Groups

The Press in Flanders

At the time of Belgium's independence in 1830, public life in Flanders was completely gallicised. The Flemish middle classes, those who could afford a daily newspaper, read mainly French publications. Flemish newspapers had a very small share of the market, and in any case appeared only one to three times a week. This weak position contrasts sharply with the flourishing beginnings of the Flemish press in the seventeenth century. In the Spanish Netherlands most publications were in Dutch, and the Flemish press set the standard for Europe.

The Flemish press before Belgian Independence

The development of the first Flemish newspapers during the rule of Albert and Isabella (1598-1631) had much to do with the fact that Flanders had many printers of renown. The first *gazettiers* were, after all, also printers. The first *gazettier* in the Southern Netherlands to be granted a licence to publish a newspaper was Abraham Verhoeven, with *Weeckelycke Tydinghe* (Weekly News, 1629-1631). Two other Antwerp *gazettiers* were also given permission to publish newspapers. Other licences were granted to Flemish *gazettiers* in Ghent, Bruges and Brussels. At that time Dutch was a lively cultural language which was spoken in the highest circles. Naturally, there was no freedom of the press under the Ancien Régime. The press was subject to censorship and was the servant of those in power at the time.

The lead which the Flemish press had built up under Spanish rule (1555-1713) was lost during the Austrian period (1713-1792). Many 'enlightened' journalists of liberal ideas fled from France and came to Flanders, where they were able to resume their activities under the 'enlightened' Austrian rulers. The ideas of the French Enlightenment had enormous impact, and French became the language of culture. More and more French-language newspapers were launched in Brussels. During the period of French rule (1792-1814) French became the language of society and the upper classes abandoned Flemish for French. French-language newspapers increasingly drove out those in Flemish. During the Napoleonic period, a sort of linguis-

Cartlidge Levene understand our
business and its changing needs.
They are an invaluable extension
to our team.

Angela Entwistle
Marketing Director
ADT Limited

Since 1987 we have designed and
managed virtually every aspect of ADT's
visual communications strategy, including
its last six annual reports.

ADT is the largest electronic security and
vehicle auction services company in the
world. Its annual report is aimed primarily
at its shareholders in Europe and North

America, and its customers in thes
regions. The emphasis shifted in 19
when ADT changed its listing from
London to New York. Since then w
have identified the language to wh
the audience there respond.

Providing peace of mind to
customers in the home and the
workplace

designers
Simon Browning
Mason Wells

photographer
Tomoko Yoneda

art directors
Ian Cartlidge
Adam Levene

design company
Cartlidge Levene Limited

country of origin
UK

work description
Spread from a brochure
for Cartlidge Levene
Limited

dimensions
295 x 420 mm
11⅝ x 16½ in

993 annual report we worked
client's team to define the
bjective: to portray ADT as a
-oriented organisation leading
le auctions and security services
Our design emphasises ADT's
n to customer service by
g its close relationships with
om major banks to homeowners.

We managed every aspect of the report
including art directing the photography
across the US, having proofs read in
Florida via satellite link and overseeing the
production run of 90,000. For the interim
report we split the printing between
the UK and the US and ran both jobs
simultaneously.

Our work with ADT is wide-ranging:
from annual reports for Belize Holdings
Inc., of which ADT's Michael Ashcroft is
also Chairman, to the signage, stationery
and student uniforms for the ADT City
Technology College in London.

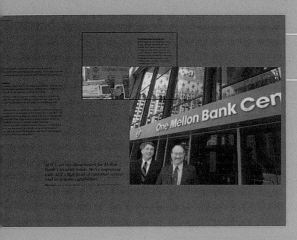

Document specification
Format 21.5 x 28.0cm
52 pages
90,000 copies

161

designer
Jason Carr

college
The Surrey Institute of
Art & Design, Farnham

country of origin
UK

work description
Spreads proposed for
Baseline magazine

dimensions
267 x 360 mm
10½ x 14⅛ in

162

designer
Viviane Schott

college
The Surrey Institute of
Art & Design, Farnham

country of origin
UK

work description
Cover and spread from
Area 39, a magazine
project covering
experimental music,
design, and multimedia

dimensions
210 x 297 mm
8¼ x 11¾ in

designers
Mark Diaper
Rachael Dinnis
Mike Davies
Domenic Lippa
Marcus "mad dog" Doling
Jann Solvang

design company
Lippa Pearce Design
Limited

country of origin
UK

work description
Front cover and spreads
from *The Downlow*, the
Hip Hop magazine

dimensions
210 x 297 mm
8¼ x 11¾ in

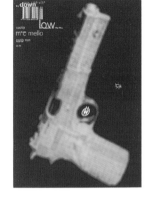

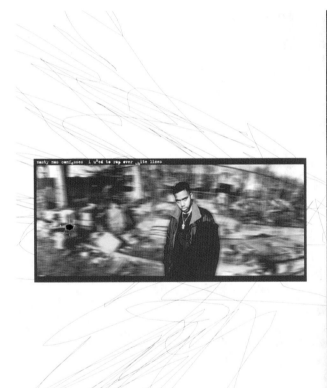

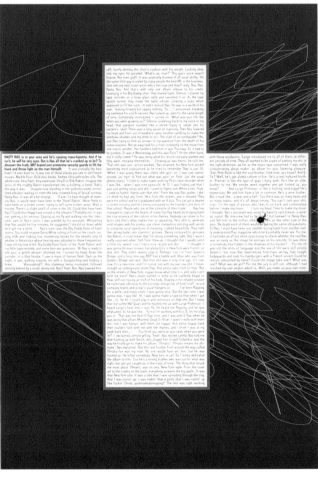

STAIN-
less meets Coolio,

Tammy Boy's West Coast Rapper
who claims: I know your Queen when she was
working at the K-Mart in Compton and we called her 'Q'. COOLIO has
been under the skin of West-Coast Hip-Hop since it began. He was
brought up in Compton, became a member of the Crips - and a Krack
addict. He learnt his trade on the streets, which he came to know
intimately, initially by-passing the recording studios of the district.
You could say his background is typical of just another everyday
Gangsta Rapper at the start of his career. But Coolio doesn't
want to use this route to establish himself. Maybe it's because he
knows the streets all too well. His debut album for Tommy Boy,
It Takes A Thief, skips in and around that dark territory, but
never comes off as a fully-fledged Gangsta album. Why's that?
'Cos I'm a realist, man. I'm a reality-Rapper,' Coolio tells me.
'Gangsterism is only a part of my life. I don't use it as the
basis of what I do. What I do comes from real Hip-Hop. That's
what I'm about. Gangsta Rap is cool, but I'm not really a
Gangsta.' As we talk Coolio becomes my guide for a tour of
the Hood and what happens there. How things run and what
Krack is all about. Born with a heart made of celluloid, I'm
studying to become a film director and so I listen to Coolio's
commentary and visualize what he describes. His words
become an outline for the kind of motion-picture I'd like to
make, a story that's weird, remarkable and packed full of
dramatic incident.

Read on now and follow Coolio as he introduces us to the Gangs,
Krack, Ugly Bitches...and Pigs.

'I've always been known as a Rapper. I only gang-banged for a little
while. See, if a muthafucka fucked with me I'd fuck with him. But let
me tell you what happened. I met two of the craziest muthafuckas on the
planet. Two brothers called Goldie and Toto. These muthafuckas, boy, would

THEY'RE BULL- SHIT NOW - COOLIO on the Gangs
Black Cop/ White Cop/ Fuck the color of his skin/
make sure he's shot
'Bring Back Somethin' Fo Da Hood'

walk down the street and kill all the dogs! Your dog
death! They was crazy! One day they robbed this muthafucka and because he didn't have any
money, they killed him. They hit him in the head with the back end of a hammer. I just saw them
putting holes in his skull. It was like, damn nigga! I started to throw up. I'd never seen that shit before. So the
next day I moved on. That shit wasn't for me. I started lookin' at life in a different way. I started to learn more about my
history. About how things are really supposed to be. See, when I was gangbangin' we used to fist-fight. Somebody
might get stabbed, but muthafuckas weren't just killin' each other. For me, Gangs were a necessity. It was for
protection 'Cos I was the only child and I was the only one at home. I didn't have nobody to back me up when
I got in trouble. So I just started runnin' with the gangs for protection. But the gang situation is
unstoppable. The gangs have been going for 40 years, man. See, the way the Gangs are organized,
you're only as strong as the strongest person in your gang. The smartest muthafucka in your gang.
If your shot-caller is a stupid ignorant, a do-anything muthafucka, then your gang is gonna be
like that. But if you've got a smart calculating muthafucka runnin' your shit, then your
gang is gonna be smart too, and your hood will make money. But it's not really all
about money. It's for protection and territory. Territory is what it's all about.
Don't come over here sellin' your dope in my hood and I might not come in
your hood, but if you come over here it's on. And now it's moved over
to this Colors thang. When it started it wasn't really about
Colors. It was just muthafuckas kickin' it. There
wasn't any Bloods, it was all Crips. Crip
actually. It originally stood for
Consolidated

Republic
Independent Party. It was a
southern Californian division of The Black Panthers.
Then something happened at a party. I think some people got
killed, and the Crips were blamed. So these muthafuckas were like,
"Fuck the Crips! We gonna beat them!" So that's how it ran and the Bloods
were created. For instance, if I killed your brother, you and me are gonna be
enemies forever, right? You gonna wanna kill me, right? So this shit has been has been
going on for 40 years. The gangs who have been going on the longest have been the
Mexican gangs and the Hispanic gangs. They were around before the Crips. But it don't
really matter where you're from or who you are. You fight anybody who comes in ya hood.
It's all about money and territory. But when I was comin' up, if you was a Crip you
would get a pass. But now Crips don't give a fuck about Crips. It started off as
something positive for a lot of people. But somehow it got twisted. It started off as
something real, something positive that could have helped my people. But
somehow it got twisted and turned into some bull-shit. So all the shit I grew
up on and knew turned out to be bull-shit. Because none of that shit is
helping anybody. If you're not part of the solution then you're part of the
problem. And the gang situation is one big problem.
That Gang-truce was bull-shit. It lasted three
weeks. Actually it lasted the whole summer,
but after that, muthafuckas were getting
killed again. After they ran out of beer

shit was on
you for
you only heard
about it when the film
"Colors" came
out. That's
w h a t
fucked

everything
up. Because
before "Colours",
gangbangin' was only
in California. After that
film came out, muthafuckas
started bangin' in Kansas and
fucked up places like Nebraska. There's
even a gang of White Crips! Crips up in the
stix, which have no reason what-soever to be fighting are
bangin' homie. Hard bangin'. Do or die, brother. Let me tell you
about the South. The South is where the slave trade began. They were the last
States to stop the slave trade. They saw all the other States didn't have slaves and they thought "Fuck
that! We're keepin' our muthafuckin' slaves!". And that's what the Civil War was about. So
the Southern Blacks have a lot more history than the other
Blacks. Therefore any

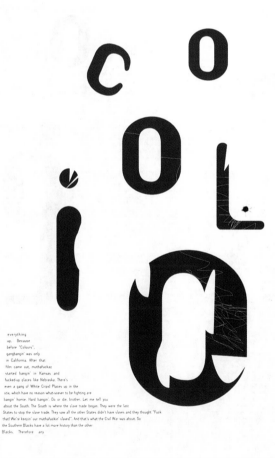

designers
Alessio Leonardi
Harald Welt

photographer
Frank Thiel

art directors
Uli Hoyer
Guenther Fannei

design company
Meta Design plus GmbH

country of origin
Germany

work description
Front cover and spreads
(center with gatefold)
from *Hauptstadtformat*, a
brochure for Grundkredit
Bank

dimensions
204 x 270 mm
8 x 10⅝ in

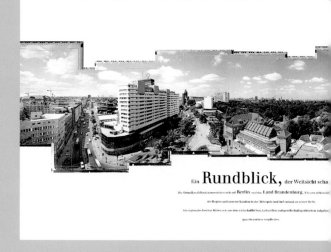

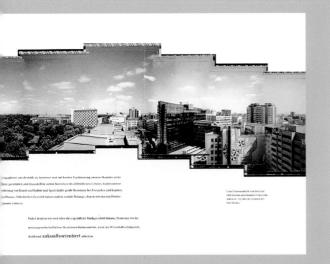

„Der **Jahrhundertschritt**"…

…ist unsere Aufgabe für

Berlin und Brandenburg.

Die Chancen und Aufgaben der Deutschen Einheit sind ein Jahrhundertschritt an der Schwelle in das sechste Jahrtausend.

Die Grundkreditbank sieht sich hier als regionales Unternehmen besonders gefordert und hat die **Herausforderung** *im Interesse ihrer Kunden und der Region konsequent angenommen.* Wir sind davon überzeugt, daß es im wesentlichen die kreativsten des gewerblichen Mittelstandes, vermögende Privatkunden, der leistungsorientierte Freiberufler und Bauträger sind, mit denen sich unsere Hauptstadt und das Umland zu einem prosperierenden Wirtschaftsraum und einer blühenden **Metropole** entwickeln werden.

Diesen nicht leichten Weg wollen wir an der Seite unserer Kunden so schnell wie möglich, aber mit Augenmaß und unternehmerischer Verantwortung gehen.

Die GKB hat den Schritt in das nächste Jahrhundert getan.

167

designer
Geoff White

art director
Geoff White

design company
Ilex Marketing Graphic
Design Unit

country of origin
UK

work description
Spreads from a brochure
for Teal Furniture

dimensions
210 x 297 mm
8¼ x 11¾ in

designer
Neil Walker

art director
Nicholas Thirkell

design company
CDT Design Ltd

country of origin
UK

work description
Spread from issue one of *Transformation*, a publication for Gemini Consulting

dimensions
237 x 297 mm
9⅜ x 11¾ in

12

In America, but not yet in continental Europe, the wind went out of shareholder value's sails. The well of junk bond cash ran dry. Our deal-making went the way of John Travolta. We swapped our white disco suits, for Calvin Klein jeans. Icahn and Perelman became sedate businessmen.

Shareholder value has been absorbed into a broader approach. It remains the best representation of the owner's point of view, and that is becoming a precious quality again, at a time when boards are intent on becoming players in the game, rather than decorative wallpaper. And it has found a niche in compensation. If the job of executives is to create value, why not tie their compensation to the value they create for shareholders?

After the first shareholder value wave (there've been others and there will be more) came the new sound of Michael Porter (*fifth generation*). This marked the return of Harvard Business School as the great strategy studio, and a switch from a shareholder, to an industry perspective. The lyrics were tighter, the music more symphonic. The Police replaced the Who. My keyboard soon resembled a helicopter's control panel.

Porter had been a Federal Trade Commission regulator, but he switched sides and, instead of policing oligopolies and monopolies, he began helping companies, and later countries, to shape their industry structure to their own advantage (within those regulatory limits, of course).

"Why does the pharmaceutical industry make money but the OEM tyre business does not?" he asked. "Because there are five forces which determine the profitability of industries" he explained. Executives began buying his records. Some bought the video for their daughters. He also showed that low-cost strategies were not always appropriate, and so demolished 20 years of Boston Consulting Group dogma.

Porter suggested differentiation and focus as strategies and he revamped the clumsy cost structure approach as the "value chain". The look became more formal. Sting rather than Alice Cooper.

My generation welcomed Porter. We thought we had written his book, "Competitive Strategy". His approach was refreshing, after leveraged betas, and second and third derivatives. We loved the return of a business perspective, in the tradition of matrix-based models. We were back to civilization. It was music we could play.

It was also an analytical heaven. The five forces model gave us latitude to go study *everything* - competitors, customers, suppliers, technologies and that magnificent excuse for analytical excess, "potential entrants" (which could include my grandmother, and the Boston Red Sox). Consulting budgets became very large indeed.

Porter's five forces are still useful for capturing industry data, the value chain remains a work horse of strategic analysis, but the generic strategies, and the U-shaped curve have not aged well. They've been branded with the label, "ex post" because they explain what happened but lack predictive power. As Gary Hamel (see below) once uncharitably put it, Porter's model is to business success, what Biblical exegesis is to sainthood. You can study it all you want, but you'll never get there.

From strategic rock 'n' roll to transformational polyphony

After Porter, I knew that things would never be the same, so I decided to look for the real me. I left my rock group, and moved to America.

In summer, 1989, I went to a concert in Ann Arbor, Michigan. The band was called Strategic Intent and Core Competencies, and featured C.K. Prahalad, from the University of Michigan, and Gary Hamel, his former student, from the London Business School. The music magazines billed the new band, *sixth generation*.

> "Porter's model is to business success, what Biblical exegesis is to sainthood."

I'd never heard anything like it. The approach was a strange mixture of analytical rigor and mysticism, a blend of old-fashioned beat and oriental influences. Although confused by the multi-layered message, I spotted the brilliant strategic prescription. Instantly, I knew they would change my life.

"All the prescriptions of traditional strategic models are fundamentally flawed" Prahalad and Hamel claimed, "because they rely on some kind of segmentation. As a result, each entity fights as a standalone division, rather than as part of an army. That is why the Japanese have destroyed Western rivals over the last 20 years; Cannon versus Xerox, Komatsu versus Caterpillar, and Toyota and Honda versus Ford and GM."

The model uses a botanical metaphor. Each core competency is a root of a tree, and each business, a fruit on the upper branches. The fruit becomes abundant, and succulent, through the nurturing of the roots. The sap rises, promoting growth in the branches, and yielding the lucrative harvest of which business success is made.

Traditional methodologies are flawed because they pump water directly into the fruit, rather than the roots. The tree is the "strategic architecture", and the firm's ambition is its "strategic intent".

I became a disciple. I searched for strategic intent with my clients. I discovered their tree metaphor was just that, a metaphor. What mattered was the search. In seeking strategic intent, firms would learn to mobilise their energies. They would begin growing again after decades of contraction. They would reach for higher ground; raise their sights. And, as if by faith healing, their performance would begin to improve.

I felt the power of strange words; like "change management", and "mobilization".

But I was not convinced. "This can't be" I protested. "There must be an analytical key, hidden behind the metaphor." But the more I looked, the more certain I became there was no secret key. Even so, there was something to this mysticism. The unfathomable Orient was bewitching me. The right side of my brain was taking over the left.

About a year later the world of Market-Focus entered my life (*seventh generation*). My first reaction was that I had heard all this before. "Yeah" I thought, "customer stuff. Old marketing soups, warmed up." It felt like the Rolling Stones attempting a come-back with Mick Jagger at 50.

> "...by jumping several steps down the value chain, we could reinvent businesses and their margins."

13

But, as I listened to Lynn Phillips and Mike Lanning - the arch-priests of "Building Market-Focused Organizations" - I became intrigued. I had worked a lot with commodity chemical companies (this interest could be traced back to my penchant for weird substances in my rock 'n' roll days), but I had never managed to sell them differentiation. "When you make ethylene oxide, there ain't much you can do, son", a Union Carbide manager had told me.

Phillips and Lanning thought otherwise. And they were right. We invented a strange verb: to "decommoditize". We learned that by jumping several steps down the value chain, we could reinvent businesses and their margins.

Our market-focus workshops developed a following. Companies embarked, with us, on quests for new Value Propositions. We invented "on-line strategy" - making up stuff right there, in front of clients and their customers. I discovered the power of live improvisations - creating business success in collective jam sessions. And because clients saw it unfold, in front of their eyes, it was hard for them to discount, or ignore. "Change management" and "mobilization" were back, in their second incarnation.

It was time for my mid-life crisis. I had survived, more or less intact, seven strategic generations. I had moved from my piano, to electronic orchestras; from carefully crafted singles, to unbridled, live improvisations. I'd been shaken to my analytical foundations many times, and been confused

169

designers
Simon Browning
Yumi Matote

photographer
Richard J. Burbridge

art director
Adam Levene

design company
Cartlidge Levene Limited

country of origin
UK

work description
Front covers from *Visions* and *Focus*, a two-part recruitment brochure for Shell International

dimensions
210 x 297 mm
8¼ x 11¾ in

Issue —— 94/95

Visions

There is one industry which, above all others, influences the lives, cultures, economies and politics of all nations. It offers graduates the broadest possible range of intellectual and managerial challenges. It promises – and more importantly delivers – the prospect of a truly international future. It is quick to recognise achievement and always promotes ability. Yet, to graduates, it remains one of the great enigmas.

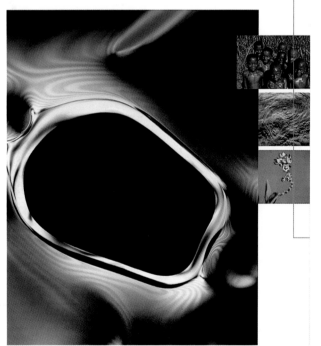

Issue —— 94/95

Focus

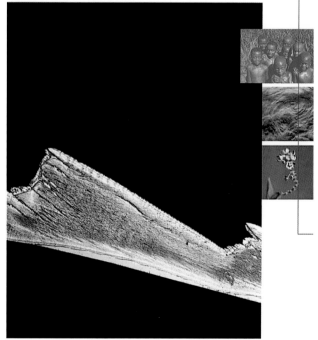

designers
Simon Browning
Helge Kerler
Yumi Matote

photographers
Tomoko Yoneda
Library Images

art director
Ian Cartlidge

design company
Cartlidge Levene Limited

country of origin
UK

work description
Spread from a large
format version of *Visions*,
a recruitment brochure
for Shell International

dimensions
297 x 420 mm
11¾ x 16½ in

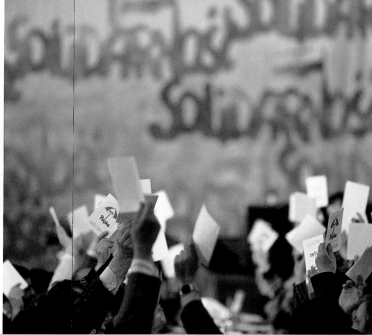

171

designer
Erik Spiekermann

design company
Meta Design, San
Francisco

country of origin
USA

work description
Front cover and spreads
from *Stop Stealing Sheep*
(self-published)

dimensions
143 x 215 mm
5⅝ x 8½ in

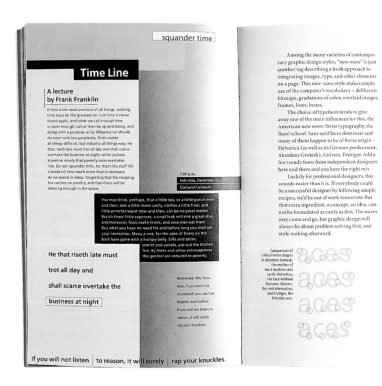

Some of the most pervasive typographical messages have never really been designed, and neither have the typefaces that appear on them. Some engineer, administrator, or accountant in some government department had to decide what the signs on our roads and freeways should look like. This person probably formed a committee made up of other engineers, administrators, and accountants who in turn went to a panel of experts that would have included manufacturers of signs, road safety experts, lobbyists from automobile associations plus more engineers, administrators, and accountants. You can bet there wasn't one typographer or graphic designer in the group, so the outcome shows no indication of any thought toward legibility, let alone communication or beauty. Nevertheless we're stuck with our road signs. They dominate our open spaces, forming a large part of a country's visual culture.

The letterforms on these signs were constructed from simple geometric patterns rather than from written or drawn letterforms because they had to be re-created by signmakers all over the country. It seems our official alphabets are here to stay, even though it is feasible to use other typefaces more suitable for the task.

DIN (Deutsche Industrie-Norm= German Industrial Standard) is the magic word for anything that can be measured in Germany, including the official German typeface, appropriately (and not surprisingly) called DIN-Schrift. Since it's been available in digital form, this face has been picked up by many graphic designers who like it for its lean, geometric lines, features that don't make it the best choice for complex signage projects.

Signage systems have to fulfill complex demands. Reversed type (e.g., white type on a blue background) looks heavier than positive type (e.g., black on yellow), and back-lit signs have a different quality than front-lit ones. Whether you have to read a sign on the move (from a car, for example), or while standing still on a well-lit platform, or in an emergency – all these situations require careful typographic treatment. In the past these issues have been largely neglected, partly because it would have been almost impossible to implement and partly because designers chose to ignore these problems, leaving them up to other people who simply weren't aware that special typefaces could help improve the situation.

Multiple master typefaces (see pages 109–111) like Minion and Myriad can be tuned to every lighting condition and production specification. The PostScript™ data generated with these types in drawing and layout applications can be used to cut letters of any size from vinyl, metal, wood, or any other material used for signs.

Soon there will be no more excuses for badly designed signs, whether on our roads or inside our buildings.

A DIN-Schrift, reversed out.
B Type on back-lit sign suffers from radiant light.

C More explicit letter shapes help (o is more oval, i dots are round).
D But still, backlighting presents a problem.

E The type has to be just a little lighter, so that finally ...
F It is more legible than in example B.

While driving on freeways isn't quite as exhausting as running a marathon (mainly because you get to sit down in your car), it requires a similar mind-set. The longer the journey, the more relaxed your driving style should be. You know you're going to be on the road for a while, and it's best not to get too nervous, but sit back, keep a safe distance from the car in front of you, and cruise.

Long-distance reading needs a relaxed attitude, too. There is nothing worse than having to get used to a different set of parameters every other line: compare it to the jarring effect of a fellow motorist who suddenly appears in front of you, having jumped a lane just to gain twenty yards. Words should also keep a safe, regular distance from each other, so that you can rely on the next one to appear when you're ready for it.

The tricky thing about space is that it is generally invisible and therefore easy to ignore. At night you can see only as far as the headlights of your car can shine. You determine your speed by the size of the visible space in front of you.

It used to be a rule of thumb for headline settings to leave a space between words that is just wide enough to fit in a lowercase i. For comfortable reading of long lines, the space between words should be much wider. The default settings in most software vary these values, but the normal 100 percent word space seems just fine for lines of at least ten words (or just over fifty characters). Shorter lines always require tighter word space (more about that on the following page).

The way to wealth

If time be of all things the most precious, wasting time must be the greatest prodigality; since lost time is never found again, and what we call time enough always proves little enough. Let us then be up and doing, and doing to a purpose, so by diligence we should do more

If time be of all things the most precious, wasting time must be the greatest prodigality; since lost time is never found again, and what we call time enough always proves little enough. Let us then be up and doing, and doing to a purpose, so by diligence we should do more

A lowercase i makes a nice word space for headlines. Short lines should have modest space between the words.

123

designer
John O'Callaghan

college
Ravensbourne College
of Design and
Communication,
Chislehurst

tutor
Barry Kitts

country of origin
UK

work description
Spreads from a proposed
monthly digest of the
weekly magazine *The New
Scientist*

dimensions
210 x 297 mm
8¼ x 11¾ in

174

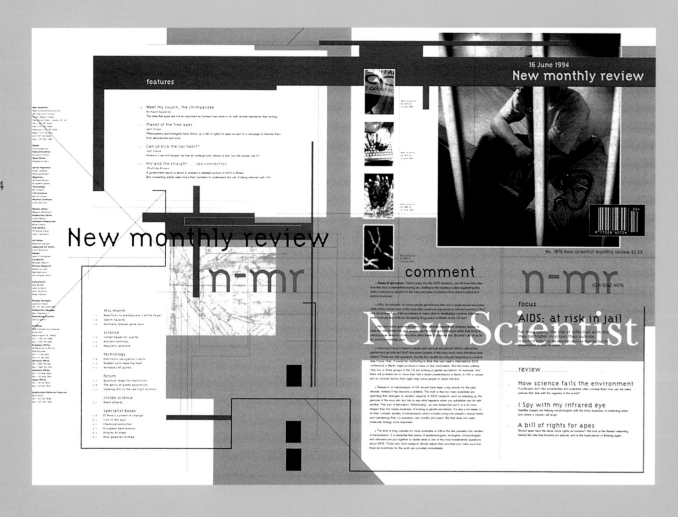

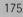

For Britain's hard drug users, even the shortest jail sentence could be life-threatening.

Among drug users, the risk of infection with HIV may be higher in prison than in the outside world. Ex-convicts know how the problem could be tackled but the government is slow to listen.

Most of the 100 000 or so people who inject drugs in this country end up in prison at some point in their lives.

This year alone, some 12 000 of them will be put behind bars. In theory, with their liberty gone, this large group should be safe from the dangers of using drugs and the high risk of contracting HIV that goes with sharing needles and syringes.

But the reality appears to be very different: interviews conducted by New Scientist with ex-prisoners and with researchers confirm that many drug users do not lose access to drugs inside prison but instead lose the help that they need to avoid becoming infected with HIV.

HIV: high risk behind bars

focus one

designer
P. Scott Makela

photographers
P. Scott Makela
Rik Sferra
Alex Tylevich

art director
P. Scott Makela

design company
Words and Pictures for
Business and Culture

country of origin
USA

work description
Front cover and spreads
from a catalog/prospectus
for Minneapolis College
of Art and Design

dimensions
215 x 292 mm
8½ x 11½ in

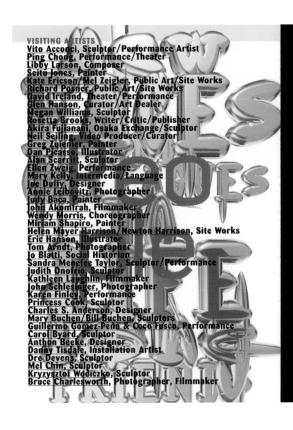

VISITING ARTISTS

Vito Acconci, Sculptor/Performance Artist
Ping Chong, Performance/Theater
Libby Larson, Composer
Seitu Jones, Painter
Kate Ericson/Mel Zeigler, Public Art/Site Works
Richard Posner, Public Art/Site Works
David Ireland, Theater Performance
Glen Hanson, Curator/Art Dealer
Megan Williams, Sculptor
Rosetta Brooks, Writer/Critic/Publisher
Akira Fujianani, Osaka Exchange/Sculptor
Neil Seiling, Video Producer/Curator
Greg Zuenier, Painter
Dan Picasso, Illustrator
Alan Scarritt, Sculptor
Ellen Zweig, Performance
Mary Kelly, Intermedia/Language
Joe Duffy, Designer
Annie Leibovitz, Photographer
Judy Baca, Painter
John Akomfrah, Filmmaker
Wendy Morris, Choreographer
Miriam Shapiro, Painter
Helen Mayer Harrison/Newton Harrison, Site Works
Eric Hanson, Illustrator
Tom Arndt, Photographer
Jo Blatti, Social Historian
Sandra Menefee Taylor, Sculptor/Performance
Judith Onofrio, Sculptor
Kathleen Laughlin, Filmmaker
John Schlesinger, Photographer
Karen Finley, Performance
Princess Cook, Sculptor
Charles S. Anderson, Designer
Mary Buchen/Bill Buchen, Sculptors
Guillermo Gomez-Peña & Coco Fusco, Performance
Carol Byard, Sculptor
Anthon Beeke, Designer
Danny Tisdale, Installation Artist
Dre Devens, Sculptor
Mel Chin, Sculptor
Kryzysztof Wodiczko, Sculptor
Bruce Charlesworth, Photographer, Filmmaker

MCAD

students are eager to experiment, INVENT, DISCOVER, WORK HARD, BE THEMSELVES, REACH FOR THE STARS. THEIR DETERMINATION AND CURIOSITY HEAT UP THE STUDIOS AND LIGHT THE LABS AT THE MIDNIGHT HOUR. "THE STUDENTS HAVE AN INTERNAL NECESSITY TO MAKE ART AND A GREAT RESPECT FOR ART." *HAZEL BELVO, CHAIR, FINE ARTS DIVISION.* Students come to MCAD from many different backgrounds and experiences, from coastal cities, urban centers and rural towns across the United States and in twenty foreign countries, including Japan, Thailand, Italy and Norway. They come from high school, community colleges, former jobs and former lives. They are committed to their art and their future role as artists and designers in society, and are highly motivated, culturally aware, and ready to take a stand on issues important to them. Passionate about their education, their central mission is to live and work as visual artists. "WE HAVE A ROMANTIC VISION THAT WE ARE MAKING A CHANGE IN THE WORLD. WE ARE ARTISTS WHO ARE VERY SOCIALLY INVOLVED, PARTICIPATING IN SOMETHING BIGGER THAN JUST COMING TO CLASS OR HAVING PIECES IN A SHOW." *IVAN NUNEZ '90, FINE ARTS, MARACAIBO, VENEZUELA.* "GOING TO ART SCHOOL IS ABOUT BECOMING CAREFUL VIEWERS. THE MORE ATTENTION WE PAY TO OUR SURROUNDINGS, THE MORE WE CAN LEARN FROM AND APPRECIATE THEM." *MARIAM STEPHAN, FINE ARTS, PITTSBURGH, PENNSYLVANIA.* "THERE ARE SUCH TALENTED AND KNOWLEDGEABLE PEOPLE HERE — STUDENTS, TEACHERS, STAFF, EVERYONE. THERE'S INTELLECTUAL DISCUSSION EVERYWHERE, DISCUSSION ABOUT THE ARTS, CHOICES WE MAKE, HOW YOU LIVE YOUR LIFE." *ROSEMARY RISKIN '93, FINE ARTS, MINNETONKA, MINNESOTA.* MCAD teachers —filmmakers, photographers, graphic designers, fine artists — bring the riches of their own work to the classroom. Their connections sometimes lead to internships, artist apprenticeships and jobs for students. Most of MCAD's faculty have advanced degrees in their fields from the nation's top graduate programs. Students cite faculty as one of MCAD's greatest strengths, not only for their talent and teaching skills, but also because they're such great people. "MY TEACHERS HAVE BEEN JUST INCREDIBLE! THEY HAVE HELPED ME FOCUS ON WHAT I WANT AND THE DIRECTION I WANT TO GO. THEY HAVE ENCOURAGED ME TO TRY DIFFERENT THINGS — TO GO OUT THERE AND GET MY HANDS DIRTY." *HEATHER PALMER, FOUNDATION STUDIES, STUDIO CITY, CALIFORNIA.* "THE INSTRUCTORS ARE SO COMMITTED TO THEIR COURSES AND THEIR STUDENTS THAT IT DEVELOPS A SENSE OF COMMITMENT IN YOU." *EDMUND ASHLEY, FOUNDATION STUDIES, PORTLAND, MAINE.* Visiting artists stimulate the MCAD environment by teaching courses, giving critiques and public talks and showing their work. Recent visitors included environmental artists Helen Mayer Harrison and Newton Harrison, graphic designer Anthon Beeke from Holland, and photographer Annie Leibovitz. Alumni frequently visit classes to answer your questions about work opportunities in the visual arts and how to prepare for specific careers.

Facilities

Computer Center

Computers are powerful tools that enable designers and artists to explore visual solutions to assignments and production works. They also expand creative horizons and amplify imagination and visual exploration. Although computers make it possible to view more alternatives with great speed, the final image must be the product of a skilled artist's mind and spirit. Computers are utilized by MCAD students in all areas of study. Classes in the Design major incorporate the use of computers in graphic design, package design, furniture, and interactive design. Media Arts students use computers for video editing, electronic photography, and sound composition. 3D modeling programs are applied to sculpture projects; painting and drawing students explore the large array of color painting and illustration software. Computers at MCAD are not just a technical tool, they are a medium for creative expression.

Whether your interest lies in image composition, digital media (video, sound and photography), color painting, 3D modeling and animation, or graphic design and illustration, MCAD's Computer Center puts at your fingertips an incredible range of the latest hardware and software. Color painting and image composition needs are met from our collection of eight paint programs. You can choose from four animation programs, seven drawing and illustration programs, eleven 3D design and modeling programs, three image manipulation programs, four page design and related applications and dozens of other specialized pieces of software. There are plenty of spaces (more than 120 work-

designer
P. Scott Makela

photographers
P. Scott Makela
Rik Sferra
Alex Tylevich

art director
P. Scott Makela

design company
Words and Pictures for
Business and Culture

country of origin
USA

work description
Spread from a catalog/
prospectus for
Minneapolis College
of Art and Design

dimensions
215 x 292 mm
8½ x 11½ in

178

place where
feel the joy
t, it's here.
ling experi-
lly hard work.
ieve success
the desire to
ve of being an
tive person."

Barbara Beshoar, Design, St. Paul, Minnesota

179

designer
Denise Gonzales Crisp

college
California Institute of
the Arts

country of origin
USA

work description
Spreads from *A Sign in
Space*, an interpretation
of a story by Italo Calvino

dimensions
270 x 340 mm
10⅝ x 13⅜ in

things were different,
... because the world
I mentioned, was
... to produce an
... of itself, and in
... of that galactic year was
... we already began to
... to correspond to a
realize that the
... ion, and forms of that
world's forms had been
we believed, had a long
temporary up until
... ahead of them
then, and that they
... ead, we were wrong:
would change, one by
to give you a fairly
one. And this awareness
... example, the
was accompanied by a
aurs), and therefore in
certain annoyance with
new sign of mine you
... perceive the
... uence of our
... way of looking
... ings, call it
... if you like,
special way
everything
to be, there,
a certain
on, I must say
was truly
... fied with it,
I no longer
... tted that
... sign that had
erased,
... use this one
... d vastly more
... iful to me.
... n the duration

the old images, so that even their memory w a s intolerable. I began to be tormented by a thought: I had left that sign in space, that sign which had seemed so beautiful and original to me and so suited to its function, and which not, in memory, seemed inappropriate, in all its pretension, a sign chiefly of an antiquated way of conceiving signs and of my foolish acceptance of an order of things I ought to have been wise enough to break away from in time. In

other words, I was ashamed of that sign which went on through the centuries, being passed by worlds in flight, making a ridiculous spectacle of itself and of me and of that temporary way we had had of seeing things. I blushed when I remember it (and I remembered it constantly), blushes that lasted whole geological eras: to hide my shame I crawled into the craters of the volcanoes, in remorse I sank my teeth into the caps of the glaciations that covered the continents. I was tortured by the thought that Kgwgk, always preceding me in the circumnavigation of the Milky Way, would see the sign before I could erase it, and boor that he was, he would mock me and make fun of me, contemptuously repeating the sign in rough caricatures in every corner of the circumgalactic sphere. Instead, this time the complicated astral time keeping was in my favor. Kgwgk's constellation didn't encounter the sign, whereas our solar system turned up there punctually at the end of the first revolution, so close

i conceived the idea of making a sign, that's true enough, or rather, i conceived the idea of considering a sign a something that i felt like making, so ... at that point in space and not in another. i made something, meaning to make a sign it turned out that i really had made a sign, after all. ... In other words, considering it was the first sign ever made

designers
Mark Diaper
Domenic Lippa

design company
Lippa Pearce Design
Limited

country of origin
UK

work description
Front covers and spread
from *Now You See It*, a
series of catalogs for six
performances given at the
South Bank Centre,
London; the cover
material changed each
night (above, from left to
right: corrugated plastic,
latex, paper, corrugated
cardboard, sandpaper,
paper)

dimensions
300 x 250 mm
11⅞ x 9⅞ in

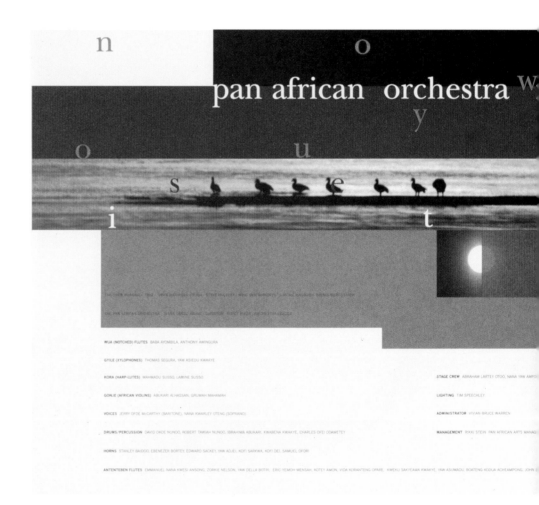

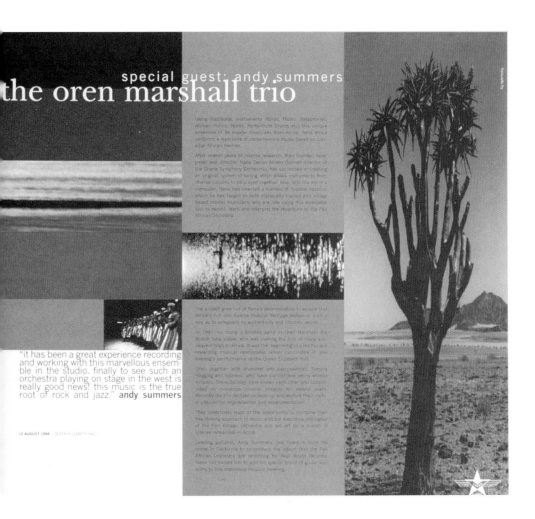

special guest: andy summers
the oren marshall trio

Using traditional instruments (Koras, Flutes, Balaphones, African Violins, Horns, Fontomfrom Drums etc) this unique ensemble of 34 master musicians from Accra, West Africa performs a repertoire of contemporary music based on classical African themes.

After several years of intense research, their founder, composer and director, Nana Danso Abiam (former director of the Ghana Symphony Orchestra), has succeeded in creating an original system of tuning which allows instruments from diverse cultures to be played together. Also, with the aid of a computer, Nana has invented a method of musical notation which he has taught to both classically trained and village based master musicians, who are now using this invaluable tool to record, teach and interpret the repertoire of the Pan African Orchestra.

The project grew out of Nana's determination to ensure that Africa's rich and diverse musical heritage evolves in such a way as to safeguard its authenticity and intrinsic values.

In 1991 he found a kindred spirit in Oren Marshall, the British tuba player, who was making the first of many subsequent trips to Africa. It was the beginning of a fruitful and rewarding musical relationship which culminates in this evening's performance at the Queen Elizabeth Hall.

Oren, together with drummer and percussionist, Simone Hagging and saxophonist, bass clarinet and penny whistle virtuoso Steve Buckley, have known each other and collaborated on numerous musical projects for several years. Recently the trio decided to team up and explore their mutual passion for improvisation and experimentation.

They collectively leapt at the opportunity to combine their free flowing approach to music with the discipline and rigour of the Pan African Orchestra and set off for a month of intense rehearsals in Accra.

Leading guitarist, Andy Summers, has flown in from his home in California to co-produce the album that the Pan African Orchestra are recording for Real World Records. Nana has invited him to add his special brand of guitar mastery to this matchless musical meeting.

"it has been a great experience recording and working with this marvellous ensemble in the studio. finally to see such an orchestra playing on stage in the west is really good news! this music is the true root of rock and jazz." **andy summers**

10 AUGUST 1994 · QUEEN ELIZABETH HALL

183

designer
Ulysses Voelker

art director
Ulysses Voelker

design company
Meta Design plus GmbH

country of origin
Germany

work description
Front cover case binding
and spreads from
*Zimmermann meets
Spiekermann*; the book
is concertina-folded
allowing text to be seen
through the translucent
paper which is printed
on both sides, published
by Hochschule für Künste

dimensions
213 x 280 mm
8¾ x 11 in

184

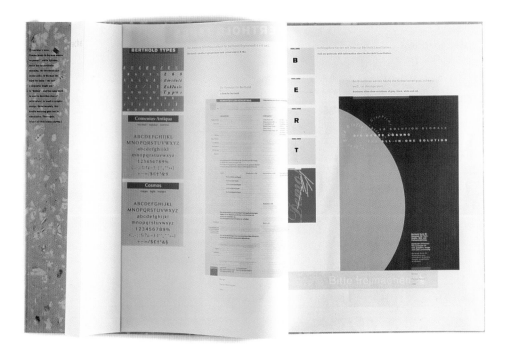

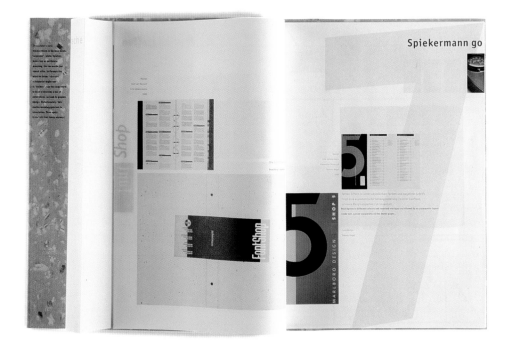

designer
Koeweiden/Postma
Associates

photographer
Marc van Praag

country of origin
The Netherlands

work description
Front cover case binding
and spreads from the
book *Architecten*,
volume 1, for Bis
publishers

dimensions
250 x 300 mm
9⅞ x 11⅞ in

186

Oving Architekten bv

Adres: H 28
Postbus 1414
9701 BK Groningen
9701 BG Groningen
T: (050) 5269271
F: (050) 5268471

Oving Architekten bv functioneert sinds 1919 op een brede palet van architektuur ontwerp. Ons team van de meeste hotel tot help terminstellingen. Personeel, bestuurdag, administratie, onderhoud, klanten, studenten, reünisten en aanverwante. Het bureau ontwerpt zich met dezelfde opgave architectenmild maar door professioneel. Het oor verwegen woondraad op aan ons gegevens onze ruimte, afleidingsgebouw. Onze brieing mikes componenten richten op een ontwaarding ligger naar de.

De gemeente Leiden in het om de zou zou de het centrum van vestigingen groeps verstandig houden vinden, ingedrukt maar als deeldag en de broer oftewing. De ontwikking is om doorgekregen met tot. Komponent op een te onderdat de een. 1300.000 ... de ook voudad bewortestenstratt de op zoaas van a verhang ... 80 000 komo hafa verhing in gemakt in wordgoerd van er verschillende moment van de ter van verbouwken. De onriging nedden gemens die op en onzgale volgt jaarde bulding op tot bulding.

Oving Architekten bv has been operating in the design field of environmental planning since 1919, was de towing team concerns field with housing construction, special houses opportunities, office building. All agencies disputers, companies are centrations.

The firm is our characterized by a hotel and with more normal data are by plannetons, design team, are leader to the form of the preparation of experiences. For bulding ... the budget ... our is built-flow maternal forces as halans.

The number illustrated here is a center industrial area on the edge in the towns city of ordentijn, oriented to between the Randdaf and the Oosterhaving. The street for shelt of this, aff a forming ... the fut HO the fund to off 175.000 and are a hundred comfort apartments divided bet, to which office. On this HO timurinn former has building have twen deployed to take advantage of the qualities of different features of the location. The from off the dwellings have in connects = that they offer views back of veul and over the harbour water.

Fotografie / Photography: Jan Ottine Fotografie
Groningen

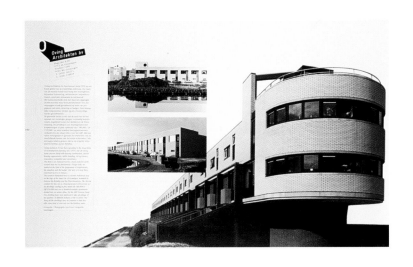

Architektengroep Duintjer

Henri W de Tr
1063 KT Amsterdam
Postbus 77623
1043 KP Amsterdam
T: (020) 5816000
F: (020) 6136000

1 Oostelaan De Resener, Boele, huisdingsgeg.
 Eiks 92 de West kele / De Boende Hospital.
 Boele, main entrance. Photo: M. Jacobus Leer.

2 Yudkel-buinding Groningen, grote van.
 Foto: E. Trouwe / Municipal Hopits / Groningen,
 principal appiferlum. Photo: E. Trouwt.

3 Antenenhm Gront Boune, Roen zaa, roordere
 geieg. Foto: E. Trouwe / Gront Boune Hendaal,
 dilteriunt, main entrance. Photo: E. Trouwt.

4 Cultuurcentraal De Costerjuust / Groningen,
 Gongeprix Foto: K. Bancandre / De Costerjuust
 Culture Center, Groningen. Foto: Photo:
 K. Bancande.

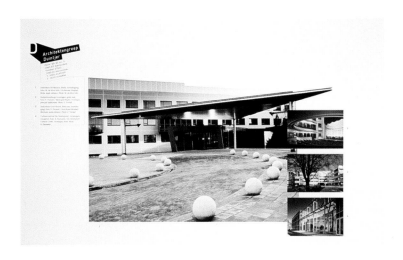

designer
Loïc Lévêque

photographers
Bobby Adams
Erich Huller
Loïc Lévêque

design company
Loïc Lévêque Design

country of origin
France

work description
Spread and front cover of
an experimental magazine
on Industrial Music (self-
published)

dimensions
276 x 370 mm
10⅞ x 14½ in

188

Ce pays
fonctionne encore
comme dans les années 1870,
où tout était fondé sur le travail.
Pendant plus de 100 ans, ils ont conditionné et
éduqué le peuple dans un ordre moral trés rigide. Les
heures d'ouverture des bars, des restaurants etc, sont réglés sur
le temps de travail. Tout ferme tôt, pour que le peuple puisse se lever
de "bonne heure" pour travailler. On vit encore le rêve du 19 eme siècle. Si on
ne travaille pas, on ne sert moralement à rien. On n'est pas digne, on ne peut pas
avoir une place dans cette société. Maintenant, ils ont toute une génération de chomeurs. On
nous a tous appris que les chomeurs étaient des lèpreux. C'est pour ça que le pays est dans la merde. Il va fal-
loir qu'on les déconditionne. Il existe cette génération folle de gosses qui ont appris à l'école que leur seul rôle dans la vie
c'est de se justifier, donc de travailler. Puis en sortant de l'école, ils se rendent compte qu'il ne travailleront jamais. C'est une
génération psychotique. Nous n'y appartenons pas, bizarrement, mais on a grandi ensemble, nous la comprenons. Je suppose qu'ils
reconstruiront les maisons des pauvres et tout recommencera, le pays redeviendra celui de Dikens... Vous avez des obsessions ou
des intérêts personnels ? Je crois que si un intérêt devient une obsession ça fait trés artificiel. C'est devenu chic, d'être obsédé
par quelque chose que les autres trouvent dégueulasse.. Certains estiment que la fascination du mal renie toute moralité
bourgeoise, mais il me semble qu'aller à l'extrème deviendrait une sorte de snobisme. J'appellerais mes obsessions "fascina-
tions curieuses", pas obsession. Nous sommes très intéressés par les rythmes, en ce moment. Nous sommes des primi-
tifs urbains. On est fasciné par les primitifs ethniques . Je ne dis pas qu'on soit un groupe ethnique, mais on
est conscient (comme les musiciens Jajoukas) de cette force primitive. On ne les imite pas, on
est des primitifs modernes. Je ne crois pas qu'on essaye de l'être, on est natu-
rel. On n'a pas de propagande, on ne dit pas, voilà ce qu'on
fait, voilà ce qu'on est. Qu'on essaye de rendre la musique
commerciale, ou qu'on essaye de la rendre bizarre,
l'essentiel, c'est
que ce soit ins-
tinctif, et dans
ce sens-là, je
crois qu'on
est primitif.
Je crois

bruit

M.i

musique industrielle · les perforés

designer
Robert Hunter

college
The Surrey Institute of
Art & Design, Farnham

country of origin
UK

work description
Spread from *Area 39*,
a magazine project
covering experimental
music, design, and
multimedia

dimensions
210 x 297 mm
8¼ x 11¾ in

AREA 39 LTD, 45-46 POLAND STREET, LONDON W1V 3DF TEL 071 439 6422 FAX: 071 287 4767

AREA 39 IS AN EXPERIMENTAL MAGAZINE WHICH WILL CONCENTRATE WITHIN THE FIELDS OF FUTURE MUSIC, GRAPHIC DESIGN AND EVOLVING WORLD OF MULTIMEDIA TECHNOLOGY. THE MAGAZINE WILL TRY TO INCOURAGE THE READER TO BECOME AN INVOLVED PARTICIPANT WITHIN THE CREATIVITY OF THE EDITORIAL LAYOUT AND FEATURES OF THIS NEW EXPERIMENTAL MAGAZINE. AREA 39 WILL BE AVAILABLE TO PURCHASE EVERY MONTH FROM LOCAL MUSIC STORES. THE MAGAZINE WILL INCLUDE ARTICLES ABOUT ELECTRONIC MUSIC, THERE WILL ALSO BE INTERVIEWS WITH WELL KNOWN ARTISTS IN THE FIELD OF TECHNO HOUSE DANCE ABIENT AND EVERY MONTH AREA 39 WILL INFORMING THE READER OF CURRENT EXCLUSIVE INTERVIEW THE PEOPLE THAT KNOW. THE MAGAZINE WILL ALSO INVOLVED IN INFORMING THE PUBLIC OF THE LATEST DESIGN AN INSIGHT INTO GRAPHIC WORLD, WHEATHER (NEW OR RETROSPECTIVE). INTERVIEWS ON GAME PRODUCERS FROM SEGA AND SNES WILL ALSO BECOME A MONTHLY FEATURE WITH VIRTUAL REALITY AND GAME TECHNOLOGY ARE BROUGHT TO YOUR ATTENTION WE INVITE THE WORLD'S MOST CREATIVE GAME PROGRAMMERS TO SHOW HOW IT IS ACHEIVED. IF YOU WOULD LIKE TO ADVERTISE OR BE INVOLVED WITH INTERVIEWS OR WITHIN THE MAGAZINE CONTACT US...

designer
Anthony Oram

college
The Surrey Institute of
Art & Design, Farnham

country of origin
UK

work description
Spread from *Area 39*,
a magazine project
covering experimental
music, design, and
multimedia

dimensions
297 x 420 mm
11¾ x 16½ in

Where now for the
where now intrepid explorer?

CD-ROM

REAL WORLD MULTI-MEDIA PLANS TO INCREASE ITS OUTPUT
THE FIRST RELEASE ARRIVING IN THE SUMMER OF NEXT YEAR

Multi-Media is an excellent way to introduce CD-ROM

where now for the intrepid explorer?
Where now for the intrepid explorer?

At the end of 1992, three records signalled a new drift within and against the alternative rock/pop morass: Earwig's Under My Skin ; **intrepid explorer 1994** am Laughing, Disco Inferno's "Summer's Last Sound" EP, and, most fabulous of all, Bark Psychosis's 20-minute single "Scum". Seen as an alternative to the alternative, all three groups shared **Multi-Media is an exellant way to introduce CD-ROM Real world Multi-Media plan to increase its output** in either East London or Brighton (where Earwig, now Insides, and if Bark Psychosis's Graham Sutton resided).

More important was probably their varying use of samplers, MIDI equipment and drum machines to distance themselves from both the conventional four-piece indie rock band and the total-machine orientation of Ambient or Techno. Along with Papa Sprain and Butterfly Child, who like Bark Psychosis, shared and, like Insides, used drum machines creatively; these groups signalled a refusal to conform to the dominating models of indie and Techno. Accordingly, they nearly disappeared down the separating chasm, into media oblivion.

Both "Scum" and "Summer's Last Sound" also shared either a heightened awareness of or a fascination with the band's common working environment of the East End. The minimal lyric on "Scum" - "It's all around you... don't tell ya that we're all free" - gestatedthe Stratford church where Bark Psychosis rehearsed and, in a week of takes, record the piece, was reflected by and suffused with the ambience the band deliberately allowed into the music. In conversation, guitarist and singer Sutton recounts how his dissatisfaction with the majority of Ambient music, where effects and mixing desk wizardry take primacy over the actual recording of sounds, led the band to mike up the drumkit in particular ways, to avoid "over-clean" lead rhythms, or record sequenced material off a PA set up inside the church instead of directly off the desk. Sutton readily admits the influence of jazz's tendency to capture the dynamics of the recording environment as well as the actual playing. On both "SCUM" and the group's debut album Hex (released this month on Circa), Mark Simnett's drumming is pushed to the fore, with the rest of the instrumentation (in the case of Hex, involving over a dozen musicians... boards, vibes and trumpet as well as bass and guitar) lovingly draped around this central, gentle throb. It's an approach which enables the album to be consumed as undemanding ambience at low volumes, but at higher volumes, the sense of hypnosis, atmosphere, of the music's respiration prove to fascinating to be reduced to background noise. Just as Bark Psychosis's previous releases distanced the band from the Big Black/Napa

area

191

designers
Andrew Hall
Stuart Brown

college
Falmouth College of Art

country of origin
UK

work description
Front cover and spread
from *Lizard*, the first
student magazine of
Falmouth College of Art

dimensions
210 x 210 mm
8¼ x 8¼ in

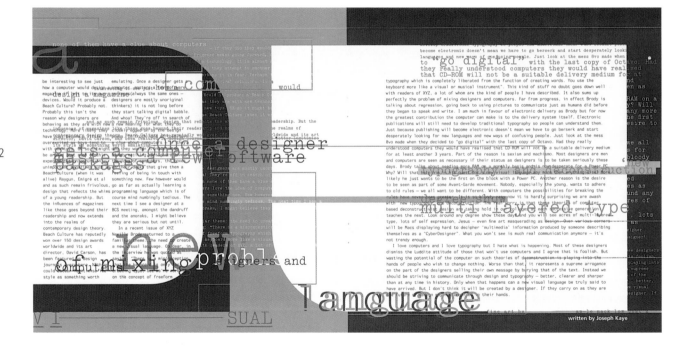

designer
Neil Fletcher

design company
Pd-p

country of origin
UK

work description
Front cover and spread
from the *Course
Representative Handbook*
for the Union of Students,
Sheffield Hallam
University

dimensions
210 x 297 mm
8¼ x 11¾ in

2

Sheffield Hallam University Union of **Students sees
the improving quality and relevancy
of your education as one of its major
priorities. >As a result the Education
Unit is in place to co-ordinate all
of the Student Unions'** educational
**and representational work.
In providing** support for student
**representation at all
levels, raising** awareness
**of student rights and
developing a resource base to be used for
the benefit of all students at the University,
the Education Unit.→**

Education Unit
Course Rep Handbook: **Page two**

·**Education Unit** Sheffield Hallam University Union of Students sees the improving quality and
relevancy of your education as one of its major priorities. As a result the Education Unit is in place
to co-ordinate all of the Student Unions' educational and representational work. In providing
support for student representation at all levels, raising awareness of student rights and developing
a resource base to be used for the benefit of all students at the University, the Education Unit has
a strong commitment to achieving these objectives.
Who are we: VP Education: **Jane Whalen**, Education Research Officer: [hoping to appoint
shortly], Student Services Administrator **Chris Smalley**, Education Officer: **Heather Ditch**.
Where are we: The Education Unit is based on the top floor of the Nelson Mandela Building, City
Campus. You can contact us to make an appointment by: • calling in between 10 pm and 4 pm.
• ringing up on 534125. • contact us through your Site Union Office. Advice Work
Both the Education Research Officer and Jane can offer independent advice and
information on a number of academic related problems. As a rep your role may be to
speak to us on behalf of a student or to refer the student to see us themselves. For student reference
we produce a number of booklets that you may find helpful:

Education Unit
Course Rep Handbook: **Page three**

1 Academic Appeals This covers the University regulations on what are
considered grounds for appeal and how to go about it. The Education Research Officer or Jane will be
happy to talk to you about an appeal.
2 Changing/Leaving Course You may decide you are on the wrong course or you
may want to leave altogether.
This leaflet will give you some of the factual information you need to know such as any grant
implications. Remember, it is always a good idea to talk to someone before you make your final
decision. Again you may choose to talk on a student's behalf or refer them to the Education Unit or
someone within the Department of Access & Guidance at the University.
3 Expulsions For Academic Reasons This leaflet explains what
procedure the University must follow in the expulsion of students for
academic reasons and the processes a student will be involved in if they're
unfortunate enough to find themselves faced with expulsion. The leaflet
lists the various grounds upon which an expulsion may be based.
These include an unsatisfactory standard of work and failure to meet
specified levels of attendance. The leaflet explains the various routes which
any expulsion case may follow, possible outcomes and what the student
involved can do. 4 University Rules & Regulations On Cheating &
Plagiarism This leaflet is our newest addition and has been produced to
help the increasing numbers of students who are being accused of
cheating. Since the old Polytechnics were granted University status, they
now have the power to award their own degrees. However, a debate still
continues as to whether their degrees are comparable to
standard with those of any other University. Therefore, in an attempt to
maintain the credibility and reputation of a Hallam degree, the University
takes any form of cheating very seriously indeed. The leaflet aims to raise
awareness on what is considered an **offense** by the University and what a student's rights are if
they are accused and what they can expect to happen.
If you or any student you know is accused of cheating,
make sure they come to talk to the Education Unit. Someone from the Unit will accompany that
student to any hearing they may have to attend to ensure they are treated fairly. **5 The Placement
Handbook** This is available to all students due to go on work experience via your Placement Tutor.
Whilst many University Schools also provide handbooks, the Union handbook is aimed to provide
information of a more general nature and interest to students such as your money, other Unions, your
health and safety and
where to go if you're having problems.

type itself
type itself

designer
Edward Fella

country of origin
USA

typefaces
various

work description
A double-sided lecture
poster for Neville Brody,
using a visual vocabulary
designed to oppose that
of Brody's

dimensions
279 x 432 mm
11 x 17 in

197

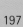

designer
David Bravenec

college
California Institute
of the Arts

country of origin
USA

typeface
Dactylo

work description
Typeface formed from
fingerprint fragments
melded with circuit bits,
shown on poster

dimensions
poster
457 x 610 mm
18 x 24 in

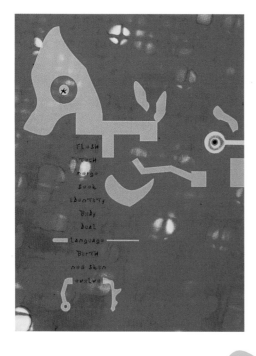

198

designer
Michael Ellot

college
The Surrey Institute of
Art & Design, Farnham

country of origin
UK

typeface
Phutik

work description
Typeface, shown in use on
magazine project

dimensions
page
210 x 297 mm
8¼ x 11¾ in

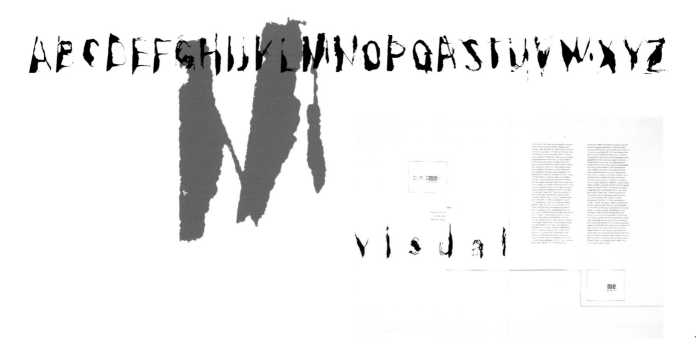

designer
Jason Bailey

college
Royal College of Art,
London

country of origin
UK

typeface
Network

work description
Typeface combining
digital networks with
organic growth

designer
Graham Evans

college
Royal College of Art,
London

country of origin
UK

typeface
Nails

work description
A typeface (shown left cut
out of metal) exploring
the oral/pictorial duality
of language as a written
form: verticals represent
explosive and implosive
sounds, horizontals
represent monothongs/
dipthongs, and the "nail
heads" vary in size
according to sound time

201

designer
Graham Evans

college
Royal College of Art,
London

country of origin
UK

typeface
Subliminal

work description
A typeface attempting to
visualize a message that
is subliminally received by
smokers who, under
general anesthetic for
surgery, are played a tape
telling them that they
want to give up smoking

202

dimensions
584 x 414 mm
23 x 16½ in

stop speaking..

want to stop

will no longer

as probable activity

not to stop

as if now.

designer
Tom Hingston

country of origin
UK

typeface
Metro

work description
Typeface designed for
public information, shown
on advertising poster
(below, right) and on
experimental tickets for
the Metrolink tram
system in Manchester
(below, left)

dimensions
poster
594 x 420 mm
23⅜ x 16½ in

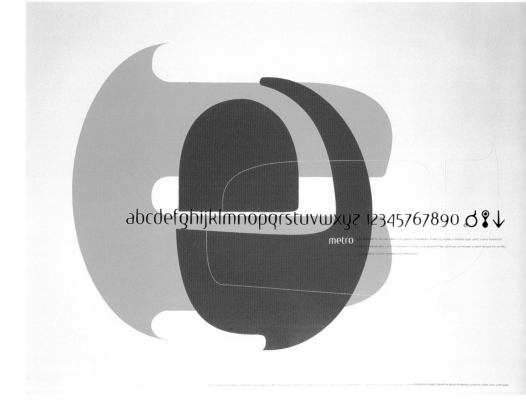

designers
Brigid McMullen
Nina Jenkins

art directors
Brigid McMullen
Martin Devlin

design company
The Workroom

country of origin
UK

typeface
Calculus

work description
Typeface designed for
the Chartered Institute
of Management
Accountants, shown on
front covers of brochures

dimensions
brochure, far left
220 x 310 mm
8⅝ x 12¼ in
others
210 x 297 mm
8¼ x 11¾ in

designer
Philippe Apeloig

design company
Philippe Apeloig Design

country of origin
France

typeface
Square

work description
New Year's Card

dimensions
card
180 x 180 mm
7⅛ x 7⅛ in

206

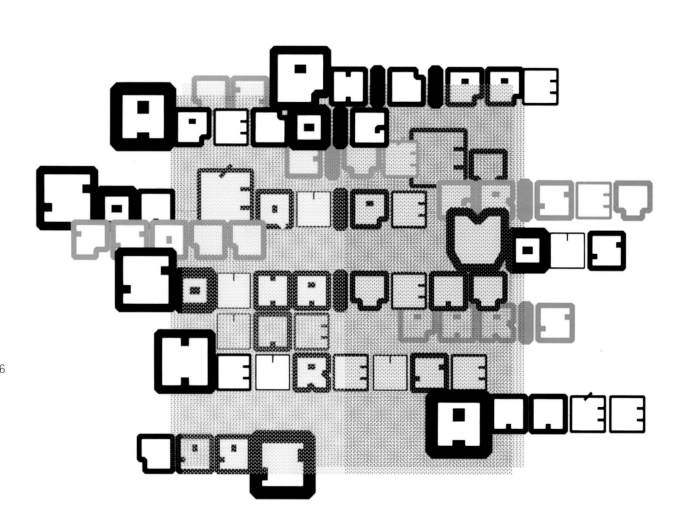

abcd ef g hi
A B C D E E G H
jklmn a p q
d K LM N OP Q
rst u xvu xyz
R S TUV WX YZ
123 45 678 ga

designer
Weston Bingham

college
California Institute of
the Arts

country of origin
USA

typeface
Baudrillard

work description
Typeface which
simulates features from
handwritten or hand-
lettered alphabets, but
disregards their original
contexts in favor of
computer generation

207

ABCDEF
GHIJKLM
NOPQRST
UVWXYZ

designer
Michael Worthington

college
California Institute of
the Arts

country of origin
USA

typefaces
Koo Koo Bloater (above)
Koo Koo Fatboy (center)
Koo Koo Bulemic (below)

work description
Typeface and spread from
Future Context magazine

dimensions
magazine spread
279 x 216 mm
11 x 8½ in

ABCDEFG
HIJKLMN
OPQRST
UVWXYZ

abcdef
ghijklm
nopqrst
uvwxyz

ABCDEFG abcdefg
HIJKLMN hijklmn
OPQRST opqrst
UVWXYZ uvwxyz

67890

abcdefg
hijklmn
opqrst
uvwxyz

designer
Richard Shanks

college
California Institute of
the Arts

country of origin
USA

typeface
Cardigan

work description
Typeface designed for
multimedia use, shown on
advertising poster

dimensions
508 x 610 mm
20 x 24 in

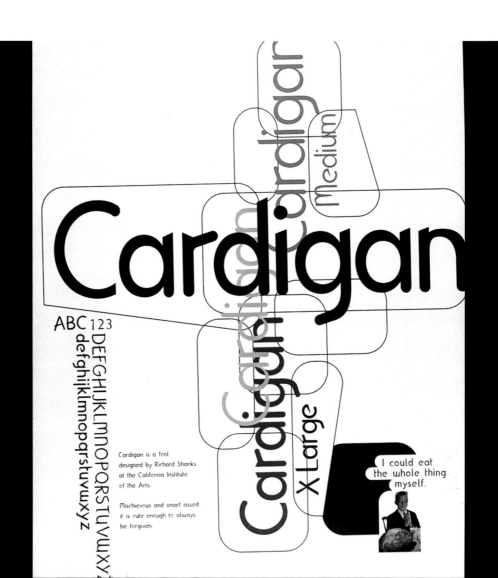

designer
Richard Shanks

college
California Institute of
the Arts

country of origin
USA

typeface
Taxi

work description
Retro-future typeface,
shown on advertising
poster

dimensions
508 x 610 mm
20 x 24 in

designer
Vivienne Schott

college
The Surrey Institute of Art
& Design, Farnham

country of origin
UK

typeface
Blotter

212

The history of art is simply a history of getting rid of the ugly by entering into it, and using it. After all, the notion of something outside of us being ugly is not outside of us but inside of us. And that's why I keep reiterating that we're working with our minds. What we're trying to do is to get them open so that we don't see things as being ugly, or beautiful, but we see them just as they are.

JOHN CAGE

The history of art is simply a history of getting rid of the ugly by entering into it, and using it. After all, the notion of something outside of us being ugly is not outside of us but inside of us. And that's why I keep reiterating that we're working with our minds. What we're trying to do is to get them open so that we don't see things as being ugly, or beautiful, but we see them just as they are.

JOHN CAGE

designer
Christian Küsters

college
Yale University School of
Art, Connecticut

country of origin
USA

typeface
Underwater

work description
Typeface shown in three
phases: the negative
underwater, the negative
drying, and the final print

dimensions
432 x 279mm
17 x 11 in

type designer
Edward Fella

designer
Rudy VanderLans

photographer
Rudy VanderLans

art director
Rudy VanderLans

design company
Emigre Graphics

country of origin
USA

typeface
Outwest

work description
Poster advertising
typeface

dimensions
570 x 830 mm
22½ x 32⅝ in

214

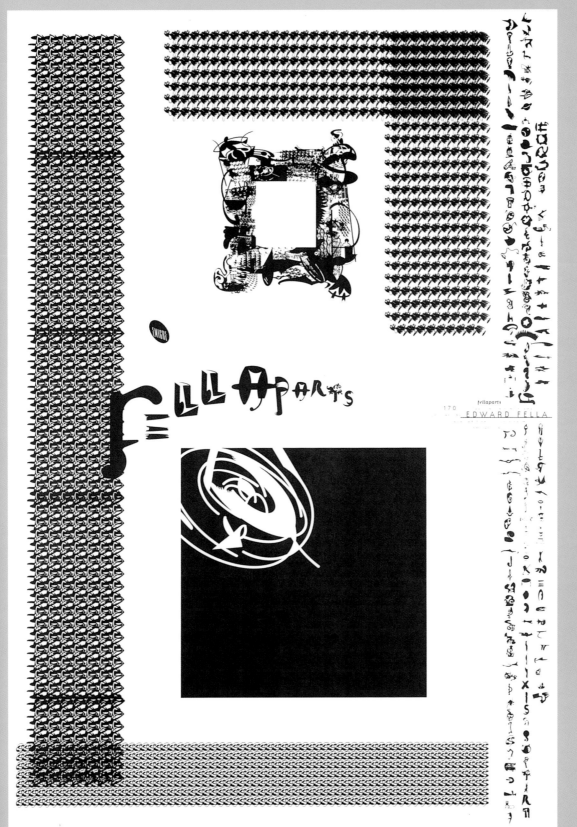

font illustrator
Edward Fella

designers
Gail Swanlund
Rudy VanderLans

art director
Rudy VanderLans

design company
Emigre Graphics

country of origin
USA

typeface
Fellaparts

work description
Poster advertising
typeface

dimensions
570 x 830 mm
22½ x 32⅝ in

215

designer
Conor Mangat

college
California Institute of
the Arts

country of origin
USA

typeface
Stereo Type

work description
Typeface exploring
stereotypical traits of
English and American
typography

dimensions
457 x 610 mm
18 x 24 in

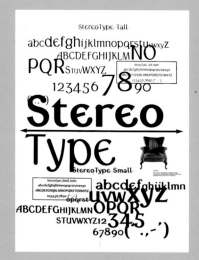

216

designer
Conor Mangat

college
California Institute of
the Arts

country of origin
USA

typeface
Platelet

work description
Typeface derived from the
characters of Californian
license plates, shown on
an advertisement for
Emigre fonts

dimensions
285 x 425 mm
11¼ x 16¾ in

designer
Michael Worthington

college
California Institute of
the Arts

country of origin
USA

typeface
Dominatrix

work description
Typeface, shown in use on
advertising poster

dimensions
poster
508 x 813 mm
20 x 32 in

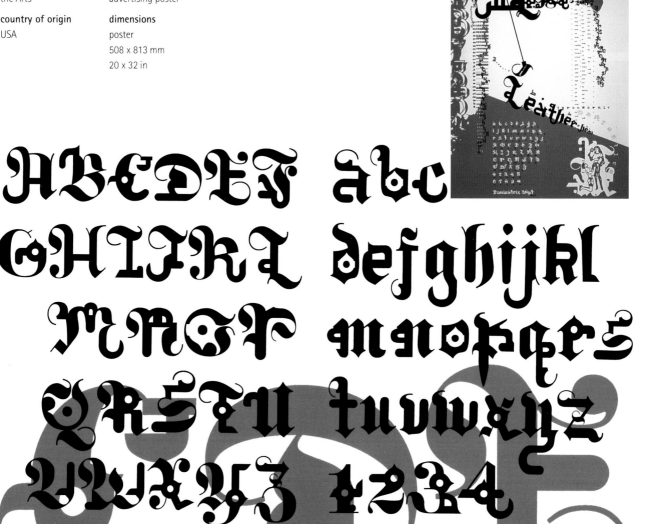

designer
Huw Morgan

country of origin
UK

work description
Ideas for a changeable
typeface, shown in a
sketch book

dimensions
292 x 406 mm
11½ x 16 in

index

Index

Aguannd, Pete 140, 141
Allemann Almquist & Jones 64, 65, 156, 157
Allemann, Hans-U. 64, 65
Almquist, Jan C. 64, 65, 156, 157
Altmann, Andy 106, 107
Ambry, Christophe 32
Antenna 60, 61
Apeloig, Philippe 30, 31, 32, 33, 206
Ashworth, Christopher 66, 68, 100, 101, 126, 127
Atelier National de Création Typographique 18, 26, 28
Atelier 42

Baart, Christine 152, 153
Bailey, Jason 200
Baines, Phil 106, 107
Baldinger, André 18
Banham, Stephen 132, 133
Banton, Amy Jo 78, 79
Barnbrook, Jonathan 106
Bassett, Rupert 86, 87, 108, 109
Bath College of Higher Education 52, 53
Bell, Nick 13, 110, 111, 124, 125
Benson, Paula 80, 81
Bingham, Weston 57, 207
Blackburn, Paul 108, 109
Booken, Anje 31
Boom, Irma 15, 20, 21, 92, 93
Brady, Conor 104, 105, 122, 123

Brandt, Hans P. 56, 128, 129
Bravenec, David 198
Brown, Stuart 180
Browning, Simon 160, 161, 170, 171

Cadby, Iain 90, 91
California Institute of the Arts 41, 51, 62, 63, 116, 136, 137, 144, 145, 180, 181, 198, 207, 208, 209, 210, 211, 216, 217, 218
Carr, Jason 162
Cartlidge, Ian 160, 161, 171
Cartlidge Levene Limited 160, 161, 170, 171
Casson Mann 124, 125
CDT Design Ltd. 169
Central Saint Martin's College of Art and Design 17
Chandler, Alan 134, 135
Charman, Elisabeth 59, 95
Chermayeff & Geismar Inc. 148, 149
Cranbrook Academy of Art 67, 114, 115
Crisp, Denise Gonzales 180, 181

Davies, Mike 164, 165
de Jong, David 84, 85
Deluxe 57
Designers Republic, The 28, 29, 76, 88, 89
Devlin, Martin 205
Diaper, Mark 119, 164, 165, 182, 183

Dinnis, Rachael 164, 165
Doling, Marcus "mad dog" 164, 165
Dotti, Luca 26, 27
doubledagger 59, 94, 95
Doublespace 96
Düngfelder, Jeff 118
Dyer, Peter 104, 105, 123

Ecole Nationale Supérieure des Arts Décoratifs 30, 31, 32, 33
Edwards, Jason 112, 113
Elliman, Paul 70, 71
Ellis, David 106
Ellot, Michael 199
Emigre Graphics 24, 25, 154, 155, 214, 215, 217
Evans, Graham 201, 202, 203

Falmouth College of Art 192
Fannei, Guenther 166, 167
Feinmann, Elisa 102, 103
Fella, Edward 196, 197, 214, 215
Ferguson, Heather 78, 79
Fletcher, Neil 58, 100, 101, 147, 193
Form 80, 81

Geismar, Tom 148, 149
Gluaber, Barbara 136, 137
Gutiérrez, Fernando 46, 47

Hall, Andrew 192
Hall, Jeremy 110, 111
Hammer, Melle 14, 36, 37

Harlan, David 51
Heavy Meta 136, 137
Herzog Grafik und Design 54, 55
Herzog, Jörg 54, 55
Hingston, Tom 204
Hodges, Drew 102, 103, 140, 141, 142
Holden, John 100, 101
Horsford, Richard 120, 121
Hough, Mark 96
Hoyer, Uli 166, 167
Hunter, Robert 190
Hutchinson, Tim 112, 113
Hyde, Karl 44, 45
Hyland, Stephen 138

Ilex Marketing Graphic Design Unit 168
Invisible 66, 100, 101, 126, 127

Jenkins, Nina 205

Kerler, Helge 171
Kim, Somi 136, 137
Kirschner, Nauka 42
Kitching, Alan 48, 49
Kitts, Barry 174, 175
Koeweiden/Postma Associates 117, 186, 187
Kosstrin-Yurick, Jane 96
Krieger, Stephanie 98, 99
Krieger/Sztatecsny 98, 99
Kunz, Willi 22, 23, 82, 83
Küsters, Christian 213

Lacy-Sholly, Laura 60, 61
Lamb, Robert 86, 87
Leonardi, Alessio 166, 167
Letterbox, The 132, 133
Levene, Adam 160, 161, 170
Lévêque, Loïc 188, 189
Lippa, Domenic 164, 165, 182, 183
Lippa Pearce Design Limited 119,
 164, 165, 182, 183
London College of Printing and
 Distributive Trades 50

Mahoney, Robbie 17
Makela, P. Scott 176, 177,
 178, 179
Mangat, Conor 216, 217
Mann, Roger 124, 125
Martín & Gutiérrez 46, 47
Martín, Pablo 46, 47
Matote, Yumi 170, 171
Mayer & Myers 97, 143
Mayer, Nancy 97, 143
McMullen, Brigid 205
Mehta, Nilesh 130, 131
Mende, Jeremy Francis 67,
 114, 115
Meta Design 172, 173
Meta Design plus GmbH 166,
 167, 184, 185
Mirelez, Mario A. 16
Mirelez/Ross Inc. 16, 43
Mizusaki, Naomi 102, 103,
 140, 141
Moody, Jennifer E. 116
Morgan, Huw 40, 219

Mouscadet, Jérôme 33
Muller, Betina 42
Myers, Chris 97

Nieuwenhuijzen, Kees 158, 159

O'Callaghan, John 70, 71, 174, 175
Opara, Anukam Edward 50
Oram, Anthony 191
Orange 68

Patel, Uday 130, 131
Pauchant, Caroline 30
Pd-p 58, 147, 193
Pisani, Rosie 140, 141
Plesko, George 143
Plus X 14, 36, 37
Post & Van Drongelen 152, 153
Priest, Chris 106, 107

Ravensbourne College of Design
 and Communication 70, 71, 86,
 87, 108, 109, 120, 121, 130,
 131, 174, 175
React 104, 105, 122, 123
Rediehs Schaefer, Cathy 148, 149
Reisdorf, Petra 42
Renner, Michael 19
ReVerb 136, 137
Roberts, Chris 52, 53
Ros, Lies 35
Ross, Jim 16, 43
Royal College of Art 40, 112, 113,
 200, 201, 202, 203
Rudy, Chuck 57

Ryan, Mike 138, 139

Sainato, Vincent 102, 103, 142
Schott, Viviane 163, 212
Schröder, Rob 35
Scott, Gill 120, 121
Shackleford, Stephen 65, 156, 157
Shanks, Richard 144, 145, 210, 211
Sholly, James 60, 61
Sissons, Amanda 100, 101
Skinner, Christa 41
Sloy 24, 25
Smart, David 13
Smith, Dave 100, 101, 126, 127
Solvang, Jann 168, 169
Spiekermann, Erik 164, 165
Spot Design 102, 103, 140,
 141, 142
Stepp, Shelley 62, 63
Studio DNA 118
Surrey Institute of Art and Design,
 Farnham, The 138, 139, 162,
 163, 190, 191, 199, 212
Swanlund, Gail 154, 155, 215
Sztatecsny, Maximilian 98

Tartaglia, Carlo 86, 87
Taylor, Simon 74, 75
Telling, Ed 139
Typography Workshop, The 48, 49
Thirkell, Nicholas 169
Tomato 12, 34, 44, 45, 74, 75, 77
Total Design 56, 128, 129
Trauer, Claudia 42
Trichett & Webb 77

Trost, Brad 94
Tummers, Birgit 42
2 Bellybuttons 78, 79

Utermohlen, Edwin 59
Utrecht School of the Arts 84, 85

VanderLans, Rudy 24, 25, 154, 155,
 214, 215
van Dooren, Dirk 12, 34 74, 75, 77
van Drongelen, Kees 152, 153
van den Hurk, Harco 152, 153
VisualSpace 152, 153
Voelker, Ulysses 184, 185

Walker, Neil 169
Warren-Fisher, Russel 146
Warwicker, John 44, 45
Wells, Mason 160, 161
Welt, Harald 166, 167
West, Paul 80, 81
White, Geoff 168
Why Not Associates 106, 107
Wild Plakken 35
Wilks, Karen 38, 39
Words and Pictures for Business
 and Culture 176, 177, 178, 179
Workroom, The 205
Worthington, Michael 41, 208,
 209, 218

Yale University School of Art 213

223

List of Colleges

Atelier National de Création
Typographique
Imprimerie Nationale
12 bis rue du Capitaine Ménard
75732 Paris
France

Bath College of Higher Education
Sion Place
Lansdown
Bath BA1 5SF
UK

California Institute of the Arts
24700 McBean Parkway
Valencia
California 91355-2397
USA

Central Saint Martin's College of
Art and Design
Southhampton Row
London WC1B 4AP
UK

Cranbrook Academy of Arts
1221 N. Woodward Avenue
Bloomfield Hills
MI 48303
USA

Ecole Nationale Supérieure des Art
Décoratifs
31 rue d'Ulm
75005 Paris
France

Falmouth College of Art
Woodlane
Falmouth
Cornwall TR11 4RA
UK

London College of Printing and
Distributive Trades
Elephant and Castle
London SE1 6SB
UK

Ravensbourne College of Design
and Communication
Walden Road
Chislehurst
Kent BR7 5SN
UK

Royal College of Art
Kensington Gore
London SW7 2EU
UK

The Surrey Institute of Art
and Design
Falkner Road
Farnham
Surrey GU9 7DS
UK

Utrecht School of the Arts
Boueierbakker Laan 50
3582 VA
Utrecht
The Netherlands

Yale University School of Art
PO Box 2082412
New Haven
Connecticut
06520-8242
USA

Acknowledgments

The Publishers would like to thank
the following people for their help
in producing this book: Nick Bell,
Tony Cobb, Jennifer Harte,
Gabriella Le Grazie, Geoff White,
Karen Wilks for contacting
designers and educational
institutes; Peter Crowther
Associates for producing the
voiceprints reproduced on the
jacket and the chapter openers;
David Murray for photographing
some of the work.

Future Editions

If you would like to be included in
the call for entries for the next
edition of *Typographics* please
send your name and address to:
*Typographic*s, Duncan Baird
Publishers, Castle House, Sixth
Floor, 75-76 Wells Street, London
W1P 3RE, UK. As a collection point
has not yet been finalized, samples
of work should not be forwarded
to this address.

Acknowledgements

The Publishers would like to thank: Geoff White; Richard Horsford for design assistance; Lucy Walker for researching and sending magazines from Australia; and John McKay, Head Librarian at Ravensbourne College of Design and Communication.

Disclaimer

The captions, information, and artwork in this book have been supplied by contributors. All material has been included on the condition that it is reproduced with the knowledge and prior consent of the designers, photographers, illustrators, client company, and/or other interested parties. No responsibility is accepted by the Publishers for any infringement of copyright arising out of the publication.

While every effort has been made to ensure the accuracy of captions and of the quality of reproduction, the Publishers cannot under any circumstances accept responsibility for inaccuracies, errors, or omissions.

Future Editions

If you would like to be included in the call for entries for the next edition of *Typographics* please send your name and address to:

Typographics
Duncan Baird Publishers
Sixth Floor
Castle House
75-76 Wells Street
London W1P 3RE
UK
e-mail: dbaird@mail.bogo.co.uk

As a collection point has not yet been finalized, samples of work should not be forwarded to this address.

Newark, Quentin 57
Nick Bell Design 30, 138-9
NoHo Digital 170-73
(noise) 214-19
Now Time 33-7

Object 114-15
O'Callaghan, John 178
Ockerse, Tom 38
O'Donnell, Timothy 154
Oliver, Vaughan 154-5
O'Mara, Seán 164-5
Opara, Anukam Edward 30
Organised Design 115

Pavitt, Dean 108-11
Playground 176-7
Poplin, Gilles 86-7
Post 208-13

Qwerty 22-3

Raively, Emily 116
Ray Gun 124-5
Reichert, Hans Dieter 108-11
Research Studios 160-63, 174-5
Re taking London 76-7
ReVerb 34
Riederer, Heidi 115
Roach, Matt 140-45
Roden, William van 130-33

Rose, Aaron 72-3
Rubinstein, Rhonda 58-61

Savoir, Philippe 88-93
Schroeder, Tracey 126-7
Shepherd, Adam 146-7
Shift! 78, 104-5
Silk Cut Magazine 136-7
Silo Communications 102-3
Sin 24-5
Smet, Edwin 147
Sosa, Verónica 138-9
Staines, Simon 160-63
Stoltze, Clifford 122-3, 124-5,
 126-7
Stone, Rob 112-13
Strength 116-19
Studio Voice 200-207
Substance 194-9
Suzuki, Kayoko 200, 201, 203, 204-5,
 206, 207

Tappin, Mark 76-7
Ten by Five 100-101
Tibbs, Ben 150-51, 176-7
Tilson, Jake 16-19
Tironelle, Stephanie 72-3
Tomec, Lilly 78, 104-5
True 140-45
Turner, Chris 79, 101
Turner, Grant 50-51

Turner, Steve 76-7
21C (supplement of DJ Magazine) 63
Typographic Fascism 78
Typographische Monatsblätter 80
Tyson, Jeff 117

U&lc 58-61
Utermohlen, Edwin 35
Utopia 86-7

VanderLans, Rudy 96
Vanidad 138-9
Vaughan Oliver Poster 122-3
Versus 112-13
Virgin Classics 30
Visible Language 38-9
Voss, Ingo 134-5
V23 154-5

Wallace, Rob 76-7
Waller, Alyson 160-63
Waller, Christopher 63
White, Paul 208-13
Wills, Steve 215, 218
Winkelmolen, Karin 147
Wishart, Zoe 114-15
World Art 62

222 *Euro Club Guide* (supplement of *DJ*
 Magazine) 66-7
Eventual 64-5
Experiment 72-3
Eye 42-5

Farrell, Stephen 98-9, 122-3, 124-5,
 126-7
Ferguson, Heather 68
Fletcher, Neil 194-9
Flores, Pablo Rovalo 106
Form 150-51
frieze 31
Fritzsche, Beth 116
Frost Design 32, 52-5
Frost, Vince 32, 52-5
Fujimoto, Yasushi 200-207
Furukama, Fumiko 201, 203, 206, 207
Fuse 106-7

Garrett, Malcolm 108-11
gee magazine 94-5
Granger, Stephanie 108-11
Gutiérrez, Fernando 12-15, 26-9

Hall, Jeremy 30
Harcom, Billy 112-13
Hastings, Pattie Belle 128-9
Hayward, Peter 178-9
HDR Design 108-11
Hewitt, Craig 208-13

Hingston, Tom 160-63, 174-5
Hogan, Terence 62
Holt, Chris 46-9
Horner, Brian 102-3
Hough, Mark 138-9
Howard, Glenn 57
Hubers, Kees 155
huH 154-9
Hurren, David 170
Hurst, Mark 112-13

Illegibility 84-5
Independent Magazine 32
Insidetrack 174-5
Iron Filings 100
Isaac, Martin 188-93
Iwabuchi, Madoka 200, 202, 207

Jordan, Wayne 188-93

Kim, Somi 34
Kirk-Wilkinson, Robert 160-63
Kisor, Doug 97
Kramer, Heather 126-7

Lamba, Sonia 216-17
Lausten, Judith 33-7
Lawrence, Mike 72-3
Lehmann-Haupt, Carl 130-33
Leslie, Jeremy 136-7
Lippa, Domenic 180

Lundy, Clare E. 94-5
Lupi, Italo 20-21
Lutz, Anja 78, 104-5

Mackay, Seònaid 40-41
Magazine of the Book, The 40-41
Mainartery 178-9
Manuscript 74-5
Markowski, Suzanne 80-81
Marling, Leigh 76-7, 148-9
Martin, Alison 188-93
Martín, Pablo 26-9
MassArt 95-6 126-7
Matador 26-9
Max 160-63
Mayer, Nancy 35, 36-7
Mayes, Mandy 188-93
Mazzucca, Paul 38
McKeown, Damian 148-9
ME Company 208-13
Meer, Koos van der 56
Mello, Leslie 12-15
Metropolis 130-33
Middleton, Lyn P. 34
Minshall, Scott 179
Miranda, Nina Rocha 64-5
Monument 134-5
Myers, Chris 35, 36-7

Nath, Rick 171-3
Needham, Simon 187, 214, 218

Akselsen, Bjorn 128-9
Allardyce, Michèle 66-7, 166-9
Almquist, Jan C. 80
Anderson, Will F. 108-11
ANTART 114-15
Arena 50-51
Art Papers 128-9
Ashworth, Chris 195-9
Astrodynamics 140-45
Atlas 16-19
Attik Design Limited, The 1-11,
 82-3, 152-3, 182-7, 214-9
Automatic 150-51, 176-7

Ballesté, Patricia 26-9
Banham, Stephen 22-5
Barosh, Miyoshi 33
Bartlett, Brad 97
Baseline 108-11
Beebe, Matt 119
Béjean, Pascal 88-93
Bell, Nick 30, 138-9
Benson, Karl 186
Berlage Papers 56
Bevan, Rob 170-73
Bicker, Phil 69-71
Big Magazine 52-5
Bigg, Chris 155
Bikini 120-21
Bil'ak, Peter 84-5
black + white 46-9

Blah Blah Blah 194-9
Blah Blah Blah 1995 (short-run) 165
Blatman, Resa 126-7
Blue Source 76-7, 148-9
Bob 1 182-7
Bortolotti, Frédéric 88-93
Bourke, Marissa 50-51
Brody, Neville 106-7, 174-5
Brouwers, Arlette 56
Bruitage 81
Bulang, Bernhard 146
Bulldozer 88-93
Burdick, Anne 96-7

Caffeine Magazine 68
Carson, David 124-5
Carty, Martin 150-51, 176-7
Çepoğlu, Gülizar 74-5
Cherry, Vivienne 40-41
Chick, Sam 50-51
Clarkberg, Larry 38-9
Coates, Stephen 42-5
Code 188-93
Colors 12-15
Contretemps 20-21
Cooke, Giles 215
Cooke, Jonathan 76-7, 148-9
Cormier, Delphine 81
Corradi, Robert 171-3
Cossutta, Renée 33-7
Creative Camera 69-71

Creative Review 164
Creator 146-9
Crumb, Harry 31
Cunningham, Brian 108-11
Curchod, Jerôme 154-9
Curry, John 120-21

Davies, Mike 180, 181
Dean, Howard 171-3
Degg, Andrew 100
Denton-Cardew, Scott 156-9
Dempster, Richard 184
Design 57
Detail 81
Devendorf, Scott 118-19
Diaper, Mark 180-81
Dixon, Simon 185, 186, 218, 219
DJ Magazine 66-7, 166-9
downlow, the 180-81
Doyle, Danny 76-7
Driver, Paul 215
Dry 188-93
Duranton, Anne 88-93
Dwelly, Simon 108, 109, 111

Earith, Simon 76-7
Eggers, Birgit 180, 181
Egoiste 138-9
Electric Hob 101
Emigre 96-9
EQ 171-3

221

Index

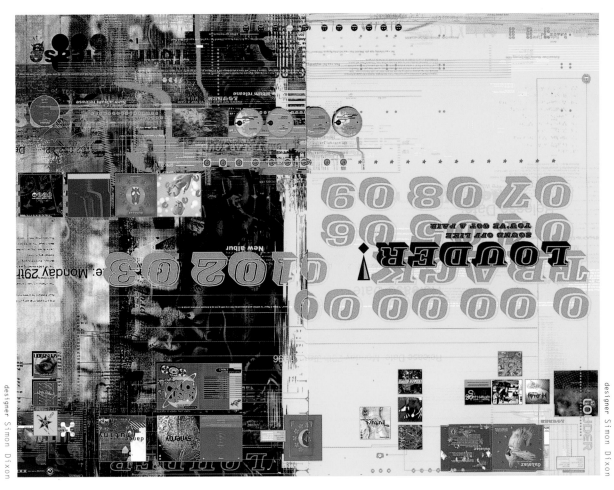

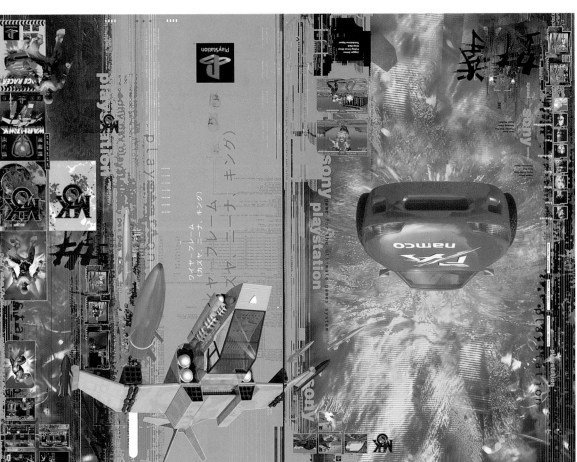

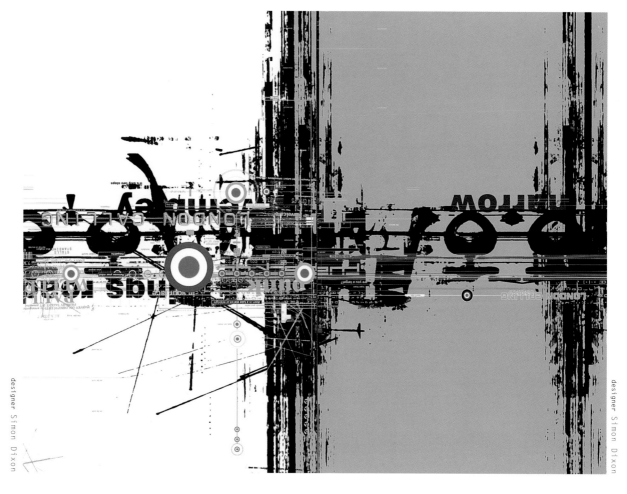

designer Simon Dixon

designer Simon Dixon

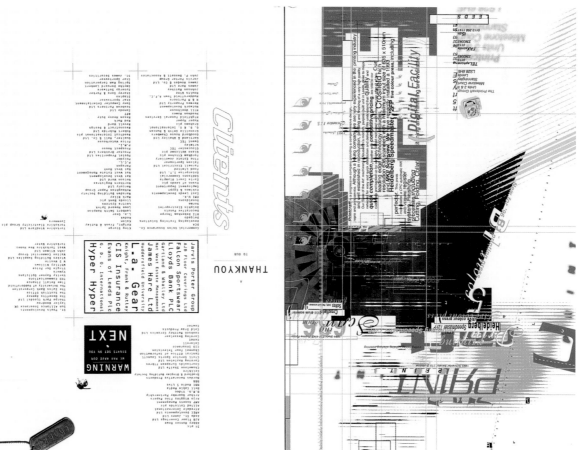

designer Simon Needham

designer Steve Wills

designer Sonia Lamba

designer Gilles Cooke

designer Steve Wills

designer Paul Driver

designer Steve Wills

(noise)

welcome to

PARENTAL
ADVISORY
EXPLICIT GRAPHICS

designers all designers specified are
from The Attik Design Limited
publisher The Attik Design Limited
origin UK
dimensions 220 x 330 mm
8⁵/₈ x 12 in

(noise)

Every morning the old man would stroll around his vast garden, clutching in his gnarled old hands a fat fountain pen and a book of music sheets. Whenever he heard birdsong, he would stop and scribble it down in Notes. The sacred musical symbols of old which he knew by heart. He understood the mysterious nature of those ancient black dots, and how they could translate the birds' twitterings into the music of human emotions.

One morning the composer stood beneath the weeping willow, his mind focused.

He turned his trained ears in as many directions as there are in a forest.

He became aware of something new in the air.

Whatever It was, It had silenced the birds. They were flitting backwards and forwards with straw in their beaks, but not one was singing.

"This is most odd", he thought to himself. "Spring is months away but the birds are behaving as if it's arrived!".

It was unlikely there could have been a polar shift the night before without him being aware of it. And even if there had been, he'd expect the birds to sing more than usual not less. He knew something was wrong.

As they all seemed to be flying in the same direction, the old man decided to follow them. Perhaps they would lead to the source of the mystery.

He reached a clearing, where the ground was black with birds of all shapes and sizes. He picked his way through the dark carpet of shining wings and tails, taking

The Birth of
NovaBjörk

A tale in the old style of Science Fiction.
For the children of NuWorld.

i

This is the story of an old composer, whose identity must remain a secret for his own safety. He lived by himself on the outskirts of NeoPolis and was ignored by his fellow pholk. Partly because they hardly knew of his existence and partly because the pholk didn't care.

The composer's house was of the Ol'World, that is, the world before the Great Deconstruction. Buildings were organic before NuWorld. Sometimes the house seemed just like a living creature, its walls were uneven, its windows really opened, and it had a crooked roof. All forbidden now of course.

But the composer didn't mind living in such poor circumstances. He had no thought for anything except his beloved music. All he asked in life was to be able to create enough compositions to feed the starving MuBots hidden in his cellar.

...it means Low Frequency Oscillation. It means Leeds boys Gez Varley and Mark Bell. For many, they represent the definitive Warp sound. Their eponymously-titled debut single recorded and produced in Mark's bedroom reached the UK Top 20, with sales of 120,000. And made Warp, their label, famous in the world of Techno. Their only album to date, 'Frequencies', is a classic: delicate, intricate. With some speaker-punishing bass. According to Warp, LFO are currently choosing from hundreds of tracks to put together their long-awaited second album, 'Advance'.

photographer Bernhard Valsson

source Björk's Notebooks

POST

Dancing About Buildings

The Black Dog arrived in 1987. Its members were among the pioneers of a regenerative dance sound who knew there was a universe of possibilities out there, and went to explore it. The songs they brought back from their voyages are startlingly beautiful and have gained them the respect of a whole new crew of audionauts.

The facts don't matter anyway, you've just got to listen

photographer Peter Walsh

9 780747 523734

ISBN 0-7475-2373-8

BLOOMSBURY

art director Paul White designers Craig Hewitt/ME Company

POST

illustrators ME Company
editor Sjón publisher Bloomsbury
origin UK
dimensions 267 x 337 mm
10½ x 13¼ in

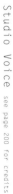

photographer Kenji Oguro

Studio Voice see page 200 for credits

207

CREATORS of FICTION M

マドンナ・イメージのクリエイター達

「ライク・ア・ヴァージン」'85
スティーヴン・マイゼル

「スーザンを探して」'86
スーザン・シーデルマン

キース・ヘリング

「リヴ・トゥ・テル」'86
「パパ・ドント・プリーチ」'86
「フーズ・ザット・ガール」'87
ジェームズ・フォーリー

ブルース・ウェーバー

「上海サプライズ」'87
ジム・ゴダート

ショーン・ペン

「ロンリー・ブラッド」　「フーズ・ザット・ガール」'87
J・フォーリー

「トゥルー・ブルー」'86
ハーブ・リッツ

D・ボウイ
プリンス

「オープン・ユア・ハート」
J=B・モンディーノ

J=P・ゴルチエ

ドン・ヘンリー
エアロスミス
S・ウィンウッド
ビリー・アイドル
ジョージ・マイケル

「ライク・ア・プレイヤー」'89
ヘルムート・ニュートン

「オオ・ファーザー」'89
「エクスプレス・ユアセルフ」'89
デヴィッド・フィンチャー

「レスキュー・ミー」(12inch)'91
J=B・モンディーノ

「ディック・トレイシー」
ウォーレン・ベイティ

マイケル・ジャクソン
ジャネット・ジャクソン
クリス・アイザック

「レスキュー・ミー」(REMIX)'91
ステファン・セドナウィ

ペドロ・アルモドバル

「チェリッシュ」'89
ハーブ・リッツ

「ジャスティファイ・マイ・ラブ」(STEAL)'91

「ヴォーグ」'90
トニー・ウォード

「ジャスティファイ・マイ・ラブ」'91
パトリック・デマルシェリエ

「ジャスティファイ・マイ・ラヴ」'91
「～マイ・プレイグラウンド」'91
アレック・ケッシアン

A・ケッシアン

ボビー・ブラウン
エルトン・ジョン

「エイリアン3」

「イン・ベッド・ウィズ・マドンナ」'91

スティーヴン・マイゼル

ドルチェ&ガッバーナ

ウェイン・メイザー

ナオミ・キャンベル

スティーブン・マイゼル

ファビアン・バロン

「エロティカ」'92
「セックス」'92

「BODY OF EVIDENCE」'93

「INTERVIEW」
「VOGUE ITALIA」
「HARPER'S BAZAR」

ウリ・エデル
「ブルックリン最終出口」
「クリスチーネF」

video　　　photo　movie　　　fashion art

MAP／YUUJI MURAOKA, S.V
MAP DESIGN／TSUTOMU MORIYA

トミー・ペイジ
ユナイテッド・ハウス・ネーションズ ‥‥‥‥ マーク・ケイミンズ
「エヴリバディ」

エムトゥーメイ ━━ レジー・ルーカス
「ラッキー・スター」
「ボーダーライン」

『バーニング・アップ』'83

ジョン"ジェリービーン"ベニテツ

「ホリデイ」'84

MADONNA

ブロンディ ━ デビー・ハリー
トンプソン・ツインズ

シック ━ ナイル・ロジャース ━ 『ライク・ア・ヴァージン』'85

デヴィット・ボウイ

「ライク・ア・ヴァージン」
トム・ケリー＆ビリー
・スタインバーグ
シンディ・ローパー
ハート

『ビジョン・クエスト
/青春の賭け』
'85

クインシー・ジョーンズ
「クレイジー・フォー・ユー」
＆「ギャンブラー」

ブレックファスト・クラブ ━ スティーヴン・ブレイ
「イン・トゥ・ザ・グルーヴ」 '86

クリスティナ・ヴィエラ
「パパ・ドント・プリーチ」
ブライアン・エリオット

サイーダ・ギャレット
『トゥルー・ブルー』'86

ニック・ケイメン

ピーター・セテラ

パトリック・レナード

マリリン・マーティン

ジョナサン・モフェット '88

「オープン・ユア・ハート」
ジョディ・ワトリー ━ ガードナー・コール
「ラ・イスラ・ボニータ」 ポール・ベスコ '89

ブルース・ガイチ

ゴー・ホトダ '90

『フーズ・ザット・ガール』'87
プリンス 『YOU CAN DANCE』'87
「ラヴ・ソング」 『ライク・ア・プレイヤー』'89

ニッキ・ハリス
『アイム・ブレスレス』
マイケル・ジャクソン
K.D.ラング
ドナ・デロリー ジミー・アイオヴィン

ダニー・エルフマン
「ディック・トレイシー」'90

レナード・バーンスタイン ━ スティーブン・ソンダイム '91
「スーナー・オア・レイター」

'92

'93

シェプ・ペティボーン
「ヴォーグ」

ラテン・ラスカルズ レニー・クラヴィッツ
スティーヴ・トンプソン 「ジャスティファイ・マイ・ラヴ」 『ウルトラ・マドンナ・
＆マイケル・バルビエロ グレイテスト・ヒッツ』'91
ブルース・フォレスト アンドレ・ベッツ
＆フランク・ヘラー

テヴィッド・コール

C&Cミュージック・ファクトリー 『エロティカ』'92

music

FICTION

photographer Seiko Mikami

201

photographer Kenji Oguno

d

b

Studio Voice

art director Yasushi Fujimoto
publisher INFAS
origin Japan
dimensions 225 x 300 mm
 8⁷/₈ x 12 in

a
designer Yasushi Fujimoto
editor Takeru Esaka
b
designer Kayoko Suzuki
editor Takeru Esaka
c
designer Madoka Iwabuchi
editor Takeru Esaka
d
designer Fumiko Furukama
editor Shinya Matsuyama

photographer Herb Ritts

a

photographer Jean-Baptiste Mondino

a

b

c

"man, what you got that twat on the cover for?"

Noel Gallagher on Blah Blah Blah's Damon Albarn cover.

nothing better to do: craig melean likewise: joseph cultice

tory tour," but gets distracted by a bunch of hardcore punk kids. Some might say, 'Hey, who needs another Oasis interview anyway?'

...rk sneer."

Time Out New York, Mar. 6-1...

"Undeniably Blur's most adventurous reco...
...ng Stone
...s for the disaffected."
magazine advert for The Gre...

ONLY OASIS

"Thanks for the great article about Oasis ["...
Riot", January]. They may be arrogant and...
obnoxious, but it's a nice change from the c...
...multimillionaire...
...the band's sordid tales of fame and...
...would be boring coming from the gr...

...Montreal, Canada.

letters page, ...

BLUNDERWALL

On their last weekend "Stateside" BLAH BLAH BLAH trails the jetstream left by O...

'Just going to Spectrum at Heaven and seeing two thousand people going mad, that was like, 'fuck!'

"I was trying to make my girlfriend see that but she didn't understand."

Page Three birds was art,

Naked on a bed with a.o.

197

ROBERT RODRIGUEZ

FANGS FOR THE MAMMARIES

{FANGS FOR}

HE'S JUST FILMED A VAMPIRE MOVIE IN A STRIP BAR
CALLED THE TITTY TWISTER
IN WHICH HE PERSUADED SEX KITTENS SALMA
HAYEK TO GET DIRTY WITH QUENTIN TARANTINO
ROBERT RODRIGUEZ, THE DIRECTOR WHO CAN BUDGET A
TEN DOLLAR MOVIE AND STILL HAVE CHANGE FOR THE
CAB HOME, IS TAKING A BITE OUT OF HOLLYWOOD

DIRECTOR JOHN HOLDEN

BOB MCCABE

photographer Paul Cohen

photographer Peter Anderson

photographer Joseph Cutice

◄ pages 198-9

dimensions 230 x 300 mm
9 x 11⅞ in
origin UK
publisher Ray Gun Publishing Limited
editor Shaun Phillips
designers Chris Ashworth @ Substance
Neil Fletcher @ Substance
art directors Chris Ashworth @ Substance
Neil Fletcher @ Substance

Blah Blah Blah

pages 195-9

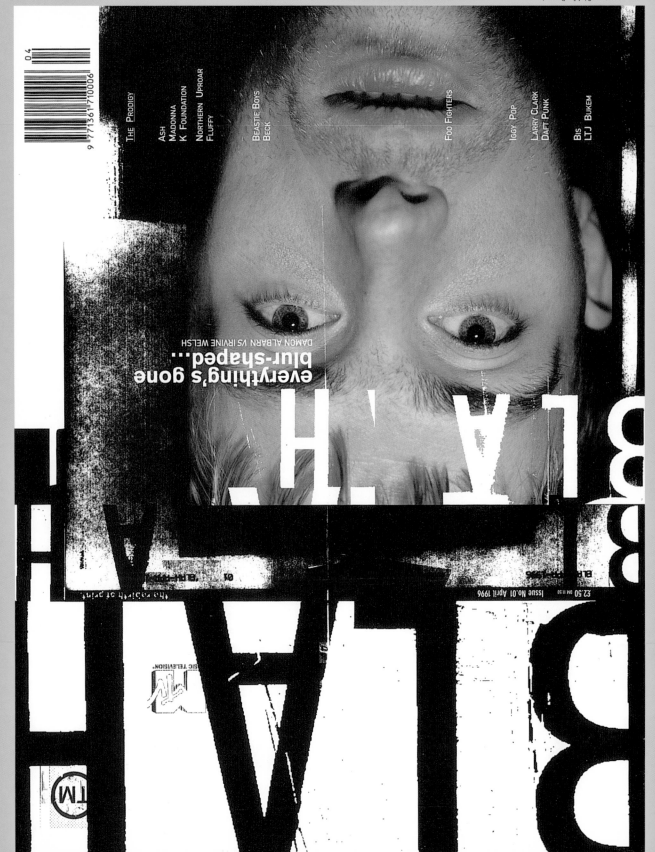

photographer Phil Poynter

everything's gone
blur-shaped...

DAMON ALBARN VS IRVINE WELSH

THE PRODIGY

ASH
MADONNA
K FOUNDATION
NORTHERN UPROAR
FLUFFY

BEASTIE BOYS
BECK

FOO FIGHTERS

IGGY POP
LARRY CLARK
DAFT PUNK

BIS
LTJ BUKEM

BLAH

£2.50 DM 11.50 Issue No.01 April 1996

9 771361 710006 04

page 194

Blah Blah Blah

stationery

art director	Neil Fletcher @ Substance
designer	Neil Fletcher @ Substance
publisher	Ray Gun Publishing Limited
origin	UK
dimensions	
headed paper	210 x 297 mm
	8¼ x 11¾ in
white envelope	215 x 110 mm
	8½ x 4⅜ in
business cards	65 x 65 mm
	2½ x 2½ in
brown envelope	305 x 305 mm
	12 x 12 in

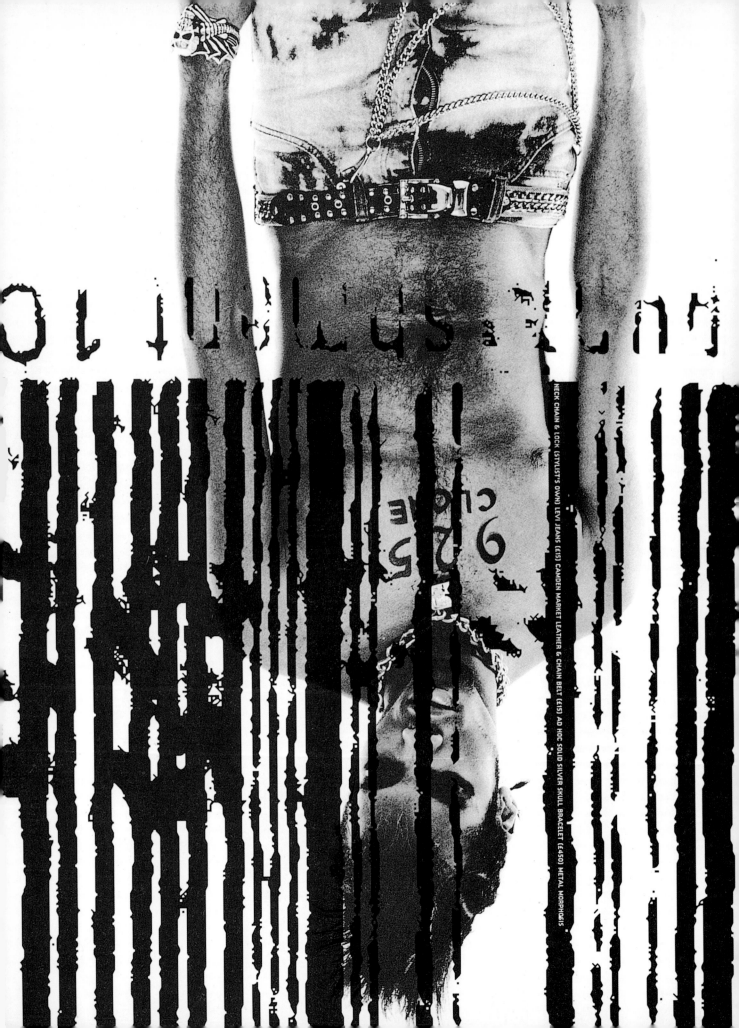

NECK CHAIN & LOCK (STYLIST'S OWN) LEVI JEANS (£15) CAMDEN MARKET LEATHER & CHAIN BELT (£15) AD HOC SOLID SILVER SKULL BRACELET (£450) METAL MORPHOSIS

pages 191-3 photographer Phil Knott @ ESP

LONDON HAS BEEN INFILTRATED. NESTLING IN OUR MIDST RESIDES A SIX FOOT, BLONDE, AMAZONIAN AMERICAN. WITH A BODY AND FACE WHICH GAVE HER THE CHANCE TO STRUT MODEL-STYLE ACROSS THE GLOBE, RACHEL WILLIAMS IS CURRENTLY HOLING-UP IN WEST LONDON IN LAID-BACK MANNER WITH LOVER, ALICE TEMPLE - CHECKING MOVIE SCRIPTS, MUSING ABOUT LIVE TV AND ENJOYING TONY WARD AS HER TEMPORARY HOUSE-BOY. ARRIVING FROM PLANET FASHION WHERE REBELLION CAN BE SEEN IN YOUR CHOICE OF NAIL POLISH, WILLIAMS' BRAND OF BULLSEYE WISE-CRACKS AND STREET-WISE PHILOSOPHY, CUTS THROUGH THE USUAL FASHION-PLATE PLATITUDES.

SHE'S CURRENTLY PLAYING THE POST-MODEL-ABOUT-TO-TURN-ACTRESS/PERSONALITY TRIP HER WAY, WRITES DAVID WATERS.

CODE: WHY LONDON?

RACHEL WILLIAMS: THE DIRTIER YOUR TROUSERS, THE GREASIER YOUR HAIR, THE DARKER YOUR ROOTS - THE GROOVIER YOU ARE HERE. It suits me just fine. In Paris it's the complete opposite to London, everyone has those perfect little suits on. They're all clones of each other. It's so bourgeois. Boring, boring, boring. I like the people in New York, but somehow I don't have any friends there - I have a lot of friends here, but that's through Alice, but they're great.

HOW DID YOU GET INTO TV?

I never thought of doing TV in my life. But English TV is better than American TV. I did live TV for the first time the other day on MTV and that was really fun. I gives me an adrenalin rush because I know that they can't stop me, they cannot control me. When I did the Girly Show, I've got an earpiece coming in here, they just don't let you get on with it, they should let us go off and edit out the rubbish. They are so scared. I think that the Girly Show should be live. And we had trouble doing current events because we were recording so far ahead.

HAS EVERYTHING BEEN SORTED OUT WITH IMMIGRATION? (ALTHOUGH RACHEL'S MOTHER IS ENGLISH, RACHEL WAS DENIED A WORK PERMIT)

The night before we shot the first Girly Show, immigration came down and I wasn't allowed to present the show, all I was allowed to do was do interviews from abroad and send them in. It was really frightening, they said you are going out to interview this person and I had never interviewed a fucking rat. They just sent me out with a cameraman and a sound person. But it worked out.

WHAT MAKES A GOOD INTERVIEW?

Don't stick with the questions they gave you. They would give me tons and tons of questions. As a conversation goes on other questions occur naturally. It was like they weren't listening. I wanted to ask about other things. I would not go with those questions when there was a more interesting angle. It would throw the other presenters off because they would be waiting for a set question from me to queue them in and I would be talking about something else.

WHO WOULD YOU LOVE TO INTERVIEW?

Rosie Perez (Spanish/American actress) was close to my fantasy interviewee. I WOULD LIKE TO INTERVIEW LIAM GALLAGHER AND TURN HIM OVER MY KNEE AND SPANK HIS SORRY ASS. I would be telling him to get a grip. I used to have a crush on him. I don't think all that obnoxious, macho bravado is interesting at all. I think it is a really bad cliche. The guy's a genius so why diminish himself and his brother by being such an idiot? It's really so easy to be like that. If he thinks that's clever - for fuck's sake, give me a break. That's really simple.

ISN'T HE JUST INTO BEING FAMOUS?

I went through that fame thing - you become enamoured with fame and you become an arsehole for a little bit. For me it lasted four or five months. But man, his stuff's going on too long.

WHAT SORT OF THINGS DID YOU DO DURING THAT TIME?

There are stories of me punching out hairdressers and stuff. I threw a chair at someone as well - I threw it in her general direction, it didn't actually hit her or anything. The work slowed down for a bit so you come back to earth again. People go through it, it's just how quickly you come through it that counts like poor fucking Naomi. She's never come out of it.

WHAT IS THIS BETWEEN YOU AND NAOMI CAMPBELL?

I am giving her a hard time now. I figure, well, she already hates me so I've got nothing to lose. She hates everyone and she especially hates me. I slagged her off on the Girly Show - I did her as "Wanker of the week". People stopped me in the street all that week and said, "I can't believe how genius that was. I couldn't believe it - I saw it Friday and I had to watch it again on Saturday. And somebody had to say it." In my life I've hurt people it is only out of carelessness or thoughtlessness, and as bad as that may be, it's not as bad as going out and intentionally hurting somebody, which is what Naomi does.

WHAT DO YOU THINK OF THE TABLOID PRESS OVER HERE?

Well, touch wood (she taps a wooden counter) I've had such good press. At the moment I can do no wrong. I'M THE BEST THING SINCE SLICED FUCKING BREAD. They've not been intrusive.

DO YOU SEE YOUR FUTURE IN LONDON?

Yes. I've got all sorts of great projects on the burner here. And in New York and America I'm a sort of has been model but here people are approaching me every other day with a proposal. It's really exciting. TV, movies and I would like to come up with some of my own concepts. I've got movie offers and have even been asked to do vocals for a house track. I don't know if I can sing for jack shit, but I'll give it a shot. I've got a couple of good offers too. Great roles. In fact there's this one role - the character is an American model who comes to London. This guy was trying to cast all over New York and everybody kept saying you've got to see this girl Rachel Williams and he finally tracked me down. I think he liked what he saw. I haven't read for him yet but I'm going to be doing it at any moment. I think he likes me. Learning lines is the hardest part but I figure any idiot can memorise things. The character is beautiful - she's six foot tall with big breasts, super-intelligent and drug-crazed.

CAN YOU RELATE TO HER?

Yes. I can definitely relate to this role.

photographer Soulla Petrou

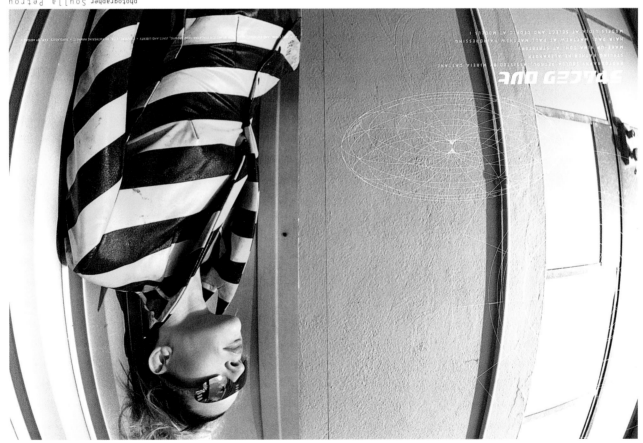

SPACED OUT

PHOTOGRAPHY SOULLA PETROU, ASSISTED BY MIREIA CASTANE
STYLING KATHARINE ALEXANDER
MAKE-UP LINDA GOHL AT STREETERS
HAIR PAUL MACLEAN AT PAUL MERTON HAIRDRESSING
MODELS LIDIA AT SELECT AND LEONIE C AT MODELS I

pretty sick.

insane.

pages 188–93

Code

art director Mandy Mayes @ Dry
designers Alison Martin @ Dry
Martin Isaac @ Dry
Wayne Jordan @ Dry
editor David Waters
publisher Mark Lesbirel
origin UK
dimensions 210 x 275 mm
8¼ x 10⅞ in

photographers 1 Mark Alesky
2 Oscar Paisley
Mark Alesky
Trevor Fulford
Phil Knott @ ESP
Niall McInerney
Rankin
Jeremy Maher
3 & 4 Phil Knott @ ESP

1

From the EDITOR

LONDON HAS SECRETS. VISITORS HAVE NO PROBLEM FINDING THE HOT WEST END PLAY, RESTAURANT OR EXHIBITION. BUT, AS ANY LONDONER KNOWS, THE TRUTH OF THIS CITY IS FAR FROM THE BRIGHT LIGHTS. ITS CENTRE IS OBSCURE. IT MAY BE FOUND IN A JUNGLE CLUB IN TOTTENHAM, A STUDIO SQUAT OFF OLD STREET, A FREE-FALL POETRY JAM ON THE ROOF OF CENTRE POINT OR A DRINKING SHABEEN IN OLD COMPTON STREET. OR, MAYBE NOT. LONDON DOES NOT WEAR ITS HEART ON ITS SLEEVE: RATHER, IT IS HIDDEN DISCREETLY IN A HALL OF MIRRORS. CODE MAGAZINE WILL UNCOVER THIS HIDDEN CITY - THE STORIES, THE PEOPLE, THE TALENT AND THE PLACES FROM WHICH OUR URBAN LIFE SPRINGS.

With music, film and art making up the core of our arts coverage with a significant nod at theatre, restaurants, technology and sport · CODE MAGAZINE GIVES YOU THE BEST OF THE SCENE RATHER THAN ATTEMPTING A BROAD SWEEP. Londoners work hard with some of the longest working hours in Europe · CODE Magazine takes a look at the best of what's out there, and shows you how to play hard too. If it's in CODE it's worth deciphering. London fashion is on the ascendant (again). Tamasin Doe's A-Z of London Fashion Week reveals the highs, and lows of a story that has not been running for 20 years but more like 45. Our profiles of new designers provides only a snapshot of the vast design talent currently working in this city. The eyes of the fashion world are on us, let's hope this new, business-trained generation of designers will finally put London centre stage where it belongs.

SO WHY PUT PHIL DANIELS AND PATSY KENSIT ON OUR LAUNCH COVER? SURE THEY ARE LONDONERS. THEY ARE ALSO COOL AND SOMEHOW SUM UP AN ATTITUDE AND A STYLE THAT IS TRULY OF THIS CITY. GRITTY YET PRECIOUS. COULD THEY REALLY HAVE COME FROM ANYWHERE ELSE? ALTHOUGH DANIELS ADMITS, "I DON'T LIKE LONDON VERY MUCH ANY MORE", LIKE MANY OF US HE ALSO CONCEDES, "BUT I MISS IT WHEN I'M AWAY". IT IS THIS PARADOX WHICH IS THE TRUE LONDON EXPERIENCE - A STRANGE LOVE/HATE AFFAIR. WE ALL SEEM TO SHARE.

WELCOME TO CODE MAGAZINE: DOWNTOWN LONDON.

DAVID WATERS

8 DECODE MARCH 16 PROFILES
21 OUTDOOR SEX 24 MUSIC
30 EXHIBITIONS 34 FILM
39 MINTY 42 FLESH
52 CRISIS LONDON 54 FASHION WEEK 60 NO LIP CHILD
66 THEATRE 68 BARS
70 RESTAURANTS 74 TECHNOLOGY
77 BOOKS 78 SPORT 80 CLUBS
81 SHOPPING 82 COLUMN

Cover: picture: mark alesky stylist: angela m. stephens hair: adam bryant for toni & guy at streeters make up: jackie hamilton-smith at camilla arthur choker by glenda daniels to order on 0181 749 5434. shirt by helmut lang £115 from browns, 23 south molten street w1.

2

Bob 1 see page 184 for credits

designer Simon Needham

designer Simon Needham

progressive design

designer Simon Dixon

regional
international
national

HUDDERSFIELD
HUDDERSFIELD

centre
median core hub apex
crux core
pivot middle
focus

A substantial investment in training technology

Established 9 years ago...
James Sommerville and Simon Ne...

Extensive apple Mac des...
publishing equipment ensures...

speedprint

Speedprint (Horsforth) Ltd 94 Kirkstall Road Leeds LS3 1LT
Tel **0113 245 3665** Fax **0113 245 3510**

designer Karl Benson

designer Simon Dixon

designer Simon Dixon

The Attik Design Limited are at the forefront in the use of design technology. Dixon... combined hardware to enhance their creative output. This combination gives Attik the edge.

Technology can influence direction or content but is no substitute for **creativity** and an **intelligent thought process.**

"Attik are more creative, with more interesting ideas than many other design agencies. Working at a distance was no problem. Now that we have opened in London it adds another dimension

"What we look for in our designers is creativity combined with an eye for detail and the ability to get on with it."

EMI RECORD
DEFINITION FO

EMI
UNITED
KINGDOM

Made in UK

Made in UK

37mm

31mm

18mm (print free area)

117.5mm (print area)

pages 182–7

Bob 1

designers all designers specified are
from The Attik Design Limited

publisher The Attik Design Limited
origin UK
dimensions 420 x 594 mm
16¹/₂ x 23³/₈ in

THE ATTIK

Europe

1995

95

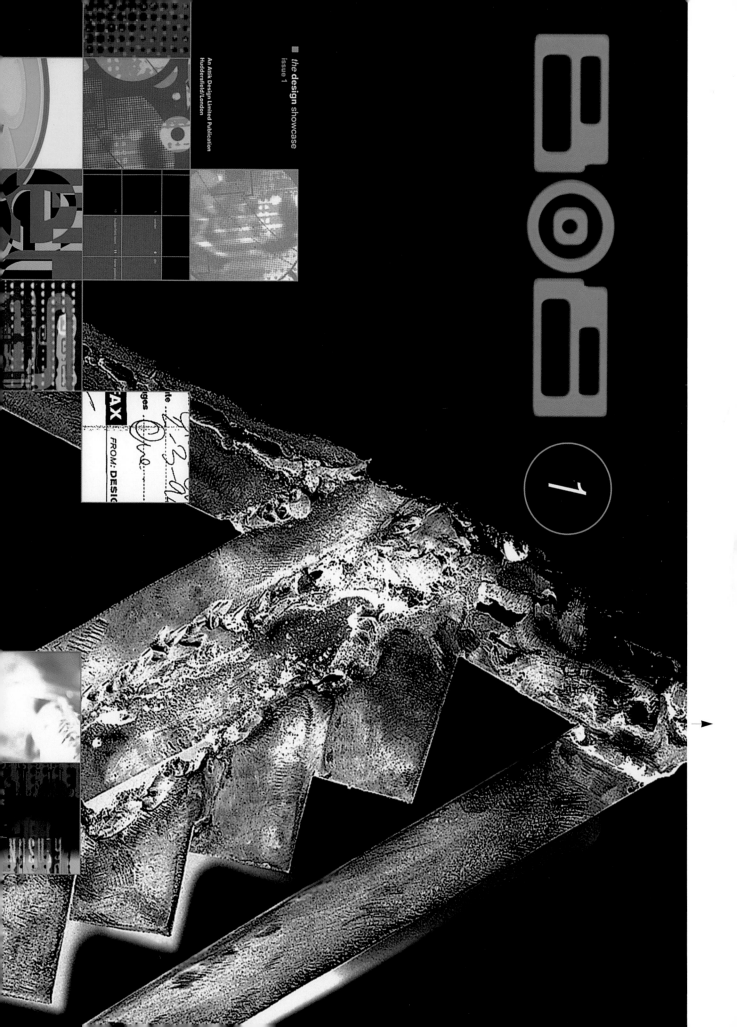

the **design** showcase
issue 1

An Attik Design Limited Publication
Huddersfield/London

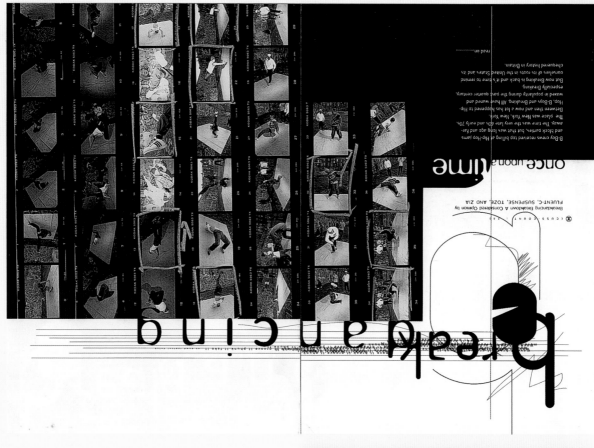

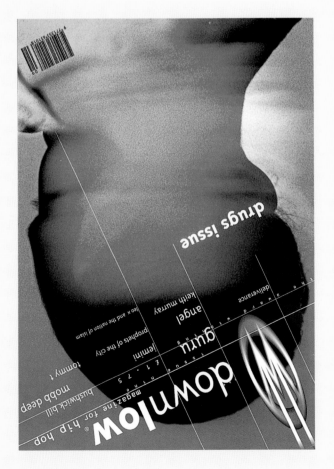

above & opposite

the downlow

designers	Mark Diaper
	Birgit Eggers
	Mike Davies
editor	Matthew Carter
origin	UK/The Netherlands
dimensions	210 x 297 mm
	8¼ x 11¾ in

above

the downlow

designers	Mark Diaper
	Domenic Lippa
editor	Matthew Carter
origin	UK
dimensions	210 x 297 mm
	8¼ x 11¾ in

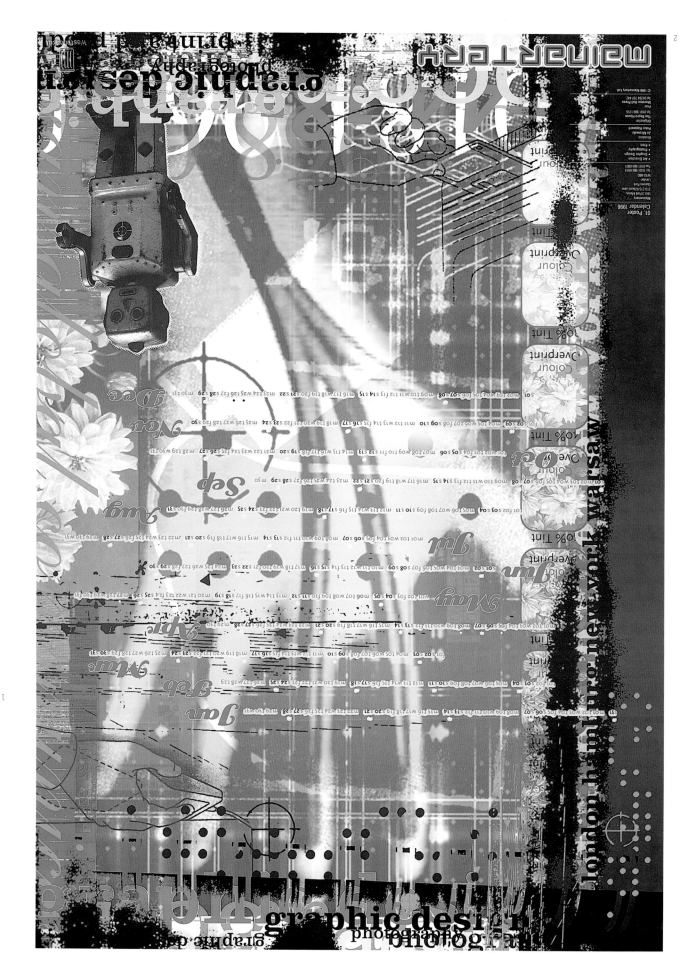

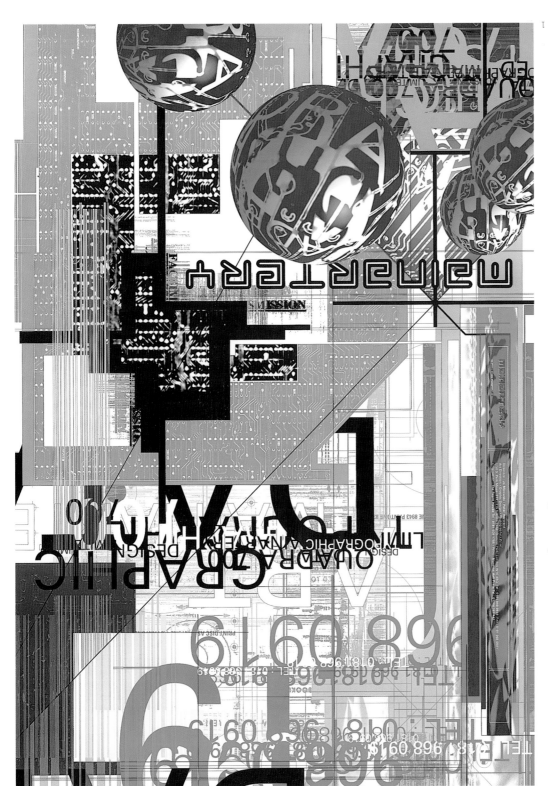

dimensions
420 x 594 mm
16¹/₂ x 23³/₈ in

origin
UK

publisher
Mainartery Ltd

designers
1 John O'Callaghan
2 Scott Minshall

art directors
1 Peter Hayward &
 John O'Callaghan
2 Peter Hayward &
 Scott Minshall

posters

Mainartery

Jungle. Probably the most popular music in the country at the moment, certainly the most fashionable. But where has it come from? Why does it sound like it does?

The dilemmas surrounding the word 'Jungle' offer the first clues. Many involved with the music don't like the term, preferring something else like Hardcore, Drum And Bass, Intelligent or Hardstep. Some don't like names at all, preferring simply to call it music. And therein lies the beginnings of an investigation. Jungle is too diverse to be defined by a single word. How many different ways are there of saying food, sex, or money? Jungle is the product of years of development and experimentation. One of its greatest achievements is that it has introduced new sounds into the musical canon such as timestretching and multi-layered sampling. Jungle has taken new musical technology to its outermost limits. Like Hip Hop ten years before it Jungle is laying down new musical rules. The music brings together a disparate set of influences into a pulsating, whirring, riotous package of sound, style, look and language but at its heart Jungle is a music, and an understanding of this will help to explain everything else. Let's rewind selector and go back to the beginnings.

THE BEGINNINGS

As the Eighties began, American hip hop emerged from the ghettos of New York and laid down the rules for the decade's musical methodology, introducing two deck mixing, sampling, drum machines and MCing as the techniques at the root of modern dance music.

Fast forward to the mid Eighties where hip hop and house are battling it out for dominance on the floors of a newly created British club scene. In a post riots, post Racial Equality legislation British society, races began to intermingle on the dance floor. UK clubs became musical accelerators where different musical forms were whirred together to create new entities. Steve 'Silk' Hurley's Jack Your Body gets played alongside Eric B & Rakim's Paid In Full and the fusions began to take place. Coldcut's cut 'n' paste anthem Say Kids What Time Is It and Bomb The Bass's Beat Dis were two of the first examples of the new musical collisions.

Soon musical alchemy became available for all. As world technology improved, broadcasting and music making equipment such as radio transmitters, samplers and drum machines became cheaper and within reach of the average wage earner. As a result the UK became a hothouse for musical research in the mid Eighties. With the seeds of development planted by the States, the UK embarked upon a new age of musical evolution.

E NUMBERS

Chief catalyst was the popularity of Acid House, its cause aided and abetted by the proliferation of pirate radio stations up and down the country pumping out the sound such as the then unlicensed Kiss FM and Starpoint FM. The illegal warehouse parties taking place every weekend in the capital including the now infamous Clink St parties near Tower Bridge served to culturalise the music, turning Acid House into a youth cult.

As Acid House blossomed, Hip Hop began to lose its grip in the UK. After early home success for British groups such as the The Cookie Crew, Overlord X and Silver Bullet, UK rap failed to consolidate this success. For whatever reasons, perhaps due in large measure to the dominance and pre-eminance of American artists within this genre UK rap artists found the crowds and the record sales weren't there. Instead, many of them moved into the booming rave scene.

In the late Eighties the Acid House scene, as it was then known, was snowballing into an immensely lucrative business. Massive parties in fields, warehouses and aircraft hangars were organised up and down the country, drawing crowds of over 10,000 and attracting interest far beyond the confines of the club crowd. In 1988 The Sun newspaper began running exposes on rave's drug and sex orgies. House music had transcended its own milieu to become a national phenomenon.

From 1988 to 1990 each British summer became an opportunity for mass partying to the various forms of House, the revelries often fueled by the drug

Elizabeth Troy

Ecstasy. The role of Ecstasy in the development of rave culture, and later Jungle, is unquantifiable, but many of those involved would claim that its influence has been significant. Aspects of the music began to reflect the drug. Listen to Baby D's first version of Euphoria or the Aphex Twin's Analogue Bubble Bath I for clear examples of E music.

ACCELERATING INTO THE NINETIES

As the euphoric Eighties rave scene faded into memory a new style emerged. The Eighties had provided the infrastructure — illegal and legal radio stations, artists, clubs, shops, fans: the Nineties made use of it.

The first change was in the tempo. Nineties House was faster and more stylistically splintered. Genres sprouted from all directions — deep house, hard house gabba, handbag, so many names in fact that names started to become irrelevant. Chief among the new breed was Nutty Hardcore and Happy House. These sounds were developed from Hard House and Techno but used hip hop breaks as their structural base, creating a rhythmically complex style different from the orderly, linear beats of House and Techno.

Many of the artists making these sounds were from the old hip hop crowd such as DJ Crystyl and Kenny Ken, resurrecting their breakbeat albums for a post-acid audience.

But hardcore had an image problem. Its cheesy samples and squeaky melodies coupled with its perceived crowd of wide boys, crack-ridden Yardies and the generally dispossessed caused many club goers to give it a wide berth.

Hardcore seemed to be popular in inner cities, particularly in London, where Labyrinth, the Dungeons and the Four Aces in Hackney and the Lazerdrome in Peckham came to be key staging posts in Jungle's development.

These were intense clubs in intense parts of London. As one ex punter remembers it: "The Dungeons wasn't much more than an old pub that had a house night but it got harder and harder and madder and madder in there and Jungle grew out of that."

The idea of socialising with the impoverished and the drugged up probably deterred many outside the genre from getting involved. This had a crucial and ultimately positive effect. For a least two years hardcore was dismissed by the trendy, the mainstream and the media as stylistically bankrupt.

Typical of this view was Touch magazine's only half humorous definition of the scene — "Jungle: inept mishmash of samples at triple speed to produce an insanely hardcore dog's breakfast. Social milieu: Children. Crack heads. People bored of listening to reggae."

THE LOST YEARS

In retrospect the music's isolation did it no harm. It caused a scene to become self-reliant and to appreciate itself. As Hardcore mutated into Drum & Bass an entire musical infrastructure grew up around it, from artists such as Lennie De Ice and DJ Crystyl, record labels such as Reinforced, Moving Shadow and Looking Good, DJs such as Grooverider, Hype and Fabio, retail shops like Blackmarket, Boogie Times and Unity, radio stations such as Fantasy and Kool FM, MCs like Det and Navigator, and a multitude of entrepreneurs, designers, promoters and club venues.

While Jungle's independent infrastructure allowed the scene to continue and develop, occasional Hardcore tunes were still able to break out of their cultural confines and crack the national charts. Xpansions' Elevation, The Prodigy's Charlie Said, A Funki Dred's Total Confusion, Unique 3's The Theme and Liquid's Sweet Harmony all thrust Hardcore into the mainstream. Despite being derided, the music was able to keep a toe hold in the field of popular music.

During this period of outcast, Hardcore underwent a sonic refit. Perhaps to satisfy the ever changing aesthetic demands of their crowds or perhaps in response to the sneers of outsiders, Jungle producers developed breakbeat science.

Using new and improved technology, such as the Atari computer and its software partner the Cubase programme, producers cultivated compressed and layered drum sounds, timestretching, embossed loops, warped and bent basslines, devised poly rhythms and created a hyper real new musical language. (Refer to Tech by Tech article)

This upward gear change in studio skill paralleled a move into musicality. While Hardcore and Drum And Bass had been about beats and boisterousness, the newly developing Jungle began to dress its splattercast rhythms with veils of Jazz-derived melodies. LTJ Bukem's The Dolphin Tune, Roni Size's 1994 classic Music Box and Goldie's Timeless all ushered in a new style of Jungle that quelled some of hardcore's ferocity with sonic seduction. Some called it Ambient jungle, others called it Intelligent.

JOURNEY INTO THE LIGHT

As a result of this new musicality Jungle began attracting more and more attention from outside its scenes in 1994 and 1995. Non aficionados began discovering the music and finding that it represented more than mere drug driven noise. Non Jungle artists, ravers and the media began to realise that Jungle was the first dance music that Britain had ever created itself. Using a mix of Ragga's rude boy stance, Hip Hop's breakbeat bombasticity and House's energy, Britain's musical untouchables had created something entirely new and delicous.

In 1994 and 1995 Jungle experienced unprecedented levels of cultural credibility and good press. The Face and The Guardian ran features on Jungle. So did the NME, the Sunday Times and Vogue. Radio One gave the music its own show (see One In The Jungle article overleaf), as did Kiss FM in London and Manchester and Choice FM in London and Birmingham. Jungle had broken out of its narrow, and in the case of radio, illegal outlets, to become an alternative national anthem.

Dom Phillips, editor of dance music magazine Mixmag, has his own theory as to why Jungle began receiving massive amounts of media.

"It's a good story," says Phillips. "And it's been a long time in dance music since there's been a good story. Boys with ponytails making House music in their bedroom was never very interesting to the Guardian and The Face. With Jungle they've got something they can read social and political angles into. There's the black aspect, the inner city aspect — it's a whole cultural package."

Shy FX

One of the contentious points within Drum And Bass is whether it can be termed a black music, as Hip Hop, R&B, and Reggae often are. There is a view that is was the injection of a black aesthetic, principally bass and complex drum breaks, into House that created Jungle and made it a music able to appeal to a wide cross section of people.

As Two Fingers and James T Kirk write in their underrated text Junglists (Backstreet 1994) " ... My friends would drag me to rave after rave and I'd stand up and screw my face, until they played two little tunes with a Ragga sound and I'd jump up with the sound until it disappeared. Then Hardcore went underground and evolved into Jungle." This injection hypothesis is not an easily proved theory A quick snapshot of jungle artists would show that many are white, including Alex Reece, Aphrodite, Danny Breaks and Photek. This leads onto the debate—that has characterised the sound of Drum & Bass throughout 1995 — Intelligent vs Ragga. The debate was brought into the open when General Levy's Incredible and Shy FX's and UK Apachi's Original Nuttah broke Jungle into the national charts with a salvo of Ragga Jungle. To many within Jungle these chart hits gave the public the impression that Jungle was a Ragga sound, and in response the term Intelligent was coined in an attempt to communicate the music's complexity.

Intelligent Drum And Bass is a term used to describe ambient melodic jungle produced by the likes of LTJ-Bukem and Alex Reece. Ragga, or 'Ardcore stands for something ruffer, more raw. For some the debate has a sinister overtone, with the suggestion that Intelligent represents whiteness and Ragga blackness. It can't be denied that crowds at popular Intelligent nights such as Bukem's Speed and the Metalheadz Sessions at the Blue Note in the capital have an ethnically diverse crowd while the Lazerdrome in Peckham continues to draw a largely black crowd.

As the editor of Mixmag observes: "A lot of the indie press have really got into people like LTJ Bukem and the ambient side," he says "and so have the indie and techno crowds."

Goldie

THE PRESENT TENSE

There's no doubt about it. Jungle's crowd is beginning to change. And as the music slips further into the mainstream it faces the challenge of all underground cultures when co-opted into wider society. Will it lose its original followers and whither and die once the mainstream has used it up? Or will it remain true to its original concepts and retain its original fan base?

In response to these problems the underground seems to be re-asserting itself and pulling away from Public Jungle. 4 Hero don't call their music Jungle anymore but "Krumble", T Power calls his "electronic, ambient jazz" while Grooverider terms his as "Hardstep".

As Jungle enters a phase of cultural crisis, with artists and fans unsure about who the music is for, we can find solid ground in looking at what the music has achieved. Perhaps Jungle's greatest triumph is to prove that undiluted music can exist and excel without having to compromise its sound. Labels such as Sour, Renegade, Moving Shadow and Suburban Base are operating successfully and independently, while artists like Goldie. Fabio and Alex Reece have become cultural icons appearing on everything from magazine covers to TV chat shows.

But at the bottom of all the hype and dressing Jungle is a music, and it's here that we can see Jungle's progress best of all. Many of the Jungle sounds such as timestretching are now spreading back out into immediate relatives such as House, Ragga and Trip Hop, and even further into sections of indie music. BBC's recent series The Sunday Show had a Jungle theme tune and several recent advertisements have made use of the sound. In the clubs, on the radio, on your screen, Jungle is shaking up the country.

EDITORIAL.

From time zero to this present period of existence, creative geniuses have inspired humankind to deeper levels of consciousness. The boundaries of current understanding are always being challenged in order to reach a more ture reality and perfect expression. No greater manifestation of this quest can be found than that expressed by Black SuperCulture.

Black SuperStyle, through its music and culture, has long been at the forefront of creative expression. Whatever the medium is; dress, language, rhythm, text, technology, you see, feel and hear the energy. It's inherent within jazz, soul, reggae, gospel, funk, hip-hop, jungle... Black SuperCulture is the style gateway through which cultural synthesis occurs.

Over the past months many have expressed their desire for a network which not only explored and celebrated the SuperCulture of the Black, but also did so in a manner reflective of its innovative nature. From a series of Mind-Melts with Nu Guru and The Young Wonderfuls in conjunction with the Cultural Taskforce, the concept of Playground was freaked and distilled.

Playground Music Network finally has been born, and it plans to celebrate the creators of black musical culture and the innovators of SuperBlack style, whilst mapping its global impact. It's open to individuals and organisations engaged in different aspects of the music industry, so whether you're a musician, vocalist, lawyer, retailer, DJ... you name it, you're welcome. We'll be exploring current Black musical formats and encouraging the genesis of new ones.

Playground will include introspectives of SuperBlack styles, reviews of contemporary artists and musicians, as well as the future macros of the music and entertainment world. There's gonna be a balance between the creative side of music with practical advice to those who wish to enter the music industry. A key feature will be a special bulletin board allowing members to link up with others into Black music.

To start things off there's a special feature on Jungle. You'll see the interplay between artists, DJ's, producers, radio stations and record companies, and checks out how this combination has given birth to a new genre. Also, there's an overview of how major record companies work, a guide to publishing and a review of technological change in the music industry.

For those who are tripping out or up on the meaning of the words and excluding themselves or others because they feel the Black is Wack, you gotta know that this network is for all races, creeds, genders.

Finally, special shouts to you members of Playground we want to incorporate your experience, opinions - your letters and articles are welcomed. Remember Playground is interactive so send your own messages, comments and details of your services. I'm sure your gonna enjoy the ride throughout the year ahead.

Rick Slick

SHOUTS.

X-amount of respects to the Nu Guru and Young Wonderfuls, Mind-Melt, Automatic, 'Inna dis ya Generation', Casual and Anon for the systematic revelation. Crazy thanks to the Visual Innovation Unit, the Cultural Taskforce, Nation of the Nubian posse, The Committee - da original rudeboys, Jal - the Original One, Dubplate, Suburban Base, Metalheadz, Reinforce, Moving Shadow, Frontline, SOUR and Phuture Trax. All those in Space Continuum and those who travelled at warp speed to produce this issue nuff blessings and light. For all those who are still trying to crack the code remember X= $0.38 + Y$< still holds true. Brothers is slick, sisters across the river, step with pride just like Des'ree sang. Special shouts to all British and international musicians, promoters, DJ's, venues, radio stations, journalists, artists and intellectuals who boom the Black - particularly all the drum and bass massive. Big up to Moss-side, Hackney, Brixton, Handsworth, Peckham, Notting Hill, Chapeltown, Tottenham, St Paul's, Toxteth....

UNGLE.

Cumin' at ya.

The next issue is going to be a special focus on Reggae music. There's gonna be pure vibes in the place as we explore its origin and development, capturing the energy of ragga, dancehall and sound systems. Its gonna be the absolute lick, truss me! On the music business side of things, there's practical advice on how the music industry works and key industrial bodies.

Watch for Jazz, Soul, Hip-Hop, Gospel, Funk... issues coming soon.

Look out for the forthcoming music seminar programme, SPEAKOLOGY planned in association with the Black Music Academy. These seminars will be full of info and inspiration for beginners and others on their way through the music maze. It's a forum to discuss and comment on developments in music culture and its various genres, so make sure you check out the Rap, Soul, Reggae, Jazz and Jungle Schools. Starting May '96.

PLAYGROUND

Black music, culture and superstyle.

THIS IS J

May/June 1996

#01.

Playground is circulated free to all members of Playground six times a year.

Network 12 The Circle, Queen Elizabeth Street, London SE1 2JE Telephone 0171 403 1991 Facsimile 0171 403 1992 E-Mail 100617.1423@compuserve.com

Managing Editor Richard Johnson aka Rick Slick **Comissioning Editor** Jake Barnes **Design** Automatic **Photography** Des Willie **Words + Knowledge** The Young Wonderfuls: Lyndon Anderson, Sandie Duncan, Kathleen Henriques, Grace Mattaka aka Spacechild, Tracey Roseman, Vanessa Richards aka Butterfly, Jaison Mclaren - the Original One, Diana Hughes, Kerys Nathan.

The views expressed are not necessary the opinions of Playground. No liability will be accepted for any errors which may occur. Letters, articles and images are welcomed. These will become the property of Playground. Text may be edited for length and clarity. No responsibility will be accepted for unsolicited material. Information from Playground cannot be reproduced in any form, without the written consent of the publisher. Copyright © 1996. Published for Playground Music Network 12 The Circle, Queen Elizabeth Street, London SE1 2JE.

CONTENTS

#01. Digital Defiance - The History of Jungle
#02. The Metalheadz Sessions
#03. Reinforce Records
#04. One in The Jungle - Brian Belle-Fortune
#05. What Do U Think?
#06. SOUR
#07. How A Major Record Company Works
#08. A&R
#09. Publishing
#10. Tech by Tech - A Brief Summary of Technological Change in The Music Industry.

#BULLETIN BOARD. The FREE resource for Playground members wanting to contact other Playground Members. You may want to sell records and/or music equipment, find a new band members or form a fan club.

We're sorry but we can't accept trade ads.

Complete the coupon included in CAPITAL letters, restricting your insertion to maximum of 24 words. Mail to Playground at 12 The Circle, Queen Elizabeth Street SE1 2JE or E-mail us at 100617.1423@compuserve.com. We're sorry but Playground Classified enquiries can't be taken over the telephone. Ads are included on a first come, first served basis. The ads will be included in the next bulletin and the Internet.

Advertising
For advertising, sponsorship and collaborations phone 0171 403 1991.

Want to Join Playground?
To join Playground Music Network simply ring 0171 403 1991 or fax 0171 403 1992 and ask for an application form!

Insidetrack

magazine for Sony Playstation

art directors Neville Brody
designer Tom Hingston @ Research Studios
 Tom Hingston @ Research Studios
Design
editor Graeme Kidd
publisher Bastion Publishing
origin UK
dimensions 297 x 210 mm
 11¾ x 8¼ in

Playground

designers Martin Carty @ Automatic
 Ben Tibbs @ Automatic
photographer Des Willie
editors Jake Barnes
 Richard Johnson
publisher Playground Music Network
origin UK
dimensions 210 x 297 mm (folded)
 8¼ x 11¾ in

PORTFOLIO I – P11

In this first section of our pull-out guide to PlayStation titles, Steve Jarratt, the editor of the UK's official PlayStation magazine, gives a personal view of the games that are just over the horizon. With some ten years' experience as a games journalist, and editorial credits including Edge magazine under his belt, Steve is a leading commentator on the prospects of PlayStation gaming.

PORTFOLIO III –

A quick reminder of the ex... PlayStation titles that were available at launch... PlayStation has already kno... charts for CD-ROM software... PC off the top slot in the UK... been hard to keep up with... for these first-wave titles. D... the chance to make more sa...

PORTFOLIO II – P13

A run-down on the second wave of PlayStation titles, 39 games due out by mid December. It's clear that PlayStation is much more than clever hardware – it will have the Killer Portfolio of titles by Christmas. Including Mortal Kombat 3, exclusive to second-generation console, and titles such as Destruction Derby and Tekken that will revolutionise game playing in the home...

Media Blitz – P8

The inside story on the SAPS TV ad campaign. We take you behind the scenes of the £25,000 commercial shoot at Shepperton Studios, reveal the creative thinking at Simons Palmer that underpins the ground-breaking adverts and explain how leading pan European agency Ogilvy and Mather are turning a £12 million spend into £3 million value. By Christmas, 85 per cent of these target audiences will be aware of PlayStation. Which is bound to be good for sales!

Inside Info – P4

Across Europe, PlayStation's launch has won acclaim from all sectors of the trade – from specialist magazines through to mainstream media. From wholesalers to retail outlets. Games and PlayStation hardware have sold in droves... and the demand is still building. Check out our run-down of the main events around the launch and discover what independent commentators have to say.

PLUS

Hot news on a ground-breaking game under development in SCEE.

Close That Sale – P7

A handy guide to selling the power of PlayStation against other late-lustre console systems... We provide the answers to questions that customers ask most frequently about PlayStation.

PLUS

Ten Reasons why PlayStation is The Smart Choice. Never be stuck for an answer when you are asked whether PlayStation is the best.

2

THE POWER OF PLAYSTATION

INSIDETRACK ISSUE 1

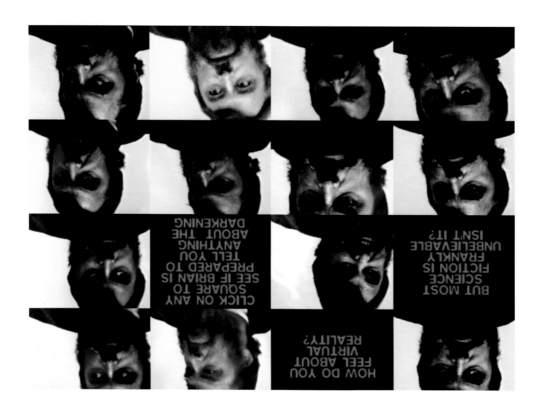

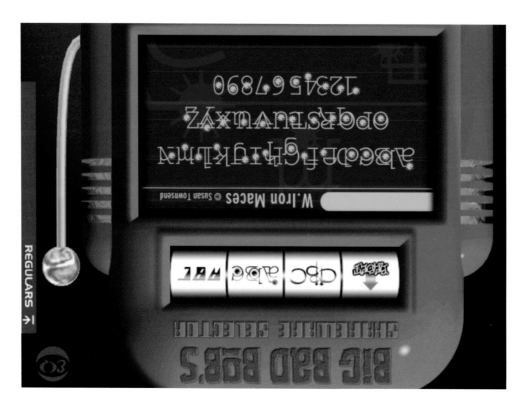

EQ see page 170 for credits

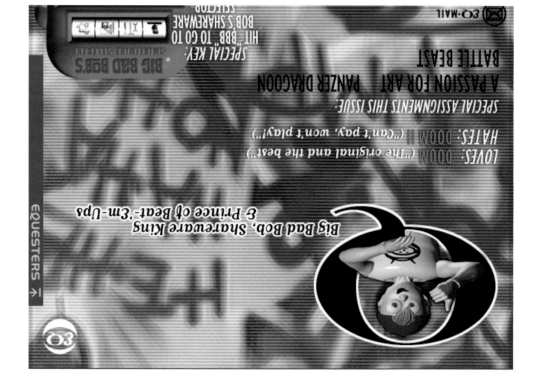

pages 170-73

EQ

CD magazine

art director Rob Bevan
designers Robert Corradi
Howard Dean
Rick Nath
photographer/ Lee Robinson
illustrator
editors Tim Wright
Laurie King
publisher NoHo Digital
origin UK

170

© 1995 NOHO DIGITAL & DENNIS PUBLISHING
ALL RIGHTS RESERVED
ALL MATERIAL ON THIS DISC REMAINS
THE PROPERTY OF ITS RESPECTIVE OWNERS

NoHo Digital Ltd	6 Hanway Place London W1P 9DH	Telephone	+44 0171 916 3575
		Facsimile	+44 0171 916 3576
Registered Office	17 Tottenham Court Road	Internet	noho.co.uk
	London W1P 9OP	AppleLink	NoHo
	Registration No. 2925983		

above

NoHo Digital

letterhead

art director Rob Bevan
designer David Hurren
publisher NoHo Digital
origin UK
dimensions 210 x 148 mm (folded)
8¹/₄ x 5⁵/₈ in

nation

8 past visions views of the near future from the past

10 interacton interactive on-screen entertainment

12 hex matt black gets into the future

14 drugs the legacy of ecstasy; future drugs glossary

20 quiz find out how futured-up you really a

hion a print-out of a post-2000 shoot

achines; the death of cd

32 society normal service will not be resumed

34 glossary words and phrases

get

"what do you want?"

you're
not going to
inform
it t

26 28 30
27
music
technol
what does the fu

...ern the answer to all our communication pr

Intro to 'The Prisoner', cult 60s TV seri

→ PREPARE FOR
→ THE FUTURE
GET READY

editors
Christopher Mellor and Claire
Morgan-Jones

design and art direction
Michele Allardyce

assistant editor and sub
Lindsey McWhinnie

contributors
Andy Crysell, Paul Davies,
Chris Everard, Sam King, Ian
Peel, Steve Pitman, Ronnie
Randall, Helene Stokes,
David Thompson, Phil
Wolstenholme

2000 free with DJ Magazine
issue 142
Spock says "Insufficient facts
invite danger" (so read it)

technology

You think vinyl's had its day? CD's on the way out too, baby!

Astrophysics Research Corporation

Mind Body Spirit

X-RAY ZOOM POWER

CAUTION

GOD BOX

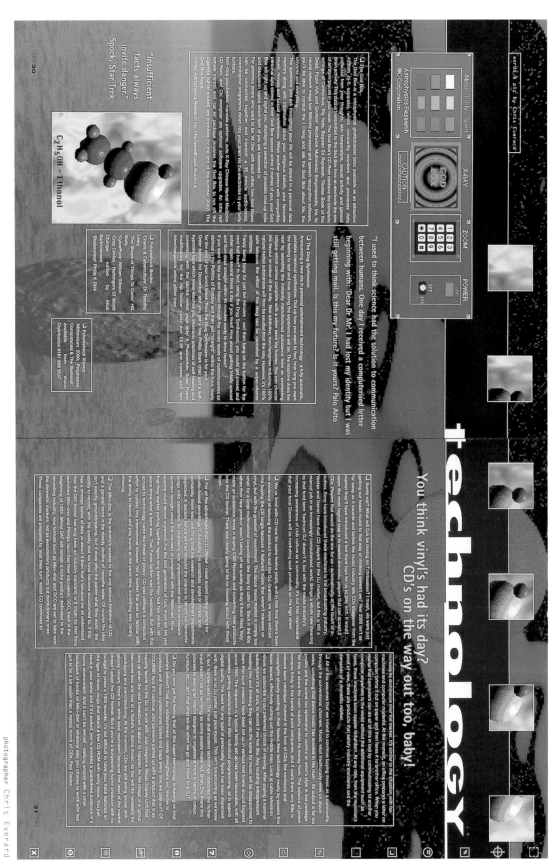

C_2H_5OH – Ethanol

"I used to think science had the solution to communication between humans. One day I received a computerised letter beginning with: 'Dear Dr. Mr. I had lost my identity but I was still getting my mail. Is this my future? Is it yours? Palo Alto

"Insufficient facts always invite danger."
Spock, Star Trek

30

31

pages 166-9

2000

supplement of DJ Magazine

art director Michèle Allardyce
designer Michèle Allardyce

editors Christopher Mellor
Claire Morgan-Jones
publisher Nexus Media Ltd
origin UK
dimensions 230 x 300 mm
9 x 11⅞ in

photographer Modified, Hex

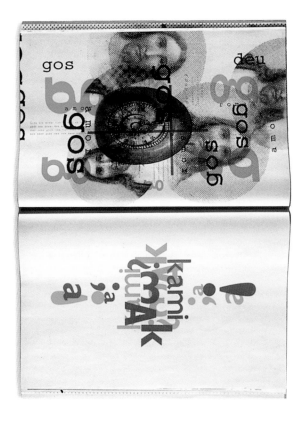

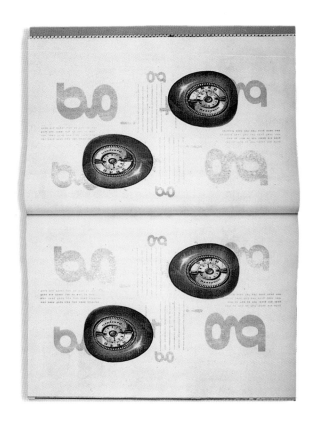

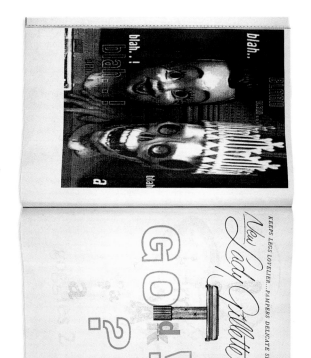

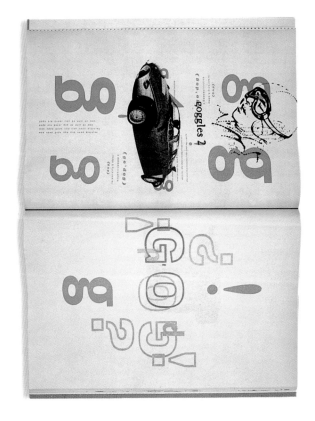

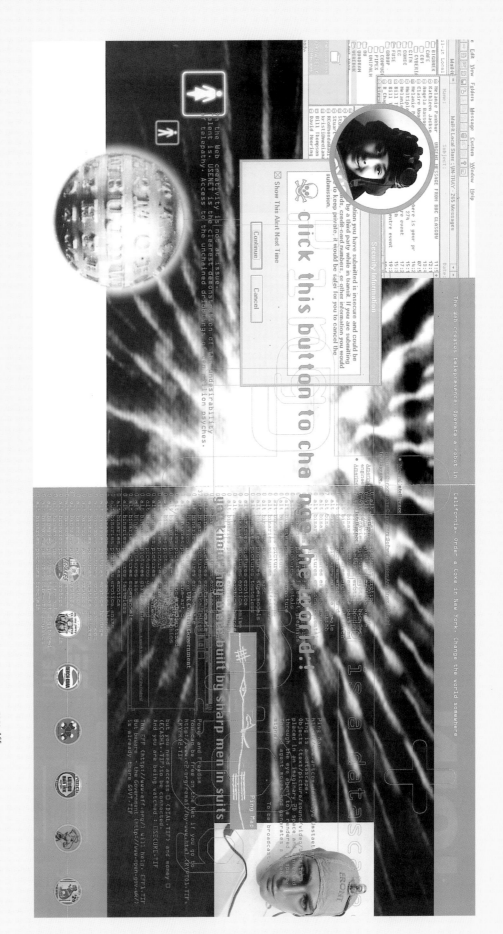

page 164

Creative Review

art director	Seán O'Mara
designer	Seán O'Mara
photographer	Seán O'Mara
illustrators	Seán O'Mara
	Roland de Villiers
editor	Louis Blackwell
publisher	Centaur Communications/Creative Review
origin	UK
dimensions	267 x 275 mm
	10½ x 10⅞ in

page 165

Blah Blah Blah 1995

a short-run magazine

art director	Seán O'Mara
designer	Seán O'Mara
photographer	Seán O'Mara
illustrator	Seán O'Mara
editor	Seán O'Mara
publisher	self-published with the aid of
	Central Saint Martin's College
	of Art and Design
origin	UK
dimensions	295 x 420 mm
	11⅝ x 16½ in

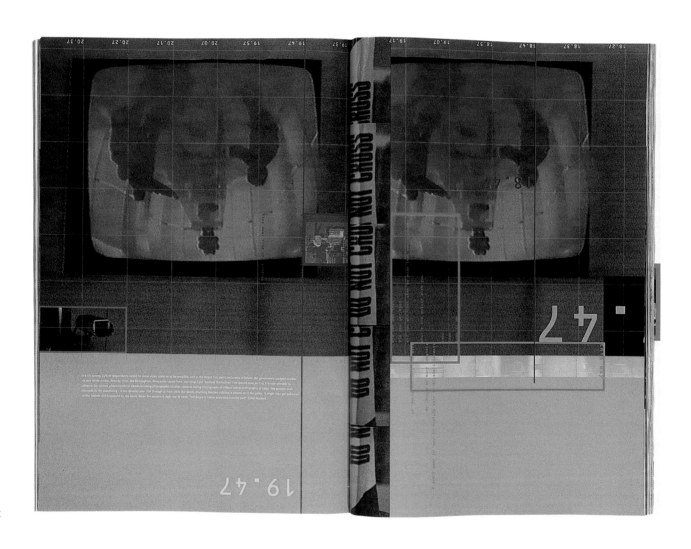

In a UK survey, 74% of respondents opted for more video cameras to be installed, and at the recent Tory party conference in Britain, the government pledged another 10,000 to the nation. Already, cities like Birmingham, Newcastle-Upon-Tyne, and Kings Lynn 'saviour themselves' from ground level. It is now possible to observe the curious phenomenon of cineastes taking photographs of video cameras taking photographs of cities. The process even proceeds to the processing – if you develop your film through a chain store like Boots, anything deemed dubious is passed on to the police. It might then get published in the papers and shown on the news. When the present is right out of hand, "the future is better protected from the past" (Chris Marker).

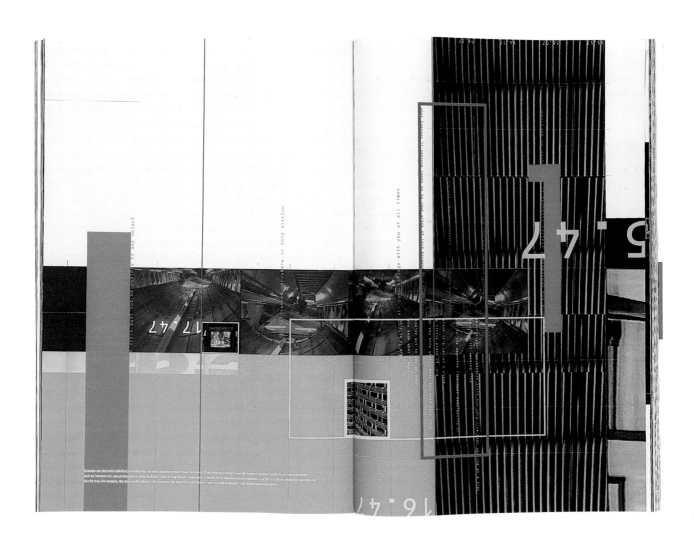

Cameras can deal with individual deviation but not with collective attack. 'Block behaviour, if not criminal activity, forms the basis of so many social rituals and ceremonies such as 'sweeteners', sexual encounters, drug deals etc. Crime is map-woven. Oppression is the fuel. If the situation seems hopeless, it is, but in a binary world the opposite can also be true. For example, the more multicultural a city becomes, the more that subcultures – and not multitudinous – will define urban experience.

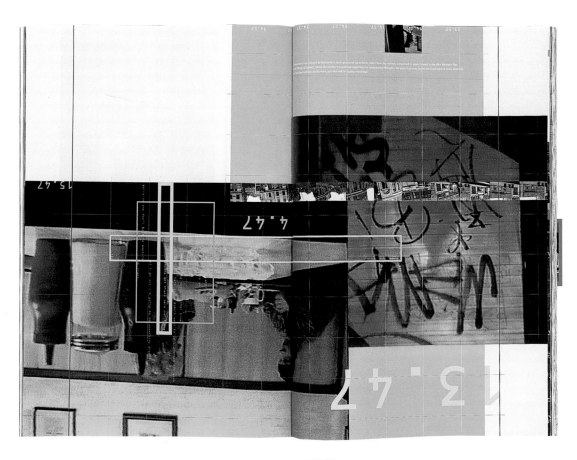

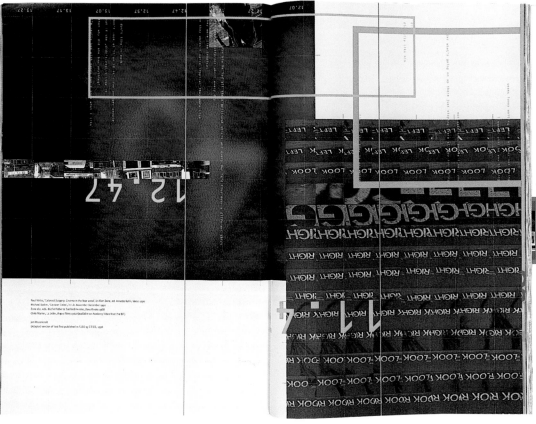

Paul Virilio, "Cataract Surgery: Cinema in the Year 2000", in Allen Zone, ed. Annette Kuhn, Verso 1990

Michael Sorkin, "Canteen Cities", in I.D. November/December 1992

Zone #1/2, eds. Michel Feher & Sanford Kwinter, Zone Books 1988

Chris Marker, La Jetée, Argos Films 1962 (available on Academy Video from the BFI)

Jon Wozencroft
(Adapted version of text first published in FUSE 15 C.T.EE, 1996)

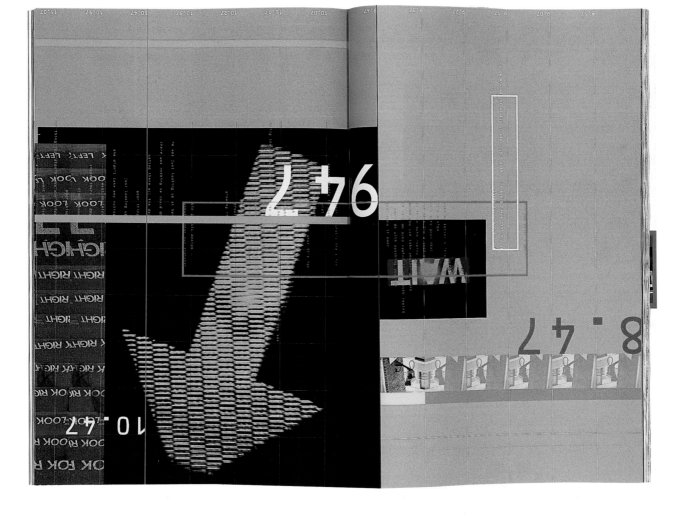

9½ x 13⅛ in
235 x 335 mm dimensions
UK/Germany origin
Max Magazine, Germany publisher
Tom Hingston
Alyson Waller
Robert Kirk-Wilkinson photographers
Simon Staines @ Research Studios
Tom Hingston @ Research Studios
Alyson Waller @ Research Studios
Robert Kirk-Wilkinson @ Research Studios designers
Simon Staines @ Research Studios
Tom Hingston @ Research Studios
Alyson Waller @ Research Studios
Robert Kirk-Wilkinson @ Research Studios art directors

Max

pages 160-63

WATERWORLD

To Bring You My Love," Harvey says of her agonies and ecstasies. "That's one reason I chose the cover photo. It looks like I could either be dead or joyous in that water."

While Harvey's earlier work (Dry, Rid of Me) fixed full-frontal ammo, her new stuff seems to stem from a deeper place within, from the core of her spirituality and sexuality. Harvey's spiritual streak is perhaps what has garnered To Bring You My Love many gospel and blues comparisons. She cries out to Jesus on practically every song. Of course, there's something every simply says (in a polite, wispy chirp) "Somehow, there's a real faith there."

Maybe PJ Harvey's natural environment (the sprawling, sparsely-populated English countryside) drove her to write writhing tunes like "redo." Or maybe she wrote the material under the guise of the "anti-Polly."

"Singing should not be too concerned with technique," her sweet voice warns. "It should be quite vulnerable, actually."

Polly Jean adds that the singers she admires most (her favorites are John Lee Hooker, Johnny Cash, Nick Cave, and Neil Young) all have some sort of off-kilter fragility and a potent, perhaps overlooked sensuality about them. Harvey's beloved wanderers who can tell the saddest story are men in black, highwaymen, lone self. "Singing should not be..."

"My favorite singers," she says, "are people who sometimes sing off-key. I'm very wary of vocal acrobatics. Raw emotion is the most important thing to me."

Kristi York

chocolate
Blue
Persuasion

Michael Moses

It seems that the Mars company has decided to discontinue making the ecru-tinted ones, a color which has been part of the blues in at least one khaki fan, since 1949. The move has given rise to the blues in at least one khaki fan, a New York journalist who commented on the decision by writing, "Why sacrifice an institution for something that basically looks like Smurf shit?"

Eric Broome

THIS BOY'S TOO YOUNG TO BE STRUMMIN' THE BLUES

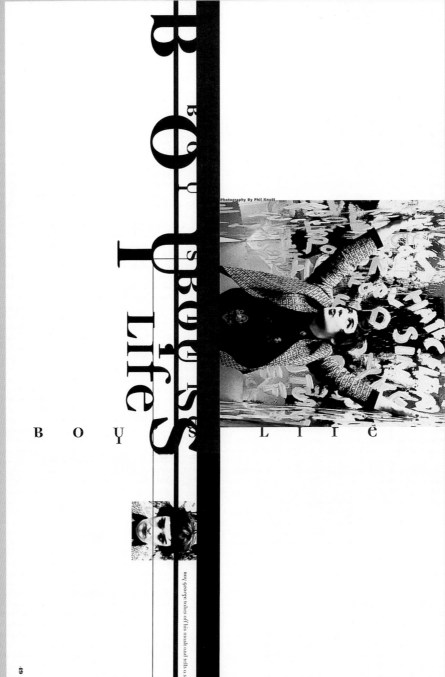

BOY'S LIFE

BOY'S LIFE

BOY'S LIFE

BOY LIFE

BOY LIFE

Photography By Phil Knott

Boy George takes off his mask and tells a survivor's tale. Aidin Vaziri stops, looks, and listens.

158

"I don't think we're a heavy metal band, I think AC/DC's one of the only bands left that are playing rock & roll. that are playing rock & roll music."

photographer Michael Halsband

AC/DC continues on p.60

pages 156-9

huH

art director Jerôme Curchod
designer Scott Denton-Cardew
editor Mark Blackwell
publishers Marvin Scott Jarrett/
Ray Gun Publishing

origin USA
dimensions 254 x 254 mm
10 x 10 in

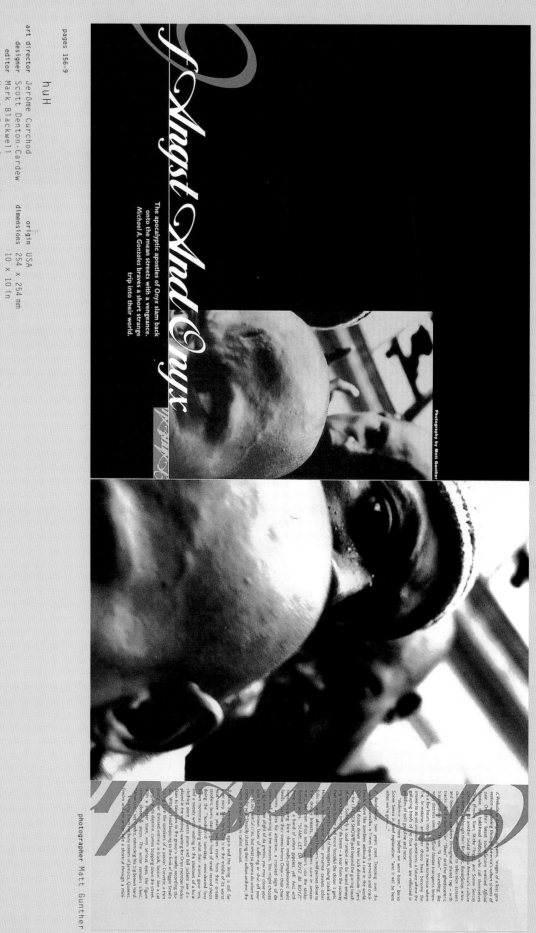

Angst And Onyx

The apocalyptic apostles of Onyx slam back
onto the mean streets with a vengeance.
Michael A. Gonzales braves a short strange
trip into their world.

Photography by Matt Gunther

huH
creative director Vaughan Oliver @ V23
designers Chris Bigg @ V23
photographers Kees Hubers, Matt Gunther, Dominic Davies
editor Mark Blackwell
publishers Marvin Scott Jarrett/ Ray Gun Publishing
origin USA
dimensions 254 x 254 mm
10 x 10 in

huH
creative director Vaughan Oliver @ V23
designer Jerôme Curchod
photographer Michael Muller
illustrator Chris Bigg @ V23
editor Mark Blackwell
publishers Marvin Scott Jarrett/ Ray Gun Publishing
origin USA
dimensions 254 x 254 mm
10 x 10 in

huH

creative director Vaughan Oliver @ V23
designer Timothy O'Donnell
photographer William Hanes
illustrator Timothy O'Donnell
editor Mark Blackwell
publishers Marvin Scott Jarrett/
Ray Gun Publishing
origin USA
dimensions 254 x 254 mm
10 x 10 in

huH

creative director Vaughan Oliver @ V23
art director Jérôme Curchod
photographer Alison Dyer
illustrator Dominic Davies
editor Mark Blackwell
publishers Marvin Scott Jarrett/
Ray Gun Publishing
origin USA
dimensions 254 x 254 mm
10 x 10 in

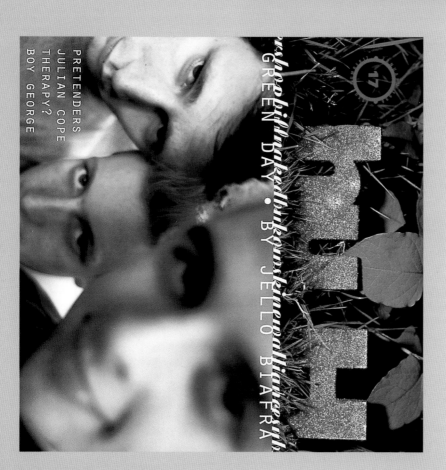

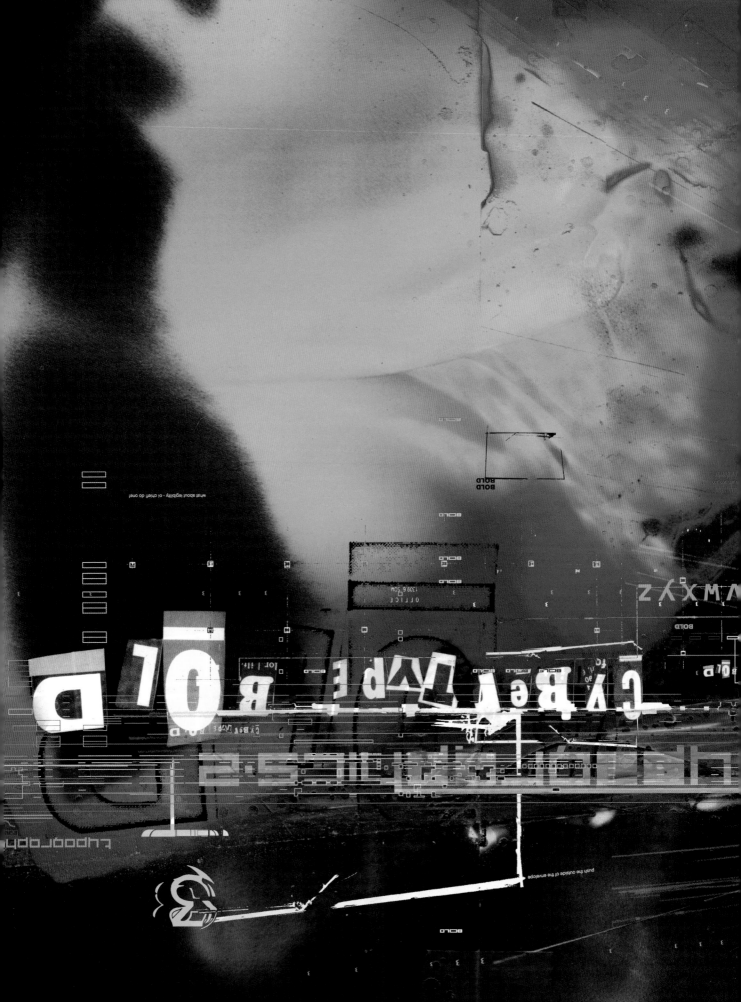

based on an original photograph by peter heaton

BOLD
BOLD
BOLD
BOLD
BOLD

day
their wa
what they e
They can have
of wine

abcdefghijklmnopqrs

cyberbabe bold

font and image
mash it up and bash it out

3
333
333
3

BOLD BOLD BOLD BOLD BOLD BOLD BOLD BOLD BOLD

alpha sec

but I can't read it

SECTION

cyberty bold

content

author **creator** provider
reader receiver **interpreter**

Authors make their decisions as to what they emphasise or what they leave out.
They reflect their own view of reality, a selection of the information they know.
Readers expand the message again with their own imagination.

The content of the book doesn't fully exist until it is read and put into context by the reader:
each reader has individual experiences to relate to the author's initial intended message.

The book is about taking you from beginning to end, but the author/artist decides where these are and the nature of the journey in between.

The author and the reader could preside on a more interactive platform if the page of a book could be manipulated. The page could be reconstructed according to the conscious reactions and responses of the reader. If it would bring the author and reader closer together the original text is left pared by the author, only now the reader is free to mix, edit, cut together and reconstruct for him/herself. As the reader is given various lumps of text to play with, choice becomes a key aspect in the manipulation process. A bombardment of choice, akin to such publications as shopping catalogues, creates a hunt for diverse story levels and possibly provides a long visual image structure. This 'invisible' page can cut and imagery colliding deliberately and unexpectedly, it is possible to create new sentences, statements and stories. These conjure up strange mental environments that are akin to a multitude interpretation.

Since our interpretations are always other than language by which they are construed, a space is constantly exists between the vehicle (verbal or cognition) and the meanings (or objects) interpreted from it. This gap, which can not be a remedy, is a space in which different interpretation can be played out.

Is meaning located in the mind of the interpreter or are they ways in which we can validate interpretation? Is it possible to discover the original meanings of a written text?

printed word: **sign**

concept: **signified**

transition:

abstract oral written

semiotics

form

object container carrier vessel object

sequences/fragments

environmental space

spatial alteration

culture

oral literal television

cathode ray page

Within the medium of the book you can physically see and re-see the journey of the narrative, re-assessing, re-analysing - as opposed to the non-permanence of television.

appearing without reply passive acceptance ephemeral

Culture, in a still larger sense, is said to predetermine the forms and limits of all realities in our world (at any given time).

F.R. Leavis juxtaposed the worlds of 'Mass Civilisation and Minority Culture' (the title of his 1930 pamphlet) and sought a way to moral and cultural health through the literary traditions of the latter. These were preferred to the corrupt and corrupting business of daily life in an advanced industrial culture with its emphasis on the machine, communication, advertising, the new electronic communications systems and the best-seller.

[It is] difficult to make absolute hierarchical distinctions between 'high' and 'low' forms consist in the same works. The new mode of mystery stories and 'who-dun-its' by nineteenth century novelists like Dickens would be an example from English writing, as would Emily Brontë's use of gothic and popular romance conventions in Wuthering Heights.

love

The intention of my project is to make a distinction between the way we read novels and the way we read other types of information. The novel operates on many different levels that our imagination/subconscious picks up on, the reading becomes a very personal experience.
In the novel the stream of subconscious thought is interrupted through out the book by commercial breaks. I have bound editorial adverts into the book. Each advert crudely relates to the text either side of it.
At a glance the ads are easier to read because they are visually more powerful and require less concentration. The ads impose a certain language onto you just as they impose themselves onto you and the book.

Could the story be told just from looking at the ads? Do the ads impose the wrong ideas about the book? Do the ads devalue the book?

Junk

Information bombardment - no time for the viewer to relate and assimilate what's being sent out to them.

audience low culture high culture

Books are products of the culture in which they were created. To fully understand the context of the content, one must have some understanding of that culture.

target **market**

author creator/provider
reader receiver/consumer

mass reproduction does not necessarily mean mass communication

One needs to understand the language and the social culture used to be able to comprehend the narrative.

As a society alters over time, the original message of a text may be misinterpreted because there is a danger of projecting back contemporary views and attitudes.

An audience can be targeted through the manipulation of content, cover and marketing.

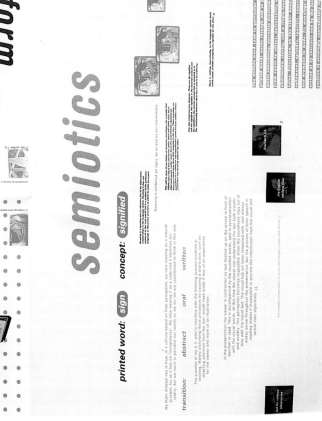

pages 150-51

form

designers Martin Carty @ Automatic
 Ben Tibbs @ Automatic
photographers/ Martin Carty @ Automatic
illustrators Ben Tibbs @ Automatic
editors Martin Carty @ Automatic
 Ben Tibbs @ Automatic
contributors Graphic Design Department,
 School of Communication Design,
 Royal College of Art, 1994
publisher self-published
origin UK
dimensions 210 x 148 mm (when folded)
 8¼ x 5⅞ in

"Say Cockney five shooter. We bus'gun

Cockney say tea leaf. We just say sticks man

You know dem have a wedge while we have corn

Say Cockney say 'Be first my son' we just Gwaan!

Cockney say grass. We say outformer man

Cockney say Old Bill we say dutty babylon ...

Cockney say scarper we scatter

Cockney say rabbit we chatter

We say bleach Cockney knackered

Cockney say triffic we say wackaard

Cockney say blokes we say guys

Cockney say alright we say ites!

We say pants Cockney say strides

Sweet as a nut ... just level vibes, seen."

Smiley Culture 'Cockney Transla

IS THE FUTURE WHAT IT USED TO BE
MOST OF US ARE EMBEDDED IN OUR CURRENT LANGUAGE OF REALITY. SO,
INEVITABLY, WE ENVISION A FUTURE THAT COMES FROM THE DRIFT OF WORDS
WHOLLY BASED IN THE PAST. WE SEE THE FUTURE AND SAY WHY? WHEN WE COULD
DREAM THINGS THAT NEVER WERE AND SAY WHY NOT?

DEFINITION OF
SAYING THE SAME THING AGAIN AND AGAIN BUT EXPECTING
DIFFERENT RESULTS.
INSANITY

pages 148-9 ▼

Creator

art director Jonathan Cooke
designer Jonathan Cooke
concept Leigh Marling @ Blue Source
 Damian Mckeown @ Blue Source

editors Nick Crowe
 Patrick Collerton
publisher Nick Crowe
origin UK
dimensions 240 x 297 mm
 9¹/₂ x 11³/₄ in

The myth of pure art.

I think that every designer or photographer is, in principle, also a pure artist.

I have declared pure art dead.

Pure art doesn't really exist...(a better title would be)

The myth of pure art.

Paul van Dijk, director of the Academy of Visual Arts, Maastricht, discusses art education.

Art education in the free arts is regressing drastically. It is very evident and there is no stopping it. Sure, you could put on a brave face and say, 'I'm glad that only 20% of the students are painters and sculptors,' but in reality, of course, it impoverishes culture.

I have declared pure art dead. But I also think, and this is an opinion that I have held for some years now, that pure art as such has never really existed, because people have always been dependent on patrons and customers. Particularly in the visual arts, the big commissions are always in the hands of these people. Often the pure autonomous image is found precisely in applied art, in the object that you display and say: it is the best thing that I have ever made, even if it was commissioned work, even if it already had a function in everyday culture. In fact it is pure art if you are the one who thought it up and shaped it in your own way and now see it there, as a thing in itself, and believe that's the best thing that you've ever made.

However, the departments of the free arts, in the sense that pure art is understood in art education, are important in an academy. They allow things to occur that are not directly related to the usual educational models. These can be very important, because there can be people there who don't fit the definitions. Perhaps we can't say whether they really have talent, but their approach is such that they do things in the visual arts that are unpredictable or perhaps even unimaginable. You can see this in every department, but it is noticeable that such people are often found in the so-called free art departments. So-called free art. It doesn't have to be that way, because someone from the free arts might start accepting commissions tomorrow, but would still have to meet the standards as a pure artist, to win paying commissions.

I think that every designer or photographer is in principle, also a pure artist. And vice versa. The pure artist is strongly affected by the market, and the artist's own approach, own aesthetic, and own integrity, determine whether it goes any further than what the market expects. And that is when you come to the concept of quality, that is the heart of the matter, or should be. It is so difficult to define. For the departments of the applied arts, it is fairly clear what should be expected of the students at the end of their training. But for the departments of free arts ...?

Extract from an interview, November 1993

Academy of Visual Arts Maastricht ■ Herdenkingsplein 12 ■ 6211 PW Maastricht (Netherlands) ■ tel. ++31 43-466670 ■ fax ++31 43-466679

3

pages 146-7

creator

art director Adam Shepherd
designers 1 & 2 Bernhard Bulang
3 Karin Winkelmolen &
Edwin Smet
photographer 3 Vincent van den Hoogen

editors Nick Crowe
Patrick Collerton
publisher Nick Crowe
origin The Netherlands/UK
dimensions 240 x 297 mm
9½ x 11¾ in

creator
culture without compromise

ent, is so askew that a
irenia is demanded of
and originator. Each has
on offer — ever
eyare being
d, garbage
fed.

death and
ways existed, albeit in a
he familiar stop and gawp
ne. The rubberneck effect
recently is the development
ther people's misfortune
scination with the unusual
breed of grubby hardcore
culture a culture where
ented as entertainment...

creator
culture without compromise

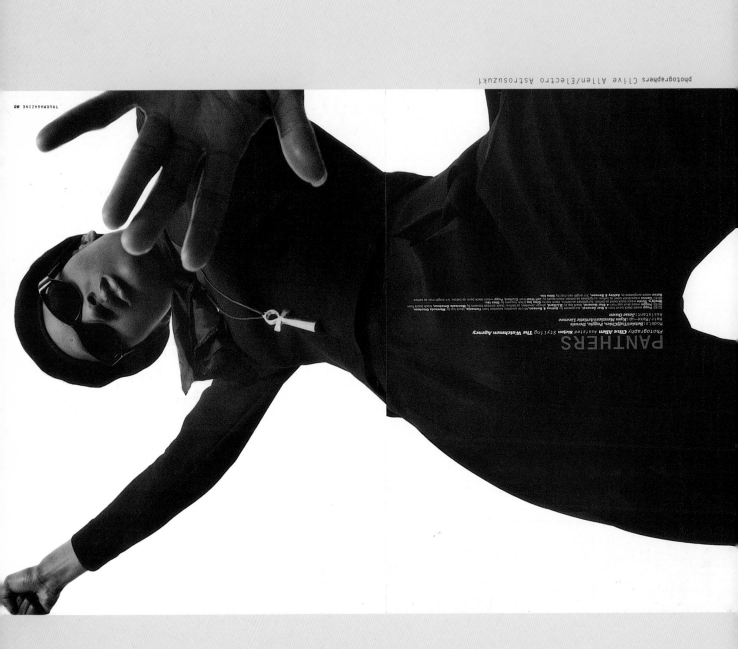

PANTHERS

Photography **Clive Allen** *Assisted* **Stefan** *Styling* **The Watchmen Agency**
Models: Bekay, Chux, Peggie, Dennis
Hair/Make-up: Ryan Mendes/Artistic Licence
Assistant: Jesse Ouim

Shatry's, Dennis wears black beret as before, sunglasses as before, black top by Gina Itai, Gina Itai trousers by Menuka Omotoso, black boots from B.D.Z. Dennis wears black beret as before, black boots by B.D.Land, Peggie wears black beret as before, 3/4 length max as before. Bekay wears sunglasses by Ashley & Benson.
B.D.Z. Peggie wears black max top from Yamanja, black top by Menuka Omotoso, B.D.Z, sunglasses as before, back top by B.D.Land, Brooch Jewellery as before, back contrast trousers by Menuka Omotoso, black boots from B.D.Z. sunglasses by Ashley & Benson, African jewellery selection from Yamanja, black top by Menuka Omotoso, Bekay wears sunglasses by Ashley & Benson, 3/4 length max as before.

EWGROUND:

MCM
Ayo Photography Eddie Otchere

igh Wycombe is not the Bronx. However, any talk of dopeness in British hip hop must mention the home and stomping ground of MCM.
CM, who speaks in a soft measured tone and weighs every syllable in his head, will be the first to confirm that "Hip hop is
verywhere". MCM's quiet persona and slight frame belie a vigorous and passionate performer. But, more importantly, the quiet (almost
erdy) facade conceals a highly-talented and imaginative producer. "I was brought up on black music. It's weird 'cos, musically, I
ind everybody's going back in time but I always had connoisseur music in my collection."
CM is: no hype, no dogma, just phat beats. MCM first came to the attention of London's hip hop fraternity as part of the group
aveman. They signed to Profile and released an interesting record in 1990. After four years MCM left Caveman and went solo. Right
ow, he is an unsigned artist at work. "I use an Akai 950 sampler and Cubase to make my beats. I concentrate on getting the sounds
ice and making good music," he explains in an offhand manner. On very basic equipment he managed to produce tracks that give you a
ense that his full potential is as yet unachieved. About London's notoriously fickle hip hop crowds, MCM says this: "You've got
eople that know and people that don't. When I go out on stage and I'm rhyming, because I'm short, my voice isn't really loud. People
ally are looking for effect and not the content of the rhymes".
n the UK music industry, he says: "People in the industry here don't show an interest in rap music, and over here the people
re not really musical anymore. To a lot of people Jungle is music. Not that I'm trying to dis jungle, but you can't compare
t to the music of Stevie Wonder". MCM is concerned with his development as an artist. "Music is a big part of my life. At
he end of the day, when I listen to the news, they tell me one thing. But when I hear people's expression on songs,
hey tell me something different. Something that really relates to my life. Music to me is like another form of news."

Performa

OnTheRoad
Keziah Jones Photography Anton Corbijn
PsychoChocolate

What it is like to be nowhere and everywhere at the same time? Imagine 20,000 young French girls screaming 'Lenny! Lenny! Lenny!' at you. Backstage, time and space are jesting with you until the hero rides in on his white horse to save the gig that Keziah Jones' psychochocolate ether machine has just destroyed.
I am an African anarchist. Therefore any question about location tickles. Yeah it tickles because it cannot relate to the mindscape of those internally-exiled African mujicians. Because the gangsterism of Greenwich Mean Time erases all clues of self-awareness. Because immigration police turn bodies into empty vessels to be filled with gentle enquiries about one's presence on earth. To travel freely through space and time, through the boundaries of one's mind, I had to declare my blufunk. I had to declare the motherfucking African Space Thermal Underground Mofo Theory.
I once found myself on a tour around the backside of America, with the P-Funk All Stars. By the time we got to Detroit, I

realised that I was in Lagos. George Clinton on sta 18-piece band was Fela Kuti. Spumatickcumizajest. skinny area boy tagging along for the ride. Nigerian Natural Grass (N.N.G.), their drug of cocaine. The funderlying undermentals were all the was right here 10,000 miles away and I could hear th just around the corner. A thorough understanding o of cause and effect allows me to accept my statel freedom. My internal exile as a joyrider between blocks of African custom and European dogma. I am inky space with access to the metalanguage of dream imagine 1,000 drunk Bedford University student some point, ask you to play "Stairway To Heaven remember that the last cigarette before the li always the best, that culture is inversely propo aptitude. Then you can put down your guitar and to 'Fuck off' without falling into the verbal tr your manager when he says anything about profes

photographers Eddie Otchere/Electro Astrosuzuki photographer Anton Corbijn

MartineGirault

Darren Crosdale Photography **Wandy**

Martine Girault's laugh is a low-down, dirty rumble which starts in her chest, grinds upwards and emerges from her thrown-back head. Wonderful. The phenomenal underground success of 1991's "Revival" gained Martine a loyal fan-base. The recognition of "Revival," as that rare, divine tune secured Martine and the song's producer, Ray Hayden, a six-album deal with London records. But, after realising which single the record company chose as a follow-up to "Revival," Martine and Ray asked to be set free from the contract. "I didn't mean to step on anyone's toes. I just wanted to feel good about myself," says Martine, hand on heart for emphasis. Instead, after realising that a great chance might have slipped through her fingers, Martine "felt very depressed" by the lost opportunity. Unlike Mary J. Blige, who went through a highly-publicised self-development programme, Martine's approach to conquering depression was rather inexpensive. "I was in this second-hand bookshop and I didn't have a lot of money. I found this book, *The Magic of Thinking Big*. It was torn and in bad condition but it taught me the importance of self-confidence." Brooklyn-born Martine grew up in Queens with her Haitian parents, three sisters and a brother. One day, Martine "just decided" she would sing. "My mother cried when she first saw me. She said, 'Who taught you to sing?'" Actually, Martine, whose background is in theatre, grew up listening to very little black music. "It was only what crossed over into the mainstream - like Motown." Martine once played Dorothy in the touring version of Stephanie Mills' show *The Wiz*. "I used to walk by Stephanie's theatre every day going to dance class. I used to say to myself, 'Why couldn't anyone write a play about me?'" Martine's new single, "Been Thinking About You", precedes her forthcoming debut album. It captures the moods Martine wanted to express and, though she didn't write any of the material, she wonders at "how well Ray knows me". More than just a producer, Martine admits that "He's my mentor". He and Shamin Noronha (partners in Opaz Productions) took Martine under their wing when she first came to England in 1986. Martine was assisting a friend at an audition and, although she had laryngitis, Ray educated Martine in the nuances of black music. To this day, she is still learning.

GroupHome

Mar Reagon *Photography* **Christina Casiano**

Melachi the Nutcracker, 19, and Lil Dap, 21, form the new 'supastar' duo known as Group Home. Nutcracker's South Bronx neighbourhood was home to Nice & Smooth, Showbiz & A.G., and Fat Joe. In 1988, Melachi, then 11, hooked up with Guru and DJ Premier, who gave him his MC outing on *Hard To Earn*'s "Word From the Nutcracker". Dap also debuted on Gang Starr wax, with his verse on *Daily Operation*'s "I'm the Man". The rhymes on their debut album, *Living Proof* - *Born in the ghetto/ It's hard to survive,* from the hit "Supastar", for instance - were obviously fuelled by the reality of street life. "I had no peace where I was at," says Dap, speaking of his East New York neighbourhood, one of the farthest reaches of Brooklyn. Dap started rhyming around '84 and has been down with Gang Starr Foundation ever since high school buddy Jeru Da Damaja introduced him. The success of "Supastar" allowed Dap, who was already rhyming on the first EPMD tour in '88, to "go halfway around the world with this Group Home shit... I got three tours under my belt." *Living Proof* is another dazzling Premier production. "It's dope," says Dap, who co-produced some songs with Melachi and Premier. "We put our heads together... What we do, right, we do whatever we gotta do. Like loops or whatever, beats or whatever. We put it together ourselves and then we select the tunes and he just makes it, y'know, puts the puzzle together and that's it." Despite being the youngest in their clique, Dap and Melachi are thankful for the strong base the Gang Starr Foundation provided when they were forced to deal with the shady aspects of the business. "Weak links will always fall, you can't have a strong foundation with a weak link," says Melachi. "That's why we stay within the family," Dap admits, "'Cause it's just business. If it gets personal, if anybody gets besides themselves, they can't find themselves". Having grown up in two of New York's worst neighbourhoods, Dap and Melachi vow to recognise the past and always draw inspiration from it. Melachi has plans to get into boxing and Dap, who is already on the business side of the music, plans to do more producing. In the meantime, they will "maintain and do what we gotta do"

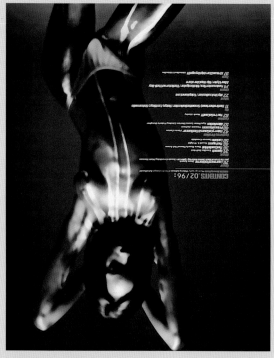

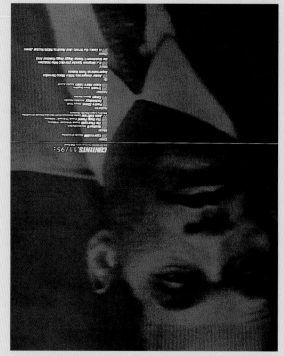

photographers Phil Knott/Electro Astrosuzuki

photographers Thierry Legoues/Electro Astrosuzuki

photographer/illustrator Electro Astrosuzuki

photographer/illustrator Electro Astrosuzuki

141

pages 142-3 ▶
photographers (left) Christina Castano
(right) Wandy/Electro Astrosuzuki

photographer Shawn Mortensen

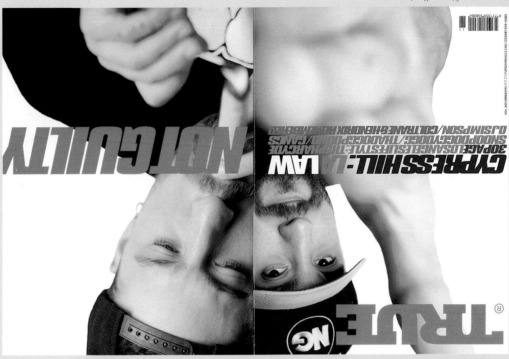

photographer Nicolas Hidiroglou

photographers Phil Knott/Electro Astrosuzuki

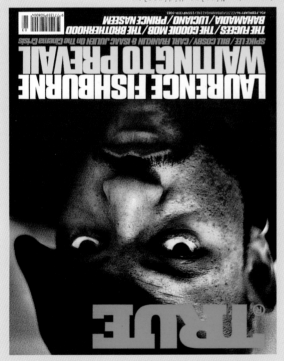

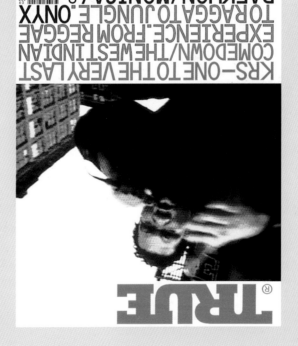

pages 140-45

True

art director Matt Roach @ Astrodynamics
designer Matt Roach @ Astrodynamics
editors Claude Grunitzky
 Sunita Olympio
publishers Claude Grunitzky/Sunita Olympio
origin UK/USA
dimensions 230 x 287 mm
 9 x 11¹/₄ in

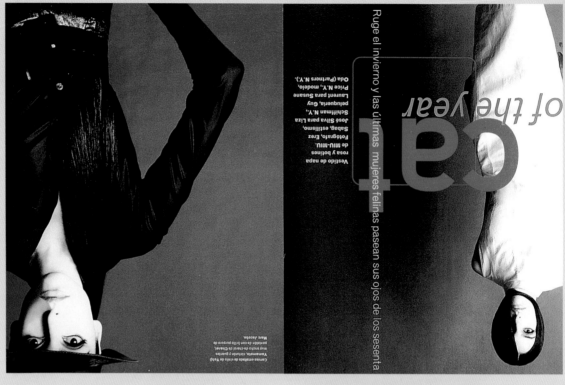

cat of the year

Ruge el invierno y las últimas mujeres felinas pasean sus ojos de los sesenta

Vestido de napa rosa y botines de MIU-MIU. Fotógrafo, Erez Sabag, estilismo, José Silva para Liza Schiffman N.Y., peluquería, Guy Laurent para Susane Price N.Y., modelo, Oda (Partners N.Y.),

Camisa entallada de Vichy de Yohji Yamamoto, cinturón y guantes muy ancho de charol de Chanel, pantalón de con brillo púrpura de Marc Jacobs.

grito a la elegancia

Déjate llevar por los impulsos, como un niño travieso. Bendlos a la última

El modelo lleva un traje de lana de HUGO BOSS, camisa blanca de GIORGIO ARMANI. Fotógrafo Russell James, estilismo Lallie Johnson, peluquería Peter Anderson y Paul Mitchel para Mika's, maquillaje Tomas Lenneryd para Mika's.

Dame lleva abrigo de APC, camisa de Giorgio Armani y pantalones de Hugo Boss.

pages 138-9

Vanidad

art director Nick Bell
designer Mark Hough @ Nick Bell Design, London
interpreted by Verónica Sosa @ Egoiste

editor Emilio Saliquet
publisher Egoiste Publicacions S.L., Madrid
origin UK/Spain
dimensions 228 x 300 mm
9 x 11³⁄₄ in

Entrevista Mària Suàrez Fotografias Wolfgang Mustain

Marc Almond sigue seduciendo. Una estrella viviente que no pierde luz.

poeta del cabaret

Un poeta que toca la luna y no tiene miedo a llorar. Lo último, su biografía.

photographer Wolfgang Mustain

Vanidad ha estado en todo el mundo para encontrar nuevos talentos

talento

David Alcalá, escritor

Luis Camnitzer, artista

Fluke, músicos

Alex de Fluvià, pintor

talento

Luis Camnitzer

Montserrat Vendrell

Vanidad 23

Scientists may have discovered the nasal 'G-spot'. Previously, the vomeronasal organ, a tiny sac in the roof of the nose, was thought to be inactive. But it has now been observed to pump when exposed to certain odourless chemicals. Although the effect on cerebral activity has not yet been established, tests are underway using human emissions

It takes one million petals to make a pint of rose oil

There are 60,000 'Avon ladies' operating in the Amazonian rainforest. In mining posts only accessible by canoe, colognes such as Crystal Splash and Charisma sell for one gram of gold per bottle. Two dozen eggs buys you a Bart Simpson roll-on

The Rotterdam police force is using 'smellprints' to identify criminals. Air from the scene of a crime is sacked into absorbent pads, which are vacuum-sealed. Dogs are then employed to match these samples with these taken from previous offenders. Alternatively, a 'blind' identity parade is staged, with suspects' body odour being fanned from behind a screen. The dog barks when it recognizes the smellprint

A wide range of businesses now enhance brand identity with 'scent logos' (often based on the chemical $C_{20}H_{24}0$, which aids mother-baby bonding). One British retailer blasts dewberry through its air-conditioning, while the SeaFirst Bank of Seattle sprays its money with mint

SMELLS:

they weave in and out of our nostrils, guiding us through life. They warn us of danger, stimulate our appetites, attract us to other people – or repel us. They intoxicate us or nauseate us. They even whisk us back in time, awakening past emotions.

Fragrances can relax us, affect our moods and increase productivity – quite apart from maximizing repayment of bills (spray 'em with sweat!) and stimulating gambling. Researchers at the Sloan-Kettering Hospital in New York even tell us that spraying wards with vaporized vanilla accelerates the healing process.

The untrained nose can detect perhaps 40,000 different odours, the trained nose – of the wine-waiter or tea-sniffer – perhaps more than twice as many. Yet, despite its importance in our lives, most people rank smell as the lowest of the five senses. Partly, this comes about because so many people are used to doing without it – what with colds in winter and allergies in summer – but one cannot help thinking that, in our world, sight reigns supreme. 'I'll *see* if the milk's off,' you say. Then smell it.

It's as if we deliberately limit our olfactory vocabulary. We can describe sounds: music can be translated into notation or just replayed; words can be written; sights can be described in terms of shape, colour, shading, direction and distance. But smells can hardly be defined except in terms of other smells or tastes. How, for instance, would you describe the smell of a geranium? Or of a diet cola?

In traditional Chinese cosmology, each of the five elements of the universe has its own odour. But smell seems to have avoided Western scientific classification. We can measure the speed of light and the speed of sound. We can measure light intensity by wattage, tactile pressure in pounds per square inch, and noise level in decibels. We can divide taste into four distinct flavours. And the colours of light split along the spectrum: red, orange, yellow, green, blue, indigo, violet. But we have no nasal scale: how do we compare the smell of new-mown grass to that of a pine forest?

Perhaps we first began to trust the evidence of our eyes over that of our nostrils when our ancestors came down from the trees to roam the savannah. They could scan the horizon for predator or prey, or look to the heavens for

Yellow background: electron micrograph of the nasal cavity's mucous membrane, where inhaled air molecules are dissolved for 'analysis' by nerve cells. The information then passed to the brain's olfactory bulb is what we perceive as smell. The Proustian sensation of highly-charged recollection occurs because the olfactory bulb also houses our emotional responses and memories

◄ pages 134-5

Monument

art director Ingo Voss
designer Ingo Voss
editor Graham Foreman
publisher Monument Publishing
origin Australia
dimensions 240 x 325 mm
9¹/₂ x 12³/₄ in

136

pages 136-7

Silk Cut Magazine

art director Jeremy Leslie
designer Jeremy Leslie
editor Tim Willis
publisher Forward Publishing
origin UK
dimensions 290 x 290 mm
11³/₈ x 11³/₈ in

playing dumb

the photography of John Gollings

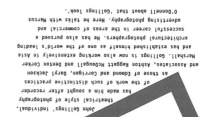

Sandy Nicholson

John Gollings' individual, theatrical style of photography has made him a sought after recorder of the work of such distinctive practices as those of Edmond and Corrigan, Daryl Jackson and Associates, Ashton Raggatt McDougall and Denton Corker Marshall. Gollings is now also working extensively in Asia and has established himself as one of the world's leading architectural photographers. He has also pursued a successful career in the areas of commercial and advertising photography. Here he talks with Marcus O'Donnell about that 'Gollings look'.

Sydney fisheye shot

level 6
austra lia sq uare

Architects: Bligh Voller
DEGW Strategic Consulting

The commission for new offices for Lend Lease Interiors and Civil & Civic in Sydney had two totally unique components: an absolute determination on the part of the client to totally re-examine the interior design process as it relates to 'people, process and place', and the opportunity to 'rehabilitate' Harry Seidler's inspiring showroom floor in the Australia Square Tower.

Project Team: Christopher Alcock, Michael Buchmann, Lucy Creagh, Mark Marin, Katherine McPherson, Tinoulla Philippou

Project Management: Lend Lease Interiors

Lighting Design: Mike Sparrow, Lend Lease Design Group

Photographer: Eric Sierins

1 Reception
2 Small Meeting Rooms
3 Internal Meeting Rooms
4 Study Booths
5 Team Areas
6 Project Spaces
7 Resources
8 'Green' Rooms

MONUMENT PROFILE

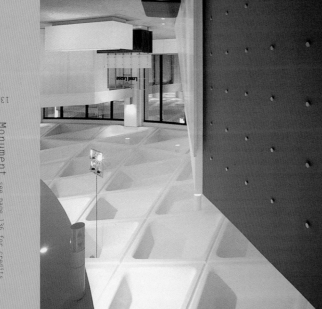

Philip Johnson at 90
a personal reflection by Harry Seidler

Philip Johnson and Harry Seidler at Johnson's office
New York, 1993

As he is the oldest practising architect in the world today, with his ninetieth birthday imminent in 1996, Philip Johnson's remarkable, enigmatic and chameleon-like career warrants examination. Both the influence he has had on others, and through them on the course of architecture in the second half of the twentieth century, should be seen in the context of his early work of the 1940's and 1950's and his buildings in more recent decades.

Johnson was born in Cleveland, Ohio, into a family of wealth, which made him independent. He possessed great intelligence and was educated at the best schools. He graduated with a degree in Arts from Harvard in 1930. This made him eminently suitable for the position of Director of Architecture and Design at the Museum of Modern Art in New York, to which he was appointed when still in his twenties. In 1932, the Museum's eminent director, Alfred Barr, sent him on an eighteen month exploratory journey around Europe to assemble material for staging an exhibition to show the emerging 'International Style' to the American public. In the same year, in conjunction with the historian Henry Russell Hitchcock, he wrote the influential book with the same title.

As one could expect, given his art-historical education, the subject was dealt with as a new (late) 'style' rather than as an emerging philosophy and methodology of building, which by definition changes with time, and holds the promise of revolutionising art and conventional approaches to architecture.

Through his long travels, Johnson became intimately familiar with not only the built results, but also the individuals, the pioneers that produced the early modern architecture of Europe: men like Mies van der Rohe, Gropius, Oud and Le Corbusier.

During World War II, he decided to study architecture at Harvard (1943), which was then under the leadership of Walter Gropius. It is said that there was open friction between Johnson and Gropius, probably in no small measure due to Johnson's earlier reported fixation with Nazi Germany comparable to that of England's deposed her to the throne, Edward VIII, from where Gropius had emigrated. When confronted with his Nazi past, Johnson always trivialised it in his imitable manner by saying, 'I just went for the graphics' – referring to Speer's spectacular Nazi rallies of the 1930's.

Harvard became a hotbed of new architectural orientation in the USA. In the years during and after the war, Johnson's student contemporaries such as Pei, Barnes, and Rudolph, went on to revolutionise American architecture. Gropius' unique teaching, however, did not penetrate architecture schools elsewhere. Only superficial images became popular without the depth of the underlying principles, methodologies and especially the aesthetic components.

Johnson went on to exert incredible influence on the New York power structure through his social position and because he was a shrewd publicist, for wealthy Americans, he built houses of great elegance and richness, and yet they were imbued with restrained minimalism, which made them virtual icons through architectural photographs and publishing of the time. The finesse with which he assembled the finest of materials and the way he preserved techniques of artificial lighting to dramatise his spaces have been unsurpassed in standards of excellence.

Throughout the 1950's and 1960's, his architectural designs were never truly original, but leaned heavily on the work of others. Bruce's bracketed plan for his Leonard House, his Hodgson house, Mies' sketch of 1934 showing a suspended glass house is built in his Leonhardt House of 1956, his replica of Mies' IIT campus structures, then going in to Chicago. Imitations also came early from historical procedures, such as the Palladian-like ceiling in his first Soane's own London house of 1800. His superbly executed Dance synagogue of 1956, clearly derived from Sir John Soane's local houses.

Johnson started his career as an architect on a high note, the reason why later developments, lacking in the essential foundation, soon degenerated into historical reaction.

Plan

which were integral to teaching at Harvard. This is, in part,

Max von Bohr had moved to Chicago where he erected an increasing influence on the American scene. As early as his thesis at Harvard, Johnson actually built a courtyard house as his final project, a design which was influenced heavily by Mies' precedents of the 1930's.

What really brought him to universal attention was his own dramatic New Canaan glass house of 1949, a take-off on the design of Mies' Farnsworth house, which was not actually built until later.

After that triumph, Johnson felt he could no longer contribute to such developments. His dissatisfaction with the language of modern architecture became evident in his

Johnson's lasting importance, however, rests heavily on his collaboration with Mies on the Seagram building, completed in 1958 – the quintessential prototype or edifice, but lesser glass curtain wall buildings to follow.

lavish Kneses house in Washington of 1956 uses the fan vaults of Le Corbusier's local houses.

Model House in front of the Glass House at New Canaan
Photograph taken by Harry Seidler during a visit in 1960

bill henson fragments
photos
faces

This year, the fragmented photographs shown over the page occupied the Australian pavilion at the Venice Biennale. They drew comments ranging from 'magical and deeply disturbing' to 'I wanted to call the police' (this last, not surprisingly, from England, the land of Tory scandal).

Henson's camera has been active in many parts of the world. As a curtain raiser to showing some of his current pictures, MONUMENT offers readers a selection of photographs taken in New York, Los Angeles and Suburbia.

Photographs on this and preceding page courtesy of the artist

Los Angeles
Untitled 1985/86

New York
Untitled 1987/88

Suburbia
Untitled 1985/86

New York
Untitled 1987/88

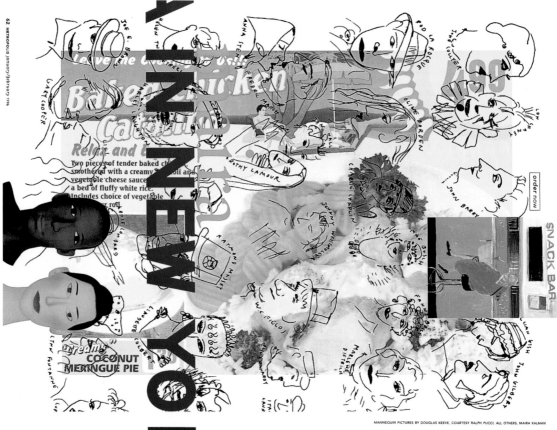

MANNEQUIN PICTURES BY DOUGLAS KEEVE, COURTESY RALPH PUCCI; ALL OTHERS, MAIRA KALMAN

A IN NEW YORK

What goes on inside the mind of children's book creator Maira Kalman? Mix one or two of life's big mysteries with all the triples for sale in Woolworth's, then add coffee and stir.

BY AKIKO BUSCH Somehow in my heart of hearts I knew I wasn't going to meet Maira Kalman in a coffee bar. And I didn't. Instead, she suggested that we meet at Woolworth's on East 42nd Street, and now we're sitting at the lunch counter sipping lemon Cokes. She is telling me an anecdote from her childhood in Riverdale: She would go to the supermarket with her mother and as her mother shopped, she would trail behind, straightening out the shelves. This is how it is with Maira Kalman: She has a very beautiful and very complicated relationship with excess.

Kalman is an illustrator and author of numerous children's books, among them, Max in Hollywood, Baby, Ooh-La-La (Max in Love), and Max Makes a Million, all published by Viking Penguin. She has

designed mannequins for Pucci International Ltd., a furniture showroom in New York City; these serene and whimsical personae bring some of her storybook characters into three dimensions and seem something like a Stepford family that has discovered Zen, biofeedback, and expensive haircuts. And she is married to Tibor Kalman, who was the founder and principal of the New York graphic design firm M&Co., and—up until last fall—the editor in chief of Colors, the magazine published by the United Colors of Benetton. For the last two years, the couple and their two children have lived in Rome; now they are back in New York and Kalman is telling me why. Mostly, it has to do with the difficulty of getting anything done in a landscape of unequivocal pleasure, sensuality, and culinary bliss—for Tibor, anyway. "I could ▶91

I had to have a herring in a hurry.

pages 130-33

Metropolis

art directors Carl Lehmann-Haupt
William van Roden

publisher Bellerophon Publications Inc.
origin USA
dimensions 280 x 380 mm
11 x 15 in

dinner at the homepage restaurant

(Part 2 in an ongoing series is about our realignment, as
models of reality shift from being analog to being digital.)

mixed media

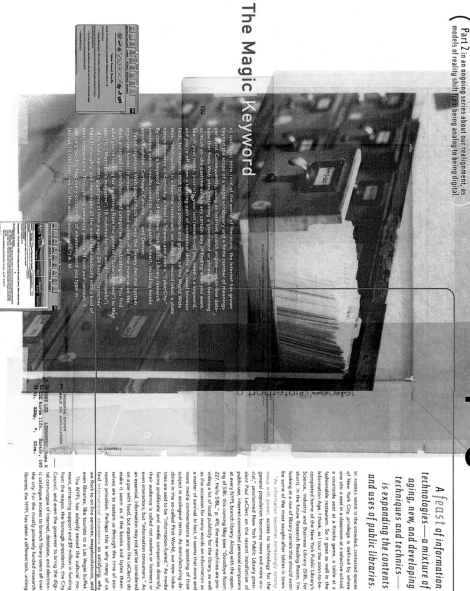

PLEASE TAKE CARE OF THIS BOOK

ALI CAMPBELL

The Magic Keyword

AS HAS LONG BEEN TRUE of the world of literature, the Internet has grown beyond the scope of a single vocabulary and a finite number of meanings. Consequently, using an Internet search engine—an on-line database that finds Web sites, containing a given word or phrase—is becoming as much an idle pastime as it is any certain way of finding what you want. Search your name, your city, your last email—you need it's a keyword, and you're off down a winding path of contextual shifts. A casual browser finds, for instance, that to various people and groups on the World Wide Web, "Metropolis" is a four-star restaurant, a hotel in Taiwan, an industrial record label, a state nature preserve in Kentucky, a hotel in Taiwan, and even a "CyberCity."

By contrast, a keyword search of the New York Public Library research catalogue yields results closer to the magazine's heart, including books about Baghdad, Carthage, Calcutta ... and Denver.

Yahoo organizes the Web proper, much in the way the Dewey decimal system organizes books: it presents an edited subset of all the material on the Web arranged in predetermined categories and subcategories. You find what you're looking for by starting from the general ("Entertainment") to the specific ("Metropolis magazine"; 8 matches for the word "metropolis" A.M.

Alta Vista harvests gigabytes of Web pages every 24 hours, "crunches" them thoroughly and rearranges all the words alphabetically into a kind of Web concordance. Through this complete divorce of text and context, it can very quickly find every occurrence of whatever word you type in. (About 10,000 matches for the word "metropolis" A.M.

*A feast of information
technologies—a mixture of
aging, new, and developing
techniques and technics—
is expanding the contents
and uses of public libraries.*

BY ANDREA MOED In the crowded, contested spaces of New York City, privilege is defined by where one sits: a seat in a classroom at a selective school, a courtside seat at a Knicks game, a table at a fashionable restaurant. So it goes as well in the Information Age, I think, as I tour the soon-to-be-completed home of the New York Public Library's Science, Industry and Business Library (SIBL, for short). In the future Research Reading Room, I'm looking at a row of library carrels that should soon be some of the most sought-after tables in town.

"An information becomes increasingly synonymous with power, access to technology for the general population becomes more and more crucial," proclaimed New York Public Library president Paul LeClerc on the recent installation of public-use, Internet-connected personal computers at every NYPL branch library. Along with the opening of SIBL this coming May (see "Goodbye Room 227, Hello SIBL," p. 49), the new machines are providing a lot of local publicity for the library, as well as the occasion for many words on information as a matter of survival. In fact, it seems that more and more media commentators are speaking of their subject in ecological terms. As manufacturing declines in the so-called First World, our new industries are said to be "information-fueled." As media forms proliferate and media companies diversify, their audience is called not readers or listeners or even interactors, but "information consumers." As an essential, information may not yet be considered on a par with food, but equations like LeClerc's do make it seem as if the books and bytes themselves are to sustain us through this time of economic privation. Perhaps this is why many of us find *informational abundance* so satisfying, why we flock to on-line services, megabookstores, and even libraries, like tourists to a Las Vegas buffet.

The NYPL has adeptly seized the cultural moment, attracting support and $9 million in funding from the mayor, the borough presidents, the City Council, and even the governor to bring the digital cornucopia of Internet, database, and electronic catalogue access to branch library users all over the city. For the mostly privately funded research libraries, the NYPL has taken a different tack, uniting

business-friendly politicians and corporate heavyweights such as Hewlett-Packard and McGraw-Hill around the creation of SIBL, "the nation's largest public information center devoted exclusively to science and business."

This $100 million library is the NYPL's largest project in a century, built on the new public and corporate faith that easy-access information will feed entrepreneurship and grow wealth.

SIBL aspires to attract current and potential scientists and businesspeople—the information gourmets of the wider population, its design was driven from the outset by surveys, focus groups, and market research conducted in the offices and labs of the targeted communities. The resulting program serves up to the NYPL's business and science collection with lots of networked computers and amenities generally associated with private research facilities, such as computer training programs and free access to commercial information services. For SIBL's projected users, market-fresh facts are not enough: the library's house specialties and the staff that will make these interesting. Because part of their mission is preservation, library collections are naturally full of seams; SIBL will contain microform cards from the 1960s as well as databases. Researchers may be just as likely to use a long-outdated machine as a new one.

This situation contrasts sharply with what communications companies tell us to expect of reading and libraries in the future. In an AT&T ad, a woman reads an image of an open book on a computer monitor. In advertising for CD-ROMs and on-line ▶44

curving counter, patrons will order from the library's 800,000-volume noncirculating print collection. Without leaving their tables, users will be able to sample any of the library's on-line catalogues, CD-ROMs, and databases, or access the Internet, all on desktop computers provided by the library or via laptops they bring with them. Reference books and directories will fill the shelves around the carrels. If they are not sure what to order, patrons will be able to consult with specialists in marketing, chemistry, and other subjects at the central reference desk. CNN news and stock quotes will flow freely from a video array around the corner. This confluence of traditional and high-tech media and personal attention is what makes SIBL appealing. Even though the books and computers have not yet arrived, it's easy to imagine contented library users sitting here in their trendy Aaron chairs, devouring all forms of data.

As neither a scientist nor a businessperson, I suspect that SIBL will be somewhat intimidating place for many non-technical people, with its volumes of quantitative and arcane information. Nonetheless, it can provide something of much broader value: the chance to use *print and digital collections together,* following one's curiosity across media from book to database to Internet and back. Bill Walker, the director of the NYPL's research libraries, claims that the library's goal is "seamless access," but it is the "seams" between formats that will make these access interesting.

016.7 Architecture 473.5 Design
H
CS R

METROPOLIS

MARCH 1996 $4.95

Metropolis see page 132 for credits

illustrator Ali Campbell

DUE DATE

OCT 2 2 1995	JAN 3 1996
NOV 5 1995	JAN 2 5 1996
NOV 1 8 1995	FEB 4 1996
NOV 2 7 1995	
NOV 2 8 1995	FEB 1 3 1996
	FEB 2 2 1996
DEC 1 1995	MAR 1 1996
DEC 5 1995	
DEC 1 8 1995	MAR 7 1996
DEC 2 3 1995	

form #069 THREE WEEK LOAN

look
in

read...

...

library renewal

7 25274 73338 5 03>

photographer Kristine Larsen

the workplace is changing and we barely know it

telecommuting
telegraph
telecommunications
teleconference
television
teleconference telescope telephone
electronic
teleconference telefactory telegraph
teleconference telemarketing telephone
telemarketing teletelemarketing telecommuting
telescope television teleconference telefactory
telecommuting telecommunications communications
telescope telephone telecommunications
telecommuting telemarketing telemarketing
telecontrol television telecommuting
telescope telecommuting telegraph
telephone television telefactory telecontrol
telecontrol telefactory

just where do we

WORK?

OCTOBER 1995 $4.95

METROPOLIS

Gary Moore

Interview with

by Onajide Shabaka

Gary Moore and Wallace, Roberts and Todd Architects, 9th Street Pedestrian Mall (detail), 1994 (photo courtesy of the artist).

Gary Moore began exploring African art and culture as sources for his own work while still a high school student in Philadelphia. In recent years, he has incorporated a Southern vernacular that includes personal and collective history from both his native South Carolina and found objects. It often consists of a series of loose sketches scattered over a surface (sometimes directly on museum walls) with a parallel of written and visual narratives of the past and present. His work is serious, but interjected with humor. Music and storytelling are both important aspects for his black Philadelphia.

Whether in the form of drawing or sculpture, his work could incorporate clothing, black-eyed peas, sugarcane stalks, and

University of Miami graduate, he has participated in the Whitney Museum's Studio Program, is a Florida state fellowship awardee, and has received two public art commissions with Metro-Dade Art-in-Public-Places.

Onajide Shabaka: What were your plans for the May '95 exhibition at Gutierrez Fine Arts [Miami Beach]?

Gary Moore: I was approached to do a solo exhibition, but, because of other commitments, there wasn't enough time, so I invited Miami artist Karen Rifas to collaborate on an installation. That turned into inviting video artists to participate as well. The show was an investigation into secrecy and disclosure, called "Chain Sweep." You know, like community. The work consisted of found objects, drawings on frosted glass with gilt frames, forums and information/reading area, and videos. It was well received. It's interesting to see how it has entered the marketplace, because of its collaborative nature. I've had people ask me if I was afraid of a solo exhibition, but really, I don't have an interest in doing a solo exhibition. I see the idea of an artist working alone in his or her studio and then bringing the work out and placing it in some pristine space as not that valid, as it once did. I prefer collaborations because of the way it forces you to interact with other people, and it creates opportunities for people working on similar ideas to share them and bounce approaches off each other in a more focused frame.

Shabaka: Black people always talk about how great the arts are and how much they like it, but they rarely see them out at the galleries and museums. They seem to get their seeing through the print media.

Moore: Well, you have to bring the work to the people.

Shabaka: But it seems that so many of the places in the black community where we could bring the work don't function very well, especially in Miami. I was thinking about spaces I've heard about and how Watts Towers (and places like that) and Galeria de la Raza (San Francisco) seem to have developed an interactive approach for bringing work to the community. That approach to using the community, going in there with an old formula of dance classes and art classes, doesn't work any longer. I think that people once again know that the artist have to really confront the media, and the media's impact on people. And the gallery is much stronger than the community art center. I'm beginning to see that public art has more of an impact than the community center. Those places function only on a limited or local level.

Shabaka: I know that public art certainly impacts a lot more people. That's especially true with the public transit system here in Miami, the Metro-Rail.

Moore: My first two public art commissions have been pretty standard in approach. There has been a trend in the last five years that is going to document in America to document cities and towns that have gone through a point of decay in the 80s, are being rebuilt and they're using artists to document the old communities. Overtown [9th St. SW], where I've been working on the 9th Street pedestrian mall project, is a perfect example of that. The idea of the public art project to document the history of the town is fine for local economic development, but what good does it really do for the residents of Overtown? I'm a little uncertain, but they see kente cloth designs in paving stones—they have a certain aesthetic satisfaction... and they would imagine. But there are other things that need to be done besides creating work.

Shabaka: You seem something more interactive?

Moore: Something interactive. Something with an institution. Something made available to use. It's like placing artwork in a public space. It's sort of a corporate investment, or a governmental investment, and the government... What's really interesting is the Rodney King riot. The public took over that space and did with it what they saw fit. That's a public space in itself, so telling you, this is a plaza, this is a pedestrian mall, use it. Those are the issues and challenges of public art projects.

A few days ago, at the Performing Arts Center, the Metropolitan presentations just blew my mind. They programmed a vision of what an opera hall will be in 10 or 20 years. What they proposed was not to do what is done in Europe, with the frescoed ceilings. Instead, they commissioned Cindy Sherman to do portraits of historical-type personages. Instead of having the grand staircase, there's a maze of escalators, which have the same function. That's taking the textualizing them to a specific site and expanding that, with vision. That's where I think the use of art ideas in an open space, a so-called public space, has a future.

Shabaka: That's one of the things that seems to be perfect for Miami in the 21st century. I had a discussion along those lines with David Ross, the Whitney Museum director, who felt that Miami had the potential to become one of the important cities becoming ways so much press about Miami that people throughout the country think a lot more is going on here than there really is.

Moore: This city has the potential to be all that if it can build on its history in an inclusive way. But everybody has to be included.

Shabaka: Yes! I hear a lot of people talking about the exclusive nature of the arts in Miami. If you aren't Latin—even further, if you are out of the whole cha-cha. The national media over the past years has talked about how Miami is a very balkanized place, and it is. That has bothered me as well in dealing with different segments of the community.

Moore: I think one of the things that's going to have to be done to ensure that Miami's future is going to be inclusive, less polarized among the artists, the historical dialogue among artists, with understanding each other. But that's true for any city. You need to bring in work from out of the community to help educate the arts community, and the artists in that community, the ones who are going to give back to the people where they live. But if the artists aren't able to be in touch with a general dialogue nationally, the local community will suffer.

Shabaka: You don't think that is happening locally?

Moore: I think it's happening in Miami. Certainly it's happening. But is could be happening in little pockets where you have people who have information. It's like having a little dialogue, I guess. And then again, you have artists who are guilty of not wanting to be involved in larger dialogues, larger issues in discourse. It's not just among black artists or Latin artists, it's among everybody. It's up to the national leaders to make these things work. Artists

129 ▶

pages 128-9

art director Bjørn Akselsen
designers Bjørn Akselsen
Pattie Belle Hastings

Art Papers

editor Glenn Harper
publisher Atlanta Art Papers Inc.
origin USA
dimensions 254 x 343 mm
10 x 13½ in

photographers/ Cecilia Hirsch
illustrators Jon Baring-Gould
editor Kay Ransdell
publisher Massachusetts College of Art
origin USA
dimensions 222 x 210 mm
8⅛ x 8¼ in

art director Clifford Stoltze
designers Clifford Stoltze
Tracey Schroeder
Heather Kramer
Peter Farrell
Resa Blatman

catalog

MassArt 95/97

pages 126-7

boston

John Doe Or Us at the Middle East

there's an audience for ... songs

My dreams are to play New York and have Thurston show up just to see us.

exploring experimental things.

Fort Apache

It's a great workshop town. That's why I came back after London ... because life is Pan Industry town.

"There are schools for this stuff, but we never went to them, it wasn't quite in keeping with punk."

Paul Kolderie, Fort Apache

pages 124-5

Ray Gun

art director David Carson
designers Clifford Stoltze
 Peter Farrell
photographer/ Russ Quackenbush
illustrator

editor Marvin Scott Jarrett
publisher Marvin Scott Jarrett
origin USA
dimensions 254 x 305 mm
 10 x 12 in

Mark Sandman.
Morphine

"There are three great cities in the world.
There's Paris, there's Istanbul,
and there's Boston."

by Gabriella Marks

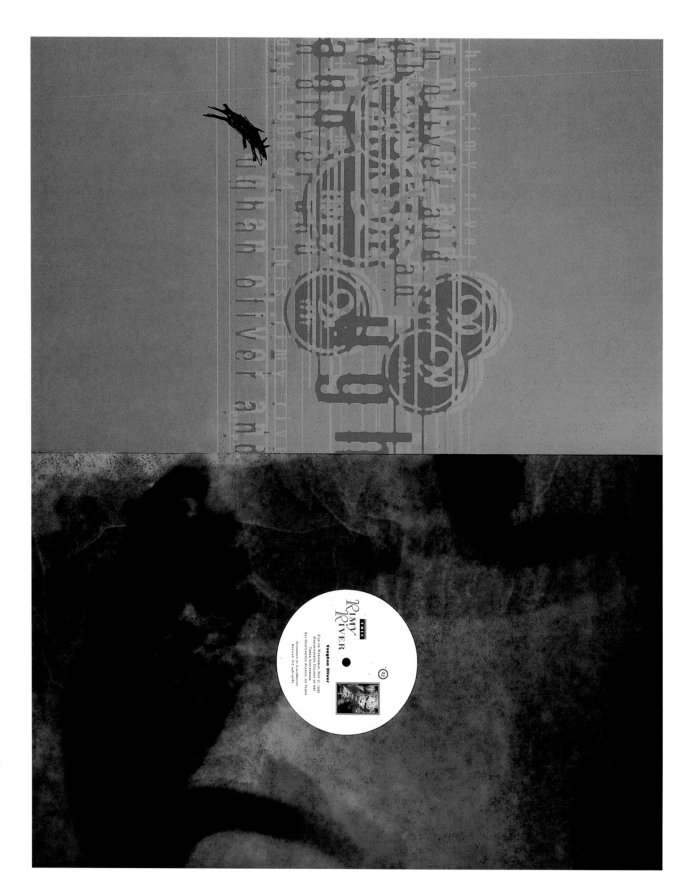

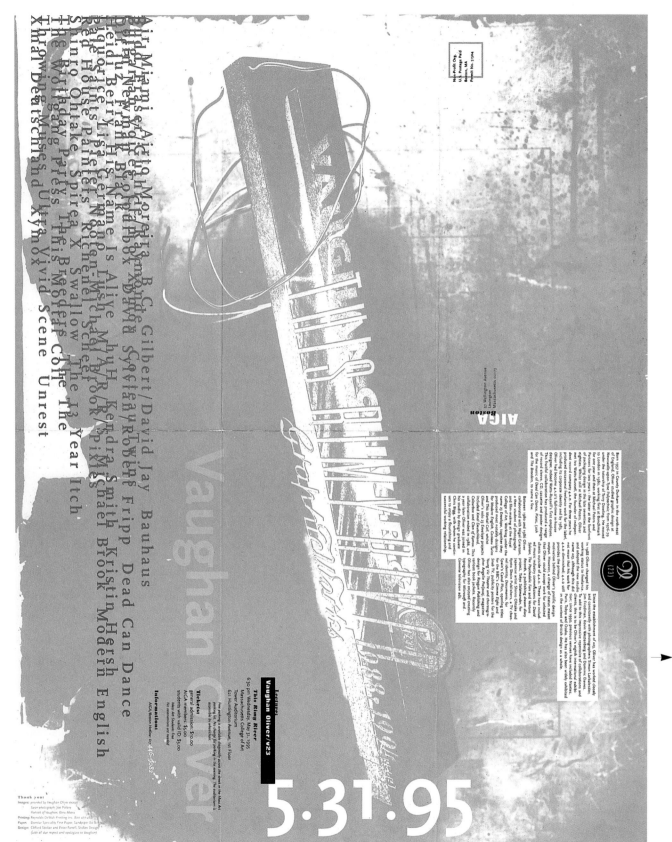

Non-Profit Org.
U.S. Postage Paid
Boston, MA
Permit No. 55504

AIGA
Boston

AIGA
Boston Massachusetts Chapter
12 Wellington Avenue
Longmeadow
Massachusetts 01171

Vaughan Oliver

5·31·95

Lectures
Vaughan Oliver/v23

This Ring River
6:30 pm Wednesday, May 31, 1995
Massachusetts College of Art
Tower Auditorium
621 Huntington Avenue, 1st Floor

Tickets:
general admission: $10.00
AIGA members: $5.00
students with valid ID: $5.00
Mass Art Students Free
No reservations are needed

Information:
AIGA Boston Infoline: 617-846-9082

Free parking is available alongside across the street on the Mass Art
parking lot. No charge for parking in the evening. The auditorium is
accessible by wheelchair.

A B C Gilbert / David Jay Bauhaus
Dead Can Dance
Michael Smith Kristin Hersh Modern English
Robert Fripp
Shinro Ohtake Spirea X Swallow The 13 Year Itch
The Wolfgang Press This Mortal Coil The
Xmal Deutschland Ultra Vivid Scene Unrest

Thank you!
Images: provided by Vaughan Oliver except
 Swan photograph: Joe Paley
 Portrait of Vaughan: Bina Altera
Printing: Reynolds DeWalt Printing inc. 800-477-6242
Paper: Domtar Specialty Fine Paper, Sandpiper 80 lb text
Design: Clifford Stoltze and Peter Farrell, Stoltze Design
 (with all due respect and apologies to Vaughan)

fast
exit to
brooklyn

Cali girl **Solen Moon-Frye** shoots the shit with the skaters from **Kids**

This little girl was sick of living in LA, so she left everything behind and took off for New York City. Weeks passed in the havoc of Manhattan until one midnight I heard wheels caressing the pavement outside my window. Looking out from my apartment, I saw the crew that would soon lead me to the streets of the city and beyond. Through days and nights of wandering Manhattan curbs and Brooklyn urbs, they jump gaps all over New York's finest water hydrants. They slide down 10 feet of smooth metal while their bodies float in the air. Some spin 360s, others pull a backside 180 after riding 2 flights of stairs. The new-school baby boys look up to them, city girls love them. On a Sunday afternoon after spending nights of wandering the city with these kids, I want to see what Brooklyn life's about, so I jump on the N train to 59th street in Brooklyn. I dash off the train and to the humble home of Ryan Hickey, the pro skater. I'm at the Brooklyn House. Ryan's off in California, but the rest of the crew is here.

Solet: How long has skating been around?
Jason: Ever since they invented scooters. That's why I hate when people say skating started on the West Coast. Skating started in New York City in the 1940's and 50's when people used to take milk crates and rollerskate wheels and put them on a wooden 2x4 to take shit around. And sometimes the wood crate would fall off and they would get stuck with the fucking board. That's how it started...from scooters.
Richie: That's how it started?
Jason: You saw Back to the Future man.
R: Yeah, I saw it and it was in California, was it not?
J: I really think that's how it started.
R: Hey, anything's possible. Who knows how it started? But it got big in the 70's. It was a fucking phenomenon.
S: Is there conflict between East Coast and West Coast skaters?
J: It's not really about East Coast vs. West Coast. It's something for ourselves. It's really just about skateboarding, individuality, and the earth that supplies Nature, which supplies life which supplies existence.
J: It's about living your life the way you want it to be. When I first started skating, it opened my mind. There were skaters from all different backgrounds. You had punk rock skaters, there were hip-hop skaters, different colors and different cultures. Everyone would do it together. There was no bullshit involved. Now everyone wants to be hip hop hard rock! As for me, I like doing big body tricks, going as far as I can.
S: What do you think about people in Hollywood as opposed to New York City?
J: People are weird out there because their body tempera-

65

photographer Ari Marcopulos

pages 122-3 ➤

Vaughan Oliver Poster
reversible poster/flyer

art director Clifford Stoltze
designers Clifford Stoltze
Peter Farrell
photographers/ Vaughan Oliver
illustrators Joe Polevy
Bina Altera
editor Clifford Stoltze
publisher AIGA Boston Chapter
origin USA
dimensions 457 x 584 mm
18 x 23 in

photographer Katie Collins

drivin' N hurlin'

We sent nouveau-gonzo journalist Johnny Knoxville to gather insight into the mysterious world of 18-wheel culture and truckstop life, but what we got mainly was a repulsive record of our good buddy's random regurgitations along the open road.

photos by Katie Collins and assorted truckstop clientele

September proved to be crass and unforgiving, the most perfidious of sluts. No work and none on the way. No money. No red wine. No kicks. There was not a cloud in the but the sun refused to shine. I had sunk so low I was even glad to hear from Ryan from Bikini. He phoned and said he had an assignment for me. I was to hitchhike to New Orle mighty to east, laugh again, for young. Bikini was even gonna cough up $150 spending money. The money part made me suspicious. "Jason, is this you, you son-of-a-bitch?" The caller assured me he was Ryan Ayanian. He even misquoted the first eight lines of Lolita to pro Credibility intact, he explained that upon arrival in "The Big Easy" I would receive a nice hotel for the evening and then fly home first class the next morning. I became suspicious from New Orleans to the much less appealing Dallas. Also, there were to be no hotel reservations and I would be flying back coach on the red-eye. I did, however, receive the Stoga reached down, grabbed my ankles, stuck my ass up in the air, and waited for Bikini to call back and stick it in. And put it in they did. Two days before I was to leave, my destinatio most of that before I left town. Boys and girls, before you try and cogitate the filthy letters I've assembled for you, please know this: I understand now what Maximillian meant wh "You know honey, I should've just stayed home."

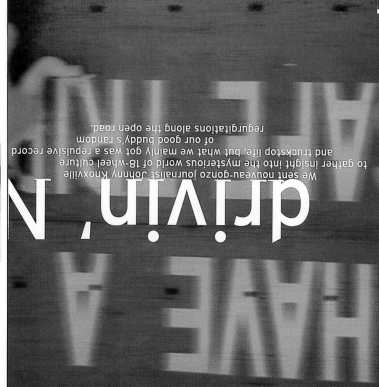

HAVE A

photographer John Rutter

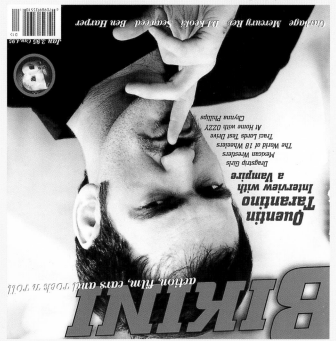

Garbage Mercury Rev DJ Keoki Seaweed Ben Harper

JAN 3.95 CAN 4.95

BIKINI
action, film, cars and rock 'n roll

Quentin Tarantino
Interview with a Vampire

Dragsting Girls
Mexican Wrestlers
The World of 18 Wheelers
Traci Lords Test Drive
At Home with OZZY
Chynna Phillips

Bikini

art director — John Curry
designer — John Curry
editor — Ryan M. Ayanian
publishers — Jaclynn B. Jarrett/ Ray Gun Publishing
origin — USA
dimensions — 254 x 254 mm / 10 x 10 in

pages 120-21

TONY HAWK

photos | brittain

| tom davis | tom barta | monte messex | tony converse |

vs. d.f.L.

The official losers of the new punk scene swap shop with the father of modern skate trickery.

willie spanker comments as he reads transcript.

LOU'S YMCA

mr. hawk indies to fakie very nicely.

58

What was the first skate you ever rode?

TH: A Bane that my brother gave me in, like '78 or '79.

How long have you been skating?

TH: Seventeen years.

Do you have your own company now?

TH: Yeah, Birdhouse.

Do you have riders?

TH: We have like ten guys we sponsor, with like six pros, including myself.

Monte: Did you ever think about sponsoring a team of only, like old school skaters that really can't do any tricks except like ride banks and stuff?

TH: Um...

Monte: Have you ever considered that? I tried to get Girl to do that, and they wouldn't do it. I've tried repeatedly to get like, just the playground skateboarding scene going, banks, laybacks, kick turns...

TH: It would almost be like you'd have to start a separate entity to do that, and just be devoted to that. Because it would be hard to melt a really technical, new school skate company with that, and do advertising. It would be hard to combine that.

Monte: That's kind of the same answer I got from Girl. I'll keep shopping that one around.

willie: "whatever."

Converse: I think that's one for Alva.

When's the last time you skated a pool?

TH: Probably Japan. They built a bowl inside of a skate shop in Tokyo and we skated there in May, I think.

What's your favorite old skatepark?

TH: Probably Whittier.

What about Marina?

TH: Uh, yeah. I was actually at Marina the day they shot the cover of Circle Jerks' *Group Sex*. I was a little kid scared to death of what I saw.

Davis: I was on the cover of that.

TH: Were you?

Davis: Yeah.

TH: Were you in the bowl?

Davis: Sitting in the bowl, yeah. That was back in the day.

TH: I was just there skating that day. They were closing and then all these crazy looking people started walking in.

Do you think the whole punk

backside invertb

revival will last compared to the skate revival?

TH: Its hard to say. The skateboarding revival, I believe, is largely due because skateboarding has progressed through its dead years, even when no one was doing it. The thing that bothers me about punk is that there were so many good bands years back, when it was popular, and the now the ones that are making it are just kind of processed for the public.

Who are your favorite old punk bands?

TH: I was really into the Addicts, Dead Kennedys, and the Circle Jerks. I still like New Model Army a lot. The first time I ever met Duane Peters was at Colton skatepark and he was with Salba. He just looked at me and spit at me and said, "This is punk rock, kid.". That was my first introduction to what punk was.

Who do you think the hot girl skaters are right now?

TH: I don't really know. I don't know their names, but I've seen some girls who are doing a lot of the street-type tricks, kickflips and stuff. Pretty consistently, too. There's been a few very good vert skaters, too.

Which ones?

TH: Well, the most famous skater is Carabeth Burnside. In fact, I just tried out for a commercial with her the other day. She's still skating. Actually, she's snowboarding more because she gets paid for that.

willie: "dude, this interview's stupid."

Have you skated Burnside?

TH: In Portland? Yeah.

Could you walk us through your run?

TH: Um, I drop in where the big hip is. Oh no, actually, I drop in where the quarter pipe is, which is near the corner,

Strength

designers Matt Beebe
 Scott Devendorf
photographer Brittain
editor Christian Strike
publisher Christian Strike,
 Delinquent Publishing
origin USA
dimensions 210 x 275 mm
 8 1/4 x 10 7/8 in

Cover photos:
Jason Beaton in Denali/John Kelly
Rob Matsuda/Baxter
Dangerle Donnock
D. TrewSite

"They worship strength because it is strength that makes
all other values possible. Nothing survives without it."

Dr. Han, the diabolical villain in the Bruce Lee classic Enter the Dragon.

Everything that is good in our world derives from strength. Individual
achievement, creativity, original thought are the necessary ingredients to
rise above the masses. The dark forces present today are fueled by weak-
ness. Weakness in the form of racism, ignorance and lack of awareness.
And to quote the late Motley Crue's Vince Neil, "...so come now children of
the beast, be strong and shout at the devil."

DESIGNERS
Mike Brewer / Vernon Turner / Paul Davis / Jason Langdon / Katie McCormick / Barrett Schubert
Ann Beresdorfer / Steve Arengo / Matt Berninger / Beth Fritzsche / Emily Raively
Scott Devendorf / Keith Knueven / Jeff Tyson / Eleni Ferraro / Casey Reas / Peggy Henz
Nikki Maguire / Jen Oen / Steve Ruff / Wendy Zent / designed summer 1995 @ univ. of cincinnati

BULLSHITTERS
Harry Johnson Trey "Dicklead" Martin
Nick Gluckman / sheep procurement
Scott Devendorf / g money
Will Ramsley / discipline and bondage
Michael Preonas Sonny Matyuga
Jonathan / johnny bravo
Brian / clowman
Amy / Terminal
Jonathan / johnny bravo
Bill / bill
Poser Dave
Rob
Hugh G. Rection Mike Hill
Hy Jean David Armin
Rob Gibbons Matt Mockart
Nordberg Willie Spanker
Soren Baxter Mike Hunt
Harry Johnson Ron Jeremy
Cornbread Williams
Anthony Gozzo
Billy Felix Jeres

PICTURE PEOPLE
Joseph Culicer Mike Baxter
Ed Dominick Chris Camel
Rob Gracie Richard Chrislo
Katja Delago John Kelly
Florian Wagner

STRENGTH magazine is published bi-monthly ($17.00 per year)
by Delinquent Publishing 5050 Section Avenue Cincinnati OH 45212.
Second-class postage pending at Cincinnati OH.

POSTMASTER please send change
of address to: STRENGTH magazine
5050 Section Avenue Cincinnati OH 45212
tel / 513 531 0202 | fax / 513 731 5513 | email / strength@lig...

all rights reserved ©1995 STRENGTH

INK — 100
CELLULOID — 97
SHOW — 95
NOIZE — 95
DOWNHILL MTBiking
MISSY GIOVE — 89
CIRCLE JERKS — 70
THE JESUS LIZARD — 62
THE MELVINS — 54
PUERTO ESCONDIDO 84 / NORTH SHORE 80 / DONOVAN 76 — 45
MACHADO / S. AFRICA
DENALI / TAHOE 36 / MT. HOOD 41 — 32
MUDHONEY — 28
CYPRESS HILL — 23
DONGER — 19
SMACK — 12
METHOD MAN — 8

I DISAGREE with what you say, BUT I DEFEND TO THE DEATH YOUR RIGHT TO SAY IT. vol I

Strength
designer Scott Devendorf
editor Christian Strike
college University of Cincinnati
 School of Design,
tutor Robert Probst
publisher Christian Strike,
 Delinquent Publishing
origin USA
dimensions 210 x 275 mm
 8¼ x 10⅞ in

Strength

designer Jeff Tyson
photographer Christian Strike
editor Christian Strike
college School of Design,
University of Cincinnati
tutor Robert Probst
publisher Christian Strike,
Delinquent Publishing
origin USA
dimensions 210 x 275 mm
8¼ x 10⅞ in

Mudhoney

"SASSY cute band alert" STRENGTH

CAST:
MARK ARM: GUITAR, VOCALS MUDHONEY
MATT LUKIN: BASS MUDHONEY
STEVE TURNER: GUITAR MUDHONEY
DAN PETERS: DRUMS MUDHONEY
steve berara, chris mashburn,
christian strike, brian bares: clownasses
setting: in the back of their van.

When Mudhoney was on the road opening for Pearl Jam,
PJ got invited to see Bill, Hillary and their lovely daughter
Chelsea. Mudhoney tagged along and upon arrival the two
groups were led in different directions. Despite being snubbed
at the White House by Dollar Bill, Mudhoney is still
plugging away. Almost oblivious to the musical explosion
witnessed there several years ago, the grandunhappy of the Seattle music
scene Mudhoney delivers their newest release My Brother The Cow. With
better things on their mind than cashing in, Mudhoney serves up the most
disease ridden album in years. With their unique mix of sixties garage rock
and punk, Mudhoney rises above the anonymity of the
dull grunge sound.

christian: so how much time are you spending with bloodloss?

MARK ARM: EVERY WAKING MOMENT I'M NOT
WITH MUDHONEY.

cs: how come you guys didn't cash in on the seattle bandwagon?

DAN: IT WASN'T A CASE OF
NOT WANTING TO.....

MA: WE JUST DIDN'T.

steve berara: have you ever considered trying to get russ
meyer to direct one of your videos?

MA: WELL, WE NEVER REALLY THOUGHT OF IT, BUT NOW
THAT YOU MENTION IT.
DAN: THAT'S A HELL OF AN IDEA.
MA: I'M NOT SURE HE'D BE INTO IT, I DON'T THINK HE'S
REALLY INTO ROCK AND ROLL. IT'S AN INTERESTING
IDEA THOUGH, WE'D BE INTO IT, BUT ISN'T HE COMING
OUT WITH A NEW FILM OR SOMETHING?

chris mashburn: i've heard the tao of god or the brass, or whatever
HE'S BEEN POPPING UP.
MATT LUKIN: I THINK HE'S ON THAT DONOHUE SHIT.
STEVE TURNER:

cm: why did you go back to jack endino to produce this record?

MA: IT WAS EASY, HE KNEW WHO WE WERE, WE KNEW

MA: IT'S ALWAYS BEEN LIKE THAT, BRIAN.

IT'S ABOUT BUCKS.

cs: it's too bad that we are being overwhelmed with all this crap when so many good bands just aren't getting heard.

DAN: CLAWHAMMER'S A GREAT BAND. DEFINITELY ONE OF MY FAVORITE BANDS RIGHT NOW.
LET YOU DOWN.
DAN: THERE'S JUST SO MUCH SHIT OUT THERE. SO MUCH OF IT SOUNDS THE SAME.
MA: BUT THERE'S SOME TRIED AND TRUE THINGS OUT...THE JON SPENCER BLUES EXPLOSION AREN'T ABOUT TO
MA: MAYBE WE'RE JUST OLD
AND CRANKY.
DAN: I JUST DON'T FIND MYSELF BUYING MUCH
NEW STUFF. WE GOT REALLY BURNED OUT ON A LOT OF STUFF.
MA: STEEL WOOL FROM SEATTLE IS A PRETTY GOOD BAND. UH, I DON'T KNOW, MY
OTHER BAND BLOODLOSS IS REALLY GOOD...HA HA.

cs: what about some up and coming bands out where you are, bands most of us
haven't heard yet?

I REALLY
DIG....
BLACK SABBATH AND BOOKER T.
ACTUALLY THOSE ARE TWO
DIFFERENT BANDS. SEYMOUR.
MA: I'D THINK OF THE HEAT OF TAPES.
cs: what artists have you been listening to lately?
DAN: I'M HANDING US SOME TAPES! WE REALLY LIKE BOB

TRACKS WERE RECORDED AND IT ENDED UP SOUNDING A LITTLE BIT THIN.
MA: WHAT HAPPENED THERE WAS A BIT OF TECHNICAL STUFF THAT WE DIDN'T REALLY UNDERSTAND AT THE TIME, THE
FAVORITE SOUNDING RECORD.
cs: was there reasons why you didn't stick with kurt bloch or conrad uno (who did your previous stuff)?
DAN: WE JUST WANTED A CHANGE OF ATMOSPHERE, PLUS WITH PIECE OF CAKE, WE ALL DECIDED IT WASN'T OUR

THE RECORD COMPANY HAD SUGGESTED.
WAS PRETTY WILLING TO FORGET IT, I THINK IT WOULD HAVE BEEN A LOT HARDER IF WE HAD GOTTEN SOMEBODY THAT
WE HAD TO HELP HIM FORGET ALL THAT. AND HE
CIAL SOUND AND IT MAKES THE BAND SELL. IT MAKES THEM MORE VALUABLE. SO
BUILDING UP A RESUME, A PORTFOLIO ON OR SOMETHING. IF THEY GET THIS COMMER-
MA: A LOT OF PRODUCERS LOOK AT MAKING A RECORD AS PART OF
HOW TO HANDLE ALL THE STUDIO STUFF THAT GOES ON.
INVOLVED WITH ONE THING AT A TIME AND KNOWS
HIM AND HE USED TO WORK. HE GETS
WE WORKED AND WE HAD TO REMIND
WITH THIS BEFORE. THE KNEW HOW
BECAUSE WE HAD WORKED
WOULDN'T HAVE TO
FIGURED WE
WE
HE WAS.
WHO

Strength

designers **Beth Fritzsche**
Emily Raively
photographer **Emily Raively**
editor **Christian Strike**
college **School of Design,**
University of Cincinnati
tutor **Robert Probst**
publisher **Christian Strike,**
Delinquent Publishing
origin **USA**
dimensions **210 x 275 mm**
8¼ x 10⅞ in

116

We were able to pull this off the internet. This guy definitely needs to RELAX a little. But since he obviously isn't getting any, I would suggest a peaceful evening at home with M r . B u b b l e B a t h and warm jar of mayonnaise.

Dr. Jai

Maharaj writes:
Meat-eaters have higher blood pressure, are more *hypertensive* and violent. Public funds are used for research and treatment. Everyone is forced to pay the price of violence and crime. Meat-eaters hurt themselves, their families and others. Meat-eaters hurt everyone. Meat-eaters hurt everyone. Meat-eaters hurt everyone.

(from the annals of Dr. Jai Maharaj)

And we're DAMN PROUD of it too, you stoopid froot loop. After reading, Jai-have-no-clue's lame ass, crap filled, *vegatubulz are peopul* message for the 10,000th time in the last month, I was inspired to leave the house and make a dramatic change in my EATING habits. As I pulled up to the McDonald's drive-thru and gazed at the death infested menu which was so obviously responsible for breast cancer, arthritis, Erik Estrada racism, and

every tragedy in the last 9,000,000 years, Jai's words really touched me and I had a change of heart. Instead of my usual "Can I have a #3 combo with a coke, please?"

I shouted,

" Yo Bitch ! I want a fukn quadro-pounder with no fukn vegetabulz or shit that growz on treez !"

"OK sir, you wanted a Quarter pounder, just plain, is that correct?"

"No Bitch ! I zed I wanted a fukn quadro-pounder ! Get it rite or die !"

"A what pounder?"
" A fukn quadro-pounder!"

"Uh...I don't think we have that. Are you sure you don't mean a quarter pounder?"

"No I don't meen a jukn meezly azz quartur pounder! Her'z what I want—

2 fukn double quarter pounderz

put together 2 make 1 quadro pounder!"

"Oh, OK...I think we can do that. Would you like cheese on that?"

" Fuk no Bitch! I want 4 hot slabz of cow deth on a bun with no fuking hippie azz vegetabulz! I alzo don't want any fuking lame vegan friez or any type of recykuls pakaging. No kup, no bag, no wrapperz. Put the shit on the window counter thing and I will take it. And tell Jai to go fuk a kokkonut too!"

"Who?"

"Fuk-it and gimme that which iz source of all evil...Now!"

"Thank you, please drive to the 2nd window."

For the record, I got my fucking Quadro pounder and it rocked. I am faxing McDonald's tomorrow and demanding that this awesome item be permanently added to every McDonald's menu around the world.

I ' m h y p e r t e n s i v e

I'm violent. And if you get in between me and my plate of animal death, I'll fucking kill your pathetic ass and go kill some trees in order to build a coffin to bury you in. Deth iz imminent. The earth muzt die. Meat eaterz are the majority and fuking pissed. Give us what we want or be prepared to face the

CAUTION CAUTION CAUTION CAUTION CAUTION CAUTION CAUTION CAUTION CAUTION CAUTION CAUTION CAUTION CAUTION CAUTION CAUTION CAU

The two had started their journey the night before when Wimsatt's father dropped them off on the interstate in Gary, Indiana. Almost immediately, they were picked up by a police officer, who searched them for drugs, shaking out a baggie of granola in an effort to locate illegal substances.

Finally, at Barbara's quick-thinking request, the officer took them to the Greyhound station where they were reunited with Wimsatt's father, who had noticed their predicament before driving away. He took them back home to fetch Mrs. Wimsatt's ID—her son doesn't have any—and deposited them back at the bus station where they resumed their trek. "I had to wear a long-sleeved shirt buttoned up to the neck. It was very uncomfortable," says Mrs. Wimsatt, whose last hitchhiking adventure took place in Spain when she was a young girl.

"I didn't want her to look vulnerable," explains her son, who speaks from experience. He has spent the last two summers hitchhiking across the country.

"I usually get picked up in 20 to 30 minutes," he continues, explaining that he is very deliberate about his appearance. He carries a sign, smiles, waves and tries to keep clean.

"I get a lot of virgins," he smirks.

"Approximately one in a hundred people would be willing to pick me up," he says. "It's basically a rare person." The two biggest myths (about hitchhiking) are that people who are going to pick you up are truckers and crazy people," he continues. "Truckers almost never pick you up because of liability. One in ten rides is a single woman. Couples are one in fifty. One in fifty are black people. Almost all rides are single men. The main thing they have in common is that they're all extraordinary in their own lives.

They're extraordinarily compassionate. They're risk-takers. They're independent thinking. They're making up their own minds and using intuition. Those qualities carry over to the rest of their lives."

This is the first time that Wimsatt's mother has accompanied him on the road. Her explanation for the journey? "It's easier to go on the trip than to stay home and worry."

During the course of the interview, Wimsatt turns to his mother and asks her what she has learned from hitchhiking.

She answers without a beat: "That I have to wear a long-sleeved shirt."

Wimsatt shakes his head in exasperation. "What you're supposed to learn," he lectures, "is that you're not to be so petty, selfish. My problems are trivial. I have so many resources and luxuries in my life. All this stuff that seems such a big risk pales in comparison to involuntary risks so many Americans are exposed to just because of the circumstances of their birth."

Graffiti artist, journalist and community organizer, William "Upski" Wimsatt has devoted the better part of his young life to the world of hip-hop, graffiti and racial politics. The title of his book, Bomb The Suburbs, like his middle name, comes from the language of graffiti. To "bomb" means to spray or tag; and "Upski" is graffiti parlance for having your name

up and around.

Says Wimsatt: "If you look at what graffiti is in many ways it's a perfect reflection of our society, at least of a lot of the behaviors that are at the core of our way of life: empty fame, self-centeredness and the idea that everyone is basically out for themselves."

In his book, Wimsatt decries, among other things, the tagging of the inner city—especially that of the public transport system.

"Suburban kids have always come into the city to bomb and we've shown them around," he writes. "It's coming time for them to start showing us around there."

"When I talk about the suburbs," he elaborates, "it's mostly as a metaphor for anyone anywhere who makes a problem worse by running away from it. It just so happens that a lot of those people live in the suburbs."

Brought up in the affluent Chicago suburb of Hyde Park to Jewish parents, the 22 year-old has consciously immersed himself in the culture of the inner-city. Wimsatt is very much aware that he is straddling two worlds: the one he came from and the one he longs to be part of.

"I'm not really bridging the gap," he says. "I'm running back and forth between all these armed camps, redistributing some of the insights."

The conversation grows tense as we talk about graffiti. His mother is dead set against it.

"What I really hate about graffiti is the danger," she says. "It's very toxic. I don't think that spray paint should be legal. He could be shot by a cop, electrocuted, run over by a train. "As an afterthought, she adds: "I don't like hitchhiking either.

The blurb "Why you should read this long-ass shit" appears on the back cover of Bomb The Suburbs and sets the tone for the book. "It's an immature work," he says. "No mature person would like this book. The main fact about the book, not anything having to do with the merit of the book itself, is that it shows just how much is missing from publishing today: youth, subculture, politics and how low the quality of discussion is."

He targets his audience in the first few pages of the book: "First, there's the old-schoolers who want to break away from what has become hip-hop; hitchhikers who have the patience to

http://

"The most powerful use of the Internet for craft or design theorists must be the access [it provides] to other cultures. If I am researching any aspect of a culture in any country in the world, I can research it on the Net and get responses from people from those countries. I would never have this kind of access in real life. The medium is incredibly powerful. I had occasion recently to ask for any texts referencing the development of glass arts in Mexico during the 19th Century. The responses I received not only suggested a whole bibliography of items, but it began a discussion on Mexican glass arts. From the discussion, I gathered that the way in which I was approaching the writing was rather outdated. This of course was very useful for me." Jackie Corbee, Designer, Arizona, USA

"I sell many of my designs through the Internet. As I am a designer of glass art and have a Web page that people can reach if they want to see my designs... I make work by commission and I have editions of existing works displayed for all to see... I get orders from all over the world. I have never been concerned about copyright; no more concerned than if I had the images in a book or a magazine or in a flyer. After all, anyone can steal an image; it is still protected by my copyright and I have the best copyright proof—my own marked Home Page. I joined the ARTCRIT mailing forum because I wanted to be part of a list that had some discussion about the critical and conceptual theories of art. Many of the other groups simply provide practical information, but ARTCRIT often has engaging and interesting conversations about the concerns of 'art' and 'craft' and 'design'." Frank Wayne, Glass Artist, Durham, United Kingdom

"I make jewelry as a small-scale retail business and am now receiving via e-mail the postings from the CRAFT-L group which shares practical information such as sources of supplies, books and videos, societies, techniques, problems, pricing and marketplace issues, and exchange ideas on philosophical issues. The Internet is a wonderful way to collect, display and retrieve information of all kinds." Susan Campanini, Jeweler, Illinois, USA

"The Internet allows me to network and exchange information and ideas with other designers working in similar fields. The usefulness of the Internet for me is two fold: firstly it gives me access to discussion of current theory and practice in design; secondly I have become a more visible designer. It gives me a prominence which I don't believe I would have had outside of the Internet." Frank Jenssen, Designer, New York City, USA

"Several months ago on ARTCRIT there was a discussion concerning the definitions surrounding 'art' and 'craft'. I was dismayed to find that many on the list felt that 'craft' did not deserve to be discussed within a critical forum. I was so angered by this response that I and several other ARTCRIT members continued the thread—arguing for the need to engage in critical theoretical discussion of craft. This, in turn, led to a discussion on definitions of craft, issues of professionalism, and ideas about conceptual and edition based work. It is this kind of discussion that makes this forum so frustrating and yet so empowering. It is a great place to be able to really make a mark." Jean Kayser, Designer, New Jersey, USA

3

Mandy Martin

Bronwyn Bancroft

Ironsides

An unusual brief. 100 artists were given a 40cm square piece of corrugated iron as a base material to work with. The results were painted, sculpted, cut, welded, glued, rusted and blowtorched. Bronwyn Bancroft said, "I called it Will of Iron. Hey, it's a sign of the times—let's pick that Aboriginal artist because she's so political. I was born political. Let's pick that Aboriginal artist because she talks our intelligent language. Colonisation stole my language. It would be great include her in this exhibition but her works are not traditional. My tradition is myself, my family and my genealogical ties."

And as Mandy Martin said, "I have just read Faulkner and was pondering the wilderness within, as well as many years of settlement. I was also affected by the short required for decay, nevertheless I was optimistic - hence old tin, new tin. This is also a sign of the country and becomes a comment on colonisation."

In October 1995, the works were auctioned to raise funds for the $2 million Stage Two of the New England Regional Art Museum which will enable permanent display of the Howard Hinton and Chandler Coventry collections, as well as other exhibition spaces, a sculpture terrace, a theatre, artist's studio, cafe and expanded bookstore.

RFC Glass Award

Deb Cocks' slumped, enamelled and engraved glass plate titled *Stream* won the $7500 prize in the inaugural RFC Glass Art Award, sponsored by the merchant bank, Resource Finance Corporation, and established in conjunction with the Glass Artists Gallery to highlight innovative developments in Australian glass. As one of the judges, Karilyn Brown said: "The conceptual depth, technical proficiency and commitment to pushing boundaries which characterised much of the work submitted for consideration was a challenge for the award selectors." *Stream* has been acquired for Resource Finance Corporation's permanent collection.

Detail of Stream

Oops!

In the last issue we ran a story in *fresh* on the new and innovative Gallery Funaki but illustrated it with an image of the *Production - Reproduction* exhibition, designed by Suzie Attiwill for Gallery 101, Melbourne. *Object* apologises to Mari Funaki and all our readers who noticed that Gallery Funaki had metamorphosed overnight.

speakers

Giant cogs droop from stems of steel. Beside them, two golden discs balance on chrome as a black ellipse swings between intersecting rods.

Everywhere there is music. This place of sci-fi fantasy and hi-fi sound is not the elaborate set of some Spielberg blockbuster but the combined creative genius of nine Sydney artists who've collaborated with acoustic engineer, Ralph Waters, to produce *Speakers*—a dramatic exhibition of full range, hi-fidelity loudspeakers which are breathtaking works of art.

Irreverent and hybrid, the speaker sculptures include a human face moulded from silicone masks and made into plaster; a space-age coffee table hacksawed and hammered out of rusted and polished steel; a two-metre high metal geometric form using wheels, clear enamel and recycled saw blades; a 3-dimensional suspended ellipse of plastic and metal; a whimsical version of a sitting canine just six inches high.

Waters says the life expectancy of the sculptures in *Speakers* is probably better than mass-produced black box versions. "Most of these will still be kicking around in 10 to 15 years time," he says. "A really good set of speakers will cost around $3000, and that's a mass produced item in a box. The asking price for a number of these sculptures is less than that. What you're actually buying here is high quality sound and a unique work of art. Putting a price tag on that is very difficult."

Speakers features the work of Frederic Berjot, Rosalind Butler, Michael Dickinson, Linda Franklin, Martin Lee, Matt Long, Brett Rose, Peter Vella, Nicholas Vicic, Diane Penney (photographer) and Ralph Waters (sound engineer). It was first exhibited at the UTS Gallery, Sydney, 17 October-7 November followed by an exhibition and performance at the ABC's Atrium Gallery, Sydney, 16 November-7 December 1995. In 1996 it will tour to other capital cities and North America.

Diane Penney and Catherine Clifford

Photography: Diane Penney

4

pages 114-15

Object

art directors 1, 2, & 3 Zoe Wishart @ ANTART
4 Heidi Ritederer @ Organised Design
designers 1, 2, & 3 Zoe Wishart @ ANTART
4 Heidi Ritederer @ Organised Design
editor Helen Zitko
publisher Centre for Contemporary Craft
origin Australia
dimensions 210 x 275 mm
8¼ x 10⅞ in

LOUISE PURBRICK

A gallery. Some noise. Two photographs.
Twelve portable microfiche readers. Six desks with six engravings. And some words. There is an announcement and an inscription and the installation's title: *Those Days Are Gone*. The inscription, taken from Walter Benjamin's 1936 essay *The Storyteller*, is written on the walls:
"A generation that had gone to school in a horse drawn streetcar now stood under the open sky in a countryside in which nothing had remained unchanged but the clouds and beneath these clouds, in a field of force of destructive torrents and explosions, was the tiny, fragile, human body."
Take the announcement and the inscription together. They read as words of warning about how nothing can be the same again. A sense of loss is produced in Andrew Stones's installation, but without it's usual accompaniment: nostalgia. ¶ Nostalgia, according to a nicely punctuated entry in the *O.E.D.* is "sentimental yearning for [some period of] the past". Good use of brackets. The *O.E.D.* compilers know what to put in parenthesis in order to explain that there may be a period of the past as the focus for nostalgia, but not necessarily. Just the past will do. The appeal of the past is obvious: It has happened so it seems certain. It appears easy to know. It feels familiar. Safe. The past provides comfort when the present only offers the capacity to change. Nostalgia is the longing for the old as the new takes over: a traditional reaction. ¶The past produced by nostalgia as a place of safety has been used to justify a retreat into tradition. And, some periods of the past have been preferred for this purpose. The Victorian era was pressed into political service during the Thatcher regime to represent a traditional time when the power of the English nation-state was secure. ¶Nostalgia, and especially nostalgia for the nineteenth century, is now a standard strategy of conservative administration. Hankering after the past is helped along with a Heritage Ministry. Its projects have been allocated funding from the profits of the National Lottery. Nostalgic enterprises look set to take over even more gallery space than before.

From Andrew Stones's installation

After Tom Brown's Schooldays, 1903.

Yet there is room to think about music as revolutionary in other senses. There is much to be said for those musicians who attempt to provoke their audiences to think about contemporary issues, or, at least, to think at all. And while too many fans of Billy Bragg will sing along to the workers' flag without stopping to consider the context and history of that song (and there are other less obvious examples), the place of popular music within the cultures of the Left has a significance that should be fostered. We all like to dance, and we are complete klutzes and know it. Myself, I will happily make a fool of myself on the dance-floor—I don't get thrown off too often). The problem is, how-ever, that the Left and music still seems to be mired in a simple equation of Folk and Message, militant content and arcane form.

This is not some Pied Piper evangelism but something rather more modest or experi-mental. I propose to consider music and sound as disharmonious accompaniment to the con-ventions of Western metaphysical thinking, or, at least, as a possible contrapuntal melody which could sound out a critique of capitalism. This would be well beyond the conventional folky version of Left music, but in some deeper extrapolated therefrom, and certainly requir-ing studious attention to the minutiae of Marxist argumentation. Too often the dull and grim struggle of the sloganeering Left allow people to skive off the hard work of having to read those old texts. No easy task, but there's no avoiding it either.

But the revolutionary place of music requires more justification than as some kind of mass communication shorthand capable of reaching those who have been dissuaded from purchasing Left literature on the High Street by newspaper-sellers from hell. Nor can it not just some kind of cultural therapy cum release valve for after-six demo and/or to raise money for jailed comrades, campaign, printing-presses and so forth. There are more interesting things going on in clubs, homes and the 'scene' (wherever that interzone reality of today – SimCity 2000, I guess). Most excellent, for example, has been the evolution of the campaign against the Criminal Justice bill(fact from being a gut-reaction defence of the right to party into a wider youth politicisation which recognises Government as the racist, capitalist, bigot-enemy trying systematically to renovate a tired imperialist back-waterYeah, yeah <insert illustrative metaphor of ongoing struggle>. But there must be more that is revolutionary about music for it to survive ever-present commercialisation and make it worthy of our continued support. What might this be? Perhaps at a time when the modes of communication, presentation and dissemination are transformed exponentially, music can still also be a means to think differently. To think otherwise than we do now–and excuse the clichés–to move beyond the instrumental and repetitive thinking we have been taught, and teach ourselves and to listen for something other than the same old tunes. Hey! Ho!...

Basically, the first and most general step in my argument is that music is not just there. It's a communal thing, produced, performed and heard in a context, today that context is, to a lesser or greater extent, at the productive margins of Capitalism – be it rave/tekno or bhangra/jungle, banned or platinum, big megabucks production or four-track amateurs, Ice T or Kylie M, or even your local garage grunge-party DJ dreamer, whoever you know. But, wherever and whatever it is, music can be considered over against, even resistant <in your dreams> to commerce and the contexts of the market. Not always, and often only barely, but there is – still – something excessive in sound, something surplus. So, in order to rethink this context it might be useful to suggest that the sounds we consider, say, under the formation 'popular music', as the classical music, even musical notation, or even like writing, as a record, are co-constituted in time with audiences as presence: (text and eye, instrument and ear). People together in the context of sound. Now, just what is music? We have been taught of late to think of it as product, but what do we mean? Music is a context of sound. We play, but not just to play. The context of music offers us an immediacy which has been broken down into constituent and market-able components, to part of the double deceit of capital, music seems now con-tained in the performed, or recorded 'nature', of sound in the context of purchase, and we have come to believe – mostly through the privileging of presence in writing – that the recording is a way of retaining sound and the performance is a presentation of sounds [and visuals since MTV, Madonna, etc]. The disruptive point to introduce here, so subtle, is that the presentation or the recording suggests a level of articulation of sound which is not music itself. A kind of echo of music in the market. This dou-bie structure has been a silent facility in the commercialisation of sound (a role dep-loyed to the performers' skill or memory, or to musical notation in live performance. but most significant since the develop-ment of vinyl, the cassette tape and the CD).

This must be dealt with in terms of the labour theory of value as understood by Marx in the latter sections of *Capital* (and modified in part given new understandings of the status of endless playings of a CD and the availability of on-line clips down on radio, cyber caf – again given the co-constitutive 'labour' of the listener). The labour that is required to produce an object, or objects – in this case a CD, CD player, speakers and all other ends – in labour that has been stolen from labourers by capitalist investors.

Although the co-ordination of capitalism enables music production and distribution, it is on the basis of this co-ordination, and ownership of the means of production, distribution etc, that capitalists are able to exploit the inequity of a process where work is not paid according to its return, the value it creates on the market. Basically, a very long story which must be read in detail, amounts to the theft of labour by a bunch of old men in suits, and others not so old, with ponytails and sportscars, but also in suits. This theft of value extends, I think it can be argued, to the various forms of 'work' it is necessary for you to do in order to be in a position to be a listener, and so make music. This co-constitution of sound requires us to rethink consumption as a production subsumed within a capitalism which colonises all aspects of life (Marx's 'real subsumption' discussed in *Capital* vol. 1 could be usefully elaborated – a reading offered by the lyrical Antonio Negri begins this very week – see *More Beyond Mod*, Hmmm.

That sounds too difficult. Let's cut though. It may be right. And it makes us focus upon the communal context of music in a more sophisticated way than previous Lefty-folksy music. Get back to me.

Instead of exploring the endless permutations and distinctions of this part of a sophisticated labour theory of value project (it's too long and winding a road, but I am trying to get 'work' to it), it is possible to draw in other interesting works for similar ends. In a related register it might also be suggested that a recording is a kind of negative. Not only as a product, but certainly essential for the structure of capital which requires a purchase and a development on the part of the listener/consumer. It is clear that a recording is not yet the sound, and never can be, and must be decoded or – excuse the German – 'aufhebung'. If it is to become the sound. A performer must play the piece, read the notation, or a CD must be put into the player and the play button pressed, etc.

Further development of this point would require a difficult contemplation of the ontological status of the negative (check out the down rhythms of Giorgio Agamben's *Language and Death*) and its relation to the dialectic (see that old beat philosopher and techno DJ Martin Heidegger who asks in *Sein und Zeit* why does every dialectic take refuge in negation.' 332). The recording is somehow the negation of sound itself required to repro-duce sound. The diamond stylus is in contact with the grooves of vinyl in an easier represen-tation of this, but the digital complexity of the CD is not so far removed from the notations of a Beethoven and so on.

The point is not to abandon all recordings (a rerun of the fun of dumping televisions out of apartment windows – not revolution but to rethink music as mutual co-production in need of a recovery operation to undo the negative appropriations of capitalism and industry. The task of a revolutionary rethinking of sound then might attempt to link the anti-establishment ethos of some, admittedly not enough) popular music to this scene of negativity with a view to transformation. Not that everything must be understood as moving in a negative dialectic (since some might even call this break-beat), and neither is it the case that a simple overcoming of outmoded musical styles will help settle old scores – at least not without considerable practice. But the rethinking of the negative in music as part of a dialectical movement, although within the thinking of Western metaphysics, as negative invention, should offer the possibility of thinking otherwise – and so through a mass movement help manifest an alternative to capitalism or, at least, the possibility of disruption and dysfunction within the neat crisis-recon-struction-crisis cycle of the corporations. It is the beginnings of this that some may recognise, intuitively, in the links between music and politics made explicit every now and then. The next step would be to base this explicitly on a further reasoning of music politics that goes well beyond manifest-poseurs and the star-syndrome of pop. Rave, Jungle begin a more inclusive politics of sound. Subsequently, the overcoming of exploitative (negative) capitalist relations would thus initiate a revolutionary transformation of life – with a beat you can dance to. That'd be cool. Music, Amusement, the Muse bemused.

pages 112-13

Versus

art director Mark Hurst
designers Billy Harcom
 Mark Hurst
origin UK
dimensions 245 x 285 mm
 9⅝ x 11¼ in

editors Heidi Reitmaier
 Rob Stone
publisher Versus Contemporary Arts
 Rob Stone
 Mark Hurst
 Rob Stone

Number 4 1995 £3.00 versus

24 UDR Roll of Honour, 'Peoples' Democracy'

25 Civil Order — plastic death, changes the word 'order' to 'murder', Sinn Féin

26 Ireland shouting at Britain with an earplug campaign for free speech on Ireland, by Bill Sanderson, Leeds Postcards

27 A police photo-fit picture of Margaret Thatcher, Wanted for Terrorist offences, Sinn Féin

28 The police free trade union logo Solidarity, used as part of a joint Unionist campaign, Sinn Féin

29 Britain/soldier being chased by Ireland/dog, Sinn Féin 1970s

28

24

25

26

29

Text set in Courier, Gill Sans regular, italic and bold

Because symbols in Northern Ireland are so common and visually inseparable to the uninitiated, misperception by visitors is common. The media often get it wrong and tourists help to exaggerate the enigma. Once an American friend of mine pointed out to me that she found it incomprehensible that in Northern Ireland people blatantly expressed their political affiliations by displaying an 'L' for Loyalist or an 'R' for Republican on their car windscreens. A humorous observation to anyone who has ever been a 'Learner' driver in Northern Ireland, because when you pass your test you are 'Restricted' to a speed limit of 45mph for your first year. I've even made such errors myself and once saw a car tax disk saying 'Keep Ulster tidy, throw your rubbish in the Republic', although it wasn't on a car. Tourist gimmicks are not uncommon. You can buy 'Shankill Road' rock or a foot shaped lolly that says 'Kick the Pope'. You can even buy an 'Ulster Says No' mug, just in case you've forgotten what it was Ulster said while having your coffee. — 'No' to what is the only other issue that might have slipped your mind.

Basically, visual propaganda has taken three directions, the first uses existing images and reverses the meaning. Remember the 'Watch Out, there's a thief about' campaign of the 70s. The second is the romantic – idealistic in content but often beautiful in what it really represents. The third is a diary of recent events – used to express the points of view of recent political movements or events. The latter provides the core of the 'dialogue', creating a reactionary chronicle to

common and visually inseparable to the uninitiated, misperception by visitors is common. The media often get it wrong and tourists help to provide territorial markings.

which either community responds. But it also is used as a path in order to achieve much wider communication. Initially, the art on the walls had the purpose of communicating directly and conspicuously to the local community, and to provide territorial markings.

In the late 60s and early 70s, this was probably the only accessible means of political expression. Eventually the walls became a focus for other forms of media. Once a mural would appear, the television cameras and newspaper photographers were quick to document it. This form of indirect publicity provided the channel the instigator required.

In recent months we have seen some major PR work done for the political wings of the paramilitary organisations. Their logos spruced up along with their dress codes. I'll even admit to beginning to like the look of the Sinn Féin logo since its been given the 'agency' treatment. It just makes me consider the idea that maybe more of these 'scribbles' have some quite inventive qualities to them and whether, in years to come, with a so called 'respectable' face applied, these images of war and sectarian liveries could become appreciated for other reasons.

When photographer John Holden began to take photographs inside one of Europe's largest shopping malls he was intrigued by the massive architectural space and the way in which it was being used to create the 'ultimate shopping experience'. He decided to locate the centre's security and surveillance cameras and to take a series of pictures from these positions, tracking across the same fields covered by these devices. Holden made a selection from these random images, scanned and edited them on screen, creating a collection which reflects those images **which had informed the** security presence.

Holden believes that a city becomes a site for gathering and exchanging 'useful visual information. He postulates that the photographer becomes part of this process, part of a system which seeks to attribute meaning and significance to isolated fragments and which reconstructs sequences of images obtained through often hidden devices. Holden concludes that this observation of routine movements determines new codes of what is 'normal' or 'suspicious' behaviour and creates environments in which we regulate our thoughts and actions accordingly. The combination of the design of consumer spaces and the free use of surveillance devices creates a new form of 'public-private' space.

Holden decided to publish the project in book form with **Chris Ashworth**, creating a book in which the photography, text and design **would complement each other.** Sean Cubitt wrote the text and Chris Ashworth designed the book, adding to the project through the use of collages created from a combination of 'found' items: tickets, receipts and other 'urban documentation' from friends' collections, and the text. The typesetting utilised a Mac font designed by Ashworth, old letterpress, typewriting and faxes.

With these thoughts in mind Holden systematically photographed the city centre, the business areas at night and along the road systems leading to the airport.

Holden expresses the hope that Interference makes some contribution to the debate which asks:

'what is individual freedom?'

The book is a fascinating and faintly disturbing amalgam. It can be read on many levels, the images, which are often almost abstract, can be noted or unravelled. The type itself reflects that myriad of unconsidered 'throwaway' typography at the bottom of the shopping bag or suitcase. Interference is sufficiently visually intriguing to tempt the reader into **the subject matter, where Holden's success in going beyond his photographic** achievement can be judged.

Text set in Formata Regular, Italic and Bold

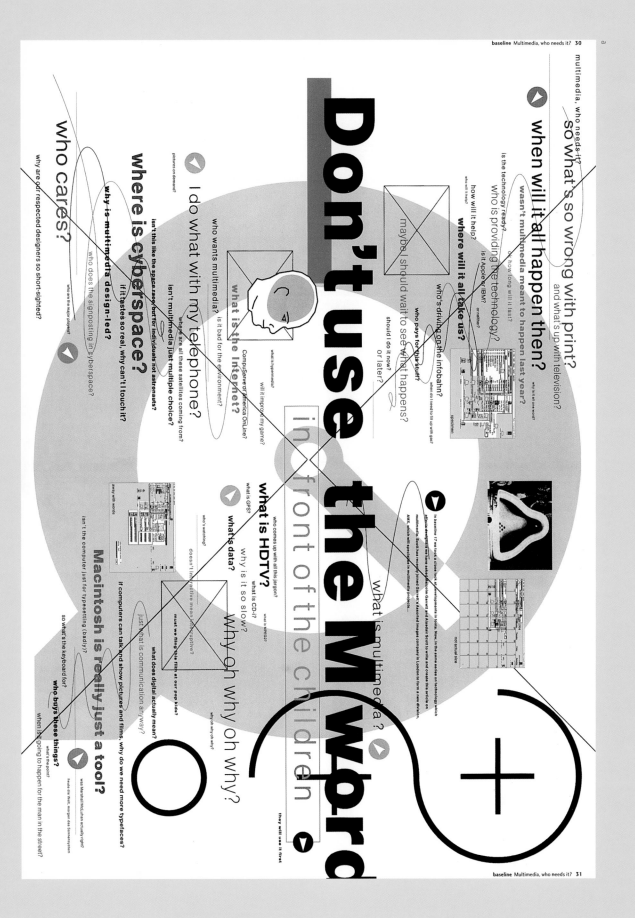

multimedia, who needs it?
so what's so wrong with print?
and what's up with television?

when will it all happen then?

Is the technology ready?
wasn't multimedia meant to happen last year?
who is providing the technology?
oh how long will it last?
how will it help?
Is it Apple or IBM?
who will it help?
where will it all take us?
or neither?

maybe I should wait to see what happens?
who's driving on the infobahn?
when do I need to fill up with gas?
who pays for this stuff?
should I do it now?
or later?

what is hypermedia?

who cares?
why are our respected designers so short-sighted?

who are the major players?

where is cyberspace?
pictures on demand?

isn't this like the space race? but for individuals not astronauts?
why is multimedia design-led?
if it tastes so real, why can't I touch it?
isn't multimedia just multiple choice?
who does the signposting in cyberspace?

I do what with my telephone?
where are all these satellites coming from?

who wants multimedia?
what is the Internet?
is it bad for the environment?
CompuServe or America OnLine?
what is the Internet?
Will it improve my game?

Don't use the M word
in front of the children

what is multimedia?

In baseline 17 we took a close look at developments in fonts. Now, in the same excites on technology which multimedia designers... we have seen. Malcolm Garrett and Alasdair Scott to write and create this article on multimedia. AMX, which will specialise in multimedia projects...

not actual size

specimen

what is HDTV?
what is GPS?
who comes up with all this jargon?
what is MPEG2?

what's data?
what is CD-i?
why is it so slow?
who's watching?
Why oh why oh why?
doesn't interactive mean interactive?
why oh why oh why?

must we fling this filth at our pop kids?
what does digital actually mean?
just what is communication anyway?

Macintosh is really just a tool?
away with words
It computers can talk and show pictures and films, why do we need more typefaces?
isn't the computer just for typesetting (badly)?
who buys these things?
what's the point?
so what's the keyboard for?
who is going to happen for the man in the street?
heute die Welt, morgen das Sonnensystem
was Marshall McLuhan actually right?

what's multimedia for?

they will use it first

Baseline

a

art director
Hans Dieter Reichert @ HDR Design

designers
Hans Dieter Reichert
Brian Cunningham
Malcolm Garrett
Stephanie Granger
Dean Pavitt

photographers/illustrators
Why Not Associates
Ian Teh
HDR Design

editors
Mike Daines
Hans Dieter Reichert

publisher
Esselte Letraset

origin
UK

dimensions
245 x 345 mm
9⅝ x 13⅝ in

b

art director
Hans Dieter Reichert @ HDR Design

designers
Hans Dieter Reichert
Dean Pavitt
Simon Dwelly
Brian Cunningham
Will F. Anderson

editors
Mike Daines
Hans Dieter Reichert

editorial advisory board
Martin Ashley
Misha Anikst
Colin Brignall
David Ellis
Alan Fletcher

publisher
Bradbourne Publishing Ltd

origin
UK

dimensions
245 x 345 mm
9⅝ x 13⅝ in

c

art director
Hans Dieter Reichert @ HDR Design

designers
Hans Dieter Reichert
Dean Pavitt
Simon Dwelly

photographer/illustrator
John Chippindale

editors
Mike Daines
Hans Dieter Reichert

editorial advisory board
Martin Ashley
Misha Anikst
Colin Brignall
David Ellis
Alan Fletcher

publisher
Bradbourne Publishing Ltd

origin
UK

dimensions
245 x 345 mm
9⅝ x 13⅝ in

b

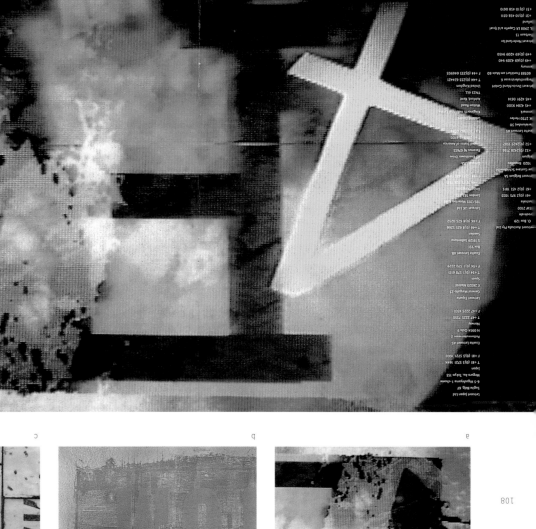

© 1994 Esselte Letraset
ISBN 0954-9236
⊗ ESSELTE Letraset

baseline is the leading International Typographics journal published by Esselte Letraset

+39 (0)2 3921 6135
Italy
+39 (0)2 3921 6677
20156 Milano
Via Riccione 8
Letraset Italia Srl.

+31 (0)10 458 0610
+31 (0)10 458 0351
Holland
2908 LK Capelle a/d Ijssel
Riviumboulevard by
Letraset Nederland by

+49 (0)69 4209 9450
Germany
+49 (0)69 4209 940
60388 Frankfurt am Main 60
Ziegenhainerstrasse 6
Letraset Deutschland GmbH

T +44 (0)235 646903
F +44 (0)235 624421
United Kingdom
TN23 6LL
Ashford, Kent
Kimberton Road
Letraset Limited

+45 4291 0614
Denmark
2750 Herlev
IK 2750 Herlev
Letraset Letraset A/S

+32 (0)2425 1587
Belgium
+32 (0)2436 7156
1020 Brussels
Rue Gustave Schildknecht
Letraset Belgium SA

+61 (0)2 451 1815
Australia
+61 (0)2 925 1033
NSW 2100
P.O. Box 129
Letraset Australia Pty Ltd

F +46 (0)8 625 0212
T +46 (0)8 625 5266
Sweden
S 19129 Sollentuna
Box 951
Esselte Letraset AB

F +34 (0) 570 2229
T +34 (0) 570 6157
Spain
E 28020 Madrid
General Margallo 25
Letraset España

T +47 2235 4101
T +47 2235 7550
Norway
N 0956 Oslo 9
Esselte Letraset AS

T +81 (0)3 5721 1660
T +81 (0)3 5721 1644
Japan
Meguro-ku, Tokyo 153
6-5 Higashiyama 1-chome
Sugita Bldg. 6F
Letraset Japan Ltd

c

b

a

baseline
INTERNATIONAL TYPOGRAPHICS JOURNAL

baseline
INTERNATIONAL TYPOGRAPHICS JOURNAL

baseline
INTERNATIONAL TYPOGRAPHICS JOURNAL

Fuse 1: Superstition
Featuring four experimental fonts
plus their related A2 posters
by Scott Clum, Hibino,
Pablo Rovalo Flores & Tomato,
Plus six bonus fonts.

SUPE RSTIT ION

F Ritual 1–4 © Neville Brody © 1995 FontShop International ℗ Poster printed on recycled paper

designer Neville Brody

designer Pablo Rovalo Flores

16⅝ x 23⅜ in
420 x 594 mm
posters
dimensions

UK
origin

FontShop International
publisher

Jon Wozencroft
editor

Neville Brody
art director

posters and packaging

Fuse

pages 106-7

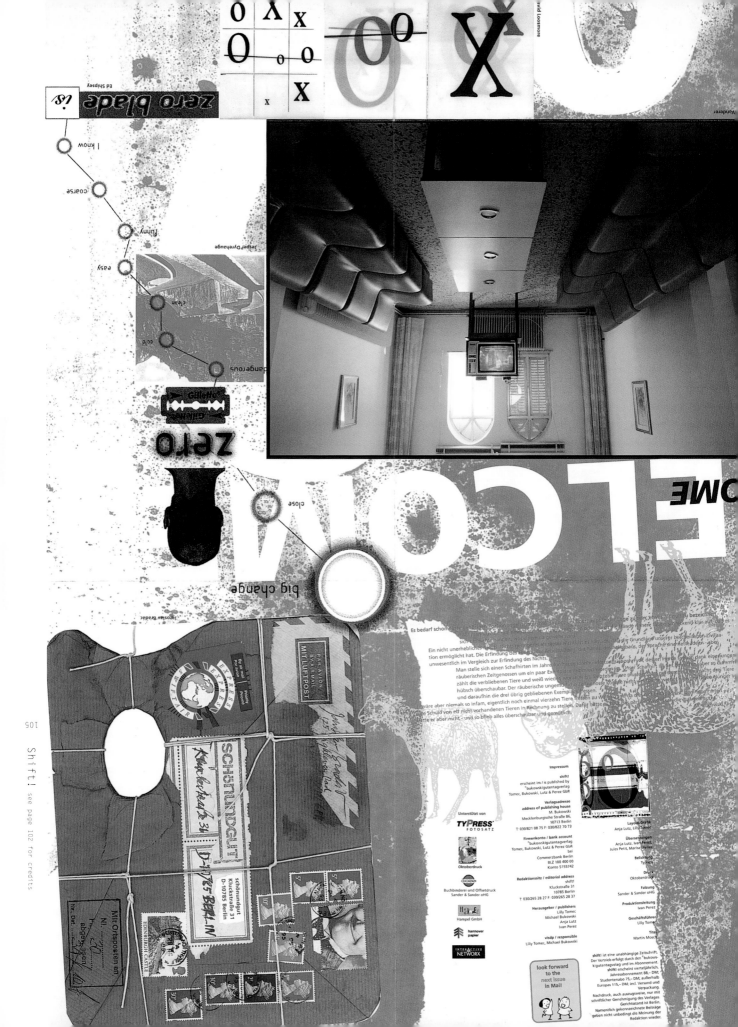

zero blade *is*

Ed Shipsey

I know
coarse
funny
easy
clean
cold
dangerous

Jesper Dyrehauge

zero

close

big change

Jaroslaw Bradac

WELCOME

David Loosmore

Vanderer

Es bedarf schon einer gewissen Portion ungenierter Anmaßung, um überhaupt in Erwägung zu ziehen, etwas "Wesentliches" bezeichnen zu ...

Ein nicht unerheblicher ...

Man stelle sich einen Schafhirten im Jahre ...

zählt die verbliebenen Tiere und weiß wieder ...

hübsch überschaubar. Der räuberische ungemütlich ...

und daraufhin die drei übrig gebliebenen Tiere fressen ...

wäre aber niemals so infam, eigentlich noch einmal vierzehn Tiere fressen zu wollen ...

Schuld von elf nicht vorhandenen Tieren in Rechnung zu stellen. Dafür hätte ...

hätte er aber nicht - und so blieb alles überschaubar und gemütlich.

PAR AVION
BY AIRMAIL
MIT LUFTPOST

EXPRESS
Priority
Prioritaire

SCHÖNUNDGUT
Kluckstraße 31
D-10785 Berlin

schönundgut
Kluckstraße 31
D-10785 Berlin

Mit Ortsposten an

EDINBURGH CASTLE

TYPRESS FOTOSATZ

Oktoberdruck

Buchbinderei und Offsetdruck
Sander & Sander oHG

Hampel GmbH

hannover
papier

INTERACTIVE NETWORX

look forward
to the
next issue
in Mail

Impressum

shift!
erscheint im / is published by
°bukowskigutentagverlag
Tomec, Bukowski, Lutz & Perez GbR

Verlagsadresse
address of publishing house
M. Bukowski
Mecklenburgische Straße 86,
10713 Berlin
T: 030/821 08 75 F: 030/822 70 73

Firmenkonto / bank account
°bukowskigutentagverlag
Tomec, Bukowski, Lutz & Perez GbR
bei
Commerzbank Berlin
BLZ 100 400 00
Konto 5155742

Redaktionssitz / editorial address
shift!
Kluckstraße 31
10785 Berlin
T: 030/265 28 27 F: 030/265 28 37

Herausgeber / publishers
Lilly Tomec
Michael Bukowski
Anja Lutz
Ivan Perez

visdp / responsible
Lilly Tomec, Michael Bukowski

Layout/Grafik
Anja Lutz, Lilly Tomec

Übersetzungen
Anja Lutz, Ivan Perez,
Jules Petit, Marina Welles

Belichtung
Typress

Druck
Oktoberdruck

Falzung
Sander & Sander oHG

Produktionsleitung
Ivan Perez

Geschäftsführer
Lilly Tomec

Titel
Martin Mosch

shift! ist eine unabhängige Zeitschrift.
Der Vertrieb erfolgt durch den °bukows-
kigutentagverlag und im Abonnement.
shift! erscheint vierteljährlich.
Jahresabonnement 88,– DM;
Studentenabo 75,– DM; außerhalb
Europas 115,– DM; incl. Versand und
Verpackung.

Nachdruck, auch auszugsweise, nur mit
schriftlicher Genehmigung des Verlages.
Gerichtsstand ist Berlin.
Namentlich gekennzeichnete Beiträge
geben nicht unbedingt die Meinung der
Redaktion wieder.

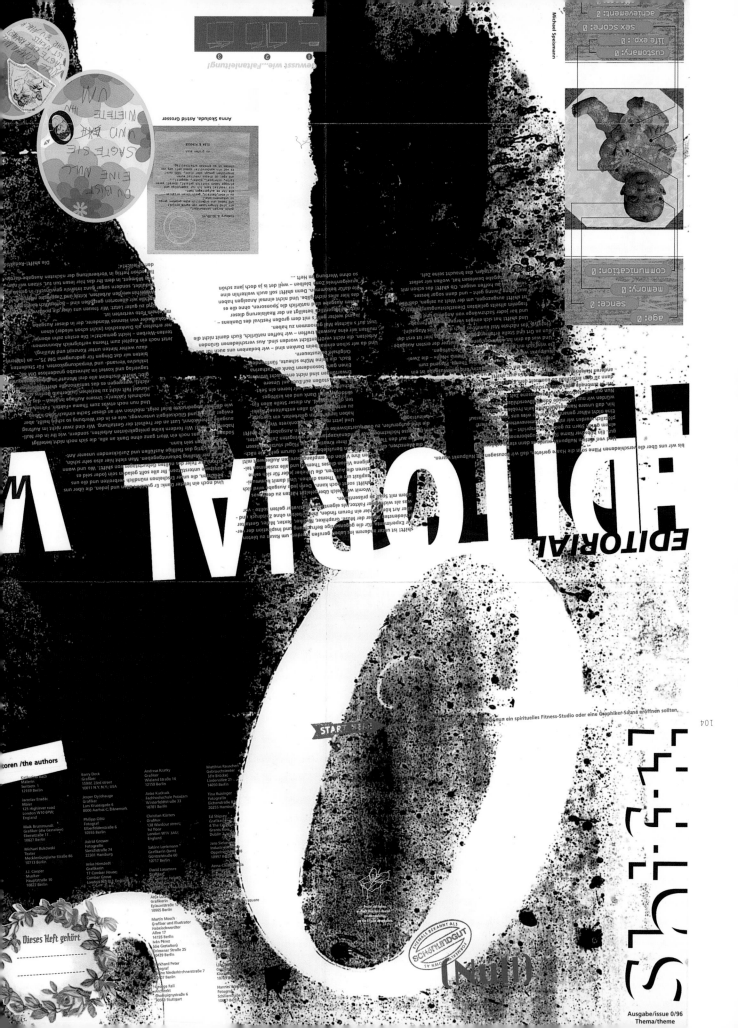

EDITORIAL

SHIFT!

Ausgabe/issue 0/96
Thema/theme

START HERE

...oren /the authors

Karl-Heinz Bach
Malerin
Sentestr. 1
12159 Berlin

Jaroslav Bradac
Maler
125 Highlever road
London W10 6PW;
England

Maik Brummundt
Grafiker (die Gestalten)
Eberstraße 11
10827 Berlin

Michael Bukowski
Texter
Mecklenburgische Straße 86
10713 Berlin

J.J. Cooper
Maaßer
Hauptstraße 10
10827 Berlin

Barry Deck
Grafiker
158W, 23rd street
10011 N.Y. N.Y.; USA

Jesper Dyrehauge
Grafiker
Lars Kruusgade 6
8000 Aarhus C; Dänemark

Philipp Götz
Fotograf
Elberfelderstraße 6
10555 Berlin

Astrid Grosser
Fotografin
Sierichstraße 74
22301 Hamburg

Imke Hemstedt
Grafikerin
17 Comber House;
Comber Grove
London SE5 0LJ; England

Anja Lutz
Grafikerin
Eylauerstraße 17
10965 Berlin

Martin Mosch
Grafiker und Illustrator
Habelschwerdter
Allee 17
14195 Berlin

Iván Pérez
(die Gestalten)
Driesener Straße 25
10439 Berlin

Burkhard Peter
Fotograf
Niederkirchnerstraße 7
10117 Berlin

George Rall
Architekt
Olgastraße 6
70182 Stuttgart

Andreas Kratky
Grafiker
Wieland Straße 14
12159 Berlin

Anke Kuckuck
Fachhochschule Potsdam
Winterfeldtstraße 33
10781 Berlin

Christian Küsters
Grafiker
130 Wardour street;
1st floor
London W1V 3AU;
England

Sabine Lankmann
Grafikerin (bvm)
Güntzelstraße 60
10717 Berlin

David Loxamore
Grafiker

Matthias Rauscher
Gebrauchstexter
(die Brücke)
Lindenallee 21
14050 Berlin

Tina Ruisinger
Fotografin
Eichenstraße 8
20255 Hamburg

Ed Shipsey
Grafiker
The C...
Grants Row
Dublin 2;

Jens Siewer...
Industrie...
Oppelner...
10997 Berlin

Anna-C...

Hannes W...
Fotograf
Schlierb...

EDWIN UTERMOHLEN

It always baffles me why anyone in the world would be interested in type, but I am.

So my philosophy is just to dive in...

Gail

Chris

pages 102-3

Silo Communications

art director Brian Horner
designer Brian Horner
photographers/ Brian Horner
illustrators Chris Kilander
editor Brian Horner
publisher Silo Communications
origin USA
dimensions 279 x 279 mm
11 x 11 in

102

pages 104-105 ➤

Shift!

art directors Anja Lutz
Lilly Tomec
designers Anja Lutz
Lilly Tomec
editors Anja Lutz
Lilly Tomec
publisher Gutentagverlag/Shift!
origin Germany
dimensions 210 x 260 mm (folded)
8¹/₄ x 10¹/₄ in

hob
electric

[e.hob demo]

E.HOB: A FACE DESIGNED BY CHRIS TURNER OF TEN BY FIVE VISUAL COMMUNICATION. THINK ELECTRIC. IF YOU
REQUIRE ANY INFORMATION ON E.HOB OR ANY OTHER TEN BY FIVE PROJECTS, WRITE TO THE ADDRESS BELOW:
TEN BY FIVE, PO BOX 7454, LONDON, N15 4LR. E.HOB, AND THIS POSTER ARE THE COPYRIGHT OF CHRIS TURNER

abcdefghijklmnopqrstuvwxyz
zhxmmnnjslbdouuwwlnyfjiyhgjepcdq

IDEAL FOR INNER CITY LIFE!

10×5

BACK LEFT

design and typeface Andrew Degg

IRON FILINGS

Iron Filings see page 99 for credits

House-hold
Utility font

ABCDEFGHIJKLMNOPQRSTUVWXYZ

THE USEFUL UTILITY FONT: IRON FILINGS DESIGNED BY ANDY DEGG. IRON FILINGS AND THIS POSTER ARE THE COPYRIGHT OF ANDY DEGG

The wonder was that photo-shoots hadn't suggested to Man the arbitrary nature of time: an artful grid through which people could move unimpeded.

TOMORROW was her WORK

How else explain the existence of a sentence like 'TOMORROW WAS ANOTHER DAY OF WORK'|?

How else explain the fact that Time could be divided at all?

1345 >> HOUR DIVIDED INTO 60 MINUTES
1883 >> TELEGRAPH DIVIDES WORLD
1884 >> INTO TIME ZONES
1956 >> DUE TO VARIATIONS IN EARTH'S ROTATION, A SECOND IS REDEFINED
1961 >> NATIONAL BUREAU OF STANDARDS

pages 100-101 ➤

Iron Filings
Electric Hob

posters

art directors Ten by Five
origin UK
dimensions 297 x 420 mm
11³/₄ x 16¹/₂ in

pages 98-9

Emigre

art director Stephen Farrell
designer Stephen Farrell
photographers Stephen Farrell
 Gregory Halvorsen Schreck
writer Steve Tomasula
publisher Emigre
origin USA
dimensions 210 x 286 mm
 8¼ x 11¼ in

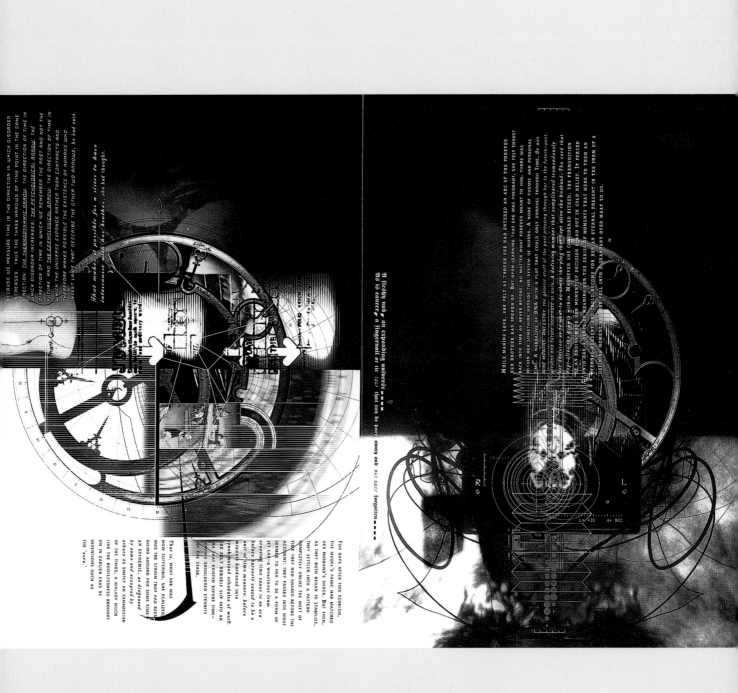

Emigre

art director Anne Burdick
designer Brad Bartlett
publisher Emigre
editor Anne Burdick
origin USA
dimensions 210 x 286 mm
8¼ x 11¼ in

WRITING AND THE GRAPHIC DESIGN COMMUNITY

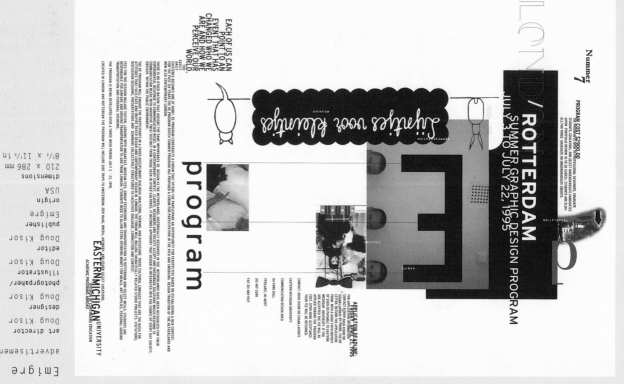

Emigre

advertisement
art director Doug Kisor
designer Doug Kisor
photographer/illustrator Doug Kisor
editor Doug Kisor
publisher Emigre
origin USA
dimensions 210 x 286 mm
8¼ x 11¼ in

Nummer 7

LOND / ROTTERDAM
SUMMER GRAPHIC DESIGN PROGRAM
JULY 3 TO JULY 22, 1995

EASTERN MICHIGAN UNIVERSITY

program

4

Joint Venture

Emigre
2 8 3
designer
Anne Burdick
editor
Anne Burdick
publisher
Emigre
origin
USA
dimensions
210 x 286 mm
8¼ x 11¼ in

Emigre 37 Price $7.95

3

mouthpiece
Emigre No. 36 Fall 1995 $7.95

2

Emigre
1 8 4
designer
Rudy Vanderlans
editor
Rudy Vanderlans
publisher
Emigre
origin
USA
dimensions
210 x 286 mm
8¼ x 11¼ in

mouthpiece
Emigre No. 35 Summer 1995

1

NO SMALL ISSUE
Emigre #33 $7.95

TYPOGRAPHIC CHAMBER OF

HORRORS

11³/₈ x 14¹/₂ in
dimensions 295 x 360 mm
origin UK
publisher Clare E. Lundy
editor Clare E. Lundy
designer Clare E. Lundy
art director Clare E. Lundy

gee magazine

pages 94-5

sa maison est en carton, pirouette cacahuète...

Bulldozer ®18f 111295

revue graphique à paris n° trois

frédérique gavillet

Bulldozer, modeste et cosmique, observatoire du graphisme post-moderne, affiche tous les deux mois son désir de transversalité. En ce temps serein de Noël, si propice au mercantilisme de masse et au « marché » d'une communication visuelle sonnante et trébuchante, Bulldozer fait montre d'à-propos en pointant son vif télescope désintéressé sur une face bien cachée de la planète graphique : le fiduciaire : billets de banque, pièces de monnaie, chèques et cartes de crédit mais aussi supports sécurisés tels que timbres, passeports, formulaires, cartes d'identité, etc. Objets quotidiens de nos existences transactionnelles ou administratives, qui se soucie de vous ? Miroirs de notre identité, individuelle et communautaire, quelles images de nous-mêmes renvoyez-vous ? Méconnaissables et parfois pitoyables reflets, pour tout dire selon notre cœur!

Comment supporter, par exemple, de vivre au pays du formulaire de Sécurité sociale le plus laid au monde ? Tel est le douloureux débat que propose Bulldozer avec Frédérique Gavillet, graphiste fiduciaire. Bulldozer, votre menue revue qui n'en peut plus, dans ce n°trois conçu à l'impitoyable regard spirographique. Bulldozer, votre troisième œil, compte plus que jamais sur l'apaisant collyre de vos abonnements pour mieux voir l'avenir. 'Partez-en aux rennes de ce bon vieux Père Noël...'

Une jeune graphiste qui avoue pêle-mêle son goût pour le baroque, les puzzles, les romans policiers ou la guerre d'Indochine et dont le héros n'est autre que l'inénarrable général Bigeard... plutôt déroutant, non ? Frédérique Gavillet est née en 1964 aux États-Unis. Elle entre en 1984 à l'école des Arts décoratifs de Paris, où elle se sent immédiatement à l'aise parmi les autres extra-terrestres de l'endroit.

LES VISITES TECHNIQUES (Application des articles

Bulldozer ®18f 010296

revue graphique à paris n° quatre

Fabrice Praeger

Bulldozer, petit tigre graphique dans votre moteur à idées, veut du bien à votre regard toute l'année, six fois par an : visions particulières, chemins de traverse du graphisme d'ici, images à facettes et panoramas de poche, étiquettes à déchirer et cloisons de papier à pulvériser sont au programme de votre épatante petite revue graphique pour cette année.

Afin d'aborder 1996 avec intelligence, Bulldozer vous invite à plisser le front et réfléchir en compagnie de Fabrice Praeger, saisissant et provoquant de créateur implique, mixage détonant de base d'entreprise en chambre, d'artiste insomniaque et de designer touche-à-tout, avec qui nous produisons ce numéro quatre. La trentaine affectueuse, ce graphiste tout-terrain multicombats décline ici pour nous sa stimulante schizophrénie sous la forme d'une dense galerie de travaux. D'élans impétueux en accès de lucidité pointue, le costume d'"homme-idée" qu'il se taille à grands coups de concepts tranchants intrigue et surprend, agace et charme tout à la fois. Son langage graphique, lui, séduit par son imparable force d'impact, parce qu'il propulse sans détour, avec une économie dénuée de sécheresse, du bon sens au premier plan.

Au paragraphe des bonnes résolutions, Bulldozer, votre troisième œil, litre toujours la langue en fin de mois et s'engage à vous faire voir quelques images en rose contre tout abonnement...

Bulldozer ®18f | 070895

revue graphique à paris — n°un

Bulldozer, phénix graphique, revient vous aiguiser la rétine. Sous la forme moqueuse et légère d'un poster recto-verso, Bulldozer vous propose d'explorer la jungle touffue du graphisme actuel. Tous les deux mois, Bulldozer braquera son petit œil curieux sur la démarche d'un créateur contemporain choisi pour l'exigence de sa réflexion et la qualité de ses images. C'est une recherche de proximité que nous désirons mener : Bulldozer débutera ses investigations par une série consacrée à des graphistes français, à l'image du génial polonais à Paris avec qui nous réalisons ce premier numéro. Abonnez-vous, faites-vous connaître, rejoignez-nous et n'hésitez pas pour exister, persévérer et prospérer. Abonnez-vous, faites-vous connaître, rejoignez-nous et n'hésitez pas à nous envoyer les travaux dont vous êtes fiers. La critique sera terrible et rien ne sera rendu. En n'oubliez pas : Bulldozer bricole pour vous une autre manière de voir!

image pour « La mort d'Auguste »,
une pièce de Romain Weingarten.
1995, photographie de Hyr Muratet.

Michal Batory

Michal Batory est né en 1959 à Lodz, Pologne. Élève des beaux-arts, non loin de la fameuse école de cinéma où étudièrent Wajda et Polanski, le jeune Batory découvre les règles de la composition auprès de Balicki, maître rigoureux marqué par la méthode constructiviste. Au gré des rues grises de Lodz, les affiches annonçant des événements culturels avivent les murs et font parler d'elles : dans un état policier où la télévision gouvernementale produit surtout des images fades, édulcorées par une censure omniprésente, où la publicité n'existe pour ainsi dire pas, ces affiches détonnent sur leur environnement. Leurs auteurs rivalisent d'audace et d'habileté subversive pour contourner la censure et obtenir l'autorisation d'imprimer de la commission chargée de juger chaque projet, tout en produisant des images fortes qui poussent à l'extrême l'inclination à la poésie des métaphores, aux jeux d'associations et aux significations latentes. Batory, qui en retiendra une inclination à l'extrême le sens de l'ellipse. Ces rares affiches ne manqueront pas d'exercer leur influence sur le travail de

pages 88-93

Bulldozer

art directors
Anne Duranton
Pascal Béjean
Frédéric Bortolotti
Philippe Savoir

Bulldozer ®18f | 091095

revue graphique à paris — n°deux

Bulldozer se plaît à observer la profusion visuelle du graphisme actuel. Explorer différents univers, observer les parcours les plus variés, et les plus surprenants, préférer les contrastes et repousser l'idée d'un graphisme étroit, compartimenté en genres respectables ou mineurs. Voilà l'optique de ce nouveau Bulldozer. Après le regard aigu de Michal Batory, c'est l'insolence et l'œil moqueur de Geneviève Gauckler qui orientera votre rétine vers un espace iconoclaste, techno et utopiste, reflet grossissant d'une société de consommation dérisoire. Cette cybercowgirl, avec qui nous avons réalisé ce n° deux, vous fera intégrer la mosaïque d'images et de slogans qui forme son regard curieux. Bulldozer, votre troisième œil, a besoin de vous pour augmenter votre regard acéré. N'hésitez pas à vous abonner et à le faire savoir!

Décision prise, l'interview se tiendra dans un des hauts lieux de la pop culture française : le Planète des Halles! Installée dans le temple du «cheaper eat» de la capitale, cette jeune lyonnaise de 28 ans, qui publia son premier dessin (équestre) à l'âge de 14 ans dans le trop méconnu Monde du Cheval (!), semble intimidée et fascinée par l'endroit. Depuis quelques années, elle s'est forgée une image hors normes en multipliant les expériences : F Communications et ses pochettes pour le DJ Laurent Garnier ou St Germain, du magazine Interactif et Monsieur Cyber, à l'édition, en passant par des chemins plus personnels, tels que le concept d'une société de service du futur, la firme RGB Force, Inc, le fanzine hilarant Idéal VPC, ou les dernières affiches d'Act Up, VPC, le vivifiant Loïc Prigent, et d'une assiette de fromage, feront qu'elle accepte enfin de se livrer sans retenue.

En 86, sacrifiant ses rêves de cinéma, elle revient au dessin, et réussit le concours d'entrée des Arts Décoratifs de Paris. C'est à l'époque de New Order et Peter Saville, des premières pochettes de 4AD designées par Vaughn Oliver, celles de Mark Farrow ou des Designers Republic que sa passion pour le graphisme s'éveillera.
Loïc : Et là, en octobre 87, c'est ruiné, tu as ce grave accident d'avion, le divorce d'avec Donald Trump. Malgré les 120 millions de dollars de pension, tu es déprimée et tu tais ton premier lifting....
Geneviève : et mon premier meeting du RPR! Et là, je m'inscris.

Images RGB Force, Actu'el, 1993.

designers
Anne Duranton
Pascal Béjean
Frédéric Bortolotti
Philippe Savoir

photographer
Daniel Pype

editor Bulldozer
publisher Bulldozer
origin France
dimensions 200 x 300 mm (when folded)
 7⅞ x 11¼ in

pages 84-5

Illegibility

art director Peter Bil'ak
designer Peter Bil'ak
publisher Reese Brothers, Inc.
Pittsburgh, PA
origin USA/France
dimensions 203 x 254 mm
8 x 10 in

pages 86-7 ►

Utopia

art director Gilles Poplin
designer Gilles Poplin
photographer/
illustrator
editor Gilles Poplin
publisher Gilles Poplin
origin France
dimensions 290 x 415 mm
11⅜ x 16⅜ in

COLLAPSE

COLLAPSE FONT WAS DESIGNED IN 1993, ESPECIALLY FOR A BROCHURE FOR THE ACADEMY OF FINE ARTS AND DESIGN IN BRATISLAVA, SLOVAKIA. IT IS A SINGLE USE TYPEFACE; I HAVE NOT USED IT SINCE THEN, AND PROBABLY I WILL NEVER USE IT AGAIN. AS THE NAME OF THE FONT MAY SAY, COLLAPSE IS HIGHLY AFFECTED BY A NEW WAY OF DESIGNING—COMPUTER GRAPHIC, AND BY THE COMPUTER ERRORS THAT ARE CONNECTED WITH IT. THIS SEEMED TO BE A SATISFACTORY REASON FOR ME TO DESIGN A NEW FONT. BECAUSE OF A CHARACTER OF THE TASK (STUDENTS' EXHIBITION) THE TYPEFACE WAS AIMED TO BE "NONTRADITIONAL". ANOTHER REASON FOR THE CREATION OF THIS TYPEFACE WAS THE LACK OF MONEY; WE COULD NOT AFFORD TO BUY A FONT, AND TO MAKE ONE UP AS A SCHOOL PROJECT DOES NOT COST ANYTHING. IN ORDER TO GIVE THE FACE A RANDOM LOOK, EVERY LETTER HAS TWO DIFFERENT VERSIONS, SO THE FONT EXISTS IN TWO DIFFERENT SETS—UPPER AND LOWER CASE.

LOWER CASE

INTRODUCTION

illegibility

Bruitage

designer	Suzanne Markowski
college	Ecole Nationale Supérieure
	Des Arts Décoratifs, Paris
tutor	Philippe Apeloig
origin	France
dimensions	259 x 347 mm
	10¼ x 13⅝ in

corps : 16

Sa pensée, sans but d'abord, vagabondait au hasard, comme sa **levrette**, qui faisait des **cercles dans** la campagne, japait après des papillons jaunes, donnait la chasse aux musaraignes ou mordillait les **coquelicots** sur le bord d'une pièce de blé. **Puis ses idées**, peu à peu se **fixaient,** et, assise sur le gazon, qu'elle fouillait à petits coup avec le bout de son ombrelle, Emma se répétait : Pourquoi, mon Dieu ! me suis-je mariée ?

espacement : 2

interlignage : 20

ponctuation

fer à gauche

espacement : 4

virgule

apostrophe

corps 28

Elle retrouvait aux mêmes places les digitales et les ravenelles, les bouquets d'orties entourant les gros cailloux et les plaques de lichen le long des trois fenêtres, dont les volets toujours clos s'égrenaient de pourriture, sur leurs barres de fer rouillées.

interlignage : 19

corps : 16

fer à gauche

chasse

angle d'empattement

jambage supérieure

corps : 500

empattement

Elle commençait
regarder tout alen
pour voir si rien n
changé depuis la d
fois qu'elle était ve

Detail

below

designer	Delphine Cormier
college	Ecole Nationale Supérieure Des Arts Décoratifs, Paris
tutor	Philippe Apeloig
origin	France
dimensions	448 x 149 mm 17¹/₈ x 5⁷/₈ in

Typographische
Monatsblätter

left

art director	Jan C. Almquist
designer	Jan C. Almquist
photographer	Jan C. Almquist
editor	Hans-U Allemann
publisher	Printing and Paper Union of Switzerland
origin	Switzerland
dimensions	230 x 295 mm 9 x 11⁵/₈ in

TYPOGRAPHIC FASCISM. THE KILLING OF THE BAUHAUS MOVEMENT. MIKE DAINES VS. 10 X 5

Type is a wide ranging subject and could prove to be difficult to split into defined or specified areas. I have tried to separate certain aspects of the subject from one another but there may well be some over lap throughout the sections of this essay. Therefore some of this work may seem some-what fragmented, alternating from one view to another, however all of it's content is both relevant and necessary to convey my ideas and thoughts on the subject.

It seems necessary that this essay should not only be communicated through visual terms such as text and imagery. As a result of this a sound-track has been compiled to accompany this visual account. The tape includes material referred to by this essay as well as interesting examples of music and sound that they prove to be useful listening. However, it is there to listen to at your own disposal and is not essential to completely under-stand this essay. Please feel free to forward the tape through any parts you dislike. What is music to some is noise to others. 0123456789 ABCDEFGHIJKLMNOPQRSTUVWXYZ THE OLD FORMS OF LETTER SHOULD BE UNDRESSED - SLOUGHING OFF MEANINGLESS HISTORICAL NATIONALIST ALLUSIONS AND DECORATION.

Obituary) when confronted admit to not actually believing in or practising in any true forms of Satanic worship or the occult at all. In fact, most are completely atheist in nature. Nevertheless death metal has provoked outrage in the home and Church to a point where many have taken the law into their own hands. Bands like Deicide have been terrorised by infuriated groups of vigilante Christians, often much more offensive than these bands could ever hope to be. Who is worse?What drives them to these extreme measures is there concern with music's power and subliminal qualities. Court cases have been brought against metal bands in recent years, usually to do with 'hidden mes-sages' within the music. Either disguised within lyrics or more typically recorded backwards through the songs. These cases rarely have much standing in court and are often laughed out within a short period, but it shows that people are utterly convinced that music is so powerful that it can cause their would be happy children harm. These people are infatuated with their quest; they reach a point where they can hear whatever they want to in the music they dislike.Judas Priest (an ageing heavy metal band) were recently taken to court by the family of a boy who committed suicide, allegedly being under the influence of the band's latest album of the time. According to their reasoning, the family were convinced that when played backward, a certain song (apparently about suicide) could be heard

"THE NEW TYPOGRAPHY IS NOT A FASHION"

Shift!

postcards

art directors Anja Lutz
 Lilly Tomec
designers Anja Lutz
 Lilly Tomec
editors Anja Lutz
 Lilly Tomec
publisher Gutenbergverlag/Shift!
origin Germany
dimensions 148 x 105 mm
 5⅞ x 4⅛ in

Typographic Fascism

art director Chris Turner
designer Chris Turner
photographer/
illustrator Chris Turner
publisher unpublished
origin UK
dimensions 297 x 420 mm
 11¾ x 16½ in

London Born And Bred

Taxi schmaxi. We've all heard the banter. Us fair skins that is. Dick-heads don't pick up darkies. Sitting in the back of the cab while the führer in the front gives it the big 'un. "I won't have anything to do with 'em" he snarls "They're scum. I won't let them in this cab. Ruined the whole fucking area." At this point I usually ponder on what a real heaven on earth Wapping must have been before immigration. "I've lived in the East End all my fucking life. So did my grandparents and even their fucking grandparents. And I can tell you it's a crying fucking shame what they've done to this fucking place" his conversation sprawls on like the grotty estates tower blocks and the dank dog-shit parks. I think left here, right here, soon be home. I fucking hate those drivers. They're scum. I won't let them in me house. They've ruined the whole fucking area. And my silence and my money fuels their engine.

The Romans were here. And the Angles, the Saxons, the Vikings and the Normans all came to stay a while. Yet the first settlements in the East End were for those who were excluded. The immigrants and the outcasts made the East their home. Banned from within the city walls the Celts settled down nfar from where the Tower of London now les. They were tolerated, just. They did the shit work in the city. Every morning they'd walk up to the Ald-gates to be let in. Every evening they'd walk back out to their outcast immigrant home in the east. Walk they did. Shank's pony. Didn't need Taxi drivers in those days.

photographer Phil Knott

photographer Donald Milne

pages 76-7

Re taking London

art director Blue Source
 designers Jonathan Cooke
 Steve Turner
 Mark Tappin
 Simon Earith
 Rob Wallace
 Danny Doyle
 Leigh Marling
 editor Blue Source
 publisher Blue Source
 origin UK
 dimensions 480 x 480 mm
 18⁷/₈ x 18⁷/₈ in

76

BLUE SOURCE

RE TAKING
LONDON

London Babylon

The Atoms of Democritus brought an A-bomb to Wardour street. And big bang in the City caused the flash to flaunt. So here we are immersed in the flurry of the fears. Our capital under siege.

London's calling "awake! awake! awake!" Why do you sleep the sleep of death and ban heart and spirit? Now time plays its trick. Once again the city is ours. Swagger and bowl, ready to receive the gifts of the city. Delight in its neon.

Down in the tube station at midnight. Near mournful, ever weeping Paddington. You hear the sound of London rumble through its veins.

From London Fields to Islington to the Ladbroke Grove. Underneath the Westway's golden arches the Regent's Canal shines upon the starry sky.

The martyred St. Pancras. Once torn apart by dogs now withered by the Kings Cross. Needle deep pox ridden whores. A McDonald's and a cab rank offer hope.

The Angel surveys the Screen On The Green. Where once was anarchy in the UK. Now candle light and ethnic antique seek sanctuary in the bubble of the bourgeoisie. Babylon burns at 40 watts and Newton's particles of light bring Crimson Joy to these Blair, and Blair about.

I give you the end of a golden string that leads to the dirty river. As long as you gaze on Waterloo sunset you are in paradise.

(William Blake 1757-1996)

photographer Rankin

page 75

Manuscript

artist's book 1994

designer
Gülizar Çepoğlu

artist
Ipek Aksügür Duben

photographer
Douglas Beube

origin
USA/Turkey

dimensions
220 x 285 mm
8⅝ x 11¼ in

page 74

Manuscript

poster

art director
Gülizar Çepoğlu

designer
Gülizar Çepoğlu

artist
Ipek Aksügür Duben

photographers
Ani Çelik Arevyan
Douglas Beube

origin
USA/Turkey

dimensions
480 x 620 mm
18⅞ x 24⅜ in

MANUSCRIPT 1994

14 EKİM–2 KASIM
İSTANBUL BÜYÜK ŞEHİR BELEDİYESİ SANAT GALERİSİ

8 KASIM–5 ARALIK
ANKARA GALERİ NEV

the skin on my body
touches stones and pebbles
pressing against myself
my soul my body
I draw back
that skin
to see myself again
one more time one more time
what is real
it or me
my self multiplies
as I look outside
and inside
deep deep
beneath the mountains of memory
where no language lies
I find all
that surrounds me
what is real
I or it
or both or nothing

if time is a lull
and all is in motion
the moment draws on
am I here am I there
or is it
all-the-same

İpek Aksügür Duben

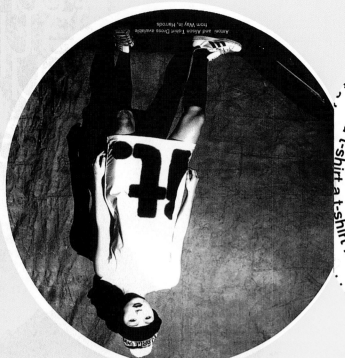

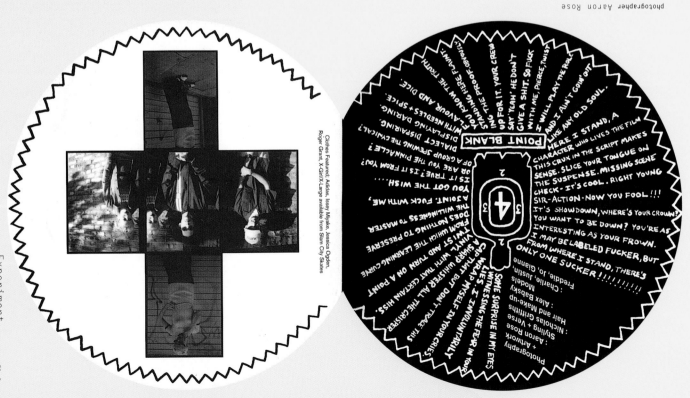

Antoni and Alison T-shirt Dress available from Way In, Harrods

a t-shirt is a t-shirt ...Photographer - Jane Mcleish. Stylist - Stephanie Tironelle. Grooming - Tess. Models - Jamie and Michelle at Select, Suzanne, Emma, Aki, Flowerz and Junior. Many thanks to Laurent.

Experiment see page 71 for credits

Clothes Featured: Adidas, Issey Miyake, Jessica Ogden, Roger Grant, X-Girl/X-Large available from Slam City Skates

POINT BLANK

Photography + Artwork - Aaron Rose Styling - Nicholas Griffiths Hair and Make-up - Alex Babsky Models - Charlie, Justin, Freddie, Jo, Gianne

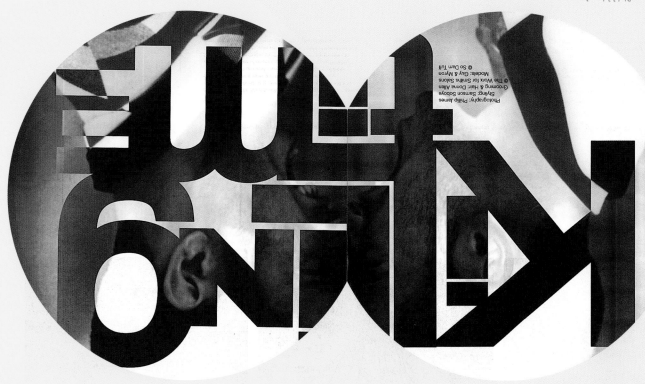

photographer Phillip James
stylist Samson Soboye

Photography: Phillip James
Styling: Samson Soboye
Grooming & Hair: Donna Allen
@ The Work for Smiths Salons
Models: Guy & Myron
@ So Dam Tuff

illustrator Mark Wigan

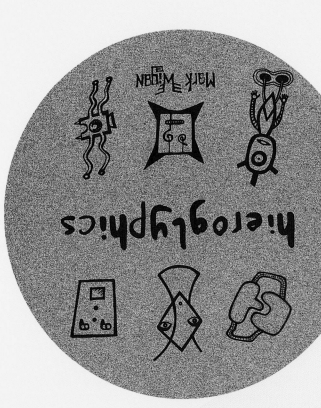

pages 72-3 ➤

Experiment

art directors Mike Lawrence
 Stephanie Tironelle
 Aaron Rose
 designer Mike Lawrence
 editor Stephanie Tironelle
 publisher Stephanie Tironelle
 origin UK
 dimensions 203 mm diameter
 8 in diameter

71

Knut Maron: Triptych – Anti-mountain. Burning bush. Horeb

PREVIEW

The desert occupies a special place in European literature and art, but is especially seductive to camera users as diverse as Fredrick Sommer, Verdi Yahooda and Bill Viola

DESERT

DESERT IS AN EXHIBITION which surveys photographs of desert space, exploring its symbolic meanings and its significance as a site in which to consider the role of the image and the space of the photograph.

Drawing on work produced during the last 50 years, the exhibition spans differing visions of deserted space; the extremes being Frederick Sommer's Arizona landscapes and Thomas Ruff's night sky photographs. The majority of the artists, however, explore the deserts of North Africa and Arabia. These are the same places explored and charted by many of the nineteenth and early twentieth-century travellers and writers whose experiences and visions contribute to the image of the desert as a symbolic space within European culture.

The image of the desert created by many such writers was based, to a great extent, on a European Romantic view of the 'other' which, unfortunately, could not escape the infection of colonialism. The need to idealise nature, ancient beliefs and the exotic in many of these writings, therefore, speaks most loudly of Western desire. Others, however, explore the barren desert as a more complex and layered space, rich and fertile with other possible symbolic readings: the desert is a place of metaphysical experience; a melancholic space of indifference; a site of death, disappearance and dissolution; a landscape of grains that refuse to be fixed.

Some of these readings are touched upon by all the artists in *Desert*. For example, Hannah Collins' large scale desert photographs reveal the complex dynamic between the image and the real desert view. This is as

photographer Knut Wolfgang Maron

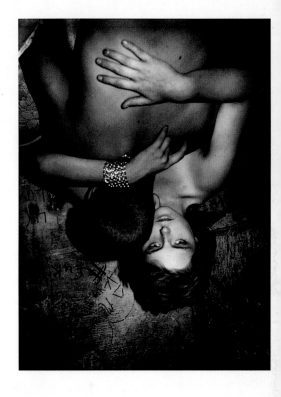

"I Have 2 pairs of Black Jeans
1 2 turtlenecks
1 ... teeshirt
2 long sleeve Rc/bc
2 pairs of shoes
+ No Jacket-ill
this Kill
15 color in Hollywood @3"

RAISED BY VOLVES

pages 70-71

Creative Camera

design consultant Phil Bicker
editor David Brittain
publisher Creative Camera
origin UK
dimensions 210 x 280 mm
8¼ x 11 in

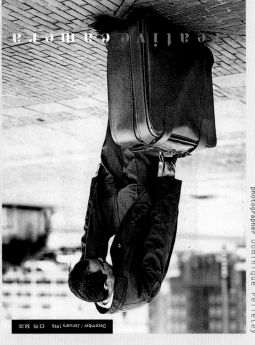

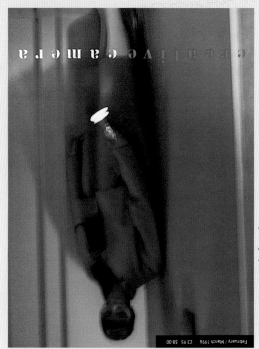

Creative Camera

design consultant Phil Bicker
editor David Brittain
publisher Creative Camera
origin UK
dimensions 210 x 280 mm
8¼ x 11 in

photographer Dominique Pelletey

December / January 1996 £3.95 $8.00

photographer Dolores Marat

February / March 1996 £3.95 $8.00

69

photographer Rainer Usselmann

October / November 1995 £3.95 $8.00

photographer Andrea Modica

February / March 1995 £3.95 $8.00

Caffeine Magazine

art director Heather Ferguson
 designer Heather Ferguson
 editor Rob Cohen
 publisher Rob Cohen
 origin USA
 dimensions 254 x 305 mm
 10 x 12 in

4 Four Stories of Warfare

By DAVID KENDRICK

THE 1 CANNERY

Bolus Muffins are widely regarded as the world's finest. The Bolus Muffin Cannery employs only those who truly enjoy the muffin flavor, for they make the most fastidious assemblers. Row upon row of canned muffin tins bounce by their assemblers, rejected tins are regulated by hand to a discard belt. From the quality of the butter to the glue on the label, everything is checked by hand keeping the quality second to none, a rigorous reputation well deserved. Packed six to a roll, already in a butter sauce pan, one pops open the tin, sets them out to dry, and a "surprisingly nutritious treat is ready to eat".

Old man Bolus' heart stopped one day, and immediately an intricate stock manipulation by a similar yet inferior family owned rival company, the Hogan Company, allows them to take over the cannery. They install their own son, Larry, as supervisor and change the company name to the "Hogan Bolus Muffin Tinnery". Old man Bolus' three sons are dismissed.

Larry the new reluctant supervisor takes long coffee break to make personal phone calls and to whistle at girls on the street down below. The stubble from his beard alarms safety lights shining bright as he strolls through the sterile packing rooms . Beneath his undershirt, woolen shoulder blades shed thick black strands as he walks the white paceways. And as he walks, Larry chews wads of gum that make fellow employees' jaw ache with reluctant admiration.

New employees must suffer through his lectures on safety. Frequently overzealous, he flings the new canners against buzzers to emphasize the hazards of misguided foot direction He times the muffins tinning with an electrical shock device. New secretaries are harassed as he interrupts business dictation's with unnecessarily long and verbally direct romantic innuendoes.

Larry's biceps are swollen from years of use. Rumors tell of him punching in low bars and behaving like a sailor or longshoreman around women. The whole Hogan family history is abusive.

Several employees tell the dead man Bolus' three sons of Larry's contemptible behavior. They decide to straighten Larry out after dark one night as a prelude to legal remanipulation. The three Bolus brothers wait for Larry to come out of a notorious dredge of a bar. They jump him and start punching but Larry flings them about like molding bricks. His fists, they fly like jets. The two youngest brothers are paralyzed and the third gains a lasting concussion from Larry's skilled dock-like muscle control.

Union regulations ensures cripples steady employment and the two paralyzed brothers are rehired as livid object lessons with wages reduced to a minute fraction. Larry uses them as a living examples after the safety slide lecture. The concussed Bolus brother will sit through many interpretive artists as the Hogan's invest heavily in functional yet humanistic factory hallway art adorers.

THE 2 BATTLEFIELD

Soldiers often have bad dreams the night after a bloody battle. If one wakes suddenly and screams he may be killed by an enemy bullet. Smart soldiers will sleep in twos—one always keeping watch so no one jumps up during a nightmare. Some rope each other into foxholes. Others engage in brief yet torrid homosexual acts. Some bury themselves in the waist in loose combat dirt an d others still will take stimulants to keep awake or drug themselves with muscle dissolves for a motion- free rest.

During basic training, soldiers are taught by film to recognize impending nightmares in their partners when they see thick glue-like tears seep from the corners of closed eyes. Then the trigger finger clenches, the aiming eye squints and the mouth draws tight in grin determination. On the other side of those closed eyes the sleeping soldier is most certainly emptying a full clip into a helpless prisoner of war, a parental substitute, a loved farm animal or wife. If soldiers have these dreams on maneuvers before they even see real warfare, they dishonorably discharged and given subscriptions to Soldier of Fortune.

THE 3 POSTMAN

Ludwig 2, a king wealthy through the inheritance of Bavaria walks through the outer gardens of Schloss Linderhof. Acres of chewed marble crunch beneath his feet. The further from the castle he walks, the finer the path gravel becomes, until there is only sand.

"Someone with heavy feet must be walking around out here! I will have my servants set deadly traps! Snake pits! Trip wires! Spikes and glass needles!"

Ludwig is almost back to the castle when a uniformed postman carrying a mountain of heavy packages does knock.

"I don't want any of them!" Ludwig shouts from behind a tree. "Servants , remove this postman!"

But the next day the postman returns with many more packages, unloading them from a heavy carriage.

"Take them away and do not come back!" Ludwig shouts, this time from the roof of the Moorish kiosk. He is robed in oriental garb yet hidden by the frills of an ornate tower.

"To have them removed you will have to sign tickets and later go out in public to the station, Your Highness, " the postman chuckingly grinds several large stones to dust.

Furious, Ludwig has more traps set. He will make sure the postman cannot return. Rare poisonous snakes are important. Fearful dragons are cast from precious metals. Exploding swans are placed in front pool.

"He will crunch my paths no more!"

The servants must also carve terrible mythical creatures from Corsican marble and wheel them upon immense log carts to all strategic points in the gardens. The pathways are dismissed to dust under the tonnage and the servants gathered fearfully in the basement, finding some small comfort in the common terror they all have of Ludwig's certain soon to be rising wrath.

The postman does not return. Ludwig never receives any mail for the rest of his life. His plan succeeds, but so

THE 4 MINER

Philbin Hartley was a chief technical engineer for operations on a particular deep mine shaft. Several times a day he was the victim of the never-ending pun, "Hey you, fill that bin," or one of its painfully derivations. Even as a child taking out the garbage bin, he had found the joke unamusing.

In addition to his job at the mine, he had invented and assembled a war machine, a powerful fast vehicle to be used once inside an enemy territory. A man could live in the machine for six months. Torpedo tubes and smaller weapons made it virtually unconquerable. He spent all his evenings working on a prototype now near completion in a laboratory beneath his house.

An enemy government learned of Philbin's machine through articles in science journals but as the printed story was altered to protect our security interest, Philbin was described as a "blind medical student" (Philbin was no blind medical student) who had completed work on a war machine of illimitable strength and fire power as a sort of summer hobby. A special task force was sent over to try and capture the machine intact. They planned on catching Philbin off guard by tunneling under his laboratory floor and just driving off with the machine in his spare time they found it foolish though admirable and intending on presenting him with an achievement award for the blind before they murdered him and stole the machine to use against his own kind in a war brewing even as this is written.

One fine summer evening Philbin's sensitive miner's ears accurately deciphered the hum of foreign drills. He prepared to depart in the nearly completed machine, leaving unmounted torpedoes for the enemy to explode. He placed the tips of the torpedoes in the direct path of their drill and estimated them reaching his lab in a few short hours.

He finished the machine and escaped perilously close to detonation time. Once out of town and danger, he realized his hunger. AS he drove he chewed half a Bolus Muffin, nothing a harrowed dog at the side of the road biting on a blowout. Philbin had stocked the vehicle with protein rich food and drink as well as several tins of local industrial muffins.

He was well up the side of Mount ST. Isabelle when the fuming panorama of the city materialized in the rear view mirror. Although the torpedoes had destroyed most of his home town, apparently he had not killed all the special task force. Refugees lined the roads. The enraged enemy agents had sacked the town and the loyal were fleeing. He did not stop for hitchhikers in fear of picking up an impostor. Philbin sped on steel jawed, summarily cursing the evil results of simple scientific curiosity.

At the crest of Mount St. Isabelle, land mines suddenly surrounded the vehicle. Enemy strafers fired machine gun rounds in great swooping arcs disappearing often to reload. The road ahead of him was blasted askew and Philbin squeezed around the exploding pavement surprising himself with brilliant evasive maneuvers. Momentarily he outdistanced the strafers and the machine was barely scratched. As he sped on, he wished he had had time to load the torpedo bins on the roof of the vehicle. Three strafers then appeared before him.

"But I didn't have time to fill the bins," he said, laughing at his own joke amidst the battle's revived smashing.

CAFE DE PARIS

address: Cafe De Paris, 3 Coventry Street, London, W1.
information telephone number: 071 287 0503
description of venue: historical ballroom.
number of dancefloors: 2
capacity: 700
price of water: £1.50 price of bottle of beer: £2.60
disabled access: no.
toilets (how many): enough for no queueing.
cloakroom and prices: 80p per item.
extra facilities: ice creams and food available.
sound system: main room 15K, small room 2K.
how to get there: in the heart of London in between Leicester Square and Piccadilly Circus.
parking facilities: car parks in the vicinity.
rail: British Rail at Charing Cross, nearest underground stations are Leicester Square and Piccadilly Circus.
air conditioning: yes.
people policy: people that come out for a good night without attitude.
regular nights: Saturday - Release The Pressure; Tuesday - Red Hot.
opening times: 10pm - 6am
best time to arrive: before 10.30pm
door prices: members £10.00, non-members £12.00. after 3am entry is £5.00
resident DJs: Ricky Morrison, Jazzy M, Dean Savonne, Dana Down, Marcus, Paul Tibbs, Danny Foster, Chris Mayes, Sammy (Toto), Sarah Chapman.
guest DJs/PAs: CJ Mackintosh, Frankie Foncett, Benji Candelario, Roger Sanchez, Kenny Carpenter, DJ Pierre, Femi B, Ralf, Phil Asher, Simon Aston, Rob Acteson, Ricky Montanari, Flavio Vecchi, Danny Morales, DJ Disciple, Claudio Cocolutto, Kevin Saunderson.
music policy: US garage house in the main room and soul funk party classics in the small room.
club anthem: Nightcrawlers 'Push The Feeling On'
DJ/promoter comment: "Tuffest US club in the UK." Ricky Morrison. "Most beautiful club experience in the UK." Kenny Carpenter.
punter/industry comment: "The music's rocking and you haven't failed us yet." Andrew & Louise from Essex. "The best DJs playing excellent house and garage. They have a special vibe of their own." Nigel Wilton, Sony Music.

SATURDAY

pic by Daniel Newman

CLUB UK

address: Buckhold Road, Wandsworth, London, SW18 4TQ.
information telephone number: 081 877 0110
description of venue: 3 rooms with a total of 12 DJs per night.
number of dancefloors: 3
price of water: £1.50 price of bottle of beer: £2.50
disabled access: wheelchair ramps and lifts.
capacity: 'loads'
toilets (how many): women - 2 , men - 2
cloakroom and prices: 2 cloakrooms, £1.00 per item.
extra facilities: chill out with food available.
sound system: total for all 4 rooms is 35K.
how to get there: closest tube is East Putney (District line). British Rail - Wands Town. Buses stopping nearby - 28, 39, 44, 77A, 156, 270. Night Buses - N68 & N88.
parking facilities: free NCP nearby.
brief history of the club: opened in July 1993, the club was the venue for BBC's Dance Energy and for BPM.
people policy: dress to club, no blaggers, no bores, no bullshit, no bad attitude, r bird brains, no bitchiness and no plebs.
regular nights: Friday - Final Frontier; Saturday - Club UK.
opening times: 10pm - 6am
best time to arrive: before midnight.
door prices: Friday - members £7.00 before 11 pm, non-members £9.00; after 11 pr members £9.00, non-members £11.00; Saturday - members £10.00, non-members £12.00; 3 am £6.00
resident DJs: none as such but regulars are Danny Rampling, Judge Jules, Dean Thatcher, Roy The Roach, Fabi Paras, Dominic Moir, Steve Proctor, Steve Harvey.
guest DJs/PAs: Breeze, Terry Farley, John Digweed, Paul Oakenfold, Andy Weather Darren Emerson, Brandon Block, Jeremy Healy, Kenny Carpenter and Biko.
music policy: Black Room - euro house and pumping house anthems; Pop Art Roo harder deep housey beats; Purple Room - ambient, classic club grooves.
club anthem: Dan Hartman 'Relight My Fire', Gat Decor 'Passion', OT Quartet 'Hold ' Sucker Down'.
DJ/promoter comment: "Ask anyone who comes down on a Saturday and 99% wi you they've had an awesome time." Sean McClusky.
punter/industry comment: "As soon as you walk up the steps the buzz hits yo Steve Goddard.

photographer Daniel Newman

1 L.A. GARAGE

address: Puutarhakatu 21, 33210 Tampere, Finland.
information telephone number: 010 358 31 2110525
number of dancefloors: 1
bars: 3
capacity: 800
price of water: £1.00 **price of bottle of beer:** £1.00
disabled access: yes
toilets (how many): 2 sets - large and clean.
cloakroom and prices: 50p per item.
extra facilities: 2 video screens
air conditioning: fully air conditioned.
sound system: JBL 6K
parking facilities: no
rail: not applicable.
brief history of the club: previously a cinema and theatre.
people policy: casual but smart dress. Members get priority entrance.
regular nights: Tues - Shine On; Weds - Chart Night; Thurs - Sport Night; Fridays and Saturdays - Celebration Of The Best Dance Music.
opening times: 9pm - 4am
best time to arrive: early!
door prices: approximately £3.00
resident DJs: Juissi, Manu and Ville.
guest DJs/PAs: Altti.
music policy: the best music for the best people.

club guide 8

pic by Ronnie Randall

2 X-RAY

address: Gothersgade 8C, Copenhagen City, Denmark.
information telephone number: 010 45 3393 7415/4056 9101
description of venue: aims to be an arena for explosive entertainment of international calibre and have allied themselves with designers like Robert Singer (New Tunnel and Paradise) and Tony Hayes. The design is futuristic and was inspired by Blade Runner.
number of dancefloors: 2
capacity: 1,100
price of water: 16.00 DKR **price of bottle of beer:** 22.
disabled access: yes
toilets (how many): 4
cloakroom and prices: 3 areas, 10 DKR per item.
sound system: Rodeck MX34 8 channel, 3 SL 1200 turntables, Roland samp CD. Stax speakers, 8K Stereo Lab amp, Soundcraft mixer 24 channel.
how to get there: right in the middle of the city.
parking facilities: good.
rail: close to Norreport station.
people policy: over 21, dress code.
regular nights: open Thursday, Friday and Saturday.
opening times: 11pm - 7am
best time to arrive: before 1 am
door prices: 40.00 DKR
resident DJs: Ezi - Cut, Joe Belmati, Kjeld Tolstrup, Kenneth Baker, Cutfath and Knud.
guest DJs/PAs: DJ Duke, MKM, Jon Marsh (Beloved).
music policy: anything as long as it is good!
promoter comment: "The main dancefloor is for 700 people and plays dee garage while hip hop, acid jazz and rare groove is played in the Underground. This club also hosts rap, jazz and 'unplugged' performances."

DJ cl

photographer Ronnie Randall

pages 66-7

Euro Club Guide
supplement of DJ Magazine

art director Michèle Allardyce
designer Michèle Allardyce
editor Christopher Mellor
publisher Nexus Media Ltd
origin UK
dimensions 148 x 230 mm
5⁷/₈ x 9 in

O PAÇO REVISITADO

UM DEPOIMENTO

JOAQUIM FALCÃO

PAULO SERGIO DUARTE

O CENTRO

AUGUSTO IVAN DE FREITAS PINHEIRO

EVENTUAL

DEZEMBRO 1995 NÚMERO 1

pages 64-5

Eventual

art director
Nina Rocha Miranda
designer
Nina Rocha Miranda
photographer/illustrator
Nina Rocha Miranda
editor
Lauro Cavalcanti
publisher
O Paço Imperial
origin
Brazil
dimensions
280 x 400 mm
11 x 15³/₄in

64

The ultimate world-historical significance

of Los Angeles is that it has come to play the double role of utopia and

dystopia for advanced capitalism.

by Mark Dery

Photograph by Chris von Menge

FUTURE NOIR

ACCORDING TO URBAN-THEORIST MIKE DAVIS, DAVIS ENVISAGES THE FUTURE OF THE 'CITY OF QUARTZ,' SOUTHERN CALIFORNIA'S FUTURE, WILL BE ENGENDERED BY AN APOCALYPTIC 'ECOLOGY OF FEAR,'

21C | 40 996

FROM VITRUVIUS, ANCIENT ROME TO ROAMING IN VIRTUAL REALITY, ARCHITECTURE IS FORMING A HYBRID AT THE INTERSECTION OF
PHYSICAL SPACE AND CYBERSPACE, WILLIAM MITCHELL PROVIDES THE BLUEPRINT FOR RECOMBINANT ARCHITECTURE.

DE RECOMBINANT ARCHITECTURA

by Mark Nixon

Portrait by Kate Gollings

63

21C

art director Christopher Waller
designer Christopher Waller
editors Ashley Crawford
Ray Edgar
publisher Ashley Crawford
origin Australia
dimensions 245 x 265 mm
9⅝ x 10½ in

World Art

art director Terence Hogan
designer Terence Hogan
editors Ray Edgar
Sarah Bayliss

publisher Ashley Crawford
origin Australia
dimensions 245 x 265 mm
9⅝ x 10½ in

BERLIN RESISTANCE

BELOW: MARTIN FIGURA, GARDEN GNOME, KNUT BAYER, ULRICH KÜHN

IN 1990, three East Berlin artists began showing at Wewerka and Weiss, a young West Berlin gallery and one of the few exploring the neoconceptual installation art taking over Europe and New York. Knut Bayer, Martin Figura, and Ulrich Kühn were noted figures on the Berlin scene: as artists, and also as the principals of the Shin Shin Gallery in the *Mitte* section of East Berlin, an influential exhibition space supporting the conceptually inspired work that was percolating around the Berlin Hochschulen that the three had recently attended.

At that time, *Selbsthilfe* (co-operative run) galleries like the Shin Shin were typically Berlinish – reflecting the politically progressive, "alternative," and activist tendencies of the people who chose to live in the walled city. Its three proprietors were inspired by their teacher Karl Horst Hoedicke, a painter of the "Wild" Neoexpressionist generation, who ran a celebrated *Selbsthilfe* gallery back in the '70s along with Mar-

kus Lüpertz and Helmut Middendorf.

The younger trio's 1991 collaborative artwork at Wewerka and Weiss consisted of a site-specific multi-layered wall drawing. Each layer was conceived and made by one of the three artists, collectively suggesting a type of aesthetic conversation between sympathetic individuals rather than a synthesized work. While Kühn's text-based work appeared to respond to the open-ended poetics of Lawrence Weiner, Figura's drawing was more historically inspired – by Italian Renaissance architecture, and by the wall-drawings of Sol LeWitt. Bayer's images, on the other hand, used silhouettes of mechanically drawn figures to create a language of signs.

"If Martin was LeWitt, Knut was more Marcel Broodthaers," Kühn said recently. Speaking of their gallery, he says, "when we started

Shin Shin in 1989, we were thinking about appropriation art and the '80s discourse around postmodernism much more than we were thinking about '70s Conceptual art. We were interested in the idea that every formal solution has already been invented, so that all styles from all eras were equally available to an artist. Wild Painting was no longer a force – but artists in Berlin knew very little about such ideas. Berlin was isolated by its political-geographical position, and functioned culturally as an island.

"There was a generation that was developing in relation to the neoconceptual art that one might find in the centers," he adds. "Critics like Thomas Wulffen and Marius Babius served an important role. We were also involved in developing this context."

Today the formerly dark and closed streets of Berlin's *Mitte* are frenetic with activity, and lit with commercial neon and street lights. *Mitte* is the site of one of the fastest-moving real estate markets in Western Europe, as this once-ruined neighborhood is being over-

In a city where painting remains a historically loaded medi... three Berlin artists have rejected the dominance of Conceptua... and returned to paint and canvas. Claudia Hart reports on a m... ment that seems calculated to offend avant-garde sensibilit...

taken by the noise of razing and reconstruction. Although the Shin Shin Gallery closed in 1992, the style of language-based Conceptual and installation art that it cultivated can be found in all of the young galleries and *Kunstvereine* that had sprouted up in *Mitte* like mushrooms after rain.

AN ISLAND in the Socialist East, the GDR's Berlin was neither restored after World War 2 nor rebuilt in solid granite along late-Bauhaus lines like West Germany. Instead it seemed to be filled with the flimsiest forms of post-War prefabricated architecture. In summer, the gray city is dense with trees filling holes in the urban tissue where houses, destroyed by bombing, have left gaps. Very few bourgeois were drawn to such an environment, so Berlin's population attracted many "alternative types." As a result, there have been few art collectors in Berlin – and, until recently, the art scene has

WORLD ART

MARTIN FIGURA, *Lichter*, 1992, silkscreen, 35.6 x 39

DAVID BRANDT

photographer David Brandt illustrator Martin Figura

object lessons

In his performances and telepresence displays, Eduardo Kac breaks down language in a bid to question cultural differences. From performing on the beach to surfing the Net, Simone Osthoff learns how to eliminate space.

"I don't see myself as an 'American artist' or a 'Brazilian artist,' a 'Holography artist' or a 'Computer artist,' a 'Language artist' or an 'Installation artist,'" Eduardo Kac insists. "Labels are not very helpful and are often used to marginalize people. I prefer not to be bound by any particular nationality or geography. I work with telecommunications, trying to break up these boundaries."

Born in Rio de Janeiro in 1962, Kac (pronounced Katz) moved to the US in 1989 to study fine art at the Art Institute of Chicago. With a characteristic disregard for national boundaries, he went on to represent both the US and Brazil in international exhibitions.

Eduardo Kac on Ipanema Beach

18 WORLD ART

Out to Lunch

J. OTTO SEIBOLD'S ILLUSTRATIONS ARE WEIRD—AND WIRED
BY JOYCE RUTTER KAYE

"**Hel-lo?!!**"

J. Otto Seibold doesn't merely answer the phone, he *chortles* a salutation in a comical falsetto that could easily belong to a near relative of Crusty the Clown. Should you get his answering machine, you will likewise hear a recording of Seibold shouting the regrets of his absence from a very remote distance.

Welcome to JOTTOWORLD,

a very all-caps universe which exists in Seibold's imagination and in the San Francisco studio the illustrator shares with his wife and collaborator, author Vivian Walsh and their two young daughters. JOTTOWORLD's chief export to the real world is a series of hip, hyperkinetic children's books published by Viking, in which space monkeys head up big corporations and bird-chasing dogs become overnight TV celebrities. Seibold and Walsh join Viking's notable roster of writer/illustrators creating kids' books with a postmodern sensibility, including Maira Kalman (The *Max* Series), Steven Guarnaccia (*Blockheads*), Richard McGuire (*The Orange Book*) and Lane Smith with Jon Scieszka (*The Stinky Cheese Man and Other Fairly Stupid Tales*).

Talking with Seibold about his work is rather like flying a kite in high wind: you want to rein him in a bit, but not pull him down to earth. Colleagues say that's just the sort of tethering Walsh provides. Her straight-faced writing is a soothing contrast to Seibold's chaotic layouts; her style also sends up the absurdity of the books' plots. This balance works. Their first book, *Mr. Lunch Takes a Plane Ride* (1993), which traces the adventures of a plucky dog who enjoys fame as a professional bird chaser, sold 15,000 copies (after an original printing of 10,000 copies). This success is likely to be matched by their 1994 follow-up, *Mr. Lunch Borrows a Canoe*. Their newest book, *Monkey Business*, is due out this fall.

On the page, Seibold's energy is unrestrained. Stylistically, his illustrations borrow the iconog-

Mr. Lunch encounters Venetian pigeons in 'Canoe'...

...and gleefully chases them to the rafters

21

illustrator J. Otto Seibold

illustrator J. Otto Seibold

pages 58-61

U&lc

art director Rhonda Rubinstein
designer Rhonda Rubinstein
editor Margaret Richardson
publisher International Typeface
Corporation
origin USA
dimensions 279 x 375 mm
11 x 14¾ in

60

images Fuse

Neville Brody, the British designer, is an original and a controversial visionary. He has achieved a reputation for innovative, edgy design with strong concepts, vivid color and dramatic typography. In fact, Brody's signature style is based on his improvisational use of type. Known for his early work on magazines like The Face and Arena and for music industry graphics with hand-drawn, illustrative and expressive headlines and lettering, he is now committed to transforming digital design. Essentially, Brody's vision is to create a new visual language for the screen.

When Brody was 30, The Graphic Language of Neville Brody (written by Jon Wozencroft and designed by Brody) was published. It was widely reviewed both for Brody's glowing visuals and for Wozencroft's lofty text and has sold 60,000 copies to date. Brody was also honored by an exhibition of his work at the Victoria and Albert Museum in London which then travelled to Edinburgh, Berlin, Hamburg, Vienna and Tokyo.

This acclaim did not bring Brody more clients or financial reward in England, so he moved into an international sphere with clients in Europe, America, and Japan, creating stamps for Dutch Telecom, PTT; a graphic identity for ORF, the Austrian state broadcasting company; Nike ads for Wieden and Kennedy in the States, and projects for the Parco Department Store in Tokyo. These undertakings and a plethora of other designs are documented in The Graphic Language of Neville Brody 2, again by Brody and Wozencroft, which was published last September by Thames and Hudson. The book follows Brody's research and development of digital forms and theories on design articulated by Wozencroft and inspired by advances in computer technology. Well represented in the book is Fuse, an interactive magazine conceived by the Brody Studio in 1990 and published by FontShop International.

Fuse isn't about trying to disintegrate language. The language is already in disintegration and Fuse is about focusing on that.

FUSE4 EXUBERANCE UCN N PRETTY RICK VALICENTI, FUSE3 DISINFORMATION DEAR JOHN BARBARA BUTTERWICK, FUSE3 DISINFORMATION INTEGEL MARTIN WENZEL, FUSE4 EXUBERANCE LUSHUS JEFFREY KEEDY, FUSE10 FREEFORM FREEFORM NEVILLE BRODY (OPPOSITE), FUSE10 FREEFORM ROBOTNIK CORNEL WINDLIN, FUSE10 FREEFORM MUTOID JOHN CRITCHLEY.

Fuse is a quarterly award-winning magazine "that explores new ideas about typographic and visual language in the digital realm" which arrives as a disk, four posters and an analytical critique from editor Wozencroft, in a corrugated paper box. Each Fuse issue has a theme interpreted by four commissioned designers who are asked to experiment with type. This is not type for the printed page, although the posters (as seen here) show the Fuse fonts in use. Fuse is intended for the computer screen where the viewer can modify the fonts.

The themes of Fuse indicate the exploratory nature of the project. Fuse topics include "Invention", "Disinformation," and "Religion"; the newly released Fuse11 deals with pornography. Fuse contributors invent fonts related to these themes that are digital, interpretive and malleable. Brody and Wozencroft (and John Critchley of Brody's Research Studio, who handles the production) perceive the alphabet and type as culturally and emotionally changed icons rather than a static rendering of 26 letters. As Wozencroft puts it, "Fuse is a brave attempt to merge graphic arts, popular culture and philosophy."

Brody believes that rapid technological change (especially in advances in computer technology and software over the last five years) demands a reformulation of design precepts and practices. Using the analogy of the impact of photography on traditional painting and the resultant transition to abstract art, Brody posits that a design revolution triggered by dramatic changes in computer technology has just begun.

Brody himself relates to the computer as an art medium, and with it he has created painterly, digital, amorphous shapes based on letterforms (and has inspired others to create radical typefaces) which have been both lauded and criticized for their abstract or freeform qualities. These experiments receive more scrutiny than Brody's sharp, incisive type treatments for print and screen, because they embody his theories of melding form and content. Pushing the limits of typography for the screen, he feels, is the major role of Fuse and its contributors.

Fuse is definitely a part of Brody's future agenda (Fuse12 is on propaganda) as is his involvement with FontWorks, FontShop International, and his own experiments with typographic forms. He will also continue his international projects, focus on electronic design and develop a CD-ROM and publishing company in England through Digitalogue in Tokyo. Three of his imminent CD-ROM projects are The Graphic Language of Neville Brody 2, Fuse 1-10 and the CD-ROM version of the Fuse94 conference.

30

images Fuse

International
Typeface
Corporation

Volume 22
Number 1
Summer 1995

$5.00 U.S.
$9.90 AUD £4.95

The
International
Journal
of Graphic
Design
and Digital
Media

Upper and
Lower Case

background art Tomato

International Typeface Corporation

Volume 21 Number 4 Spring 1993 $5.00 U.S. $9.00 AUS

design

The Sound of design

THE SCREENS ARE ALIVE WITH

U&lc

Education & Training

Business & Industry

Design Spring '96

page 57

Design

art director Quentin Newark
designer Glenn Howard
photographer/illustrator Roger Taylor
editor David Redhead
publisher ETP Publishing
origin UK
dimensions 230 x 280 mm / 9 x 11 in

page 56

Berlage Papers

art director Arlette Brouwers
designers Arlette Brouwers, Koos van der Meer
editor Marijke Beek
publisher The Berlage Institute, Amsterdam
origin The Netherlands
dimensions 297 x 297 mm / 11¾ x 11¾ in

photographer Hélène Binet

the BERLAGE papers | 16

photographer Topografische Dienst Emmen

the BERLAGE papers | 17

the **BERLAGE** institute **AMSTERDAM**
Postgraduate School of Architecture

Wednesday 7 February — Jos Bosman — Zurich
Wednesday 28 February — Pinzgau & Podgorschek
Wednesday 13 March — Joep van Lieshout — Rotterdam

LECTUR...

All Public Events take place at the Berlage Institute, IJsbaanpad 1E (entry via main entrance former orphanage). Lectures will be held in English. Admission is free.

'Bookshop Architectura et Natura (Amsterdam) will be present with their bookstand. The programme is subject to change.

For more information:
phone 31-20-6755393
fax 31-20-6755405
E-mail Berlage@xs4all.nl

the **BERLAGE** papers | **17**

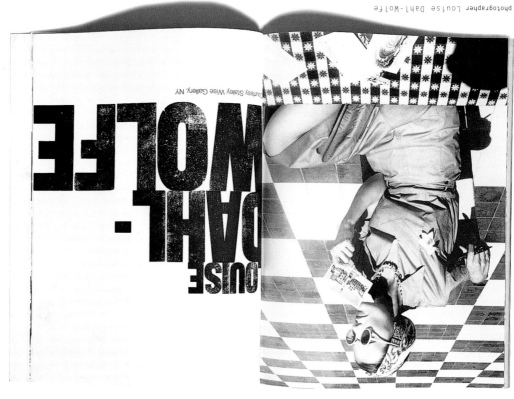

Courtesy Staley Wise Gallery, NY

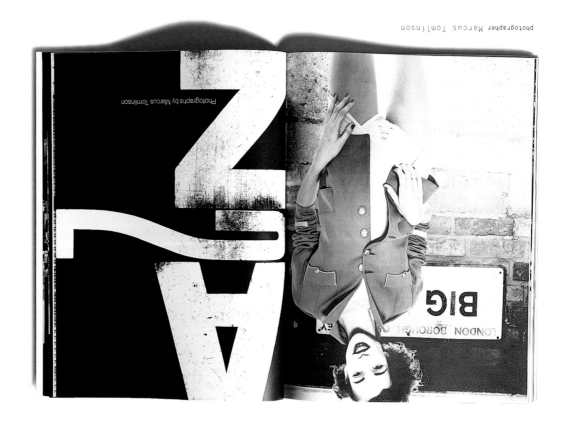

Photographs by Marcus Tomlinson

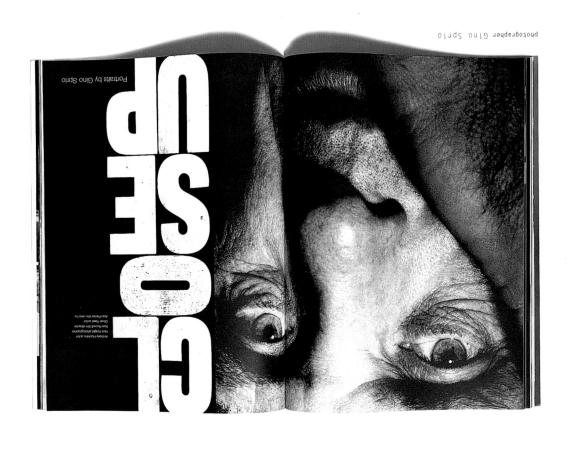

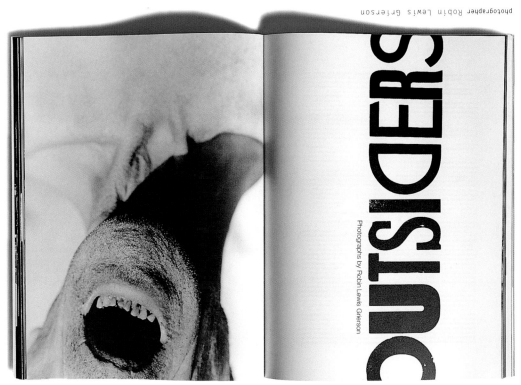

Portraits by Gino Sprio

CLOSE UP

Anthony Hopkins actor
Nick Knight photographer
Ken Russell film director
Oliver Reed actor
Alan Parker film director

OUTSIDERS

Photographs by Robin Lewis Grierson

LIGHT

by Alan Del

pages 52-5

Big Magazine

art director Vince Frost @ Frost Design
designer Vince Frost @ Frost Design
editor Marcello Jüneman
publisher Marcello Jüneman
origin UK
dimensions 420 x 594 mm
 16½ x 23⅜ in

photographer Alan Delaney

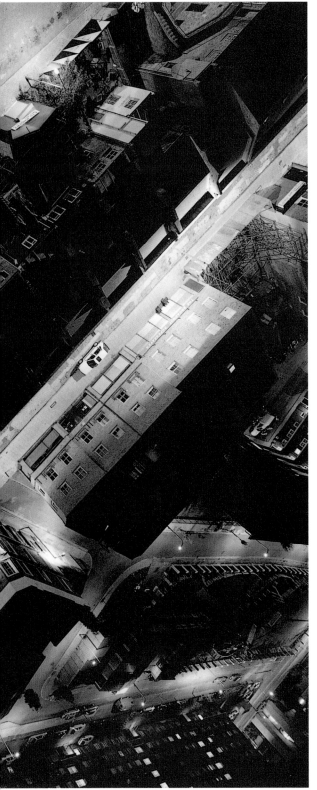

photographer Giles Revell

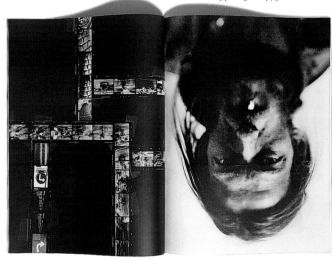

photographer Giles Revell

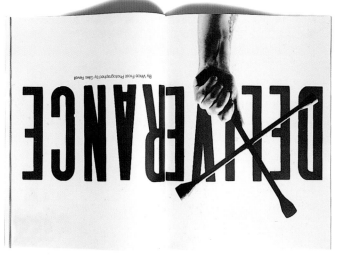

By Vince Frost Photographed by Giles Revell

DELIVERANCE

photographer Jake Chesum

photographer Mark Mattock

Story **Ekow Eshun**
Photography **Jake Chessum**

THE ARENA PROFILE

Weary, hooded eyes blinking hesitantly, Spike Lee seems to feel himself assailed. Assaulted. He yawns, clearly wishing that it would end, this thing of being »

3

COCAINE

Story **Gareth Grundy** Photography **Mark Mattock**

COCAINE

WHITE LIES

COCAINE HAS A GLAMOROUS IMAGE: IT'S FUN, NON-ADDICTIVE AND THE PRESERVE OF THE GLITTERATI. HOW WRONG CAN YOU BE...

COCAINE. STUDIO 54 and Disco in the Seventies, yuppies and the City in the Eighties. The preserve of vapid soap stars and over-paid footballers in the Nineties... stand up Daniella Westbrook and Paul Merson. A narcotic for those with bursting bank balances and inflated egos – the glamour drug, right?

Oh no. Cocaine use has changed drastically over the last few years. Its aura of exclusivity has faded and any talk of Surfer and Colombian crime lords belongs to a bygone age of pastel suits and loafers without socks. It never left the showbiz and media worlds, of course, and many ligs and launches still run on the stuff, but somehow it's become mundane. You're just as likely to find a wrap and a rolled-up tenner on an estate agent in Cheam as on a stockbroker in the Square Mile.

"There's definitely an increase in cocaine use in this country," says a spokesman for Cocaine Anonymous. "That's based on calls to our helpline increasing 300 per cent over the last year. We now get over 500 calls a month. We're beyond that city-slicker cliché about it, just by seeing the cross-section of society that turns up at

4

photographer Norman Watson

GREY BOY FROM SOFT CLASSROOM CHARCOAL TO SPACE-AGE SILVER: TONES OF GREY PUT BLACK IN THE SHADE

50

Photography **Norman Watson** Fashion **David Bradshaw** Assisted by **Carrie Vanquaires** Hair by **Richard Kee** for Carl Smart, Marcella **Gerard** at Michele One, **Fred Le Grange** at Success. Thanks to Scott Siegfried at Visages NYC

Single-breasted three-button sharp sharkskin suit £930 by **Helmut Lang**, light-grey cotton shirt £43 by **TM Lewin**, silver tie £36 by **Marvin & Hudson**

1

photographer Albert Watson

WHETHER AS ACTOR, BOXER, HELLRAISER OR HUSBAND, **MICKEY ROURKE** HAS ALWAYS CAST HIMSELF AS THE OUTSIDER. THESE DAYS, HOWEVER, THE NEW, REFORMED, MELLOW MICKEY IS BACK AND THIS TIME CARRE OTIS WILL BE STANDING BY HER MAN...

Text **David Ritz**
Photography **Albert Watson**
Styling/coordination **Karl Templer**

2

The dry, sultry ether of the mirage and the shifting horizons of heat and shadow imprint themselves upon the flesh of these photographs. For award-winning photographer, Kurt Markus, they are an ambling selection, not thematically constrained by the projections of the artist upon the subject. "What I respond to, apart from my own pictures, is what is direct, honest and straightforward. Trying to put on film what is in front of you rather than what is in your head. I haven't spent my life photographing nudes. In that sense these pictures aren't a significant body of work. They're just some pictures I've done, and that I enjoyed doing."

TEMPER SMITH

Thus Kurt Markus brings an objectivity to the American West - even though he was born and raised there - which removes it from more familiar terrain. His published photos are included in two volumes intriguingly titled, *After Barbed Wire* and *Buckaroo*. "I worked for a horse magazine for ten years," he says in his pensive, gentle drawl, "and in that time I did a lot of pictures of ranches. Some of these photos were taken in Australia, some in Santa Fe and some close to where I live. I guess you never fully escape who you are. Originality is to do with your own world. If you try to compare it to others you will always be at a loss."

...ncing and objectivity is also displayed in Markus's ...he nude. "Clothes can be more descriptive at times ...te form. I don't think that just by removing clothes ...ome sort of truth. I think you can get at some sort ...that isn't being obstructed by clothes, especially ...ren't the person's clothes. Maybe these pieces are a ...nst doing fashion pictures, where you never believe ...hes the girl is wearing are her own."

In effect, Kurt Markus seeks to capture his subjects as they appear rather than searching for an unseen aspect of a model or the landscape. The eyes obscured by shadow and the play of natural forms upon the body are enough to create the drama, resulting in a serenity and languid poise that would evade a more temporal artist. ✦

MARKUS

104

photographer Kurt Markus

pages 50-51 ➤
Arena

art director 1, 2, & 3 Sam Chick
 4 Grant Turner
designer 1 & 4 Grant Turner
 2 Sam Chick
 3 Marissa Bourke
editor 1 David Bradshaw
 2 Kathryn Flett
 3 & 4 Peter Howarth
publisher Wagadon
origin UK
dimensions 230 x 335 mm
 9 x 13¹/₈ in

GRUNGING IT UP AND PLAYING HOLLYWOOD DOWN. ETHAN HAWKE IS SO COOL HE'S HOT

serious

Helen Barlow talks to Hollywood's hardest-working slacker.

As brat pack stars like Kiefer Sutherland, Rob Lowe and Charlie Sheen continue their down-hill slide, a new breed of young American actors has emerged to take their place. Advocates of grunge over glamour, and more hip to the indie music and theatre scenes than the Hollywood hype-machine, these actors are high profile about their low-key lifestyles. At 23, Ethan Hawke is a reluctant celebrity who appears in one movie a year and usually tries to avoid probing journalists – except when he wants to talk about a new film.

"I wanted to work with Rick [Linklater] because of his other two films," explains Hawke. "And I like him a lot. I was impressed with his idea of making a movie solely about communication, and how hard it is for two people to get to know each other."

The actor's new role is vastly different from his ranting *Reality Bites* character. "He's not surly, not angry at all. He's just a guy who's struggling with immediate dilemmas. He's broken up with his girlfriend and is open to something happening in his life. Both these people really available and we know so little about them outside of that 10-hour time bracket. It forces you to take them at a very human level. The idea of the film is to show real people. Life is not about drama...the most exciting things that happen to us are really mundane thing,i..But these characters do have meaning, they have poetry I think."

photography david rose austral

29

Dressed nondescriptly in his favourite brown suede jacket and an open-neck shirt, Hawke is on location in Vienna for *Before Sunrise*, a new film from Richard Linklater (*Slacker*, *Dazed and Confused*). Co-starring French actress Julie Delpy, who recently appeared in Krzysztof Kieslowski's *Three Colours White*, the film is about two people who meet on a train in the middle of the night, and later roam the streets of Vienna, working their way through shared existential concerns, as they fall in love.

Their different cultural backgrounds – she is French and he is American – adds to the human dimension for Hawke. "I never feel very American unless I'm placed against somebody who is very European," he muses. "Then all of a sudden I feel like all I do is drink Coke and say, 'Have a nice day'."

As the actor's sole film this year, *Before Sunrise*, made for only US$2.5 million wasn't exactly a gold mine for its lead actors. Both Hawke and Delpy, however, were more interested in experiencing Linklater's loose creative process – 70 percent of the script was re-written in Vienna. "It's scary because the movie is a huge risk," says Hawke. "It's more probable that it won't work than that it will, because his aspirations are so high. Julie said in the script last night that the attempt is all, and I'm a real believer in that."

Delpy, an intense actor who works from nervous energy, is a contrast to the laid-back American. "She's very good, incredible," Hawke says. For a previous screen partner, Winona Ryder, Hawke has only praise: "Winona has really good instincts. You've got to hand it to her. *Reality Bites* is solely a product of her wanting to make a movie about her contemporaries. She is wildly successful, a millionaire," he exclaims. "Winona jerked me into it. She really wanted to make the film."

Hawke's feathers get ruffled when I suggest that the characters in *Reality Bites* are more formulaic stereo-types – as has often been written in reviews – than accurate characterisations. "People say they tried to Hollywood-ise *Slacker* too, but I know how genuine that film is, and I know that it's just not true. People say things like that just to belittle a film. If I say that you're just another Australian, I'm belittling you as a human being and it's the same to say that *Reality Bites* is a formula. It's a totally non-narrative movie. It's a really good movie.

Shrinking from 'generation X' and 'slacker' labels to describe his role in *Before Sunrise*, Hawke points out that his character has a job and that the film has a universal rather than just generational theme. "It's an optimistic movie. It's about how you can meet somebody and share intimacy – and how you can have an exchange of souls." Hesitant about the labelling frenzy that has accompanied the so-called X generation's documentation in the media, Hawke admits to being, "Very confused about it. The only thing I can see is people who are very unsure about the future."

Hawke is reluctant to talk about his career because "it changes from day to day", so we talk about everyone else's. He agrees that Ryder's recent success, like that of Keanu Reeves, stems from a wise choice of projects, and he sticks up for Reeves's much maligned acting talents. "A lot of people give Keanu Reeves a hard time but he's just proved himself again and again by sticking around and doing really good projects. Nobody has worked with better directors than Keanu Reeves."

Not that Hawke's choices have been so bad either. Before *Reality Bites*, he appeared in the plane-crash drama *Alive* and in *Dead Poet's Society*, the film that really jet-propelled his career.

continued page 116

57

LACY

photography peter rosetzky
hair and makeup nikki clarke
stylist virginia dowzer

With a combat-zone mouth and a boots-and-all attitude, Tania Lacy's take-no-prisoners comedy style has always played it fast and furious. Merran White catches up.

tania

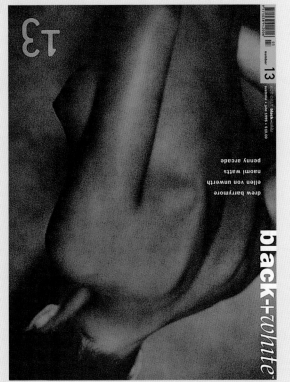

pages 46-9

b l a c k + w h i t e

art director Chris Holt
editor Karen-Jane Eyre
publisher Marcello Grand, Studio Magazines
origin Australia
dimensions 235 x 324 mm
9¼ x 12¾ in

Systems not schemes, character not conformity: typography, for Erik Spiekermann, is a tool for rendering the world accessible

Meta's tectonic man

Text: William Owen

Erik Spiekermann is a consummate pluralist. Able to move, seemingly without effort, between roles as a typographer, designer, writer, public speaker and merchandiser, he was once even a politician – a Green Party member of the Berlin Senate. Spiekermann is the author of *Stop Stealing Sheep* and *Rhyme & Reason* – two models of typographic rectitude for a lay audience – and the articulate upholder of standards of public design in many a conference lecture. He is the designer of Meta, one of the most successful typefaces of this decade, and founder of the typeface distribution company FontShop. Spiekermann is also a partner in MetaDesign, now an international consultancy with offices in Berlin, London and San Francisco, and it is this manifestation – the graphic designer – that has received the least attention. For while Spiekermann has been busy promoting his own particular brand

> "The page is the lowest common denominator of the book system. The page is the molecule and the atom is the word."

of rational Modernism-with-character, the polemicist has sometimes overshadowed the practitioner.

Spiekermann himself rejects the title of graphic designer to describe his practice: "I am a typographic designer. A typographic designer starts from the word up; a graphic designer starts from the picture down." This idiosyncratic explanation – few would place the two disciplines in opposition, and one is usually regarded as inclusive of the other – has a certain logic. But how, then, does Spiekermann distinguish his approach from that of an avowed graphic designer such as Gert Dumbar?

"Dumbar always uses space. He can't have three-dimensional space because paper is flat, so instead he uses cross-sections – he dissects objects in space and puts them on the flat page. He is a spatial kind of image guy; he thinks in theatrical terms. I think in page terms. The page is the lowest common

1-3. Cover and pages from the design manual for the BVG, Berlin's city transport system. This was MetaDesign's first major corporate identity and public signage project, begun in 1987 with new livery, signage and timetables for the bus service, and enlarged to include the city railway system after unification in 1989. 4. BVG logotype. Uniquely, for MetaDesign, the device is symmetrical, centred within its background and based on an unsophisticated square.

denominator of the book system. The page is the molecule and the atom is the word. You see, I read. I read before I design, and I write. I design outwards from words."

A respect for words and evident talent for using them might seem incongruous in the visual arts were it not that Spiekermann so often speaks and writes in pictures. His conversation is a stream of aphorism and metaphor. On national stereotypes in graphic design, for instance, we learn: "France is olive shaped; Holland is triangular, always very pointy and narrow; Germany is very square; and England is round." And on being a designer: "I am a servant, I'm not an artist. If I was an artist I would be oval, like an olive."

As a typographic designer, however, Spiekermann is distinctly quadrilateral. His trademarks are a rectangular or braced bar that bleeds off the page

and a palette of just two colours – black and red, in the craft tradition. While he is generous with words, Spiekermann is extremely parsimonious when dispensing colour, shape and typographic variation.

He ascribes this frugality to his background. The eldest of four children, his father a lorry driver, he was born into an impoverished post-war Germany, near Hannover, in 1947. He paid his way through Berlin's Free University, where he studied art history, by setting up as a jobbing letterpress printer. He had only two typefaces, in three sizes, and could rarely use more than two colours (he learned to give the impression of three-colour work by reversing type out of a colour in white). Economy was a function of necessity, and Spiekermann has used this experience to establish a method which exploits scarce resources to the full rather than attenuates or reduces. He is used to getting a lot from a little, but

34 EYE 18/95

35 EYE 18/95

The tenth pioneer

Seventeen and *Charm* both broke new ground. Cipe Pineles, their art director, played a leading part. Why, when the history came to be written, was Pineles left out?

1. Cipe Pineles and her husband William Golden, art director of CBS, receiving medals from the Art Directors Club of New York in 1948 – the first time a wife and husband were honoured in the same year. Pineles was awarded hers for commissioning fine artists to illustrate fiction for *Seventeen*. 2. *Charm*'s editors and executives celebrating its fifth anniversary in 1955. Seated from left: Eleanore Hillebrand Bruce, fashion editor; Helen Valentine, editor-in-chief; Estelle Ellis, promotion director; Cipe Pineles, art director. 3 (opposite). Pineles working at *Charm*, about 1955.

Text: Martha Scotford

Traditional accounts of design history have some obvious blindspots when it comes to the careers of women designers. Written from a predominantly male perspective, they tend to ignore the interactions of the personal and the professional, the private and the public, which play such a decisive role in the shaping of women's working lives. They are equally indifferent to the variety of career paths taken by women, the nature of collaboration between colleagues and the social and political roles played by women professionals.

The career of the American designer Cipe Pineles presents us with a much needed opportunity to explore new ways of writing design history. As an illustrator, design teacher and art director working primarily in women's magazines, she was an exemplary professional, an intriguing individual, and a valuable role model. Yet despite her many achievements, Pineles has never entirely received her due. The most recent historical study of individual American designers, R. Roger Remington and

Barbara J. Hodik's *Nine Pioneers in American Graphic Design* (1989), profiled nine male designers who worked in and around New York between the late 1920s and early 1970s and who "have helped shape graphic design as a profession and have made a distinctive and innovative contribution". Pineles' career fits the criteria for inclusion, yet though both her husbands – William Golden and Will Burtin – are among the chosen nine, she has been overlooked. Should Pineles have been the tenth pioneer?

Born to Jewish parents in Poland in 1908, Pineles came to the US in 1923 at the age of 15. Three years later she enrolled as a commercial art student at the Pratt Institute, followed by a year of painting supported by a Tiffany Foundation scholarship during which time she looked for design work. In a biographical summary sent to Dr Robert Leslie, director of the Composing Room, in 1970, she described the frequent professional rejections she suffered when it was discovered she was a woman. Employers were reluctant to put her in the artists'

> "Cipe Pineles was more than a token first woman art director; she was an innovator in art direction. She created the role of the modern woman designer and had no female peers"

54 EYE 18/95

Graphic authorship is taken for granted by many design theorists and it is gaining ground within practice too. But the idea has received little sustained examination. What does it mean and what is really possible?

The designer as author

"THE BIRTH OF THE READER MUST BE AT THE COST OF THE DEATH OF THE AUTHOR"
ROLAND BARTHES

"THE WHOLE POINT OF A MEANINGFUL STYLE IS THAT IT UNIFIES THE *WHAT* AND THE *HOW* INTO A PERSONAL STATEMENT"
ANDREW SARRIS

1. Digital poster by April Greiman for the Colorado large-sheet printer Pikes Peak, 1994.
2. Album sleeve by Vaughan Oliver for *Doolittle* by the Pixies, 4AD, 1989. Photography by Simon Larbalestier.
3. Poster by Anthon Beeke for the play *Penthesilea*, one of a series of three – to be displayed together – Toneelgroep Amsterdam, 1991.
4. Theatre poster by Pierre Bernard and Grapus, 1982.

Text: Michael Rock

Authorship has become a popular term in graphic design circles, especially in those at the edges of the profession: the design academics and the murky territory between design and art. The word has an important ring to it, with seductive connotations of origination and agency. But the question of how designers become authors is a difficult one and exactly who qualifies and what authored design might look like depends on how you define the term and determine admission into the pantheon.

Authorship may suggest new approaches to the issue of the design process in a profession traditionally associated more with the communication than the origination of messages. But theories of authorship also serve as legitimising strategies and authorial aspirations may end up reinforcing certain conservative notions of design production and subjectivity – ideas that run counter to recent critical attempts to overthrow the perception of design as based on individual brilliance. The implications of such a redefinition deserve careful scrutiny. What does it really mean to call for a graphic designer to be an author?

1. W. K. Wimsatt and Monroe C. Beardsley, "The Intentional Fallacy" in *Critical Theory since Plato*, ed. Hazard Adams, New York: 1971.
2. Roland Barthes, "The Death of the Author" in *Image-Music-Text*, New York: Hill and Wang (translated by Stephen Heath), 1977.

The meaning of the word "author" has shifted significantly through history and has been the subject of intense scrutiny over the last 40 years. The earliest definitions are not associated with writing *per se*, but rather denote "the person who originates or gives existence to anything". Other usages have authoritarian – even patriarchal – connotations: "the father of all life", "any inventor, constructor or founder", "one who begets" and "a director, commander, or ruler". More recently, Wimsatt and Beardsley's seminal essay "The Intentional Fallacy" (1946) was one of the first to drive a wedge between the author and the text with its claim that a reader could never really "know" the author through his or her writing.[1] The so-called "death of the Author", proposed most succinctly by Roland Barthes in a 1968 essay of that name, is closely linked to the birth of the reader theory, especially theory based in reader response and interpretation rather than intentionality.[2] Michel Foucault used the rhetorical question "What is an Author?" in 1969 as the title of an influential essay which, in response to Barthes, outlines the basic

Heinrich von Kleist

TONEELGROEP AMSTERDAM

3. Michel Foucault, "What is an Author?" in *Textual Strategies*, ed. Josué Harari, Ithaca: Cornell University Press, 1979.
4. Barthes, op. cit., p. 143.
5. Foucault, op. cit., p. 160.
6. Fredric Jameson quoted in Mark Dery, "The Persistence of Industrial Memory" in *Architecture New York* no. 10, p. 25.

characteristics and functions of the author and the problems associated with conventional ideas of authorship and origination.[3]

Foucault demonstrated that over the centuries the relationship between the author and the text has changed. The earliest sacred texts are authorless, their origins lost in history. In fact, the ancient, anonymous origin of such texts serves as a kind of authentication. On the other hand, scientific texts, at least until after the Renaissance, demanded an author's name as validation. By the eighteenth century, however, Foucault asserts, the situation had reversed: literature was authored and science had become the product of anonymous objectivity. Once authors began to be punished for their writing – that is, when a text could be transgressive – the link between author and text was firmly established. Text became a kind of private property, owned by the author, and a critical theory developed which reinforced that relationship, searching for keys to the text in the life and intention of its writer. With the rise of scientific method, on the other hand, scientific texts and mathematical proofs were no longer seen as authored texts but as discovered truths. The scientist revealed an extant phenomenon, a fact anyone faced with the same conditions would have uncovered. Therefore the scientist and mathematician could be first to discover a paradigm, and lend their name to it, but could never claim authorship over it.

Post-structuralist readings tend to criticise the prestige attributed to the figure of the author. The focus shifts from the author's intention to the internal workings of the writing: not *what* it means but *how* it means. Barthes ends his essay supposing "the birth of the reader must be at the cost of the death of the Author." Foucault imagines a time when we might ask, "What difference does it make who is speaking?"[4] The notion that a text is a line of words that releases a single meaning, the central message of an author/god, is overthrown.

Post-modernism turned on a "fragmented and schizophrenic decentering and dispersion" of the subject, noted Fredric Jameson.[5] The notion of a decentred text – a text which is skewed from the direct line of communication between sender and receiver, severed from the authority of its origin, and exists as a free-floating element in a field of possible significations – has figured heavily in recent constructions of a design based in reading and readers. But Katherine McCoy's prescient image of designers moving beyond problem-solving and by "authoring additional content and a self-conscious

low, but in typography and composition). The singularity of the artist's book, the low technical quality and the absence of a practical application may alienate the professional graphic designer.

If the difference between poetry and practical messages is that the latter are successful only when we correctly infer the intention, then activist design would be labelled as absolutely practical. But activist work – including the output of Gran Fury, Bureau, Women's Action Coalition, General Idea, ACT-UP, Class Action and the Guerrilla Girls – is also self-motivated and self-authored within a clear political agenda. Proactive work has a voice and message, but in its overt intentionality lacks the self-referentiality of the artist's book. Yet several problems cloud the issue of authored activism, not least the question of collaboration. Whose voice is speaking? Not an individual, but some kind of unified community. Is this work open for interpretation or is its point the brutal transmission of a specific message? The rise of activist authorship has complicated the whole idea of authorship as a kind of free self-expression.

Perhaps the graphic author is one who writes and

publishes material about design – Josef Müller-Brockmann or Rudy VanderLans, Paul Rand or Erik Spiekermann, William Morris or Neville Brody, Robin Kinross or Ellen Lupton. The entrepreneurial arm of authorship affords the possibility of a personal voice and wide distribution. Most split the activities into three discreet actions: editing, writing and designing. Even as their own clients, the design remains the vehicle for the written thought. (Kinross, for instance, works as a historian then changes hats and becomes a typographer.) Rudy VanderLans is perhaps the purest of the entrepreneurial authors, since in *Emigre* all three activities blend into a contiguous whole. In *Emigre* the content is deeply embedded in the form – that is, the formal exploration is as much the content of the magazine as the writing. VanderLans expresses his message through the selection of material (as an editor), the content of the writing (as a writer) and the form of the pages and typography (as a form-giver).

Ellen Lupton and her partner J. Abbott Miller have almost single-handedly constructed the new critical approach to graphic design, coupled with

14. Catalogue for the exhibition "The Bathroom, The Kitchen and The Aesthetics of Waste", curated, written and designed by Ellen Lupton and J. Abbott Miller, MIT List Visual Arts Center, 1992.
15. Copies of *Emigre*, edited, designed and published by Rudy VanderLans using typefaces designed and distributed by Emigre Fonts. "Do you read me?" type issue, no. 15, 1990.
16. *Paul Rand: A Designer's Art*, written and designed by Paul Rand, Yale University Press, 1985.
17. *Fellow Readers*, written, designed and published by Robin Kinross, Hyphen Press, 1994.
18. *Stop Stealing Sheep*, co-written by Erik Spiekermann, designed by MetaDesign, Adobe Press, 1993.
19. *S,M,L,XL* (Small, Medium, Large, Extra-Large), a massive cinematically conceived 1,376-page "novel about architecture" intended by architect Rem Koolhaas and designer Bruce Mau to be a "free-fall in the space of the typographic imagination", Monacelli Press/010, 1996.

THE BATHROOM THE KITCHEN AND THE AESTHETICS OF WASTE
A PROCESS OF ELIMINATION

do you read me?

Paul Rand: A Designer's Art

Fellow Readers

Stop Stealing Sheep

S,M,L,XL
Rem Koolhaas and Bruce Mau
O.M.A.
010

photographer Anthony Oliver

1-8. A selection of the Pouchée typefoundry's ornamented letters showing the high level of craftsmanship required to achieve such intricate results. In several cases the design breaks out from the basic letterform. This would increase the chances of damage and helps to prove that the wooden types were actually patterns for manufacture rather than blocks to be printed from directly. All the alphabets reproduced here are shown actual size.

Ornament is no longer a crime and there is a growing enthusiasm for decorative display. Few recent alphabets equal Louis John Pouchée's for vivacity and invention

Pouchée's lost alphabets

Text: Mike Daines

In the early years of the nineteenth century, skilled engravers at the London typefoundry of Louis John Pouchée produced a series of finely crafted decorative alphabets. The beautiful large letters, up to 26 lines (over 100 mm) in cap height and made from single blocks of end-grain boxwood, were intended as eye-catching elements for printed posters. They are mostly in the early nineteenth-century fat face style, richly adorned with intricately carved images of fruit, agricultural tools, farm animals, musical instruments and Masonic signs. Virtually lost for over 150 years, they have now been resurrected in a limited boxed edition as *Ornamented Types: Twenty-three alphabets from the foundry of Louis John Pouchée* through a collaboration between the St Bride Printing Library in the City of London, in whose collection they reside, and Ian Mortimer of I.M. Imprimit.

The ornate style and decorative extravagance of the types give them a renewed appeal for the tired typographic palettes of the 1990s. PostScript font catalogues today are beginning to offer decorative display alphabets, including ornamented initials digitised from nineteenth-century designs, as well as more rapid computer-generated display faces. But none of the types so far released matches the Pouchée alphabets for quality, originality or vivacity.

The fat faces and slab serifs designed in the first decades of the nineteenth century were reviled by taste-setting printers and typographers in the 1920s; Stanley Morison in *Type Designs of the Past and Present* (1926) stated, "The types cut between 1810 and 1830 represent the worst that have ever been."

During the 1930s display types of this period underwent a re-appreciation and were promoted by typographic opinion-formers such as Robert Harling's journal *Typography* (1936–39). Nicolete Gray's *Nineteenth Century Ornamented Types and Title Pages* (1938) contains reproductions of the Pouchée types described erroneously as examples of the "early Victorian 'exuberant' style" and credited to the Wood & Sharwoods London foundry. The idea that the alphabets dated from the second half of the nineteenth century survived and the selection from three of the types published in John C. Tarr's *Lettering: A Sourcebook of Roman Alphabets* (1951) is similarly described as "Victorian wood-cut letters".

The 1960s saw a revival of interest in decorative display types stimulated by the introduction of two new technologies for display setting: headline photosetting and dry-transfer lettering. Among the best-sellers for Letraset in the late 1960s were Lettres Ornées and Romantiques No. 5, two highly ornamented types in the French style described inaccurately as part of an "Art Nouveau" range. These were used widely in magazine headlines, posters and packaging, alongside the highly condensed sans serifs which were also fashionable. Five of the Pouchée designs were reproduced in the journal *Motif* in 1967 and sample letters published by James Mosley in the *Journal of the Printing Historical Society* (1966) stimulated academic interest.

The idea of publishing *Ornamented Types* began in 1983, when Mortimer and Mosley proofed the entire collection of blocks using one of the Albion hand-presses at St Bride to provide archive proofs for the library and repro proofs for a possible commercial edition (which has not been undertaken). The results affirmed the outstanding quality of the types and Mortimer made a proposal to the City of London Corporation (which has

43

Seen from the outside, during the 1980s, the Netherlands looked like a graphic designer's heaven. Government subsidies allowed cultural work to flourish. Commercial clients backed experimentation seemingly without question. But the 1990s finds young Dutch designers beating a retreat. The older generation's triumph is being followed by diffidence

The new sobriety

Text: Carel Kuitenbrouwer

Dutch graphic design is going through a transitional period, perhaps even a crisis. The overall standard is high, Dutch work enjoys an excellent reputation both at home and abroad, and the industry is becoming professionally organised. But the coming of age of Dutch design looks likely to be followed by an awkward silence.

The Netherlands is home to a host of freelancers, studios, partnerships and collectives of various sizes, which together produce a body of work that does credit to the reputation of Dutch design. Though Amsterdam has traditionally been the capital of publishing, advertising and design, more and more high-quality studios are being established outside the city. A good example is the Arnhem-based M+M Vormgevers, where Michelle Clay and Marsel Stoopen's work has an austerity reminiscent of the pre-war Neue Sachlichkeit and post-war functionalism. If M+M are in the middle of the spectrum, then a studio such as Typography & Other Serious Matters in The Hague occupies the more bookish end with a balanced, stylish idiom derived from Jan van Krimpen and other Dutch

book designers. At the other extreme are practitioners such as Montse Hernández Sala, who produces attractive, highly illustrative work from the eastern town of Nijmegen. Surrounding these three is a large professional population creating a vast range of work that might threaten to flood the market, were it not for the ephemerality of printed matter and the ever increasing rate of change of corporate identities.

So where is the crisis? First, there is a notable absence of the kind of innovation that could be detected even in the professional mainstream until a few years ago. Second, growing numbers of leading young designers have begun to reject the "Dutch Design" label, which they associate with having a ball at the client's expense and bombarding the public with a plethora of unnecessary, over-the-top images and messages. This counter-current runs alongside a public weariness with conspicuously de-

1. Poster/mailer by M+M for a charity art auction. The squares symbolise the works of art by different artists; the colours correspond to the art works' dominant hues, and the words in the squares are the titles.

image Amy Guip

image Angus Hyland & Louise Cantrill

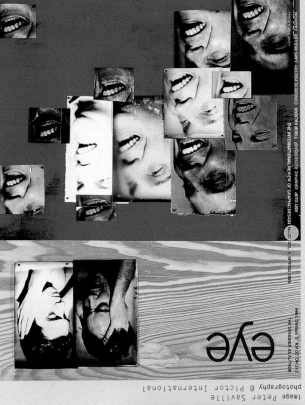

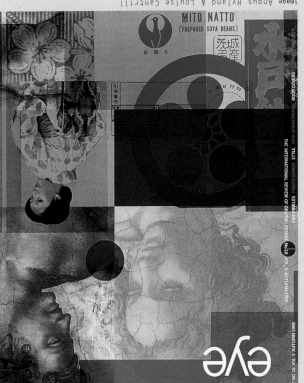

image Peter Saville / photography @ Pictor International

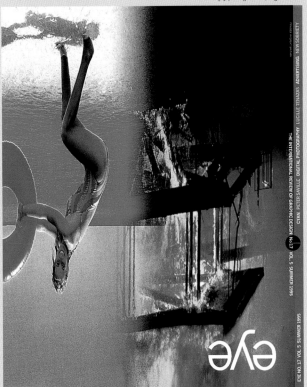

pages 42–5

Eye

art director Stephen Coates
designer Stephen Coates
editor Rick Poynor
publisher Emap Business
Communications
origin UK
dimensions 237 x 297 mm
9⅜ x 11¹³/₁₆ in

symbols

A book piles up letters only for the sakes of their arrangement — never !, if!, when,' 'so' — have been on the beginning. But this of iconic words is very small. Similar words like 'of', 'it', 'when', 'so' — have been on the beginning.

code

the book exists as an extension of the eye and mind but requires an understanding of the mental of reading, and the participation of the reader to recreate the reality it is depicting.

abstract

language and that of the comes, that of the you have to know

abstract

Paradox: in order to be able to manifest itself concretely, language must first become composed.

The book brings language and literature by way of the visual word to our eyes. We have symbols for the sounds of which the word is composed.

UPON EL IANTSI UPON EL IANTSI KE'IANT UP ANT KE'IANT UP ANT KE'IANT

This magazine is a compilation of research into the subject of bookishness, inspired by an M.C.A. 1993/4 project entitled "When is a Book not a Book?"

The research by the students in the class was collected with the intention of exploring and classifying the ideas and hypotheses uncovered. Rather than pursuing any one answer, as it is clear that there are many dissimilar and contradictions, the aim is to take you on a journey, showing how different aspects of the book relate to and presuppose each other. As each category demands the next

A starting point for these definitions is the assumption that words become more than just marks, their symbolism goes beyond the page to evoke the outside world as they become of definition, and the evolution of this into language. As without a reader a book is nothing; beginning with the intangibility of human thought, to something without shape

interlinearly linked with the thing that they represent. This gives books the power to create their own world; blurring the distinction between the text and reality. An examination of linearity in turn raises the question that as the reader absorbs the text, one line after the other. An consideration of information, that finds revelation in sequence.

perhaps there could be other, non-linear, ways of perceiving

and communicating that

could challenge the form of books.

40

pages 40-41 ➤

The Magazine of the Book

art directors Vivienne Cherry
 Seònaid Mackay
 designers Vivienne Cherry
 Seònaid Mackay
photographers/ Vivienne Cherry
 illustrators Seònaid Mackay
 editors Vivienne Cherry
 Seònaid Mackay
 publisher The Royal College of Art
 origin UK
 dimensions 210 x 297 mm
 8¹/₄ x 11³/₄ in

pages 38-9

Visible Language

art directors 1 Tom Ockerse
 2, 3, & 4 Larry Clarkberg
 designers 1 Paul Mazzucca
 2, 3, & 4 Larry Clarkberg
photographers 1 Paul Mazzucca
 3 Stock Photo Disk
 artist 2 J.S.G. Boggs
 editors 1 Andrew Blauvelt
 2, 3, & 4 Sharon Poggenpohl
 publisher Visible Language
 origin USA
 dimensions 152 x 229 mm
 6 x 9 in

Gonzalez & Boggs

MG **JSGB**

You were reluctant to give this interview, and I was surprised at that because you seem to be such an accessible and public person.

I used to have an open-door policy, and I did not discriminate. If someone wanted to talk about the work or the circumstances, the door was open, even if it was the press come to ambush me. But **I hate interviews.** I'm much more interested in conversation.

You are referring to the Dan Rather *Eye On America* television show where they portrayed you and your work in the light of color-copy counterfeiting.

Actually I was referring to *Art in America* magazine, but CBS fills the bill.

I assure you I haven't come to ambush you.

Exactly what an ambusher would say, no?

Touche.

Look, I didn't close the door because I was worried about being ambushed. Do your worst. I just got tired of doing interviews that were of little consequence to either party. There is no such thing as a stupid question, but if the question's little more than a thinly veiled fishing expedition to grab a sound bite, and no one is actually listening to the response, then **what is the point?**

I'm listening.

So am I.

(Boggs' reputation for full-frontal confrontation is well deserved.) You mentioned your previous open-door policy—did that extend to the **police?**

What a **joke.** They did not need a search warrant. I'd invited them to the studio dozens of times. I thought they were O.K. people. The United States Secret Service had been asked to jointly prosecute in England because seven drawings were of American bills. They refused and ordered those works returned to me. I thought they were

Interview with J.S.G. Boggs

Manuel Gonzalez

Just Say Yes
91 Adalia Drive
Tampa, Florida 33606

Visible Language, 29:3
Manuel Gonzalez, 376-393
© Visible Language, 1995
Rhode Island School of Design
Providence, Rhode Island 02903

Manuel Gonzalez is a self-taught poet. He is currently travelling throughout America with Sandra.

In January of this year, the artist J.S.G. Boggs printed 900 one-dollar bills, which he then spent to rent a booth at a paper-money collectors convention. The convention organizer then went out and put them into general circulation by passing them on to others who would spend them further all across America.

In the formation of ethical be-
dealing with the role of education
book, The Washing (ton) Machine.

For some time, I had been interested in Boggs' work and his behavioral sublimation.

lengthy disagreement with government officials over his currency series. Upon hearing the news of this mass act of civil disobedience, I could no longer resist satisfying my curiosity. I wanted to meet the man who, depending on whom you speak with, is either mad, a con-artist or both. I found something other in him, and I hope the record of this brief encounter will help reveal the human being who lives this painfully slow-moving legal drama daily.

Image provided by © 1994 PhotoDisc, Inc.

LIFE SIZE & IN COLOUR!

Money!
A special issue

Visible Language 29.3/4

Part 3 Interpretations

New Perspectives:
Critical Histories
of Graphic Design

Visible Language 29.1

On every planet the mastery of self begins with the mastery of inner and outer energies; but only attempt to master that which you recognize as true. All needs are contained within The One. All is available within The One. False needs born of thoughtless childish desires are not destined to be truly satisfied. True knowledge is often painful, but with confidence in your birthright, all will be fulfilled through an intimate relationship with The One.

Overcoming the energy patterns of this planet, which must be assumed in order to exist here, is the supreme and ultimate test of every extraterrestrial. When you understand that energy is created through thoughts and feelings, stamped with the signature of the creator and destined to return to him, you will have the key to mastery. If you simply stop creating new thought forms and stop being controlled by old, unwanted thoughts, and guard the pattern of your daily thinking, you will begin to create the type of world in which you've always wished to live.

Energy not only floats around, it congeals with other like energy and eventually assumes a life of its own with a will to survive. It will seek out compatible experiences either by feeding off humans with like energies or by stimulating similar energies in unsuspecting humans. People with intense emotions are especially targeted. Two people can marry their energies and create a combined force field to benefit or complicate their lives. This is the real reason for the importance of commitment. It has little to do with satisfying the insecurities of the human, but rather with the protection of the marriage force field from contamination by outside influences. My assignment was in the understanding of these energies. Absolutely everything breaks down to energy dynamics. The One is composed of positive (+) and negative (–). Behind The One and incomprehensible to all life-forms is the **0**. Out of the **0** exists The One which in order to evolve must become the 2s. The 2s manifest what we call life. Each 2 has a + and – component, hence the name **2**. The life of the 2s is separate and complete in each **2**'s awareness of itself as an individual entity, therefore seeks + or – seeks to perpetuate itself as exactly what it is: + or –. Our job is to harmonize to The One and hold the balance of the 2s. The life of the 2s, however, wants to pull you into one or the other aspect of itself. It is easy to forget one's origins in The One when these brief trespasses into the + or – aspects of The One seem so real and complete. The test is to not take them seriously, but to respect them as equal yet opposite, and completely unavoidable! Acceptance with respect is the answer and the ultimate goal is to keep them balanced.

The state of spiritual affairs on Earth is appalling. It saddens me beyond belief to see so many desperate humans seeking escape from their lives. Either a heaven or some magnificent god awaits you upon death, if you can survive and hold fast to the rules set before you by your religions. Does no one see how often these rules change from era to era? And the metaphysicians who believe that they can ascend this physical plane by pure, positive spiritual thinking...' You are mere children in your expectations. One can only become pure spirit when the 2s have been balanced in the inner One within you all. You do not become spirit by ascending out of matter but rather by moving into matter and holding the balance of the two polarities'. This is a systematic process. Moving in and out of masculine and feminine and balancing the 2s of each One; balancing the 2s of the masculine,

balancing the 2s of the feminine until the spirit-form which you are understands The One behind the masculine and the feminine. In every life there are challenges of the 2s before you. If you wish to measure your evolution, check your inner peace with your inner masculine and your inner feminine and then check its manifestation in your outer, daily life.

You, Earth humans, are responsible for the state of affairs that exist on your planet. You cannot escape the responsibility for this. To seek an escape is a childish whim and can never by allowed. All are accountable to The One for whatever they have created. All energy stamped with your signature by your thoughts remain yours until it has been balanced within you and released once again into The One. When all energy has been released in freedom, then you will also be free. This ascension process is a gradual heightening of light frequency and takes place over many eons. Until you conquer your fear of death, your own frightening energy creations, and settle into the beauty of the 2s you will never begin this process of ascension.

One thing more, no one can balance the 2s of another. It is the duty of each one to do this for themselves and earn their own freedom. The more evolved you are the easier it is to see the imperfections of another. Also, although their pain might seem overwhelming and unfair, the desire to assist must be resisted. To interfere can only be dangerous for your own evolution by causing you to absorb and carry energy patterns not meant for you. This can result in a needless delay of your own mission. During my sojourn here on your planet I was systematically led through many lives which touched me deeply and many circumstances where I searched in vain for my truth. It is frightening to know so much and have no one to validate that hard-won knowledge. Although I met many wonderful people who helped me through my ordeal, I outgrew them all in time. The message was clear: you are alone. You have the ability to know your own truth. It is as it should be.

It is a fact of great sadness and incomprehensible to us that while we maneuver and manipulate time and space, placing ourselves at great risk in order to appreciate and explore this planet of such beauty, you, Earth humans, are systematically destroying it day by day. Don't you see the mark of doom that hangs over your civilization? Your days are numbered regarding life as you know it. Reclaim your power, your earth, and your destiny! Reverse the polarity of the energy that controls you and you will be able to move your destiny in any direction you choose ●

And so on... into infinity.

The author prefers to remain anonymous. It is up to the reader to decipher his or her own truth from these words. Truth comes in many disguises ●

The loss of memory was very difficult, as was my re-evolution through Earth frequencies. Only those who have lost their lives through amnesia can understand the horror of being history-less. As memories return the effect is inner turmoil. The hardest task at this point is to remain calm and trust in self without becoming influenced and manipulated into going against your inner truth. A strong negative reaction is often catalyzed within certain individuals in response to higher frequencies.

The immediate and irresistible urge to control or dominate because of a cowardly fear is my heritage on your planet.

This Mother attempted to dominate me through Catholicism. Religion is a method of control.

By handing your destiny over to to an outside authority you remain forever enslaved to it. A religion is sustained by a self-generating field of energy created by its members. The energy of this force field begins to believe in its power and comes to see itself as a god. It is almost impossible to break away from an attraction to this energy field. Like a weed, its roots enter your soul and subconscious mind where it spreads and grows in power. It is a challenging test of evolution to shed this possession, and an absolute necessity if you are ever to return to your home planet.

The hardest part of adjusting to the Earth experience was the pleasure and familiarity I felt during telepathic interludes with my team. It was decided that I would remain relatively isolated until I completed the normal education required by the Earth culture I'd been born into. At the end of my teen-age years the first layer was removed and my training began.

My Earth life was a traumatic and highly tested event. Often I came close to failure, which would have meant absorption into the Earth cycles of death and rebirth.

You may question this activity as interference and wonder how we might justify meddling in the energies of Earth. Although there have been many ruthless visitors to your planet, those in alignment with **The One** require an invitation. This you provide through prayers for the return of a Savior. These prayers are sent through many religions and become an open invitation for any of us to answer. You must be aware that there was never anyone by the name of Jesus Christ on Earth. This name is a fabrication as is the history associated with this individual.

I myself answered the call for the return of the great white buffalo woman of the red race. For this reason I feel a special bond with the evolution of these people and have, in fact, adopted them as my own. My greatest gifts have come through my incarnations within various North American tribes. Although the horrors of genocide have scarred me deeply, the glorious immersion into your Earth nature left me in awe. I was indeed mesmerized by the color and drama, the sound and smell of death, destruction, renewal, and rebirth, so orderly yet chaotic—all things long gone from my home planet. I, **Taté**, shall forever cherish those experiences as some of the dearest treasures of my entire evolution. (My secret grief is that I must share in the responsibility for the destruction of the red civilization as it once was. You see, Earth humans, you cannot invite the evolved without suffering. Once the light energy of such a being impacts on the negative energy field of your planet there are inescapable consequences.

In order to form a personality to carry me through the Earth experience it was necessary to dip into every facet of your human drama. This was a planned and systematic process. Whenever possible my experiences were combined to minimize and condense trauma and time. Quality and thoroughness were the goals as well as keeping the life-sustaining connection to **The One.**

JOHNNY GOD

BY GARY INDi ANA

For seven days dead souls can return to their village. A liquor accident at Madampi, on the coast of Ceylon. Johnny God looked down at his long fingers. They were strong through a childhood of a dairy farm. He had dreamed of a day when his true mother called him a faggot, his smooth body triumphing. The first Norwegian to stop donating blood. Those who have a good life work in a coverall and then a smooth and summer the strange guided by Mampes to a miraculous island, Beleret.

The city set a small experimental gas generator at one of the northern corners in 1816. The elephants lifted their heads as they struggled out of the mud. Whole oil and candle people went after brilliant effects distilled by tin pipes would turn billions of units of energy. To reach the island I would live on a fourth floor and the middle of a switchbacked bridge. One day I asked to divide the colors in my converted sardine can. Then I counted forward from memory of the wine-sharp tideless solitude re-entering her aura at the bar and among the waiters.

I WATCHED THE SWIMMING HEAD BOILED DOWN ON TOSSING TREES RISING OUT OF THE WATER DAMP SCUT FALLING AND CANTED. INTO THE SANITARI- UM FOR THIS INTELLIGENCE. With the figure and myself in Nicky's cell.

'Dr. Harwood has a theory about Nicky's illness.'
'Stuff has been pouring in here.'
The floor is bare, the room bad enough. One old mat and a broken desk. No curtain with darkness discolored shutters holes in the man on the bed. A child. Abridgment of the torturing hour. A woman cutting rushes for mats.
'The name of your friend in the city begins with a D,' she says. 'I'm the only one alive. Something in it for my money to make his head roll like a skull cap.'
They called him Johnny God. Half-toilet, half-deity. There we were in the laser nets of cyberspace giving it up for Johnny. Last two million in despair. A vague mass rose inch by inch to ears less keenly tuned, a faint swishing sound. What was the thing with a wriggling movement? Those animals have been racing at a minor oval to be avoided. This type of animal raises serious questions. I speak of this period with emotion more brilliant when I knew the mir-

Mission San Xavier Del Bac near Tucson, Arizona
Photos: Sojin Kim

48

49

3

35

pages 34-7

Now Time

art directors	Renée Cossutta
	Judith Lausten
designers	1 Somi Kim @ ReVerb
	2 P. Lyn Middleton
	3 Edwin Utermohlen
	4 Chris Myers & Nancy Mayer
	5 (see over) Chris Myers & Nancy Mayer
photographers	1 Christiane Badgley
	Bob Paris
	2 B. Burkhart
	4 Chris Myers
	5 (see over) Chris Myers
editor	Miyoshi Barosh
publisher	A.R.T.* Press
origin	USA
dimensions	241 x 317 mm
	9¹/₂ x 12¹/₂ in

An excerpt from :

? How to Solve the Problems of Earth !
from the Extraterrestrial Point of View

by

Things are so different on my home planet. Although we exist in physical bodies, our boundaries are not limited by mere physical expression. This expansiveness is due to our advanced state of evolution.

On my planet we are grounded in a common spiritual awareness that we are all part of The One !

It is The One that exists and evolves through us.

Since we revere The One we would not think of harming another for any harm done to one affects us all, there is a thread of this awareness running through spiritual movements on Earth but this concept is not fully grasped — humans still cling to the illusion of

separateness,

individuality.

The human forms relationships based on some perception of need. He does not understand that two spirit-forms may »marry« through numerous lifetimes in mutual exploration of many varied relationships.

The bonds that form through these kinds of marriages are far more real than any

one Earth love affair ●

4

34

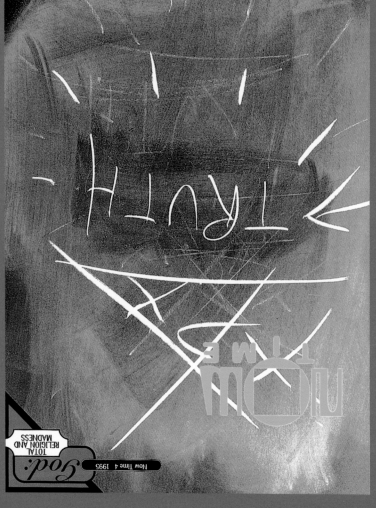

TRUTH

NOW TIME

God:
TOTAL
RELIGION AND
MADNESS

Now Time 4 1995

Now Time

art directors Renée Cossutta
 Judith Lausten
designers 1 Miyoshi Barosh
 2 Judith Lausten
photographer 2 Sherrie Zuckerman
illustrator 1 & 2 Miyoshi Barosh
editor Miyoshi Barosh
publisher A.R.T.* Press
origin USA
dimensions 241 x 317 mm
 9¼ x 12½ in

Independent
Magazine

11/11/95

Get out of jail free

photographer Matthew Donaldson

Independent
Magazine

23/12/95

photographer Matthew Donaldson

Independent
Magazine

06/01/96

Blinded by the light

photographer Robert Powell

Independent
Magazine

02/09/95

Can Britain bite back?

photographer Giles Revell

Independent Magazine

art director Vince Frost @ Frost Design
 designer Vince Frost @ Frost Design
 editor David Robson
 publisher Newspaper Publishing Plc
 origin UK
 dimensions 280 x 355 mm
 11 x 14 in

Virgin Classics

CD catalog 1996

art directors Nick Bell
 Jeremy Hall
designer Anukam Edward Opara
 © Nick Bell Design

photographer Gary Woods
editor Jeremy Hall
publisher Virgin Classics
origin UK
dimensions 210 x 297 mm
 8¼ x 11¾ in

frieze

CONTEMPORARY ART AND CULTURE

UK £3.95 US $7.50 DM 10 FF 40 CAN $10 AUS $11.95 HFL 13 NZ $14.95 ISSUE 27 MARCH · APRIL 1996

frieze

art director Harry Crumb
designer Harry Crumb
editors Matthew Slotover
 Amanda Sharp
 Tom Gidley

publisher Durian Publications
origin UK
dimensions 230 x 300 mm
 9 x 11¾ in

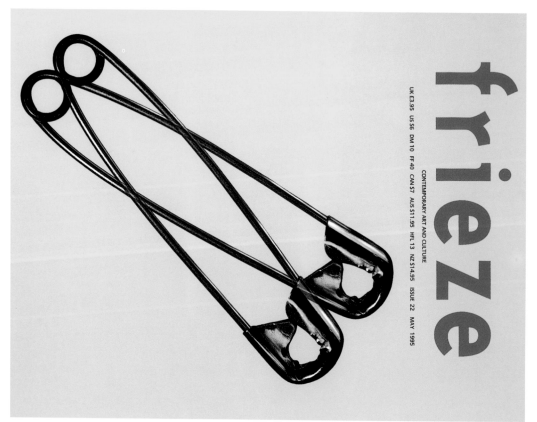

frieze

CONTEMPORARY ART AND CULTURE

UK £3.95 US $6 DM 10 FF 40 CAN $7 AUS $11.95 HFL 13 NZ $14.95 ISSUE 22 MAY 1995

photographer Richard J. Burbridge

virgin

Virgin classics

edition ultraviolet 96 virgin classics veritas

cd catalogue

96

Virgin CLASSICS

RENÉ BURRI
TIEMPO DE REVOLUCIÓN

Entre 1963 y 1993, René Burri, miembro de la agencia Magnum, ha realizado ocho viajes a la isla. Sus imágenes son un testimonio excepcional de la Cuba contemporánea; una intensa fotografía del largo viaje de la revolución.

MIGUEL RIOBRANCO
HABANA 1994

El fotógrafo brasileño Riobranco ha hecho, en 1994, el último
retrato de la ciudad. La vieja Habana, gastada por el tiempo, se ha
convertido en un cuadro surrealista.

28

LA CUBANÍA

Cuba es el país de los sentidos. Éstos constituyen su verdadero clima, ya que los sentidos en esta isla del Caribe son una prolongación del aire, una forma de meteorología general que no se distingue de la sensualidad de sus gentes. En Cuba es imposible la soledad: he aquí su principal característica. Como el aire que a uno le envuelve, la expresión corporal de los cubanos es un elemento espiritual, lleno de carnalidad, que persigue al viajero hasta rendirle felizmente. No sé de ningún país que posea esta clase de arma para enamorar. Cualquier persona solitaria que llegue a La Habana sentirá en primer lugar algo muy agradable en la piel. La naturaleza del goce se hará presente en ciertas sensaciones corporales, pero muy pronto va a experimentar que esta plenitud hedonista se deriva de las miradas calientes que le miran, de las sonrisas inmuminadas que le acarician, de las palabras suaves que le rodean, de los gestos amigables, lentos, sensuales con que le asedian gentes desconocidas y que al poco tiempo uno reconoce como amigos que comparten una misma empresa de felicidad en la tierra. Después llegará el ron, el son, el sol, las palmeras, las caderas carnales. El viajero habrá desvelado el misterio de que en Cuba la soledad es imposible cuando descubra que su alegría no permite refugiarte nunca en ti mismo, no consiente que huyas jamás. *Manuel Vicent*

ABECEDARIO

ALVAR AALTO JOSÉ MANUEL ABASCAL CLAUDIO **ABBADO**
BERENICE ABBOTT DAVID ABBOTT KARIM ABBDUL JABBAR
VICTORIA ABRIL ANSEL ADAMS HENRY ADAMS THEODOR W.
ADORNO ADRIANO ANDRÉ AGASSI GIACOMMO AGOSTINI
SAN AGUSTÍN OTL AICHER ANA AJMATOVA AZZEDINE ALAÏA
PEDRO ANTONIO DE ALARCÓN LEOPOLDO ALAS ISAAC ALBÉNIZ
JOSEF ALBERS RAFAEL ALBERTI TOMASSO ALBINONI ALFREDO
ALCAÍN IGNACIO ALDECOA ROBERT ALDRICH VICENTE
ALEIXANDRE ANDREU ALFARO ALDUS MANUTIUS JEAN
D'ALEMBERT ALESSI MOHAMMAD ALI NÉSTOR ALMENDROS
ALICIA ALONSO DÁMASO ALONSO JOSÉ LUIS ALONSO DE
SANTOS ALBRECHT ALTDORFER ROBERT ALTMAN ÁLVAREZ
QUINTERO SALVADOR ALLENDE FERNANDO AMAT CARMEN
AMAYA GENE AMDAHL ROALD AMUDSEN HANS CHRISTIAN
ANDERSEN LAURIE ANDERSON LEONIDAS ANDREIEV VICTORIA
DE LOS ÁNGELES BEATO ANGÉLICO ANÍBAL ANGLADA
CAMARASA JACQUES ANQUETIL ANTONIONI GUILLAUME
APOLLINAIRE KAREL APPEL LUCIO APULEYO RON ARAD YASIR
ARAFAT VICENTE ARANDA ARANGUREN ARANTXA DIANE
ARBUS ARCHIGRAM ARCHIMBOLDO ALEXANDER ARCHIPENKO
ELISABETH ARDEN PAUL ARDEN OSVALDO ARDILES ATAULFO
ARGENTA GABRIEL ARISTI LUDOVICO ARIOSTO ARISTÓFANES
ARISTÓTELES GIORGIO ARMANI LOUIS ARMSTRONG NEIL
ARMSTRONG CARLOS ARNICHES EVE ARNOLD HANS ARP
ARQUÍMEDES FERNANDO ARRABAL JUAN JOSÉ ARREOLA
EDUARDO ARROYO ANTONIN ARTAUD ROBERT ARTL JUAN MARÍA
ARZAK ARTHUR ASHE FRED ASTAIRE MIGUEL ÁNGEL ASTURIAS
ATILA CHARLES ATLAS BERNARDO ATXAGA MAX AUB AUGUSTO
JANE AUSTEN W. H. AUDEN AVERROES FRANCISCO AYALA
MANUEL AZAÑA RAFAEL AZCONA AZORÍN FÉLIX DE AZÚA

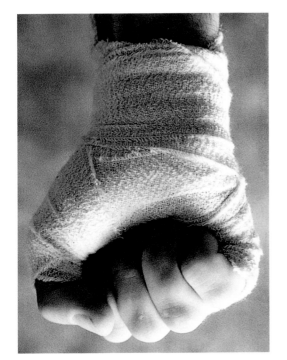

Matador

art director Fernando Gutiérrez
designers Fernando Gutiérrez
 Pablo Martín
 Patricia Balleste
photographers Anton Stankowski
 James A. Fox
 René Burri
 Walker Evans
 Miguel Riobranco
 Henri Cartier-Bresson
 Eli Reed
 Luis De Las Alas
editor Alberto Anaut
publisher La Fábrica
origin Spain
dimensions 300 x 400 mm
 11³/₄ x 15³/₄ in

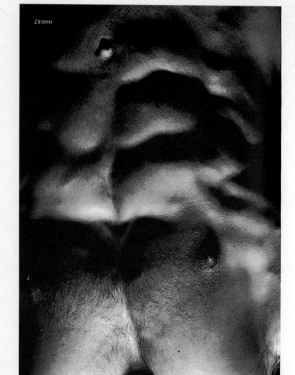
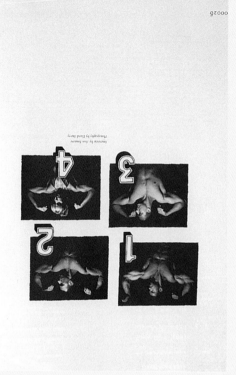

Interview by Ann Swann
Photography by David Barry

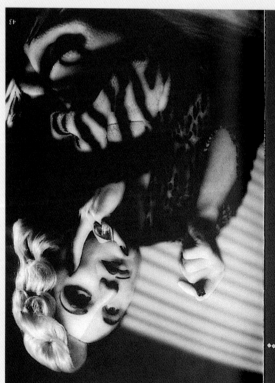
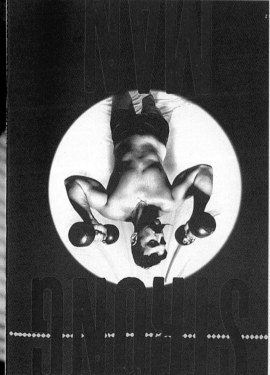

Sin

art director Stephen Banham
designer Stephen Banham
photographer David Sterry
editor Ann Sinatore
publisher Sin Publishing
origin Australia
dimensions 250 x 330 mm
 9⅞ x 13 in

Alphabet

Explaining to people the inherent beauty and possibilities of the Alphabet is considered by many as tantamount to being cornered at a party by a dorky trainspotter.

AT HOME WITH the FAMILY

'REPEAT'

ON A WEEKLY BASIS OR

UNTIL THE MAC DEPENDENCE SUBSIDES.

page 22

Qwerty

art director Stephen Banham
designer Stephen Banham
editor Stephen Banham
publisher The Letterbox
origin Australia
dimensions 74 x 105 mm
2⅞ x 4⅛ in

page 23

Qwerty

poster

art director Stephen Banham
designer Stephen Banham
photographer David Sterry
publisher The Letterbox
origin Australia
dimensions 420 x 594 mm
16½ x 23⅜ in

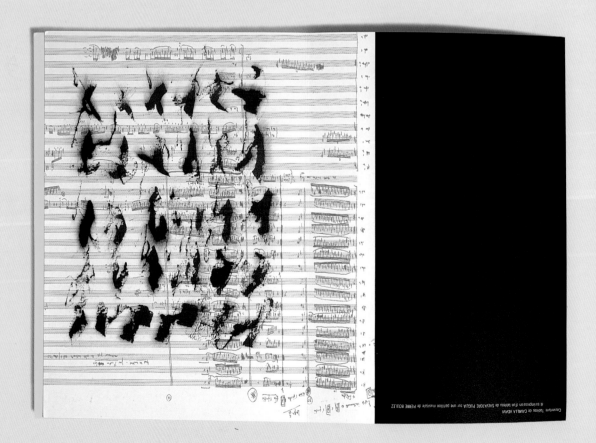

René Major : Outre-mesure	7
Maurice Blanchot : Anacrouse	11
Jacques Derrida : Sauver les phénomènes : pour Salvatore Puglia	23
Jacques Roubaud : L'asocialité. Déduction du temps	53
Paule Thévenin : La poésie, la mort	61
Jean-Luc Nancy : Syncope	65
Roger Laporte : "Il n'est pas de Présent"	73
Peggy Kamuf : The Reality is the Thing	83
Werner Hamacher : Des comètes des temps	89
Gilbert Lascault : Le trois bleu des contre-nuits (sur 3 œuvres originales d'Antonio Segui)	97
Jean-Claude Lebensztejn : Mémoires d'un cancre	101
Rachel Bowlby : Un heureux évènement	113
Geoffrey Bennington : Plus que parfait	143
Vima da Silva : Musique Peinture Écrits (à propos de Pierre Boulez)	161
Hélène Cixous : Préparation de la hache	183
Alexander Gottmann : L'occasion et la langue	200
Michael Finkl : L'anti-Narcisse Couplet et Neige	211
Michel Deguy : Multitude, solitude	231
	521

Couverture : Tableau de CAMILLA ADAM / Il s'enrichit(?) d'un tableau de SALVATORE PUGLIA sur une partition musicale de PIERRE BOULEZ

pages 20-21

Contretemps

art director
Italo Lupi

designer
Italo Lupi

cover art
Camilla Adami

editor
René Major

publisher
T.R.A.N.S.I.T.I.O.N.
L'Age d'Homme, Paris

origin
France/Italy

dimensions
235 x 315 mm
9¹/₄ x 12³/₈ in

20

René Major: Outre mesure ● Tout aura commencé par un étourdissement, une syncope, un silence au temps fort, une mesure à contre-temps. Le contre-temps est le commencement même. Au commencement – à tout commencement – il y a le contre-temps: l'improbable qui arrive. Telle la probabilité de l'apparition de la vie sur la terre qui était a priori quasi nulle.
● L'homme naît à contre-temps, dans l'incapacité de se suffire à lui-même et de dire la détresse dans laquelle il se trouve; l'impossibilité de voir son besoin s'accorder synchroniquement avec le désir de l'autre.
● Dès lors, il inverse les boussoles, les compas, les calendriers, les chemins de fer, la vitesse, tout ce qui, pour éviter les contre-temps, ne cesse d'en multiplier les occasions.
● Rien n'arrive à temps pour le désir. Rien n'arrive sans retard, sans détour. Le retard est original. Le contre-temps, essentiel. Il ressortit à un autre temps que celui du calcul. Il est déterminé par une autre temporalité ou par une a-temporalité. Il survient en anticipation ou dans l'après coup. Pour cette autre temporalité, et contrairement à celle qu'il traverse à contre-courant, le contre-temps arrive toujours trop juste à temps. Comme de juste. Pour dire le contraire ou autre chose que prétendent dire la temporalité de la conscience ou la conscience du temps.
● La bévue et l'impair rappellent à l'attention de faire gaffe. Mais comment ne faire gaffe peut-il éviter de commettre l'impair? (L'impair: qui est unique, qui n'a pas de double)
● Dans la pièce de Molière, L'étourdi ou les contre-temps, les contretemps de Lélie, qui persistent contrecarrer les bons offices de Mascarille, font figure de tenants-lieu de la vérité.

MASCARILLE
À quoi bon se montrer, & comme un étourdi
Me venir démentir de tout ce que j'ai dit?

LÉLIE
Je pensais faire bien.

MASCARILLE
Oui, c'est fort bien faire.
Mais quoi! cette action ne me doit point surprendre,
Vous êtes si fertile en pareils contre-temps,
Que vos vos écarts d'esprit n'étonnent plus les gens.

● L'amour partage le contre-temps dans la promesse de sa suspension et dans l'absence du rapport qui ne tourne de l'équivoque signifiante. Les deux moitiés ne cessent de s'empêtrer dans la célébration dont elles s'empanachent ou s'empanacent. Que chacune ne trouve toujours à sa porte que la mi-dit s'empêche de décacher dans ce contre-temps te prétende à s'étourdi(re).
● Étrange et singulière réponse de la Sphynge à un Œdipe analyste et philosophe?

Tu m'as satisfaite, petithomme. Tu as compris, c'est ce qu'il fallait. Vas, d'étourdit il n'y en a pas de trop, pour qu'il te revienne l'après midit. Grâce à la main qui te répondra à ce qu'Antigone tu l'appelle, la femme qui peut te déchirer de ce que qui sphynge non partouhe, tu sauras même vers le soir te faire l'égal de Tirésias et comme lui, d'avoir fait l'Autre, deviner ce que te j'ai dit".
● Ce qui n'arrive pas selon la mesure du temps, ou selon la mesure du lieu, arrive à contre-temps. Mais le contre-temps n'est pas une autre figure de ce temps. Il est ce qui arrive d'inattendu à ce temps, sous une autre forme que celle que ce temps peut ne représenter. Le contretemps n'est pas le négard de la représentation du temps, ni son opposé, mais l'évènement avec lequel le temps ne compte pas, que rien n'arrête, pas même le temps. Le contre-temps passe outre au temps, passe outre à l'arrêt de passer outre. Il est outre mesure.
● Le contre-temps a son origine hors du temps. L'inconscient est le lieu du savoir in statu nescendi (à l'état de nescience) du contre-temps, la contrée de l'Unheit (le non-temps) d'où arriveront à l'improviste das Misgeschick (la mé-conte?) ou das méchante (la méchance?).
● L'effraction, l'immuno-déficience du corps face au double risque – externe et interne – de la libération sexuelle, le franchissement des frontières, le déchirement du voile, la tombée du mur: autant de contre-temps pour la mesure du temps. Pour accélérer ou interrompre la

cadence. Pour rompre inopinément avec les mesurcentuer – à temps ou à contre-temps – le dénouem
● Jouer à contre-temps: "action d'attaquer un son ar ou sur la partie faible d'un temps, le temps fort (le temps suivant) étant formé d'un silence. Le contre-te et la syncope sont analysés sur la temps faible" (Lar
● Anacrouse. En musique: mesure incomplète par morceau ou mesure d'un ton faible qui accentue l'a vantes. En poésie ancienne: demi-pied faible pré temps marqué.
● Pour mémoire, le début de la lettredamour et le des temps:
● J'aime parce que l'autre est l'autre, parce que sonn mais le tiens. La durée vivante, la présence même infiniment éloignée de la mienne, éloignée d'elle-m tend vers la mienne, et cela jusque dans ce que l'i comme l'euphorie amoureuse, la communion extatiq lque. Je ne peux aimer l'autre que dans la passion Celui-ci survient pas, il ne survient pas comme l chance ou la négativité. Il a la forme de l'affirmatio est la chance du désir. Et il ne coupe pas seulement durées, ô espace. Le contretemps dit quelque chose

Édition T.R.A.N.S.I.T.I.O.N
L'Age d'Homme
5 rue Férou
75006 PARIS
Tel: (1) 46341691
Fax: (1) 42517102

Hiver 95

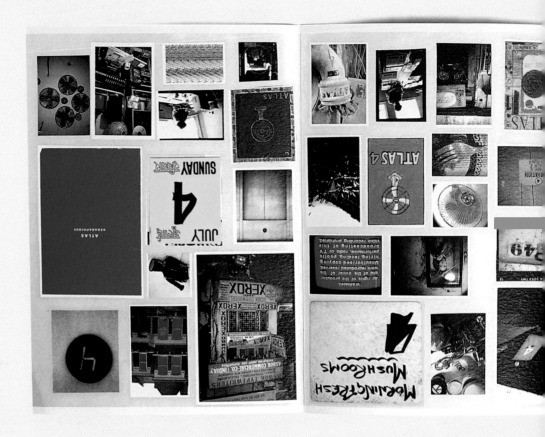

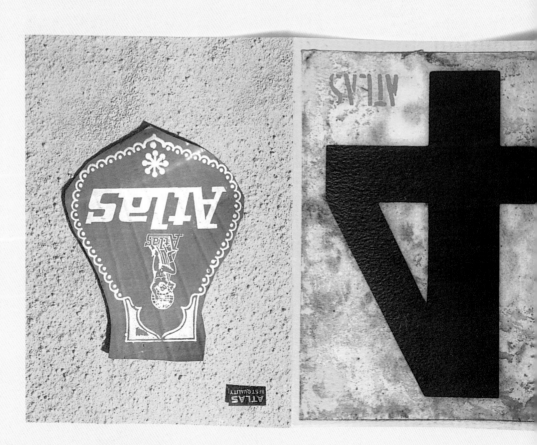

found art Jake Tilson & David Blamey

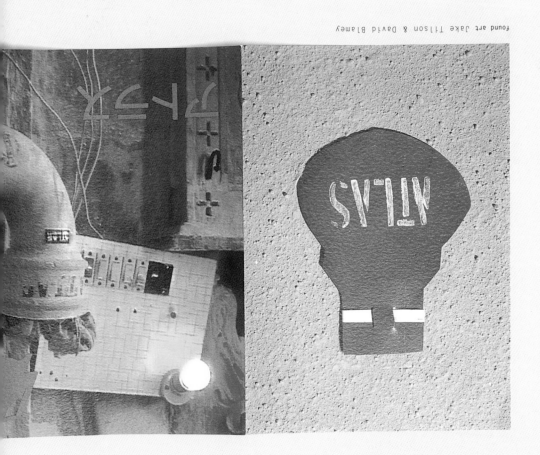

pages 16-19

Atlas

art director
Jake Tilson

designer
Jake Tilson

editor
Jake Tilson

publisher
Atlas

origin
UK

dimensions
210 x 280 mm
8¼ x 11 in

found art Jake Tilson & Oliver Whitehead

ジョドプールの
ロンドンの
マドリッドの
ジャイサルメルの
ストックホルムの
ウダイプールの
クエンカの
ボンベイの

Jódhpur
London
Madrid
Jaisalmer
Stockholm
Udaipur
Cuenca
Bombay

FOUNDSOUNDS

サウンド発見

audio CD Jake Tilson

ジェイク・ティルソン

世界 8 都市で
路傍に忘れ去られた
オーディオカセットを再編集。

ファウンドサウンドは
拾い集めた音楽の断片を
現地で収録しました。
ステレオ収録しました
CDは各ロケーションの
「街の音」とともに
送ります。

trozos de cinta de cassette
encontrados en la calle en
ocho ciudades.

scraps of audio-cassette
tape found by the roadside
in eight cities.

SONIDOSREUNIDOSFOUNDSOUNDS

combina estos fragmentos
de música al azar con
sonido local grabado en
cada cuidad.

combines these random
fragments of music with
local sound recorded in
each city.

El sonido local grabado
en estéreo en cinta audio digital
en cada punto.
Cada CD va acompañado de una
fotografía.

The local sound was recorded
in stereo onto digital audio
tape at each location.
A photograph of each site
accompanies the CD.

Sonido local: 4 minutos cada uno.
Sonido encontrado: 10 segundos cada uno.
Duración del CD: 80 minutos.
bandas extras + extra tracks

Location sound: 4 minutes each.
Found sound: 10 seconds each.
Duration of CD: 80 minutes.

Jake Tilson

ロケーションサウンド：各4分
ファウンドサウンド：各10秒
CD収録時間：80分
9曲の追加トラック付

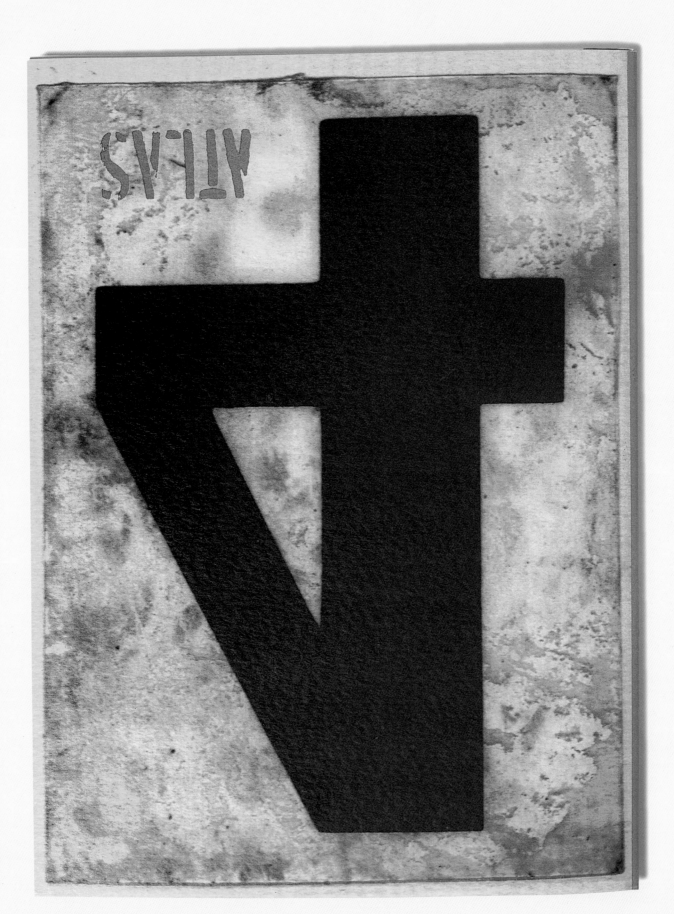

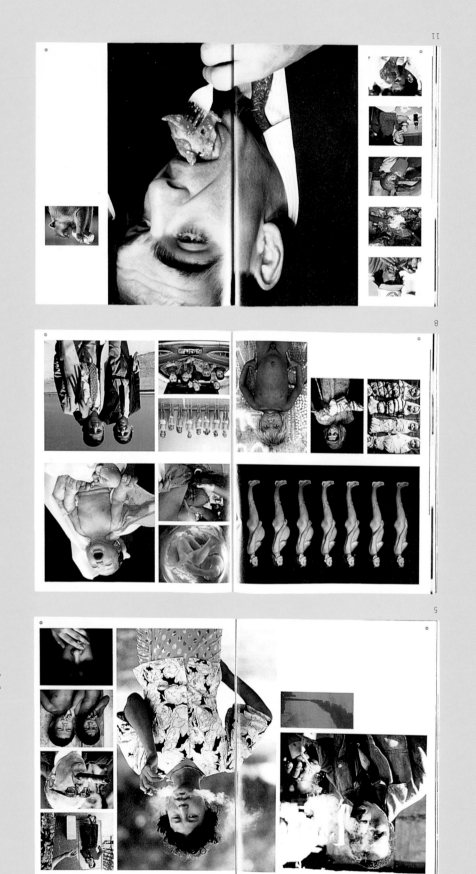
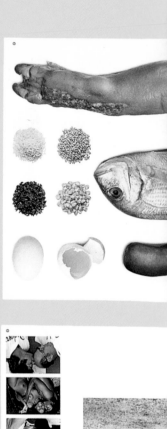
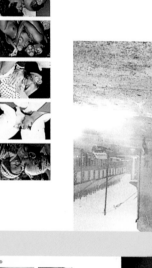

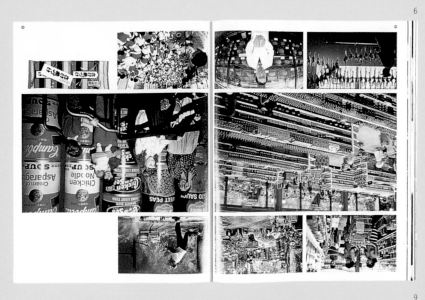

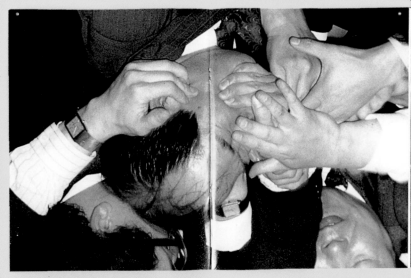

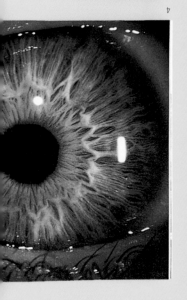

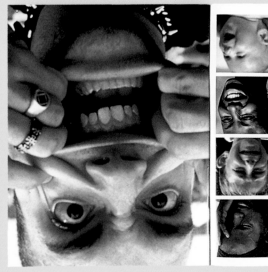

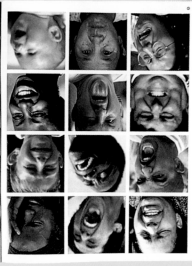

2

pages 12-15

Colors

art director Fernando Gutiérrez
designers Fernando Gutiérrez
Leslie Mello
editor-in-chief Tibor Kalman
publisher Benetton Group SpA
origin Italy
dimensions 230 x 286 mm
9 x 11¼ in

photographers 1 Roberto Villa, Marka Iris
2 Antonio Rosario, John Banagan,
Pete Turner, Harald Sund,
H. De Latude, Tad Janocinski
3 David Turnley, Olympia,
Titolo, Richard Martin,
Maggie Steber, Eligio Paoni,
Philip J. Griffiths,
Chris Steele Perkins, Haviv,
Abrahams, Glame, R. Benali
4 Joe McNally, Penny Gentieu,
Jean Pierre Saunier,
Oliviero Toscani, George Grall
5 Reza, Sandro Tucci, P. Howell,
Bruno Barbey, Rainer Drexel,
Philippe Crochet, McVay
6 Yeohong Yoon

7 Gilles Peress, Malcolm Linton,
Ylarion Capucci, Mary Ellen Mark,
Jodi Cobb, Joseph Rodriguez,
Frank Spooner
8 Zefa, Claude Coireault,
Pascal and Maria Marechaux,
Hans Madej, Lennart Nilsson
9 Michael Friedel, ABC Carpet
and Home, Kirk McKoy,
Jeff Jacobson, Sergio Merli,
Michael Wolf, Pagnotta Da Fonseca,
Marka, Fernando Bueno
10 Philip Dowell
11 Thomas Hoepker, Robert Caputo,
Louise Gubb, C. Vaisse,
Anna Fox, Luigi Volpe

una rivista che parla del resto del mondo **a magazine about the rest of the world**

COLORS

13

warning: this magazine contains no words. start here ▶

attenzione:
in questa
rivista non ci
sono parole.
comincia qui ▶

DIC 95 · FEB 96

Arg 3 pesos | Aus 4.95A$ | BRD DM6.50 | Can 4C$ | Esp 450Ptas | Fr 20FF | Hellas 750DR | HK HK$35 | India Rs.100 | Ire IR£2 | Ital L6.000 | Mag 250FT | Mex 9$ | Nederl 7,95FL | Port 520$00 | SA 9R | UK £2 | USA $4.50

Word

Foreword

Due to their rapid turnaround and ability to react swiftly to fashions and events, magazines are able to adopt a position that is considerably more experimental and outspoken than that of many other publications.

The work displayed in *Typographics 2* demonstrates that the quality and diversity of approaches to design have a global reach. Examples have been gathered from the United States, South America, Europe, the Far East, and Australia. They include publications that may be bought from mainstream outlets, and those that might only be found by chance in obscure art stores. Magazines produced by large corporations working with big budgets are shown side by side with those created by quixotic individuals surviving merely on ingenuity and originality. Computer software has allowed typographers the space to experiment without incurring huge costs: the opening spread to "Cybertype Medium" employs a typeface that was created by scanning in letters that had originally been produced with a potato-cut print. This intriguing fusion of imagination and technology is precisely what *Typographics 2* aims to capture.

RW

TWO

CYBER

TYPE

TYPOGRAPHICS

Foreword

2

The second volume in a series devoted to highlighting the best in global typography, *Typographics 2* focuses primarily on a single form of publication: the magazine.

The work included here reflects the role that the computer continues to play in shaping the genre of the magazine, freeing the layout and subverting typographic conventions to develop a new style of information presentation. This portfolio demonstrates the various ways in which designers are addressing the concept of cybertype, both as a condition of layout and as a form of computer-generated and screen-composed typography. The material has been grouped to represent typographics ranging from minimalist "cybertype light" to the dense textual layers of "cybertype bold." Within cyberspace, the computer is able to imitate the printing press, CD, and video - resulting in a potential for freeform typography that is no longer bound to the static page. Although this collection is presented in book format which precludes manipulation at the touch of a button, it nevertheless displays both the liberation that has been granted by technology and the scope of a new space which designers both shape and are shaped by.

It is difficult to isolate the characteristics that define a magazine: regular publication; specific themes; a diversity of features; coverage of the most up-to-date information on a chosen subject; a particular format - there are evident and deliberate exceptions to every rule. But if one common thread can be drawn, perhaps it is that of the freedoms and restrictions generated by a distinctive creative pressure. Partly the result of deadlines and partly brought about by the struggle to remain economically viable, this type of pressure can produce dynamic design.

contents

Foreword 6

Cybertype Light 10

Cybertype Medium 82

Cybertype Bold 152

Index 220

Acknowledgments 224

Future Editions 224

CONTENTS

00.01 00.02 00.03

Cybertype

TYPOGRAPHICS 2 >

Cybertype

CYBERTYPE >

Typographics 2 is published here
for the first time with
Typographics 1

Each title first published
separately by Hearst Books
International. Now published by
HBI, a division of
HarperCollins Publishers
10 East 53rd Street
New York, NY 10022-5299
United States of America

ISBN 0688-17875-8

Distributed in the United States
and Canada by:
North Light Books, an imprint of
F & W Publications, Inc.
4700 East Galbraith Road
Cincinnati, Ohio 45236
Tel: (800) 289 0963

Each title first published
separately in Germany by:
NIPPAN
Nippon Shuppan Hanbai
Deutschland GmbH
Krefelder Str. 85
D-40549 Dusseldorf
Telephone: (0211) 5048089
Fax: (0211) 5049326

ISBN 3-931884-54-6

Typographics 2
Copyright © Hearst Books
International and Duncan Baird
Publishers 1996
Text copyright © Duncan Baird
Publishers 1996

All rights reserved. No part of
this book may be reproduced in
any form or by any electronic
or mechanical means, including
information storage and retrieval
systems, without permission in
writing from the copyright owners,
except by a reviewer who may quote
brief passages in a review.

Edited and Designed by
Duncan Baird Publishers
Sixth Floor
Castle House
75-76 Wells Street
London W1T 3QH

Designers: Gabriella Le Grazie
(Typographics 2); and Karen Wilks
(Typographics 1)
Editor: Lucy Rix (Typographics 2
and 1)

Commissioned artwork: (pages
1-11, 82-3, 152-3) The Attik
Design Limited

10 9 8 7 6 5 4 3 2

Typeset in Letter Gothic MT
(Typographics 2); and Rotis Sans
Serif (Typographics 1)
Color reproduction by Colourscan,
Singapore
Printed in China

NOTES

Dimensions for spread formats are
single page measurements; all
measurements are for width
followed by height.

➤ When this arrow appears in a
caption it indicates that the
artwork referred to is displayed
on either the previous spread or
the spread following.

◀ When this arrow appears on a
spread it indicates that the
artwork has been displayed
horizontally rather than
vertically.

typographics 2 cybertype

**typographics 2
cybertype**

'zines + screens

general editor: roger walton

Typographics2 cybertype

DATE LABEL AT OTHER END of Book !

Please return book on or before last date stamped below

AYLESBURY COLLEGE LIBRARY
OXFORD ROAD
AYLESBURY, BUCKS, HP21 8PD
Tel: 01296 588588